Well Done

SFA 90⁺ Years and Cooking

Compiled by
Kimberly Verhines

STEPHEN F. AUSTIN STATE UNIVERSITY PRESS
2016

Special thanks to University Photographer, Hardy Meredith, for his patience and generosity, and to the faculty and staff of Stephen F. Austin State University whose recipe contributions made this book possible. Ax 'em Jacks!

The photo of tall pines is by Nesha Cowart, local winner of ImageMakers National Photography Program sponsored locally by the Nacogdoches Photographic Association, SFA Gardens education staff, and the local Boys and Girls Club.

Printed in China by
Everbest Printing Company through FCI Print Group
1st Edition
ISBN: 978-1-62288-400-1

Stephen F. Austin State University Press
P.O. Box 13007 SFA Station
Nacogdoches, TX 75962
sfapress@sfasu.edu
sfasu.edu/sfapress
936.468.1078

Distributed by Texas A&M University Press Consortium
tamupress.com
800.826.8911

The paper used in this pubication is acid free and meets the minimum requirements of the American National Standard for Permanence of Paper for Printed Library Materials Z39.48-1992

Ashton Allen, Copy Editor
Shaina Hawkins, Editorial Assistant
Tinesha Mix, Copy Editor

LIBRARY OF CONGRESS CATALOGING-IN-PUBLICATION DATA
Verhines, Kimberly D.
Well Done: SFA 90+ Years and Cooking

Endsheets: SFA Official Tartan designed by Kelcie Brown and manufactured by Collegiate Tartan Apparel.

ABOUT THE DESIGN: The tartan I designed displays the colors that run through each true Lumberjack, purple, white, light grey, and black. The first ninety threads of purple represent the 90 years the university has been opened and teaching the great individuals of tomorrow. The last four rows of thirty threads of purple represent the 430 acres the main campus of Stephen F Austin sits on in the oldest town in Texas. The twelve threads of Wilson white communicate the over 12,000 students enrolled in Stephen F Austin State University. The 120 areas of studies are shown in the six and eight threads of the black; six for the sixty graduate studies and eight for the eighty undergraduate studies. Lastly, the two six light grey threads are stitched into the tartan, one representing 1960, the year Chief Caddo, the seven and a half foot, 330 pound wood trophy for the winner of the SFA and Northwestern State football game, was made and one representing 2006, the year our current President, Dr. Baker Pattillo, took over as leader of the university. The colors and patterns represent SFA and what it means to have Purple Pride. -Kelcie Brown

How tall the pines are standing;
How tall they brush the sky!

Oh future bright 'neath the
Purple and White
All hail to SFA.
'Mid Texas pines we have
Found peaceful shrines
Where ev'ry month is May.
Long live our Alma Mater,
Honor to thee for aye.
As years unfold, happy
Mem'ries we'll hold,
All hail to SFA.

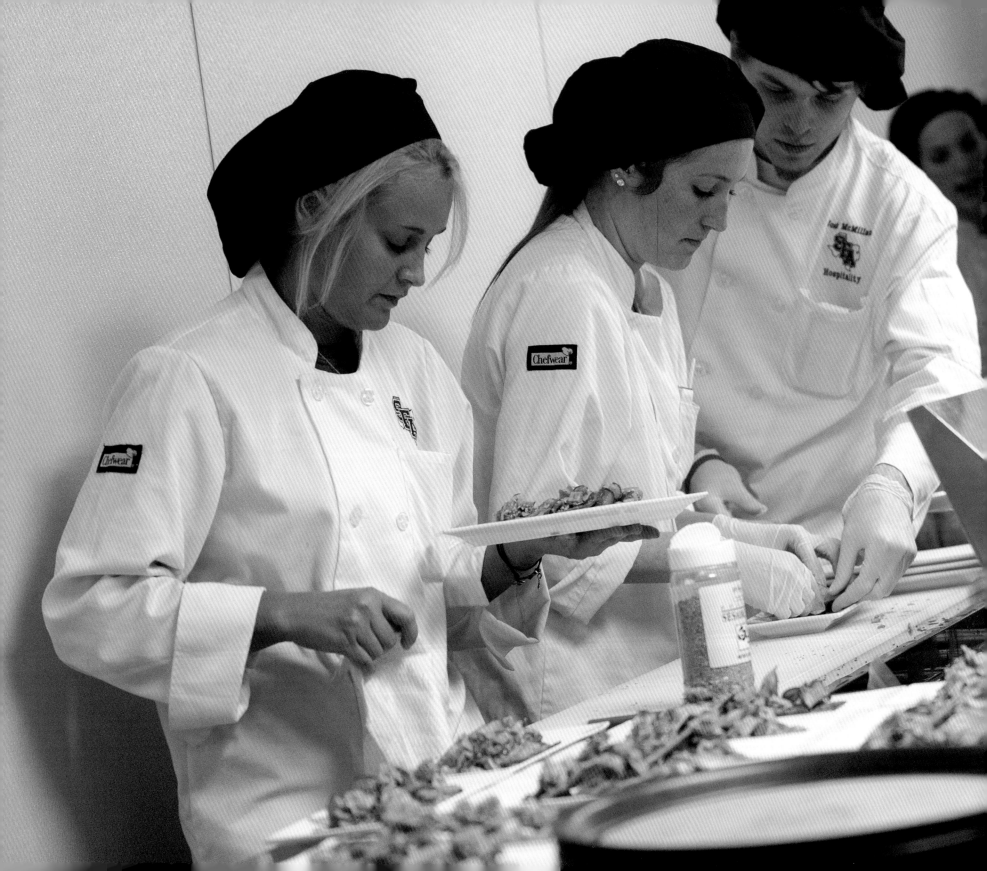

Contents

Chips, Dips, & Sips

Dinner parties or pot-luck events can sometimes be a little intimidating if you happen to not be a seasoned chef in the kitchen… While I love attending these events, cooking for them is definitely not my forte. However, as some friends and I like to joke, while we may not be gourmet chefs for dinners, we can sure make some mean appetizers! Trendy new restaurants and fancy steakhouses are a blast, but my favorite meal would have to be an appetizer buffet. I get excited to go to weddings or baby showers in part because I know they will involve a glorious appetizer spread where I can politely and unobtrusively stuff my face.

When it comes to chips and dip, my go-to favorite is Buffalo Chicken Dip (with Santitas tortilla chips and celery). One of my best friends from college gave me the recipe, and I still use it to this day as a tasty, low-fuss and easily transportable dip.

One important ingredient to any appetizer situation involving chips and dips is, of course, "sips." My co-workers at the Alumni Association know that when we are out to dinner, more often than not, I will pick out the craziest drink to try on a restaurant cocktail menu. (Note: Do NOT try a Red Hot Margarita…SERIOUS heartburn will occur). Beer and wine are great, but I like to try new drinks, things you just wouldn't make or pour at home on a random Tuesday night. For instance, after some events, like the Texas Blueberry Festival celebrated in Nacogdoches each summer, I like to incorporate fun concoctions like Blueberry Vodka Punch for those who like to cool off and relax after attending the festival. The punch has become an important tradition and a great way to beat the June heat!

SFA football games are definitely important events, and the Alumni Association is in charge of the Alumni Corner tailgate before each home football game in the fall. One of my most exciting duties for the tailgate is helping to choose each game menu. If you haven't been, you need to stop by and try some of the delicious food we have.

Each tailgate is themed based on the football team we play, which makes it even more fun. Our food ranges from a make-your-own-nacho bar to Cajun meat pies to bacon on a stick to potato salad shooters. One of the crowd favorites is a ranch dip made by our caterer that will knock your socks off and is a top request for every tailgate. Our caterer also makes the BEST punch known to man, Crystal Almond Punch, but I think they have to sign a secret agreement to never tell anyone the recipe…and believe me, I've tried hard to get it.

—Samantha L. Mora

Purple Pride Punch

One large container of Welch's Grape Juice (It has to be Welch's or you are not going to get a good purple.)
One large container of pineapple juice
One 2 liter of Sprite

Mix everything up together in a large bowl and serve cold! You can make punch ahead of time and pour it into ice cube trays and make punch ice cubes to put in the punch bowl, so that the punch would not get watered down from regular ice cubes.

Blueberry Vodka Punch

2 cups Vodka
1 bottle 7-Up or Sprite
1 bottle Hawaiian Punch Berry Blue Typhoon
1 cup Blueberries

Put ingredients into a punch bowl or beverage canister, mix, then enjoy.

Dream Bigger Menu

Slam Dunk Sliders with Sweet and Spicy Coleslaw

March Madness Meatballs

Three Point Fries

Man-to-Man Snack Mix

Nothing but Net Quesadillas

Whoopie Pies

Slam Dunk Sliders with Sweet and Spicy Coleslaw

BBQ

 3 teaspoons vegetable oil
 1 pork shoulder roast (4-5 pound) trimmed
 1 cup of your favorite barbeque sauce
 1/2 cup apple cider vinegar
 1/2 cup chicken broth
 1/3 cup brown sugar—light or dark
 1 tablespoon prepared yellow mustard
 1 tablespoon Worcestershire sauce
 1 1/4 tablespoons chili powder
 1 extra large sweet onion, chopped
 2 large cloves garlic, crushed
 1 teaspoon cayenne pepper
 2-3 packages King's Hawaiian dinner rolls
 4 tablespoons butter, or as needed

Pour 3 teaspoons vegetable oil into the bottom of a slow cooker. Add the pork roast. In a large bowl, combine the next 10 ingredients and mix well. Pour over the roast. Cover and cook on High 5-6 hours or until the roast shreds easily with a fork.

Remove the roast from the cooker and, using two forks, shred the meat. Return the shredded pork to the slow cooker, stirring the meat into the sauce. Spread both halves of King's Hawaiian rolls with butter and lightly toast, butter side down, in a skillet over medium heat. Spoon pork into the toasted buns and garnish with spicy coleslaw.

SWEET AND SPICY COLESLAW

 1 pound red cabbage
 1 pound green cabbage
 5 carrots
 1 medium sweet onion
 1/2 cup mayonnaise
 1/4 cup mustard
 2 1/2 teaspoons apple cider vinegar
 3/4 -1 cup sugar
 1 teaspoon black pepper
 1/4 teaspoon cayenne pepper or more to taste
salt to taste

Shred cabbage, carrots, and onion and toss together in a large bowl. In another medium bowl, prepare the dressing by whisking together the mayonnaise, mustard, cider vinegar, sugar, black pepper, and cayenne. Toss dressing with the cabbage mixture and season with salt to taste. Cover with plastic wrap and chill for at least 2 hours before serving.

Whoopie Pies

CAKE

 1 box cake mix
 1/3 cup water
 3 tablespoons oil
 2 eggs

FILLING

 1 stick softened butter
 1 (8 ounce) package cream cheese
 1 1/2 teaspoons vanilla
 3 cups confectioners' sugar
 food coloring for desired color

Preheat oven to 350 degrees. Mix all cake ingredients together on low speed for 30 seconds and on medium for 2 minutes. Using a small ice cream scoop (1 tablespoon), drop dough onto greased cookie sheet (leave 1 1/2 – 2 inches between each.)

Bake 8-9 minutes. Cool thoroughly on cooling rack.

Combine butter and cream cheese in a mixing bowl, add vanilla, add confectioners' sugar, slowly, mixing well. Add food coloring and mix thoroughly.

Using small ice cream scoop, drop filling on center of underside of cake cookie, top with another cake cookie and apply a bit of pressure to distribute filling. Continue with remaining cake cookies until all whoopie pies are assembled.

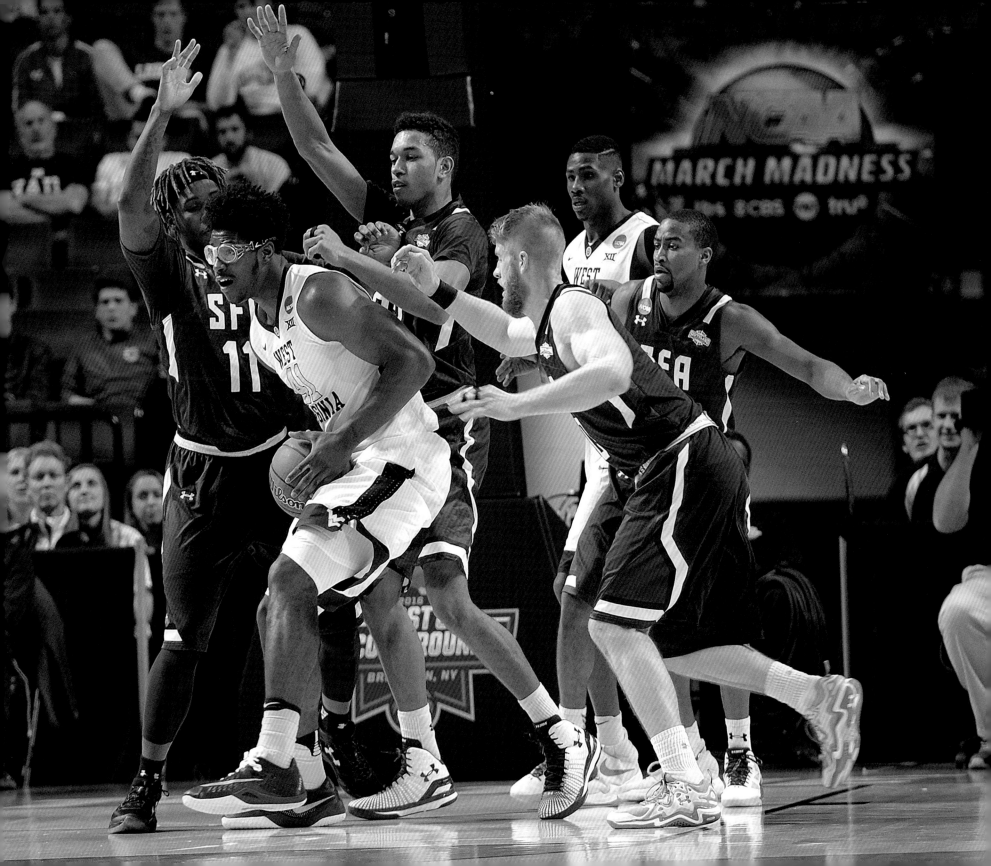

Three Point Fries

THE FRIES

 15 ounces frozen French fries (Ore Ida or your
 favorite frozen French fries)

THE BONELESS WING INGREDIENTS

 oil for deep frying 4-6 cups
 1 cup unbleached all-purpose flour
 2 teaspoons salt
 1/2 teaspoon ground black pepper
 1/2 teaspoon cayenne pepper
 1/4 teaspoon garlic powder
 1/2 teaspoon paprika
 1 egg
 1 cup milk
 3 skinless, boneless chicken breasts, cut into
 1/2-inch strips
 1 cup grated sharp cheddar cheese
 1/3 cup chopped green onions

THE HOT SAUCE

 1/2 cup Louisiana hot sauce
 1/4 cup butter
 1 tablespoon white vinegar

Heat oil in a deep-fryer or large saucepan to 375 degrees. Combine flour, salt, black pepper, cayenne pepper, garlic powder, and paprika in a large bowl. In another bowl, whisk the egg and milk together in a small bowl. Dip each piece of chicken in the egg mixture and then roll in the flour blend. Repeat milk and flour dip, so each piece of chicken has two coats. Refrigerate breaded chicken for 20 minutes.

Fry chicken in the hot oil, in batches. Cook until the exterior is nicely browned, and the juices run clear, 5 to 6 minutes a batch. Drain on paper towel covered plate and place aside.

Bake French fries on large cookie sheet according to package directions.

In a small saucepan combine hot sauce, vinegar and butter on medium heat until butter is melted and well combined. Set aside.

Arrange cooked chicken pieces on top of fries and drizzle with 1/2 of the hot sauce mixture. Cover with grated cheese and drizzle with remaining hot sauce. Place under broiler until the cheese is melted (2-3 minutes). Garnish with green onions and serve with blue cheese and avocado ranch dip.

 **Time saver: Make dips a day before.

Blue Cheese Dip

 4 ounces crumbled blue cheese
 3/4 cup mayonnaise
 1/4 cup sour cream
 1 tablespoon red wine vinegar
 1 tablespoon lemon juice
 1/4 teaspoon garlic powder
 Salt and pepper

In a bowl, combine blue cheese, mayonnaise, sour cream, vinegar, lemon juice, and garlic powder, stirring well. Season with salt and pepper. Cover and chill for 2 hours.

Ranch Dip

 1 (16 ounce) container sour cream
 1 (8 ounce) package cream cheese
 1 (1 ounce) package ranch dressing mix
 1/4 teaspoon garlic salt
 1/4 teaspoon celery salt
 2 avocadoes, peeled and pitted

Using a mixer or food processor, combine the sour cream, cream cheese, ranch dressing mix, garlic salt, and celery salt.

In another bowl, mash the avocados and mix in the sour cream mixture until well blended. Cover and chill until serving.

Center-Court Meatballs

 1 pound lean ground beef
 1 egg
 2 tablespoons water
 1/2 cup bread crumbs
 3 tablespoons minced onion
 1 (8 ounce) can jellied cranberry sauce
 3/4 cup chili sauce
 1 tablespoon brown sugar
 1 1/2 teaspoons lemon juice

Preheat oven to 350 degrees. In a large bowl, mix together the ground beef, egg, water, bread crumbs, and minced onion. Roll into small meatballs. Bake in preheated oven for 20 to 25 minutes, turning once.

In a slow cooker or large saucepan over low heat, blend the cranberry sauce, chili sauce, brown sugar, and lemon juice. Add meatballs and simmer for 1 hour before serving.

Man-To-Man Chex Mix

 3 cups Crispix
 2 cups Corn Chex, Wheat Chex, and Rice Chex
 1 cups pretzel sticks
 1 cup Cheez-It crackers
 2 cups Mixed Nuts
 1 1/2 Sticks Butter)
 4 Tablespoons Worcestershire Sauce
 6 dashes to 12 dashes Tabasco Sauce
 1 1/2 tsp garlic powder
 1 1/2 teaspoon Lawry's Seasoned Salt
 1/2 teaspoon Onion Powder
 1 - 2 teaspoons cayenne pepper

Dump cereal into a large mixing bowl. Add in pretzel sticks, Cheez-Its, and nuts. In a microwave-safe bowl, add remaining ingredients and microwave until butter is melted. Stir together and toss into cereal mixture, coating cereal.

Transfer mix onto one or two baking sheets and bake in a 250-degree oven for 1 hour and 15 minutes, stirring every 15 minutes. Let cool and store in an airtight container

Nothing but Net Quesadillas

Makes 4 servings.

4 cups coarsely shredded purchased roasted
 chicken

8 (7 inch) whole wheat flour tortillas

1 cup feta cheese

1/2 cup thinly sliced red onion

1/2 cup chopped cucumber

1/2 cup grape tomatoes, halved lengthwise

1/2 cup Kalamata olives, halved

4 tablespoons whole flat leaf (Italian) parsley
 leaves

2 tablespoon whole fresh oregano leaves

1/2 cup bottled Greek vinaigrette salad dressing

nonstick cooking spray

Coat one side of each tortilla with cooking spray.
Place tortillas, sprayed sides down, on a cutting board
or parchment paper. Sprinkle with chicken, feta cheese,
red onion, cucumber, grape tomatoes, olives, parsley,
and oregano. Drizzle with dressing. Fold tortillas in
half, pressing gently.

Heat a large nonstick skillet over medium heat for 1
minute. Cook quesadillas, two at a time, over medium
heat for 3 to 5 minutes or until light brown, turning
once. Remove quesadillas from skillet; place on a
baking sheet. Keep warm in a 300 degree oven. Repeat
with remaining quesadillas. To serve, cut each quesadilla
into three wedges.

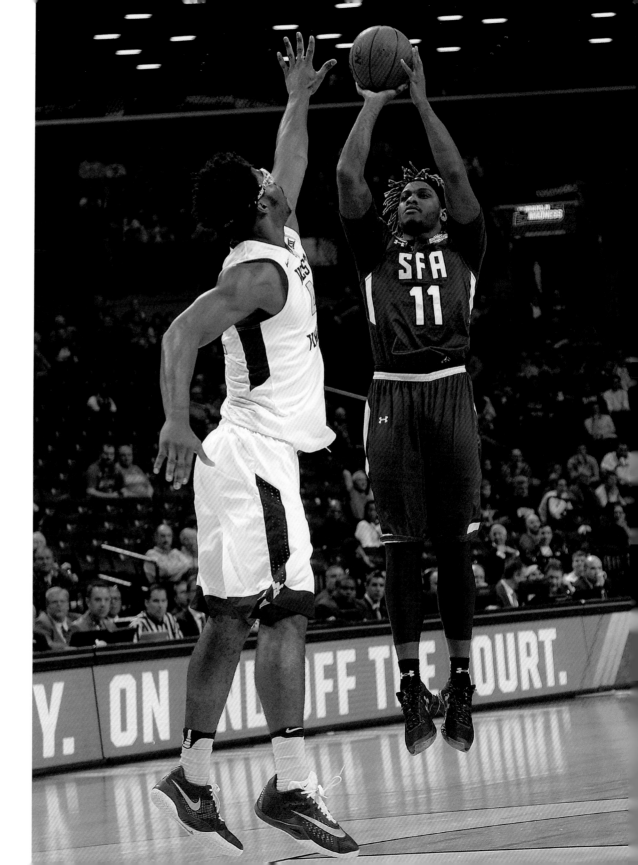

Blackened Shrimp

4 servings

32-36 unpeeled, large raw Gulf shrimp
2 teaspoon olive oil
3 teaspoons Cajun blackened seasoning
16 wooden skewers
32 fresh blackberries
16 fresh mango slices—about 3 mangoes

Light grill (medium heat if possible). Peel shrimp, leaving tails on; de-vein, if desired. Place shrimp in a large bowl, and drizzle with olive oil. Sprinkle with seasoning, and toss to coat. Grill shrimp, covered with grill lid, 2 to 3 minutes on each side or just until shrimp turn pink.

Thread each skewer with 2 grilled shrimp, 2 blackberries, and 1 mango slice.

PomPom Punch

Makes 50 (1/2 cup) servings

4 ripe bananas
2 cups white sugar
3 cups water
1 (46 ounce) can pineapple juice
2 (12 ounce) cans frozen orange juice concentrate
1 (12 ounce) can frozen lemonade concentrate
3 cups water
3 liters ginger ale

In a blender, combine bananas, sugar, and 3 cups water. Blend until smooth. Pour into a large bowl and stir in pineapple juice. Blend in orange juice concentrate, lemonade concentrate, and 3 cups water. Divide into 3 plastic containers and freeze until solid.

Remove from freezer 3 to 4 hours before serving. Using one portion at a time, place slush in a punch bowl and pour in 1 liter of ginger ale for each.

Jacks Charge Punch

13 servings

4 cups brewed vanilla-flavored coffee, cooled
1 can (12 ounces) evaporated milk
1/2 cup sugar
1/2 gallon Kroger Private Selection Vanilla
 (or your favorite vanilla) ice cream, softened
ground cinnamon

In a large container, combine the coffee, milk, and sugar stir until sugar is dissolved (I add my sugar to the coffee while it is still hot; it seems to dissolve the sugar better). Spoon ice cream into a punch bowl; pour coffee mixture over the top. Sprinkle with cinnamon. Serve immediately. (Sometimes I add some extra coffee and some extra regular milk just to make a little more.)

Axe Handle Punch

Makes 50 (4 ounce) servings

2 1/2 cups white sugar
6 cups water
2 (3 ounce) packages strawberry flavored Jell-O
1 (46 ounce) can pineapple juice
2/3 cup lemon juice
1 quart orange juice
2 (2 liter) bottles lemon-lime carbonated beverage

Bring the sugar, water, and strawberry flavored gelatin to a boil in a large saucepan; boil for 3 minutes. Stir in the pineapple juice, lemon juice, and orange juice. Divide mixture into 2 separate containers and freeze.

Combine the contents of 1 container with 1 bottle of the lemon-lime flavored carbonated beverage in a punch bowl; stir until slushy. Repeat with remaining portions as needed.

Torch Light Tacos

6 - 8 servings

1 pound ground beef
1 (1.25 ounce) package taco seasoning mix
36 wonton wrappers
1 (16 ounce) can refried beans
36 tortilla chips
2 cups shredded cheddar cheese
 optional toppings: sour cream, diced tomatoes,
 cilantro, onion, olives, or diced avocado.

Preheat the oven to 375 degrees. Spray 18 muffin cups with cooking spray. Brown beef in a skillet and drain the fat. Add the taco seasoning mix and water called for on the package and simmer for 4-5 minutes. Set aside.

Place one wonton wrapper in the bottom of each muffin cup. Layer about 1 tablespoon of refried beans on top of each wonton. Crush one tortilla chip on top of the beans. Top with 1 tablespoon of taco meat and 1 tablespoon of shredded cheese.

Repeat the layers again with a wonton wrapper, refried beans, tortilla chips, taco meat, and cheese. Bake for 15-18 minutes or until golden brown. Remove from pan and top with your favorite toppings.

Pre-Game Burners

Makes 12 jalapeño burners

12 unpeeled medium-size fresh shrimp
12 jalapeño peppers
6 bacon slices, halved lengthwise

Peel shrimp. De-vein, if desired. Cut a slit in each jalapeño pepper; remove seeds and membranes. Carefully place one shrimp in cavity of each pepper.

Wrap each pepper with 1 bacon piece and secure with a wooden pick. Place in a jellyroll pan. Broil 5 1/2 inches from heat 6 to 7 minutes on each side, or until bacon is cooked. Serve warm.

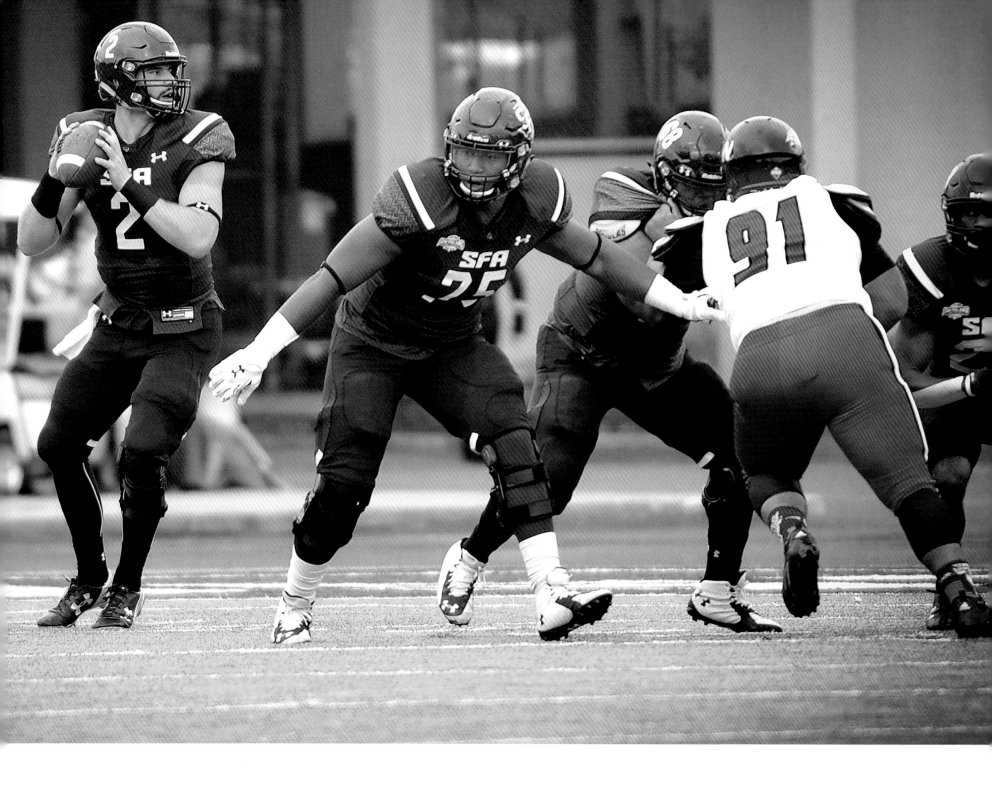

Battle Cry Bruchetta

1 (16-ounce) French bread loaf
1 medium-sized purple onion, finely chopped
1 teaspoon sugar
2 tablespoons olive oil
25 small basil leaves
1 (7-ounce) jar roasted red bell peppers, drained
 and cut into thin strips
1 (3-ounce) package goat cheese, crumbled

Cut bread into 24 slices, place on baking sheets, and broil slices 5 1/2 inches from heat 1 minute on each side or until golden brown. Set aside.

Cook onion and sugar in hot oil in a large skillet over medium-low heat, stirring occasionally, 25 minutes and then cool.

Top bread evenly with onion mixture, basil leaves, and pepper strips. Sprinkle evenly with cheese and broil 1 minute or until cheese melts. Serve immediately.

Yummy Olive Crostini

1 (4 1/4-ounce) can chopped black olives,
 drained
1/2 cup pimiento-stuffed olives, chopped
1/2 cup shredded Parmesan cheese
4 tablespoons butter or margarine, softened
2 garlic cloves, minced
3/4 cup (3 ounces) shredded Monterey Jack
 cheese
1/4 cup chopped fresh parsley
1 (8-ounce) French baguette, cut into 1/4-inch-
 thick slices

Combine chopped black olives and next 6 ingredients. Top each bread slice evenly with olive mixture. Arrange on baking sheets.

Broil, with oven door partially open, 3 to 4 minutes or until topping is bubbly and golden.

Go Jacks Sandwiches

24 pumpernickel party-sized rye bread slices
3 tablespoons butter or margarine
3 tablespoons all-purpose flour
1 cup milk
1 1/2 cups shredded sharp cheddar cheese
1 1/2 cups diced cooked turkey
1/4 teaspoon salt
1/4 teaspoon ground red pepper
1/2 cup freshly grated Parmesan cheese
7 bacon slices, cooked, crumbled, and divided
6 cherry or grape tomatoes, thinly sliced

Arrange bread slices on a lightly greased baking sheet and broil 6 inches from heat until lightly browned.

Melt butter in a saucepan over low heat; add flour, and cook, whisking constantly, until smooth. Gradually add in milk; cook over medium heat, stirring constantly until thick and bubbly. Add cheese, stirring until cheese melts. Stir in diced turkey, salt, and ground red pepper.

Top bread evenly with warm cheese-turkey mixture and sprinkle with Parmesan cheese and half of bacon.

Bake at 425 degrees for 2 minutes or until Parmesan is melted. Top with tomato slices and sprinkle with remaining bacon.

Game Day Cheese Spread

2 (8-ounce) packages light cream cheese, softened
1 cup (4 ounces) shredded cheddar cheese
3 green onions, finely chopped
3 canned chipotle peppers in adobo sauce
1 teaspoon adobo sauce from can
1/2 teaspoon Creole seasoning
1/2 teaspoon ground cumin
1/2 teaspoon chili powder
1/4 teaspoon Worcestershire sauce
1/8 teaspoon hot sauce
1/3 cup chopped pecans, toasted
assorted crackers
garnishes: green onion curls, pecan halves

Combine cream cheese and next 9 ingredients in a food processor and pulse 3 times, stopping to scrape down sides. Stir in toasted pecans and chill 2 hours. Garnish, if desired. Serve with assorted crackers and vegetables.

Southwestern Chicken Chimichangas

2/3 cup picante sauce or your favorite salsa
1 teaspoon ground cumin
1/2 teaspoon dried oregano leaves, crushed
1 2/3 cups cooked chicken, chopped
1 cup shredded cheddar cheese
1/3 cup chopped green onions with tops
6 (8 inch) flour tortillas
3 tablespoons butter, melted
shredded cheddar cheese, for serving
chopped green onion, for serving
picante sauce, for serving

Mix chicken, picante sauce or salsa, cumin, oregano, cheese, and onions. Place about 1/4 cup of the chicken mixture in the center of each tortilla. Fold opposite sides over filling.

Roll up from bottom and place seam-side down on a baking sheet and brush with melted butter. Bake at 400 degrees for 25 minutes or until golden. Garnish with additional cheese and chopped green onion and serve salsa on the side.

Bacon Wrapped Chestnuts
Makes about 32 appetizers

2 (8 ounce) cans water chestnuts, drained
1/3 cup soy sauce
1/3 cup brown sugar
10-12 slices bacon, cut in half crosswise

Marinate the chestnuts in soy sauce for 1 hour. Drain. Roll each chestnut in the brown sugar and wrap each chestnut with a piece of bacon and secure with a toothpick. Arrange on a cake rack in a shallow baking pan. Bake at 400 degrees for about 30 minutes or until golden brown. Drain on paper towels.

NOTE: These can be prepared ahead of time and stored in refrigerator until ready to bake.

Southern Fruit Dip

1 (8 ounce) package cream cheese, softened
1/2 cup firmly packed brown sugar
1 cup sour cream
1 teaspoon vanilla extract
1/3 cup coffee liqueur (Kahlúa)
1 cup frozen whipped topping, thawed

Mix cream cheese and brown sugar at medium speed with an electric mixer until smooth. Add next three ingredients, beating well; fold in whipped topping. Cover and chill 4 hours. Garnish with brown sugar and serve with assorted fruit.

Axe 'em Jacks Spread

2 (8-ounce) packages cream cheese, softened
1 (9-ounce) jar mango chutney
1 cup slivered almonds, toasted
1 tablespoon curry powder
3/4 teaspoon dry mustard
toasted slivered almonds

Process first 5 ingredients in a food processor until smooth, stopping to scrape down sides. Cover and chill 1-2 hours.

Shape mixture into a round. Chill until ready to serve. Sprinkle with almonds. Garnish, if desired. Serve with assorted crackers.

Bacon-wrapped Game Day Smokies

1 pound sliced bacon (I like Blue Ribbon or
 Wrights) cut into thirds
1 (14 ounce) package beef cocktail wieners
1 cup brown sugar (or to taste)

Preheat the oven to 325 degrees. Cut strips of
chilled bacon into thirds and wrap each cocktail
wiener, securing with a toothpick. Place on a large
baking sheet. Generously sprinkle with brown sugar
and bake for approximately 40 minutes until the
sugar is bubbly. To serve, place the wieners in a slow
cooker and keep on the low setting.

Southern Caviar

1 can black-eye peas (15-ounce), drained
1 can black beans (15-ounce), drained
1 can whole kernel corn (15-ounce), drained
2 large tomatoes, seeded and diced
1 medium onion, diced
1 medium green bell pepper, diced
3 tablespoons minced garlic (about 8 cloves)
1/2 bunch cilantro, chopped (about 1/2 cup)
1 jalapeño pepper, seeded and finely chopped
juice of 1 lime
1 teaspoon Italian seasoning
1 package (.7-ounce) dry Italian dressing mix
 (such as Good Seasons)
1/2 cup extra-virgin olive oil
1/2 cup vinegar

Combine first 11 ingredients (peas through
seasoning) in a large bowl. Stir well. Combine dressing
mix, oil, and vinegar. Pour over pea mixture. Stir well.
Chill at least 2 hours. Serve with tortilla chips.

Purple Haze Shrimp

1 red onion
1 red bell pepper
1 yellow bell pepper
2 pounds peeled and de-veined, large cooked
 shrimp with tails
1 cup ketchup
1/2 cup chopped fresh cilantro
1/2 cup fresh lime juice
3 tablespoons orange zest
1/2 cup fresh orange juice
2 to 3 canned chipotle peppers in adobo sauce,
 chopped

Slice onion and bell peppers into thin strips and
layer with shrimp in a large zip-top plastic freezer bag.
 Whisk together ketchup and next 5 ingredients;
pour over shrimp mixture. Seal and chill 12 to 24
hours, turning bag occasionally. Serve using a slotted
spoon.

Spirit Spinach and Artichoke Dip

2 cups Parmesan cheese
1 (10 ounce) box frozen, chopped spinach,
 thawed
1 (14 ounce) can artichoke hearts, drained and
 chopped
2/3 cup sour cream
1 cup cream cheese
1/3 cup mayonnaise
2 teaspoons garlic, minced

Preheat oven to 375 degrees. Mix Parmesan cheese, spinach, and artichoke hearts. Combine rest of ingredients and stir in spinach mixture. Bake for 20-30 minutes.

Barn Burner Cheesy Chicken Dip

2 (8 ounce) packages cream cheese, softened
1 cup ranch dressing
3/4 cup red hot sauce
1 1/2 cups chicken (canned, rotisserie or
 freshly-cooked)
shredded Cheddar cheese (you decide how much)
Fritos or your favorite corn chips

Beat cream cheese, ranch dressing, and red hot sauce. Fold in shredded chicken. Spread mixture into pie plate sprayed with Pam.
Bake at 350 degrees for 15 minutes. Add cheddar cheese to top. Bake additional 5 or 10 minutes—until cheese is melted. Serve hot with Fritos or your favorite chips.

Buffalo Wing Dip

2 (10 ounce) cans chunk chicken, drained
2 (8 ounce) packages cream cheese, softened
1 cup Ranch dressing
3/4 cup Frank's Red Hot Buffalo Wing sauce
1 1/2 cups shredded Cheddar cheese
salt and pepper to taste

Heat chicken and hot sauce in a skillet over medium heat. Stir in cream cheese and ranch dressing. Cook, stirring until well blended and warm. Mix in half of the shredded cheese and transfer the mixture to a slow cooker. Sprinkle the remaining cheese over the top; salt and pepper to taste. Cover and cook on low setting until hot and bubbly.

Let's Party Spinach Dip

1 cup Duke's or Kraft real mayonnaise
1 (16 ounce) container sour cream
1 (1.4 ounce) package Knorr's vegetable recipe mix
1 (4 ounce) can water chestnuts, chopped
1/4 onion, very finely chopped
1 (10 ounce) package frozen chopped spinach,
 thawed and drained

In a medium bowl, mix together mayonnaise, sour cream, dry vegetable recipe mix, water chestnuts, onion, and chopped spinach. Chill in the refrigerator 6 hours, or overnight.

Duck Dash Dip (aka Black Bean Salsa)

2 medium tomatoes
1 red bell pepper
1 green bell pepper
1 1/2 cups fresh or frozen corn kernels (about
 3 ears fresh corn)
1/4 cup finely chopped purple onion
1 Serrano chili pepper, seeded and minced
1 (15-ounce) can black beans, rinsed and drained
1/3 cup fresh lime juice
1/4 cup olive oil
1/3 cup chopped fresh cilantro
1 teaspoon salt
1/2 teaspoon ground cumin
1/4 teaspoon ground red pepper

Chop tomatoes and bell peppers. Stir together tomato mixture, corn, and remaining ingredients. Cover and chill 8 hours. Serve with tortilla chips.

Go Jacks Guacamole

6 avocados (reserve 2 pits)
1 lime juiced
3 tablespoons mayonnaise
1 clove of pressed garlic
1 medium tomato chopped
1 medium sweet onion chopped
1 teaspoon lime zest
1 teaspoon salt (or to taste)
1/2 teaspoon cayenne pepper (optional)

In a medium bowl, mash together the avocados, lime juice, and mayonnaise. Mix in onion, tomatoes, and garlic. Stir in salt and cayenne pepper.
Refrigerate 1 hour for best flavor, or serve immediately. If storing for more than one day, add avocado pits to mix to help keep guacamole from turning brown.

Axe Grindin' Green Chili Dip

2 (8-ounce) packages cream cheese, softened
2 (8-ounce) blocks Pepper Jack cheese, shredded
16 ounces smoked Cheddar cheese, shredded
6 green onions, minced
2 (4.5-ounce) cans chopped green chilies, drained
1 envelope taco seasoning mix (I use Old El Paso)

Combine first 6 ingredients in a large bowl. Divide mixture into 2 equal portions; shape each into a 6-inch round. Cover and chill 8 hours.

Place cheese rounds on serving plates; top evenly with THAT'S HOW WE ROLL SALSA (recipe below). Serve with tortilla chips.

That's How We Roll Salsa

1/4 cup hot jalapeño jelly
1/4 cup fresh lime juice
2 large mangoes, peeled and diced*
2 large avocados, diced
1 large red bell pepper, diced
1/4 cup finely chopped onion
dash of cayenne pepper (optional)
1/4 cup chopped fresh cilantro

Whisk together jelly and lime juice in a large bowl. Add remaining ingredients and stir until blended. Cover and chill 8 hours.

* 1 (26-ounce) jar refrigerated mango pieces, drained, may be substituted for fresh mango.

Easy Fruit Dip

1 package (8 ounces) cream cheese, softened
1 jar (7 ounces) marshmallow cream

Mix in bowl until well blended and serve with your favorite fruit.

Mud Bugs and Mud Balls is one of the biggest events happening during the Spring Semester. It is officially SFA's Crawfish boil and Mudball Volleyball Tournament.

Mud Bug Éttouffée

1/4 cup butter
3 tablespoons olive oil
1/3 cup all-purpose flour
1 medium onion, chopped
4 celery ribs, chopped
1 medium-size green bell pepper, chopped
4 garlic cloves, minced
1 large shallot, chopped
2 1/2 teaspoons Cajun seasoning
1/2 teaspoon ground red pepper
1 (14 ounce) can low-sodium chicken broth
1/4 cup chopped fresh parsley
1/4 cup chopped fresh chives

Melt butter with oil in a large Dutch oven over medium-high heat; stir in flour and cook, stirring constantly, 5 minutes or until caramel colored. Add onion and next 6 ingredients; sauté 5 minutes or until vegetables are tender. Add chicken broth, parsley, and chives; cook, stirring constantly, 5 minutes or until mixture is thick and bubbly. Stir in crawfish; cook 5 minutes or until thoroughly heated. Serve with hot cooked rice.
∗ 2 pounds frozen cooked crawfish tails, thawed and drained, may be substituted for fresh.

Mud Bug Dip

1/2 cup butter
1 bunch green onions, sliced (about 1 cup)
1 medium sized green bell pepper, diced
1 pound package frozen cooked, peeled crawfish
 tails, thawed and undrained

2 garlic cloves, minced
1 (4 ounce) jar diced pimiento, drained
2 1/2 teaspoons Creole seasoning
1 (8 ounce) package cream cheese, softened
French bread baguette slices
garnishes: sliced green onion, chopped parsley

Melt butter in a large saucepan or Dutch oven over medium heat; add green onions and bell pepper. Cook, stirring occasionally, 8 minutes or until bell pepper is tender. Stir in crawfish and next 3 ingredients; cook, stirring occasionally, 10 minutes. Reduce heat to low. Stir in cream cheese until mixture is smooth and bubbly. Serve with toasted French bread slices.

Mud Ball Fondue

1 cup heavy cream
1 (12 ounce) package dark chocolate morsels
1 (7 1/2 ounce) jar marshmallow crème
1/2 teaspoon vanilla extract
SERVE WITH: brownies, biscotti, graham crackers, marshmallows, chopped toasted pecans, or fruit.

Bring cream to a boil in a large, heavy-duty saucepan over medium-high heat; reduce heat to low and simmer. Add chocolate morsels and stir until melted and smooth. Stir in marshmallow crème and vanilla, stirring constantly until smooth. Transfer to fondue pot. Keep warm. Serve with desired accompaniments

Mud Bug Madness Cake

1 cup butter, melted
2 cups sugar
2/3 cup unsweetened cocoa
4 large eggs, lightly beaten
1 teaspoon vanilla extract
1/2 teaspoon salt
1 1/2 cups all-purpose flour
1 1/2 cups coarsely chopped pecans, toasted
1 (10.5-ounce) bag miniature marshmallows
Chocolate Frosting (recipe on following page)

Whisk together melted butter and next 5 ingredients in a large bowl. Stir in flour and chopped pecans. Pour batter into a greased and floured 15- x 10-inch jellyroll pan.
 Bake at 350 for 20 to 25 minutes or until a wooden pick inserted in center comes out clean. Remove from oven; top warm cake evenly with marshmallows. Return to oven, and bake 5 minutes. Drizzle chocolate frosting over warm cake. Cool completely. (Substitute brownie mix prepared according to package directions for cake batter.)

Mud Bug Pie

2 cups graham cracker crumbs
1/2 cup butter, melted
2 1/4 cups sugar, divided
2 cups chopped pecans, toasted and divided
1 (4 ounce) semisweet chocolate baking bar, chopped
1 cup butter
1 1/2 cups all-purpose flour
1/2 cup unsweetened cocoa
4 large eggs
1 teaspoon vanilla extract
1 teaspoon salt
3 cups regular marshmallows, halved horizontally
2 cups miniature marshmallows

Stir together graham cracker crumbs, butter, and 1/4 cup sugar; press on bottom and 2 inches up sides of a 9-inch springform pan. Sprinkle 3/4 cup pecans over crust.

Microwave chopped chocolate and 1 cup butter in a large microwave-safe glass bowl at HIGH 1 minute or until melted and smooth, stirring at 30-second intervals.

Whisk flour, cocoa, eggs, and vanilla into chocolate mixture. Add remaining 2 cups sugar into chocolate mixture, stirring until blended. Pour batter into prepared crust.

Bake at 350 for 1 hour to 1 hour and 15 minutes or until a wooden pick inserted in center comes out with a few moist crumbs. Remove from oven, and cool in pan on a wire rack 20 minutes.

Preheat broiler with oven rack on lowest level from heat. Place pie (in pan) on a jelly-roll pan. Toss together both marshmallows; mound on pie, leaving a 1/2-inch border around edge. Broil 30 seconds to 1 minute or until marshmallows are golden brown. Remove from oven, and immediately remove sides of pan. Cool on a wire rack 10 minutes.

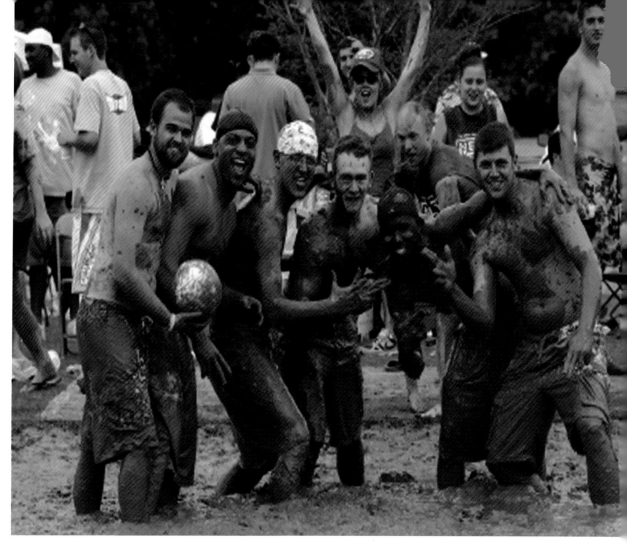

Chocolate Frosting

1/4 cup butter
3 tablespoons unsweetened cocoa
3 tablespoons milk
2 cups powdered sugar
1/2 teaspoon vanilla extract

Cook butter, cocoa, and milk in a saucepan over medium heat, stirring constantly, 3-4 minutes or until slightly thickened; remove from heat. Whisk in powdered sugar and vanilla until smooth.

Chocolate Mousse

Whip 2 cups heavy cream to form light peaks. Chill in refrigerator. Melt 10 ounces Ghirardelli Bittersweet Chocolate Chips in large mixing bowl set over simmering water. In another bowl, whip four eggs with 2 tablespoons of sugar until fluffy and thick, about 10 minutes.

Stir 1/4 cup hot coffee into the melted chocolate. The mixture will start to thicken, so work fast. Quickly stir in the beaten eggs, then fold in the whipped cream. Pour or spoon mixture into cups or bowls and chill until firm, about 2 hours.

Mud Bug Chocolate Cupcakes

1 cup chopped pecans
1 cup butter
4 ounces semisweet chocolate, chopped
2 cups sugar
1 1/2 cups all-purpose flour
1/2 cup unsweetened cocoa
4 large eggs
1 1/2 teaspoons vanilla extract
3/4 teaspoon salt
1 tablespoon instant coffee
1 (10.5 ounce) bag miniature marshmallows
Chocolate Frosting (recipe on previous page)

Place pecans in a single layer on baking sheet. Bake at 350 for 8 to 10 minutes or until toasted.

Microwave 1 cup butter and semisweet chocolate in a large microwave-safe glass bowl at HIGH 1 minute or until melted and smooth, stirring every 30 seconds. Whisk sugar and next 6 ingredients into chocolate mixture. Spoon batter into 15 paper-lined muffin cups.

Bake at 350 for 20 + minutes or until puffed. Time may vary. Sprinkle evenly with 2 cups miniature marshmallows and bake 5 more minutes or until golden. Remove from oven and cool in muffin pans 5 minutes, then place cupcakes on wire rack and drizzle warm cakes evenly with 1 1/4 cups CHOCOLATE FROSTING and sprinkle with toasted pecans. Reserve remaining 3/4 cup frosting for another use.

Mud Bug Mudslides

1 pint chocolate ice cream
1 pint coffee ice cream
1 cup milk
1/2 cup bourbon (optional)

Process all ingredients in a blender until smooth. Top with fudge sauce, whipped cream, chocolate syrup, marshmallows, and sprinkles.

Purple Pride Party Sandwiches

2/3 cup peach preserves
1/2 cup mustard-mayonnaise blend
3/4 pound thinly sliced deli roast beef, chopped
1/2 pound thinly sliced Havarti cheese
Salt and pepper to taste
1/2 cup finely chopped walnuts
2 packages (12 count) King's Hawaiian dinner rolls

Heat walnuts in a small nonstick skillet over medium-low heat, stirring occasionally, 5 to 6 minutes or until lightly toasted.

Remove rolls from packages. (Do not separate rolls.) Cut rolls in half horizontally, creating 1 top and 1 bottom per package.

Spread preserves on cut sides of top of rolls; sprinkle with walnuts. Spread mustard-mayonnaise blend on cut sides of bottom of rolls; top with beef and cheese. Sprinkle with salt and pepper to taste, if desired.

Cover with top halves of rolls, preserves sides down, and wrap in aluminum foil. Bake at 325° for 20 to 25 minutes or until cheese is melted. Slice into individual sandwiches.

Tailgate Punch

1 cup sugar
1 envelope (.22 ounce) unsweetened blue
 raspberry lemonade mix
7 cups water
1 (6 ounce) can frozen lemonade concentrate, thawed
1 (46 ounce) can unsweetened pineapple juice, chilled
1 (2 liter) bottle of ginger ale, chilled

Stir together first 4 ingredients in a 2-quart pitcher; pour evenly into 5 ice-cube trays and freeze at least 8 hours. Combine pineapple juice and ginger ale; serve over raspberry ice cubes.

Southwest Chicken Spirals

1 (7-ounce) jar roasted red bell peppers
2 cups chopped cooked chicken
1 (8-ounce) package cream cheese, softened
1 packet ranch-style buttermilk dressing mix
1/2 cup chopped ripe olives
1 small onion, diced
1 (4.5-ounce) can chopped green chilies, drained
3 tablespoons chopped fresh cilantro
1 teaspoon pepper
1/4 cup pine nuts (optional)
8 (6-inch) flour tortillas
garnish: fresh cilantro

Drain roasted peppers well, pressing between layers of paper towels; chop. Stir together roasted peppers, chicken, and next 7 ingredients. Cover and chill at least 2 hours.

Stir pine nuts, if desired, into chicken mixture. Spoon evenly over tortillas and roll up. Cut each roll into 5 slices, securing with wooden picks if necessary. Garnish if desired.

Smokin' Good Japaleños

25 fresh jalapeño peppers
14 -16 ounces cream cheese
2 cups shredded Cheddar cheese
2 (16 ounce) packages bacon

Cut stems off of peppers and cut them in half longways. Remove seeds from peppers. Fill each pepper with cream cheese and sprinkle Cheddar cheese on top. Wrap 1/2 slice of bacon around each pepper half.

Place on baking sheets and place in 450 degree oven for 10 to 15 minutes or until bacon is crispy and serve when cooled.

Red Pepper Ham Roll-Ups

Approximately 50 Roll-ups

1 (8-ounce) package cream cheese, softened
1 (3-ounce) package cream cheese softened
2 garlic cloves, finely chopped
1/2 cup finely chopped walnuts, toasted
1/2 cup pitted Kalamata or pimento stuffed olives, chopped
1/3 cup roasted red bell peppers from a jar, patted dry and chopped
1/2 teaspoon cayenne or black pepper
8 slices deli ham (Black Forest)
50 pitted Kalamata olives

Beat cream cheese at medium speed with mixer until creamy; add garlic and next 4 ingredients, mixing well. Spread about 2 tablespoons cream cheese mixture over each ham slice and roll up, starting with long side. Place roll-ups, seam side down, on a baking sheet. Fill ends of rolls with remaining cream cheese mixture. Cover and freeze 20 minutes, which will make roll-ups easier to cut. While roll-ups are chilling, place olives on small wooden picks.

After rollups have chilled, use a sharp knife and slice each roll-up into 1 inch pieces and secure each roll-up with 1 olive toothpick. Cover and chill until ready to serve.

Pecan Pesto

4 cups loosely packed fresh basil leaves
1 cup freshly shredded Parmesan cheese
1 cup toasted pecans
1 cup olive oil
4 garlic cloves
2 tablespoons lemon juice
1 teaspoon salt
1 teaspoon pepper

Process ingredients in a food processor until smooth.

Blue Cheese Ball

2 (8 ounce) packages cream cheese, softened
1 cup crumbled blue cheese
1 cup shredded sharp Cheddar cheese
1/4 cup minced onion
1 tablespoon Worcestershire sauce
1 cup chopped walnuts or whole pine nuts

In a medium bowl, stir together the cream cheese, blue cheese, Cheddar cheese, onion, and Worcestershire sauce. Transfer to a separate bowl that has been lined with plastic wrap. Cover and refrigerate overnight.

The next day, gather the cream cheese mixture into a ball. Spread the walnuts out on a dinner plate. Roll the cheese ball in nuts until coated. Refrigerate or serve immediately.

Hot Corn Dip

2 (11 ounce) cans mexi-corn/fiesta corn, drained
2 (7 ounce) cans chopped green chilies, drained
2 1/2 tablespoons chopped, pickled jalapeño
2 cups grated Monterey Jack cheese
2/3 cup grated Parmesan cheese
1 cup mayonnaise
1 teaspoon dried red pepper flakes (or to taste)
8 ounces fresh, lump crabmeat, drained (optional)

Preheat the oven to 350 degrees. Spray or butter a 9 x13 inch baking dish.

Mix together first 7 ingredients. Gently fold in crabmeat (optional) and pour into prepared baking dish. Bake uncovered at 350 degrees for 30 to 40 minutes, or until bubbly around edges. Serve warm with corn chips. Can also cook in a 4 quart crockpot, covered on high for about an hour, or on low until warmed through and bubbly.

Game Day Hanky Pankies

Makes 70 pieces

2 (1 pound packages) cocktail rye, pumpernickel or sourdough party bread
1-1/2 cups chopped onion
1 red bell pepper, chopped
1 pound lean ground beef
1 pound ground pork sausage, hot (or not)
1 pound Velveeta cheese, cubed
1 tablespoon Worcestershire sauce
1 tablespoon ketchup
1/2 teaspoon garlic salt, or to taste
1/2 teaspoon freshly cracked black pepper
sliced green onions for garnish, optional

Preheat oven to 350 degrees. In a large skillet, brown ground beef, sausage, and onion. Add Velveeta cheese, stirring until melted. Add Worcestershire, ketchup, garlic salt, and pepper, stirring to prevent sticking. Taste and adjust seasonings as needed.

Top each slice of bread with 1-2 tablespoon of the meat mixture. Bake at 350 degrees for about 10-12 minutes or the cheese is until bubbly and bread is toasted.

Prosciutto Wrapped Asparagus

1 pound asparagus (about 19 stalks), trimmed
1 tablespoon olive oil
salt and freshly ground black pepper
6 to 8 paper-thin slices prosciutto, halved lengthwise

Preheat the oven to 400 degrees. Snap the dry stem ends off of each asparagus and discard. Place asparagus on heavy baking sheet. Drizzle with olive oil, sprinkle with salt and pepper, and toss. Roast until the asparagus is tender, about 15 minutes. Cool completely.

Wrap each asparagus with 1 piece (about 1/2 slice) of prosciutto, exposing tips. Arrange on a platter and serve at room temperature.

Braised Beef Brisket

2 cans beef broth
1 1/2 cups soy sauce
1/2 cup fresh lemon juice
1/4 teaspoon cayenne pepper
2 tablespoons liquid smoke
5 cloves garlic, chopped
10 pounds beef brisket

Combine first six ingredients in a large disposable roasting pan. Add brisket to pan, fat side up, and let marinade. Cover tightly with foil and refrigerate for 24 to 48 hours.

Preheat the oven to 300 degrees. Place pan of brisket and marinade in oven and cook 6-7 hours or until brisket is tender. To check for doneness, slice a 1/4-inch thin piece of brisket from the outer portion. Hold the piece of meat between both hands and give it a slight tug. If the meat pulls apart easily, the brisket is ready to serve. If the meat does not pull apart easily, it needs to cook a while longer. When brisket is done, remove from pan and cut brisket against the grain returning slices to the cooking liquid.

Sausage, Bean, and Spinach Dip

1 sweet onion, chopped
1 red bell pepper, chopped
1 (1 pound) package hot ground pork sausage
2 garlic cloves, minced
1 teaspoon chopped fresh thyme
1/4 teaspoon crushed red pepper
1/2 teaspoon sugar
1/2 cup dry white wine
1 (8 ounce) package cream cheese, softened
1 (6 ounce) package fresh baby spinach, coarsely
 chopped
1/4 teaspoon salt
1 (15 ounce) can pinto beans, drained and rinsed
2/3 cup grated Parmesan cheese

Preheat oven to 375 degrees. Sauté chopped
onion and next 2 ingredients in a large skillet over
medium-high heat, stirring often, 8 to 10 minutes or
until crumbled meat is no longer pink. Drain. Stir in
garlic and thyme; cook 1 minute. Stir in wine; cook 2
minutes or until liquid has almost evaporated.

Mix crushed red pepper and sugar with cream
cheese and add to sausage mixture. Cook, stirring
constantly, 2-3 minutes or until cream cheese is
melted. Stir in spinach and salt and continue heating,
stirring constantly until spinach is wilted. Gently stir
in beans. Pour mixture into a 2 quart baking dish.
Sprinkle with grated Parmesan cheese and bake at 375
for 18 to 20 minutes or until golden brown. Serve with
corn chip, pita chips, veggies, pretzels, or crackers.

Mango, Tomato, and Avocado Salsa

1 mango, peeled, seeded and diced
1 avocado, peeled, pitted, and diced
4 medium tomatoes, diced
1 jalapeño pepper, seeded and minced
1/2 cup chopped fresh cilantro
2 cloves garlic, minced
1 teaspoon salt
1 teaspoon sugar
1/4 teaspoon cayenne pepper
2 1/2 tablespoons fresh lime juice
1/3 cup chopped red onion
3 tablespoons olive oil

In a medium bowl, combine the mango, avocado, tomatoes, jalapeño, cilantro, and garlic. Stir in the salt, sugar, pepper, lime juice, red onion, and olive oil. To blend the flavors, refrigerate for about 30 minutes before serving.

Sausage Stuffed Jalapeños

1 pound ground pork sausage (regular or hot)
1 (8 ounce) package cream cheese, softened
1 cup shredded Parmesan cheese
1 pound fresh jalapeño peppers, cut lengthwise
 and seeded
ranch dressing (optional)

Preheat oven to 425 degrees. Cook sausage in a skillet over medium heat until evenly brown. Drain grease.

In a bowl, mix the sausage, cream cheese, and Parmesan cheese. Spoon about 1 tablespoon sausage mixture into each jalapeño half. Arrange stuffed halves in baking dishes.

Bake 20 minutes in preheated oven until lightly browned and bubble. Serve with ranch dressing.

7 Layer Taco Dip

2 avocados, peeled, pitted, and diced
1 tablespoon mayonnaise
2 tablespoons fresh lime juice
1/4 cup chopped fresh cilantro
1/3 cup salsa
garlic salt and ground pepper to taste
1 (8 ounce) container sour cream
1 small can chopped green chilies
1 package taco seasoning mix
4 Roma (plum) tomatoes, diced
1 bunch green onions, finely chopped
1 (16 ounce) can refried beans
2 cups shredded cheese (Fiesta or Mexican blend)
2 (2.25 ounce) cans black olives — drained and
 finely chopped

In a medium bowl, mash avocados. Stir in mayonnaise, lime juice, cilantro, salsa, garlic salt, and pepper. In a small bowl, blend the sour cream and green chilies and taco seasoning. In another small bowl, combine the taco seasoning and refried beans. In a 9x13 inch dish, or on a large serving platter, spread the refried beans. Top with sour cream mixture. Spread on guacamole. Top with tomatoes, green onions, Mexican-style cheese blend, and black olives.

Fear the Ax Salsa

1 (32ounce) can crushed tomatoes
1 (32ounce) can diced tomatoes
2-3 jalapeños (remove core and seeds) **
1/3 of bunch of cilantro leaves, chopped
1 medium onion, chopped
3 cloves of garlic

Finely chop onion, garlic, cilantro, and jalapeños and add to tomatoes. Add salt, pepper, season salt, and fajita seasoning to taste. **You may want to wear gloves when preparing the jalapeño.

Muffuletta Dip

1 cup Italian olive salad, drained RECIPE
 BELOW
1 cup diced salami (about 4 ounce)
1/3 cup grated Parmesan cheese
1/4 cup chopped pepperoncini salad peppers
1 (2 1/4-ounce) can sliced black olives,
 drained
4 ounces provolone cheese, diced
1 celery rib, finely chopped
1/2 red bell pepper, chopped
1 tablespoon olive oil
1/4 cup chopped fresh parsley
serve with: French bread crostini

Stir together first 9 ingredients. Cover and chill before serving. Stir in parsley just before serving. Serve with French bread crostini. Store leftovers in refrigerator up to 5 days.

Italian Olive Salad

1 (10 ounce) jar olives (I like Mezzetta garlic
 or pimento stuffed olives)
1 (16 ounce) jar pitted Kalamata olives
1 (8 1/2 ounce) jar marinated artichoke
 hearts
1 (3 ounce) bottle capers
1/2 bunch celery, chopped
1/2 cup Italian parsley, chopped
3/4 teaspoon garlic powder
1 tablespoon dried oregano (optional)
1/2 cup olive oil

Drain olives, capers, and artichokes. Coarsely chop. Add parsley, celery, garlic, oregano, and olive oil. Stir to mix. Put in refrigerator for at least 2 days. Will last for several weeks in the refrigerator.

Axe Kicking Popper Dip

2 (8 ounce) packages of cream cheese, room
 temperature
1 cup mayonnaise
1 teaspoon orcestershire
1 cup shredded Mexican blend cheese (half
 Monterrey Jack, half Cheddar)
1/2 cup Parmesan cheese
1 (4 ounce) can chopped green chilies (undrained)
1 (4 ounce) can diced jalapeños (undrained)
1 cup panko bread crumbs
1/2 cup Parmesan cheese (yes, another 1/2 cup)
1/2 stick of butter, melted

Combine the first 7 ingredients in a mixer or food
processor and blend until smooth. Spread the dip into a
greased casserole dish. (I used a large pie plate.)
 In a bowl, combine the panko breadcrumbs,
Parmesan cheese, and melted butter. Sprinkle crumb
mixture evenly over the dip and bake in a preheated 375
degree oven for about 20 minutes.
 You want the top to brown and the dip heated
through, bubbling gently on the edges. Do NOT over-
bake this dip. The mayonnaise will begin to separate
and leave you with a greasy mess.

Bacon Crackers

36 buttery crackers such as Keebler Club
12 slices bacon, cut into thirds
3/4 cup packed dark brown sugar

Preheat the oven to 250 degrees. Line two rimmed
cookie sheets with aluminum foil. Arrange crackers
on cookie sheets in a single layer. Place a piece of bacon
on top of each cracker, then sprinkle a teaspoon of
brown sugar on top of the bacon. Bake in the preheated
oven until bacon is browned and crackers and bacon
are glazed, about 45 minutes. Drain on paper towels
before serving.

Mushroom Cream Cheese Puffs

1 (8-ounce) package cream cheese, softened
1 (8-ounce) can mushroom pieces, chopped
1/4 cup finely chopped onion
1/4 cup grated Parmesan cheese
1 tablespoon finely chopped green onion
1/4 teaspoon hot sauce
1 large egg
1 (17.3-ounce) package frozen puff pastry
 sheets, thawed
2 teaspoons freshly ground pepper

Whip cream cheese at medium speed with a
mixer until smooth. Stir in mushrooms and next 4
ingredients. Cover and chill at least 1 hour.

Preheat oven to 400 degrees. Whisk egg and 1
tablespoon water in a small bowl. Roll 1 puff pastry
sheet into a 16- x 10-inch rectangle on a lightly floured
surface. Cut pastry in half lengthwise.
 Spread 1/2 cup cream cheese mixture down center
of each rectangle and brush edges with egg mixture.
Fold each pastry half lengthwise over filling and pinch
edges to seal. Cut pastries into 10 pieces each and place
on a parchment paper-lined baking sheet.
 Repeat procedure with remaining puff pastry sheet,
egg mixture, and cream cheese mixture. Brush remaining
egg mixture over tops of pastry pieces; sprinkle with
pepper. Bake at 400 degrees for 20 to 25 minutes or until
browned. Serve immediately.

Cuban Inspired Party Sandwiches

1 (12 ounce) Cuban, French, or Italian bread
1 pound sliced barbecued pork without sauce
4 (1 ounce) provolone cheese slices
1 cup sweet-hot pickles
salt and pepper to taste
CHIPOTLE RÉMOULADE—RECIPE BELOW

Cut each bread loaf lengthwise in half. Then, cut each into 3 pieces (for 6 sandwiches). Spread the bottom half of each section with Chipotle Rémoulade. Layer with barbecued pork, provolone cheese slices, and sweet-hot pickles. Cover with top slice of bread. Press sandwiches with hands to flatten. Tightly wrap individually in aluminum foil.

Place wrapped sandwiches on grill grate. Grill 3 to 5 minutes on each side, or until heated through.

CHIPOLTE RÉMOULADE

3/4 cup mayonnaise
2 tablespoons Creole mustard
2 tablespoons sweet-hot pickle relish
1 canned chipotle pepper in adobo sauce, chopped
1 tablespoon chopped fresh flat-leaf parsley
1/2 teaspoon lemon zest
2 teaspoons fresh lemon juice
1/8 teaspoon salt
1/8 teaspoon pepper

Combine all ingredients and mix well. Cover and chill up to 3 days before serving.

Mini Italian Sandwiches

1 (5.3 ounce) container spreadable goat cheese
1/4 teaspoon garlic salt
2 tablespoons refrigerated pesto with basil (Preferably Buitoni.)
1 package ciabatta rolls or bread
1 pound thinly sliced Baked Pork Loin Roast (about 24 slices)
1 1/3 cups firmly packed arugula
1/2 cup jarred roasted red bell pepper strips
1/4 small red onion, thinly sliced

Stir together goat cheese and pesto. Spread goat cheese-and-pesto mixture on cut sides of rolls. Layer pork roast, arugula, and remaining ingredients on bottom halves of rolls. Cover with top halves of rolls.

Firecrackers

1 box saltine crackers
1 pkg. Hidden Valley Ranch dressing mix
1 1/3 cups canola oil
2 tablespoons crushed red pepper

Empty crackers into a bowl with an air tight lid. Mix ranch dressing mix, canola oil, and red pepper flakes together in a small bowl. Pour mixture over crackers. Cover with the lid and after 15 minutes turn the bowl over onto its lid and wait 15 minutes and turn bowl back upright; continue to flip bowl every 15 minutes for 1 hour. Store in an airtight container or Ziploc bag.

Spicy Jacks Pizza

1/2 cup whole grain mustard or tablespoons spicy mustard
1 pizza crust (I use Boboli Thin Pizza Crust)
2 cups shredded mozzarella cheese, divided
1 cup Vlassic cold-packed sauerkraut** (well drained)
8 ounces Canadian style bacon
1/2 cup thinly sliced sweet onion

Preheat oven to 400 degrees. Spread mustard over pizza crust. Top with 1 cup cheese, sauerkraut, Canadian bacon, and onion. Sprinkle top with remaining cheese and bake for 10-15 minutes or until crust is crispy and cheese is melted and lightly browned.

**You can find cold-packed sauerkraut in the refrigerated cases near the lunchmeat.

Jumpin/Jack Thumbprints

2 (4-ounce) packages crumbled blue cheese
1/2 cup butter, softened
1 1/3 cups all-purpose flour
2 1/2 tablespoons poppy seeds
1/2 teaspoon ground red pepper
1/2 cup strawberry preserves

Beat blue cheese and butter with an electric mixer until fluffy. Add poppy seeds, red pepper, and flour, mixing until combined. Roll dough into walnut-sized balls; cover and chill 2 hours.

Arrange balls on ungreased baking sheets and press thumb into each, leaving an indentation for the preserves.

Bake at 350 for 15 minutes or until golden. Transfer to wire racks to cool completely. Place about 1/4 teaspoon preserves in each indentation.

Oh future bright 'neath the Purple and White

"The Shack as the administration building was a very unusual college building. A counter made of 1 x 12 rough planks was the office of the Registrar and the Auditor. The Auditor [J. H. Wisley] took his books home at night. The President's Office was walled off on one corner, but the cracks in the wall were not filled. A few times he felt the need of a rather straight talk to some young man; at such times he would take him into his own car and drive away from the campus in order to have a private talk. A card table served as desk for the Dean of Women. The bookstore was in the back of the Shack, as was the equipment for the athletes. A number of books had been purchased for the library, and the librarian, at another card table, industriously classified the books of the library."

The *Daily Sentinel*, September 19, 1923

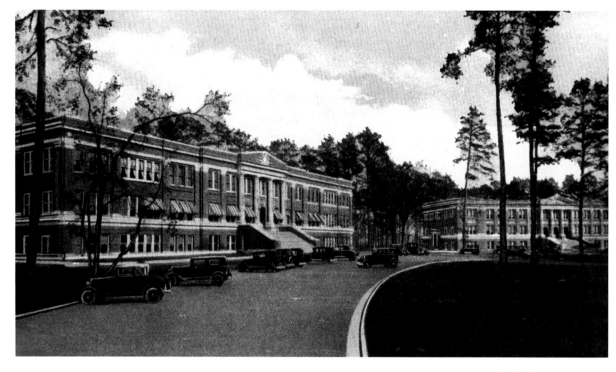

Austin Building, 1922

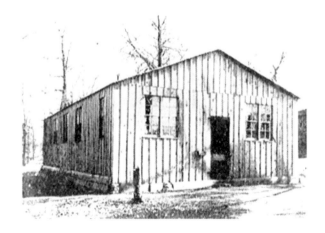

"The day they moved into the Austin Building, there were 609 enrolled in the college. The college operated on a quarter system at the time. There was a fall, a winter, a spring term, and two six week summer terms. Classes were held on Monday-Wednesday-Friday and on Tuesday-Thursday-Saturday. There were Saturday classes, as a part of the TTS schedule, but there were also Saturday classes so that teachers who were working could come to the college. Education, Agriculture, English, and History classes met on Saturdays for extended hours. Normally, classes began at 8:00 and usually were held for an hour until the last being about 3:00 in the afternoon. There were no classes from 10 to 11 on MWF. On Mondays at this time, the Literary Societies and the Dramatic Club met. On Wednesdays at 10, there was Assembly. On Fridays, the Choral Club and the Glee Clubs met.

Dr. Jere Jackson "The History of SFA"

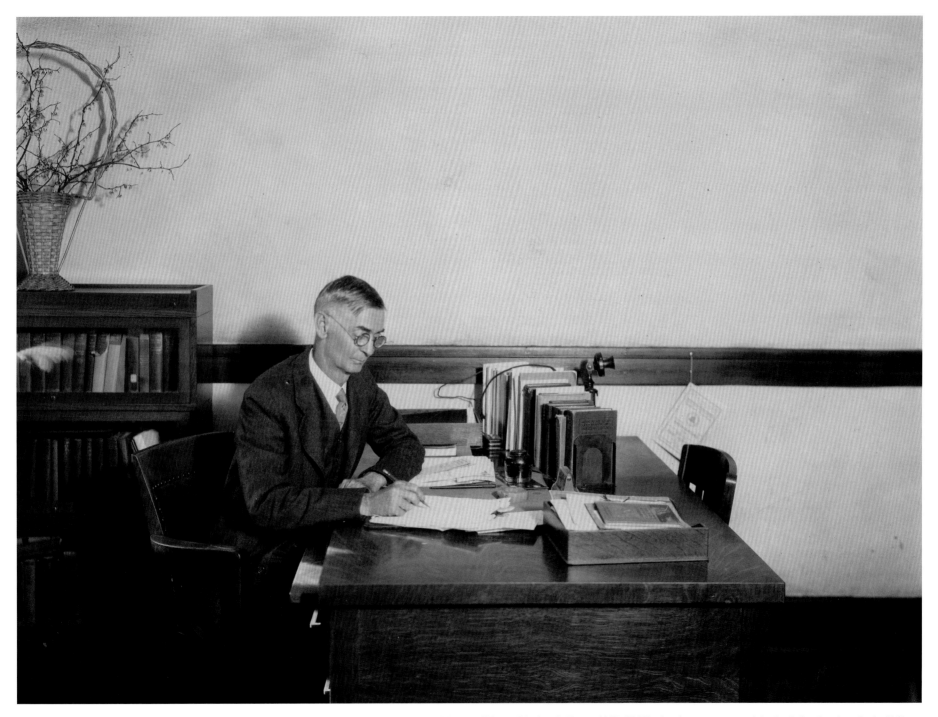

SFA President Alton William Birdwell (from 1917-1942) signing papers at his desk in the Austin building.

President's Home, 1922

Women's Recreational Center, 1935

Thomas J. Rusk Building, 1926

Home Economics Practice House, 1936

Stephen F. Austin State Teacher College Faculty, 1925

Above SFA Basketball Team, 1926
Right: SFA Baseball Team, 1927

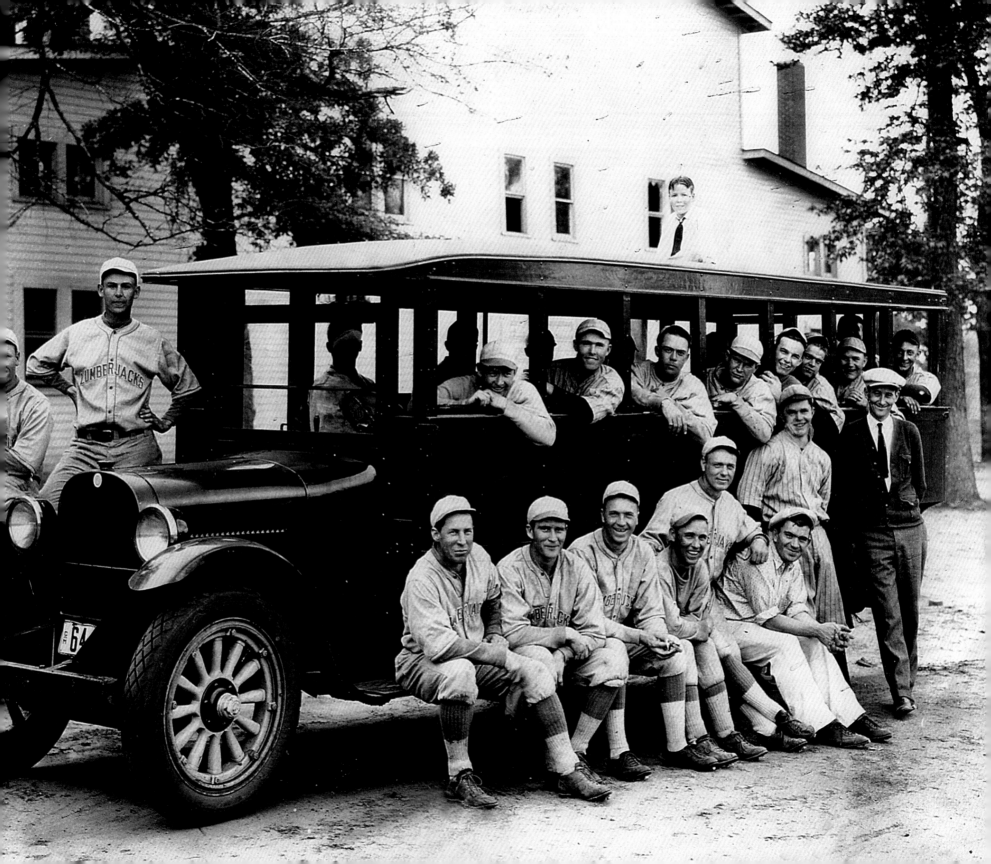

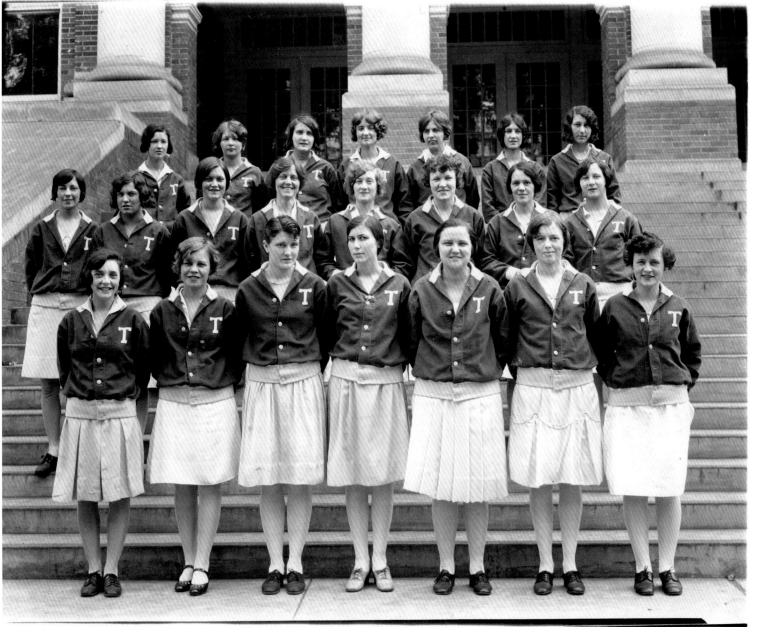

FRONT ROW
1. Elma Biggar
2. Mary Lee Walton
3. Arminta Roach
4. Joel Barham
5. Floy Ankerton
6. Ida Lee Farris
7. Maisie Moore

SECOND ROW
1. Lily Belle Sweatt
2. Jennie D. Nye
3. Vivian Conway
4. Virginia Broadfoot
5. Dorothy Finley
6. Laura Beall
7. Mrs J. T. Cox
8. Lillian Hines

THIRD ROW
1. Evie Paine
2. Annie Lee Jones
3. Catherine Lewis
4. Margie Whittington
5. Mellie Fulmer
6. Vivian Perritte
7. Eunice Sullivan

Lumberjackettes, 1928

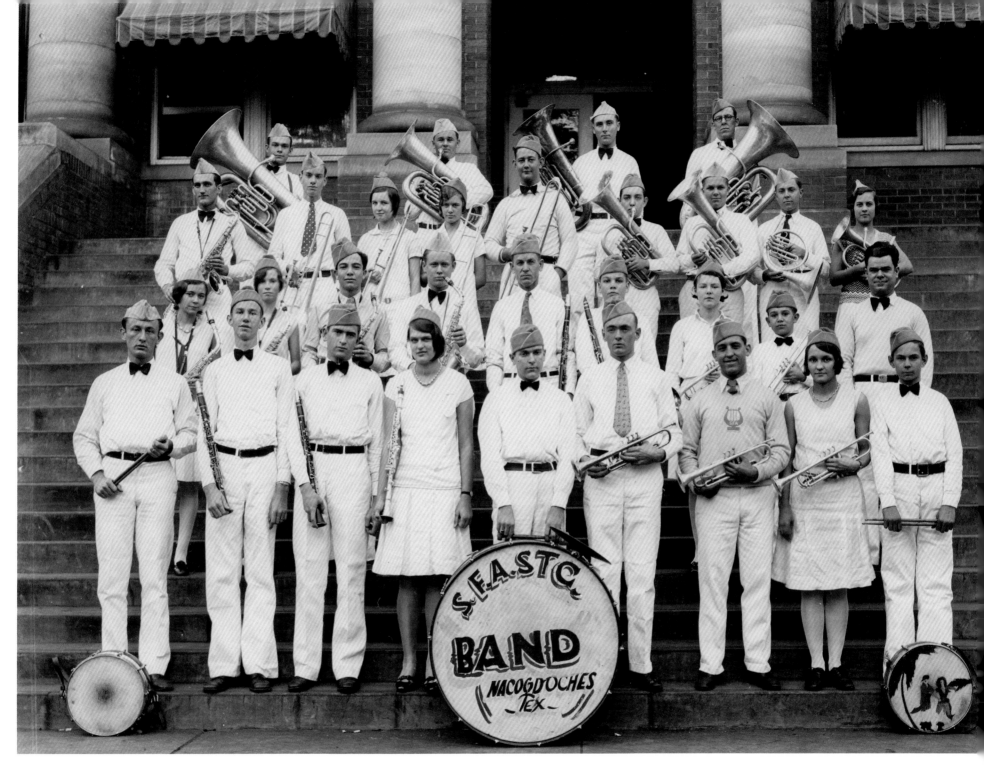

SFASTC Band, 1930

The Big Chill & Grill

The word "picnic" makes me think of a red-checkered tablecloth spread out under the arms of a beautiful old oak tree on a grassy hillside; big puffy clouds hanging in a sunny blue sky; a wicker basket with fried chicken, fresh peaches, cherries, grapes, maybe some watermelon; rich, ripe wedges of tangy cheeses; a great bottle of wine, and of course, someone you love with whom to share all this. I've had those picnics a few times in my life and they are wonderful memories, but there are other kinds of picnics that I remember that meant just as much.

I remember working in the cotton field with my father on a bitterly cold November day, and my mom bringing us meatloaf sandwiches, hot coffee for him, and hot cocoa for me. My dad turned off the cotton stripper, and I climbed from my place in the trailer where I packed the cotton down as it flew from the stripper, and we met on the side of the cotton trailer where the cold wind didn't blow so hard. I still remember how quiet the world was when the roar of all the machinery slowed to a stop. My mom had laid out an old patchwork quilt on the ground in the shade of the trailer and we ate as if we had never tasted food before. It wasn't romantic, but it was a great picnic.

We took one vacation in my life on the farm. The whole family drove to see the Alamo. It was, and still is, I think, a rite of passage for many Texas families. Back then, George and Josie, my parents, had plenty of kids (four), but not much money…especially for restaurants. We packed ourselves in that 1959 Buick and headed for San Antonio. At dinner time, my father found a roadside park and magically (it seemed to me), from the trunk, my mom pulled out a loaf of Mrs. Baird's white bread, a stack of sliced baloney wrapped in butcher paper, and a jar of Miracle Whip. It may not be true, but I remember all six of us wearing cat-eyed sunglasses as we ate our sandwiches and counted the license plates of the passing trucks and cars. We had to wear sunglasses, we were on vacation.

So, for me, picnics come in all flavors and sizes, but they all have one thing in common…sharing food under a roof of sky with people you love.

Brad Maule

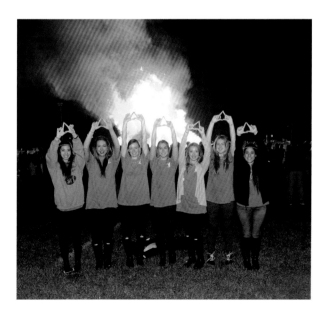

JACK'S GAME DAY BBQ

Spicy Jack Burgers

1 (5-ounce) bottle Pickapeppa sauce
2 pounds ground chuck
8 slices cheddar or sharp cheddar cheese
4 hamburger buns
Bacon if desired
Toppings: mayonaise, mustard, tomato, red onion, lettuce

Combine 4 tablespoons Pickapeppa Sauce and ground beef in a large bowl until blended. Shape mixture into 8 (4-inch) patties and sprinkle with salt and pepper. Place 2 cheese slices on each of 4 patties. Top with remaining 4 patties, pressing edges to seal. Wrap with bacon if desired. Spread a little Pickapeppa sauce over patties. Cover and chill at least 30 minutes.

Grill, covered with grill lid, over medium-high heat (350 - 400 degrees) 7 to 8 minutes on each side or until beef is no longer pink. Serve burgers on buns with desired toppings.

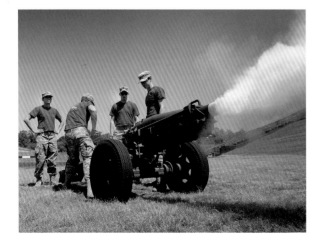

Menu

**Spicy Jack Burgers
Axe 'em Jacks Potato Salad
Best Baked Beans
Never Fail Key Lime Pie
Raspberry Lemonade**

Axe 'em Jacks Potato Salad

Serves 8

6 large new potatoes
2 hard cooked eggs, chopped
1/2 cup celery, diced
1/4 cup onion, diced
2 tablespoons sweet pickle relish
1/2 cup bell pepper, diced
2 tablespoons parsley, chopped
1 1/2 Tablespoons mustard
3 tablespoons salad oil
1 tablespoon Worcestershire sauce
1 tablespoon seasoning salt
Add mayonnaise to desired moistness
Salt and pepper to taste

Boil potatoes with skins on until tender; cut into cubes. Mix all ingredients while potatoes and eggs are still warm. Refrigerate until chilled.

First and Ten Baked Beans

4 bacon slices
1 small onion, diced
1 small green pepper chopped
4 (15-ounce) cans pork and beans drained (Campbells)
1/3 cup firmly packed brown sugar
1/2 cup ketchup
1/2 cup molasses
1 1/2 teaspoons Worcestershire sauce
1 teaspoon dry mustard

Cook bacon in a skillet over medium-high heat 4-5 minutes; drain, reserving 2 teaspoons of drippings in skillet. Sauté onion in hot bacon drippings 7 minutes or until tender. Stir together onions, green pepper, pork and beans, and next 5 ingredients in a lightly greased 11x7 inch baking dish. Top bean mixture with bacon. Bake at 350 degrees for 45 minutes or until bubbly.

Raspberry Lemonade

1 (12 ounce) can frozen raspberry lemonade concentrate
3 cups water
1 teaspoon lime juice
1 (12 ounce) can Sprite or other lemon-lime flavored carbonated beverage
1 cup crushed ice
1 cup fresh raspberries, garnish

In a large punch bowl, combine raspberry lemonade concentrate, water and lime juice. Stir in lemon-lime soda and crushed ice. Garnish each glass with a fresh raspberry.

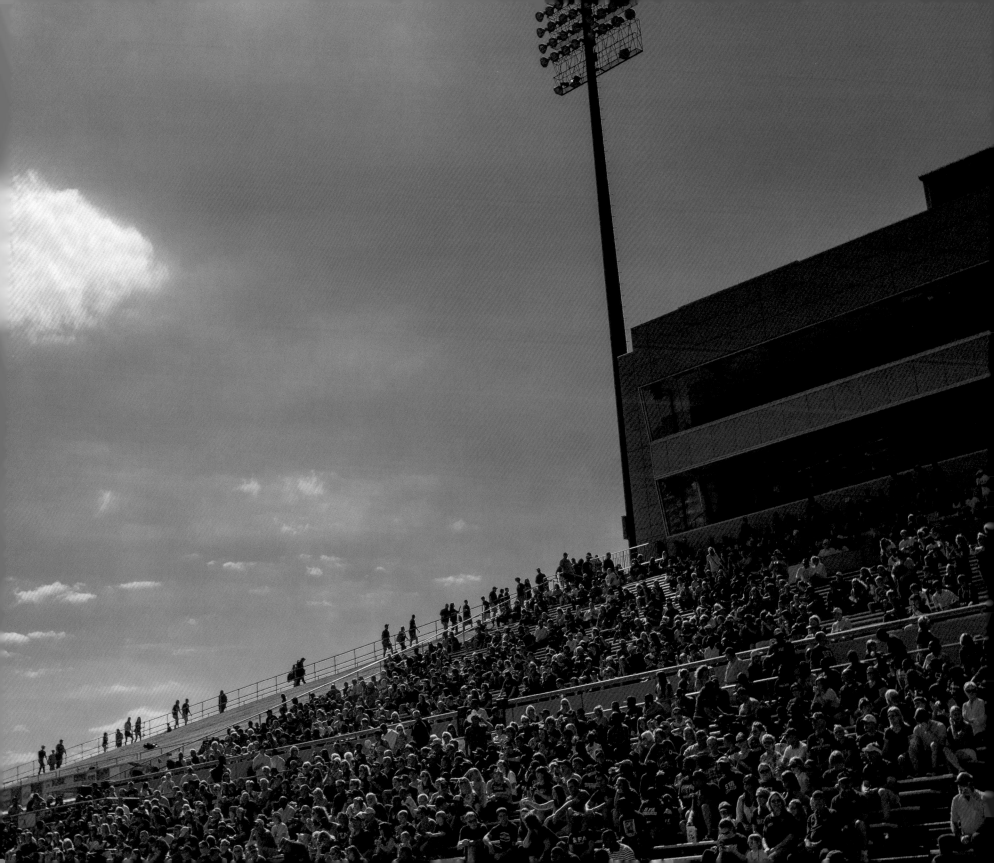

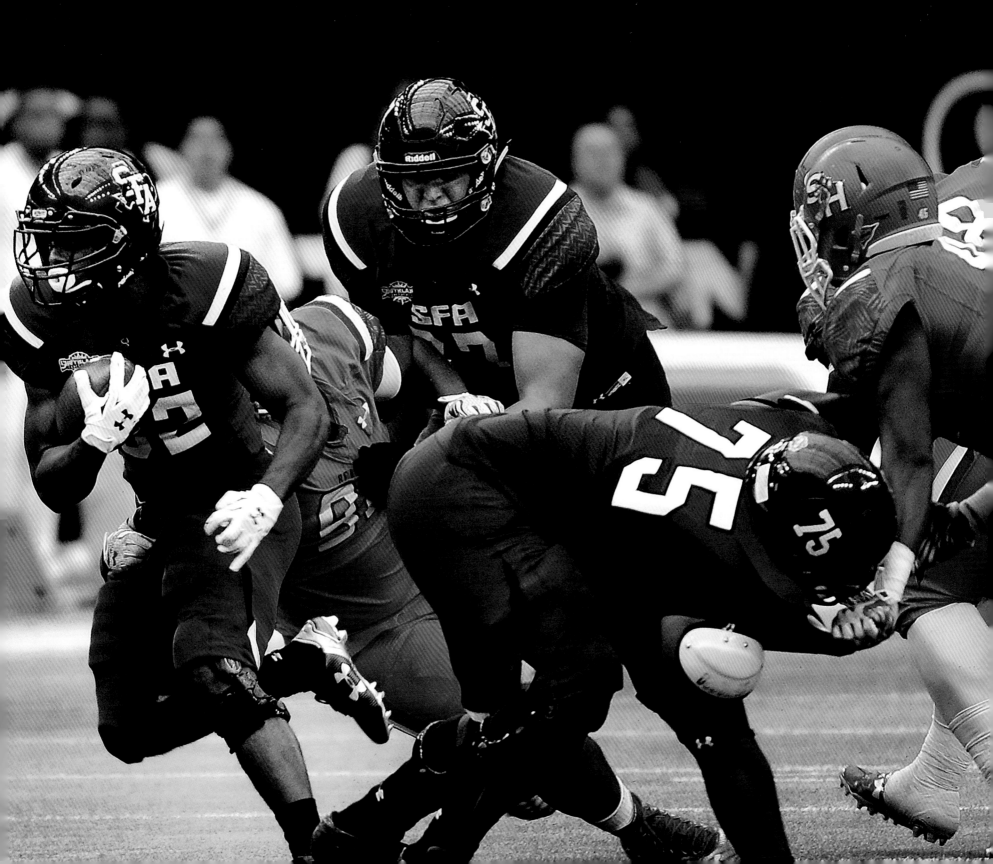

Never Fail Key Lime Pie

1 3/4 cups graham cracker crumbs
3 tablespoons sugar
6 tablespoons butter, melted
3 large eggs, separated
1 (14-ounce) can sweetened condensed milk
1/2 cup fresh Key lime juice
1 1/2 tablespoon lemon juice
2 teaspoons grated Key lime zest
3 tablespoons sugar
1 cup whipping cream
3 tablespoon powdered sugar
1/2 teaspoon vanilla extract
Garnish: quartered lime slices

Combine first 3 ingredients; press onto bottom and 1 inch up sides of a 9-inch springform pan. Chill at least 1 hour. Whisk egg yolks; add condensed milk and next 3 ingredients, mixing until smooth. Beat egg whites at high speed with an electric mixer until foamy; gradually add 3 tablespoons sugar, beating until soft peaks form. Fold into yolk mixture; spoon into prepared crust.

Bake at 325 degrees for 15 - 20 minutes or until set and lightly browned. Cool on a wire rack; cover and chill 8 hours. Beat whipping cream at high speed with electric mixer until slightly thickened; add powdered sugar and vanilla, beating until soft peaks form.

Remove sides of springform pan, and dollop whipped cream around top of pie. Garnish, if desired.

Game Day Southwest Cheesecake

Yield: 25 appetizer servings.

1 2/3 cups finely crushed tortilla chips
1/3 cup butter or margarine, melted
2 (8 ounce) packages cream cheese, softened
1 (3 ounce) package cream cheese, softened
2 large eggs
2 3/4 cups shredded Monterey Jack cheese
1 (4.5 ounce) can chopped green chiles, drained
1/4 teaspoon ground red pepper (cayenne)
1 (8 ounce) carton sour cream
1/2 cup green bell pepper, chopped
1/2 cup red bell pepper, chopped
1/2 cup yellow or orange bell pepper, chopped
1/2 cup green onions, chopped
1 medium tomato, chopped
4 tablespoons chopped ripe olives
2 bunches fresh cilantro or parsley (optional)
Salsa if desired

Combine tortilla chips and butter. Press in the bottom of a lightly greased 9-inch springform pan. Bake at 325 degrees for 15 minutes. Cool on a rack.

Beat cream cheese at medium speed with an electric mixer 3 minutes or until fluffy; add eggs one at a time, beating after each addition. Stir in shredded cheese, chiles and ground pepper.

Pour mixture into prepared pan and bake at 325 degrees for 30 minutes. Cool 10 minutes on a wire rack. Gently run a knife around the edge of pan to release sides, carefully remove sides of pan. Let cool completely on wire rack.

Spread sour cream evenly over top; cover and chill.

Arrange green peppers and next 5 ingredients attractively on top. Serve with salsa and tortilla chips.

Chicken Wings

1/2 cup soy sauce
1/2 cup Italian-style salad dressing
3 pounds chicken wings, cut apart at joints, wing tips discarded

SAUCE:
1/4 cup butter
1 1/2 teaspoons soy sauce
1/4 cup hot pepper sauce or to taste

Combine 1/2 cup soy sauce, Italian dressing, and chicken wings in a large, zip-top bag. Close bag and refrigerate 4 hours to overnight.

Preheat an outdoor grill for medium heat. In a small saucepan, melt the butter. Stir in 1 1/2 teaspoons soy sauce and the hot pepper sauce. Turn off heat and reserve.

Remove the chicken wings from the marinade and pat dry. Cook the wings on the preheated grill, turning occasionally, until the chicken is well browned and no longer pink, 25 - 30 minutes.

Place grilled wings in a large bowl. Pour butter sauce over wings; toss to mix well.

Honey Grilled Chicken

4 chicken breasts
1/2 cup lime juice
1/3 cup vegetable oil
4 tablespoons honey
1/2 teaspoon curry powder
1 teaspoon dried rosemary
3 cloves garlic, minced
1 teaspoon black pepper

Combine lime juice, oil, honey, curry, rosemary, garlic and pepper. Pour it over chickens in a ziploc bag. Refrigerate for at least 3 hours up to overnight. Grill until done and juices run clear.

Tasty Grilled Corn Salad

CORN:
 6 ears corn
 olive oil
 sea salt and freshly ground black pepper

SALAD:
 3 medium vine or Roma tomatoes, diced
 3 green onions, chopped
 1 red bell pepper, diced
 1 jalapeño, chopped
 3 tablespoons olive oil
 1 teaspoon of sugar
 juice of 3 limes
 sea salt and freshly ground black pepper
 3/4 cup fresh cilantro leaves, roughly chopped

Prepare a grill for medium-high heat, brush the corn with olive oil, and sprinkle with salt and pepper. Grill about 10-12 minutes or until cooked and browned. Cool.

In a bowl, add the tomatoes, onions, pepper, and jalapeño. Stir in olive oil, lime juice, and sugar. Stir. Remove corn from cobb and add to tomato mixture, sprinkle with cilantro and mix.

Strawberry and Spinach Salad

 1/4 cup white sugar
 1/2 cup olive oil
 1/4 cup balsamic vinegar
 1/2 teaspoon paprika
 1/4 teaspoon Worcestershire sauce
 2 tablespoons onion, minced
 2 tablespoons sesame seeds
 10 ounces fresh spinach, rinsed and torn into
 bite-size pieces
 1 quart strawberries, cleaned and sliced
 1 container bleu cheese
 fried and crumbled bacon
 1/4 red onion thinly sliced
 1/4 cup slivered almonds

In a medium bowl, whisk together the sugar, olive oil, vinegar, paprika, Worcestershire sauce, onion, and sesame seeds. Cover, and chill.

In a large bowl, combine the spinach, strawberries, bleu cheese, bacon, onions, and almonds. Pour dressing over salad, and toss. Refrigerate before serving.

Greek Week Salad

DRESSING:
 2 cloves garlic, finely minced
 1 teaspoon Italian seasoning
 1 teaspoon Dijon mustard
 1/4 cup red wine vinegar
 1/2 teaspoon salt
 1 teaspoon pepper
 1/2 cup olive oil

In a small bowl, whisk together garlic, Italian seasoning, mustard, vinegar, salt, pepper and olive oil until well combined. Chill.

SALAD:
 salt
 1 pound gemelli or other short pasta
 3/4 medium English cucumber, halved
 lengthwise and thinly sliced
 1 pint cherry or grape tomatoes, halved
 1/2 large sweet or red onion, thinly sliced
 1 cup pitted Kalamata olives, halved
 8 ounces feta, crumbled
 3 cups firmly packed baby spinach

Cook pasta according to directions until al dente, about 8 minutes, or as label directs. Drain, rinse under cold water and transfer to a bowl. Add remaining ingredients, toss with dressing and serve.

Grilled Asparagus

 1-2 pounds fresh asparagus spears, trimmed
 2 tablespoons olive oil
 salt and pepper to taste

Preheat grill for high heat. Coat the asparagus spears with olive oil. Season with salt and pepper to taste. Grill over high heat for 2 to 3 minutes, or to desired tenderness.

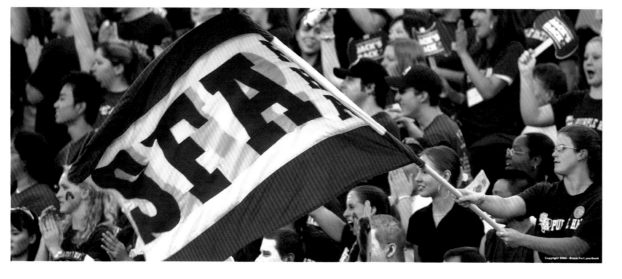

SFA Pride Street Corn

4 ears corn
1/4 cup mayonnaise
1/2 cups cacique crema Mexicana
1/4 cup cilantro leaves, chopped
1 cup crumbled cojita cheese
1 lime, juiced
Fiesta Brand red chili powder or flavored
 seasoning plus salt to taste
2 limes cut into wedges, for garnish

**Cacoque crema Mexicana is sold at Wal-Mart

Soak husked corn in water until thoroughly
saturated and cook on a hot grill or cast iron griddle
pan until slightly charred. Turn the corn frequently
so it gets cooked evenly and all over. Combine the
mayonnaise, crema, and cilantro together. Crumble
cojita cheese in another bowl. Remove husks and,
while the corn is still warm, coat generously with
mayonnaise mix. Squeeze lime juice over the corn and
shower with cojita. Season with chili powder and serve
with extra lime wedges.

Southern Slaw

1 medium cabbage, shredded
4 carrots, grated
1/2 cup sweet onion, chopped
2 cups mayonnaise
2 tablespoons celery seeds
1 green pepper, diced
1/4 cup Dijon mustard
1/4 cup cider vinegar
1/3 cup sugar
1 1/4 teaspoon salt
1/2 teaspoon cayenne pepper

Mix mayonnaise, sugar, mustard, cider vinegar,
celery seeds, salt, and pepper in a large bowl. Add
shredded cabbage, carrots, onion and diced green
pepper. Cover and chill for 2-3 hours.

Spaghetti Salad

Serves: 10-12

1 pound thin spaghetti,
 broken into 1 inch pieces
1 pint cherry tomatoes,
 chopped in half
2 medium zucchini, diced
1 large cucumber, diced
1 medium green bell pepper,
 diced
1 red bell pepper, diced
1 large red onion, diced
2 cans (2-1/4 ounces) sliced ripe
 olives, drained
1/2 cup feta cheese (optional)

DRESSING:
1 bottle (16 ounces) Italian salad
 dressing
1/4 cup grated Parmesan cheese
2 tablespoons sesame seeds
1 teaspoon paprika
1/2 teaspoon celery seed
1/4 teaspoon garlic powder

Cook the pasta according to package
directions. Drain and rinse in cold
water. Transfer to large bowl. Add
cherry tomatoes, zucchini, cucumber,
green and red bell pepper, red onion,
olives, and feta cheese (if desired).

In another bowl, whisk Italian salad
dressing, parmesan cheese, sesame
seeds, paprika, celery seed, and garlic
powder. Pour over salad and toss until
coated. Cover and refrigerate for 3
hours.

Three Bean Salad

1 can of each cut green beans, yellow wax beans,
 and red kidney beans, drained
1/2 cup chopped green bell pepper or use a
 combination of red and green
1 cup sweet onion, sliced
1/2 cup cider vinegar
1/3 cup vegetable oil
1/2 cup granulated sugar
3/4 teaspoon salt
1 teaspoon pepper

In a large bowl, combine drained beans, chopped
bell pepper and sliced onion and toss to blend. In
another bowl, whisk together remaining ingredients;
pour over bean mixture. Toss the salad until the
ingredients are thoroughly coated with the dressing.
Cover and chill for at least 4 hours.

Bacon-wrapped Asparagus

1 1/2 pounds asparagus spears, trimmed 4 to 5
 inches long tips
extra-virgin olive oil, for drizzling
a few grinds black pepper
4 slices center cut bacon or pancetta
chopped chives or scallions, optional garnish

Light grill or preheat oven to 400 degrees. Coat
asparagus spears in extra-virgin olive oil and season
with black pepper. Divide the total number of spears by
four. Wrap each bundle of four with a slice of bacon and
secure with toothpick..
To grill, place bundles on hot grill and cover. Cook
10 - 12 minutes until bacon is crisp and asparagus
bundles are tender. For oven preparation, place bundles
on slotted broiler pan. Bake 12 minutes.

Pasta Salad

1 cup chopped pecans
1/2 (16-oz.) package farfalle (bow-tie) pasta
1 pound fresh broccoli
1 cup mayonnaise
1/3 cup sugar
1/3 cup diced red onion
1/3 cup red wine vinegar
1 teaspoon salt
2 cups seedless red grapes, halved
8 cooked bacon slices, crumbled

Preheat oven to 350 degrees. Arrange pecans on
a baking sheet and bake 5 - 7 minutes or until lightly
toasted.
Cook bacon in a large skillet over medium-high heat
5 - 7 minutes or until crisp; remove bacon and drain on
paper towels. Crumble bacon.
Cook pasta according to package directions and
drain. While pasta is cooking, cut broccoli florets from
stems and separate florets into small pieces. Using a
sharp knive, remove tough, outer layer from stems.
Finely chop florets. In a large bowl, whisk together
mayonnaise and next 3 ingredients; add pecans,
broccoli, pasta, grapes, and onion, stirring to coat.
Season with salt to taste. Cover and chill 3 hours; stir in
bacon and pecans just before serving.

Corn and Tomato Salad

2 cups cooked (preferably grilled) corn kernels
2 cups cherry tomatoes, halved
1 to 1 1/2 English cucumbers, diced
juice of 2 limes plus 2 tablespoons lime zest
1/4 cup cilantro, chopped
3 tablespoons olive oil 1
2 tablespoons sugar
1 jalapeño, chopped and seeded
salt to taste.

Mix together and chill.

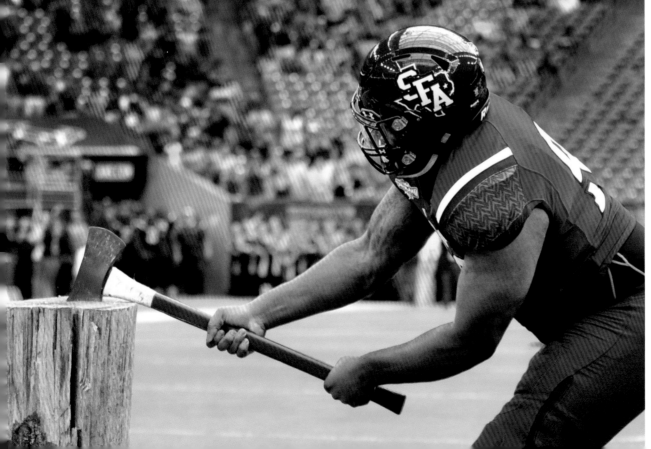

Wild Rice Salad

2 cups wild rice
2 cups brown rice
10 cups water
3/4 cup olive oil
6 tablespoons balsamic vinegar
1/2 tablespoon black pepper
1 cup craisins
1 cup chopped walnuts
1/2 bunch parsley
1/2 bunch green onions
salt to taste

Put rice in pot with water and cook on high heat. Allow to boil for one minute, then cover and reduce heat to low. Cook until all water is absorbed and rice is tender, about 45-60 minutes. Chill rice before mixing with remaining ingredients. Whisk together olive oil, vinegar and pepper in large bowl. Add chilled rice and remaining ingredients.

Mom's Apple Coleslaw

1/4 cup apple cider vinegar
2 tablespoons Dijon mustard
2 tablespoons honey
3/4 teaspoon salt
1/4 teaspoon freshly ground pepper
1/4 cup canola oil
2 (10 ounce) packages shredded coleslaw mix
4 green onions, sliced
2 celery ribs, sliced
2 small Honeycrisp, Gala, or Pink Lady apples, chopped

Whisk together first 5 ingredients. Gradually add oil in a slow, steady stream, whisking constantly until blended. Stir together coleslaw mix and next 3 ingredients in a large bowl; add vinegar mixture, tossing to coat.

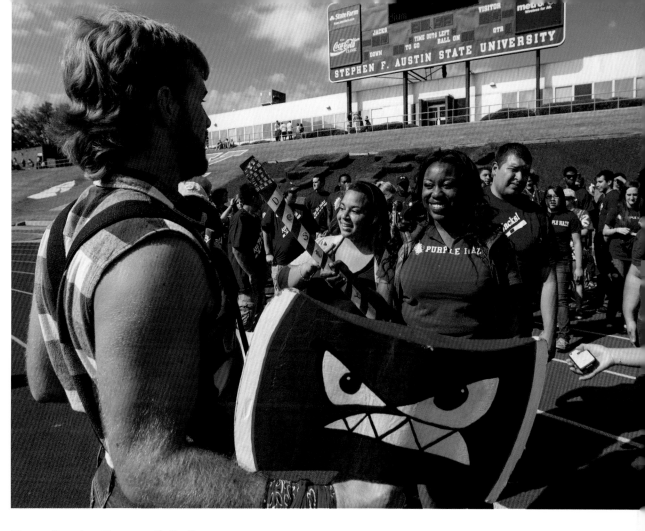

Fear the Ax Potato Salad

Serves 8

9 large red-skinned or Yukon Gold potatoes, unpeeled
9 slices of bacon
1 1/2 medium sweet onions, thinly sliced
3 tablespoons flour
3 tablespoons sugar
3 teaspoons salt
1 teaspoon celery seed
coarse ground pepper to taste
1 1/2 cup water
3/4 cup apple cider or white-wine vinegar
4-6 green onions, chopped

Put potatoes in pan and add water and salt to just cover potatoes. Cook potatoes until tender, about 25 to 30 minutes. Drain, cut into chunks and set aside. Fry bacon until crisp; remove from pan (reserve bacon grease) and crumble. Add bacon to the potatoes.

Sauté onion in bacon grease until golden, then add flour, sugar, salt, celery seed, and pepper. Combine water and vinegar and add slowly to the pan. Continue cooking, stirring occasionally, until liquid boils. Boil for one minute, then pour over potatoes. Mix gently and garnish with chopped green onions. Serve warm.

Grilled Pineapple Rings

1 fresh pineapple - peeled, cored and cut into 1
 inch rings
1 teaspoon honey
3 tablespoons melted butter
dash of Tobasco
salt to taste

Place pineapple in a large Ziploc plastic bag. Add honey, butter, tobasco, and salt. Shake to coat evenly. Chill for 1 hour or more. Preheat grill for high heat and lightly oil grate. Grill each slice for 2 to 3 minutes per side or until heated through.

Capresa Salad

1 cup balsamic vinegar
1/4 cup honey
3 large tomatoes, cut into 1/2-inch slices
1 (16 ounce) package fresh mozzarella cheese,
 cut into 1/4-inch slices
1/2 teaspoon salt
1/2 teaspoon ground black pepper
1/2 cup fresh basil leaves
1/3 cup extra virgin olive oil

Stir balsamic vinegar and honey together in a small saucepan and place over high heat. Bring to a boil, reduce heat to low, and simmer until the vinegar mixture has reduced to 1/3 cup, about 10 minutes. Set the balsamic reduction aside to cool.

Arrange alternate slices of tomato and mozzarella cheese decoratively on a serving platter. Sprinkle with salt and black pepper, spread fresh basil leaves over the salad, and drizzle with olive oil and the balsamic reduction.

Fruity Chicken Salad

1/3 cup chopped pecans
4 cups chopped cooked chicken breasts
2 cups seedless red and green grapes, halved
3 celery ribs, chopped
1 (11ounce) can mandarin oranges, drained
1 cup chopped fresh pineapple*
1/2 teaspoon salt

Preheat oven to 350 degrees. Bake pecans in a single layer in a shallow pan 6 to 7 minutes or until toasted and fragrant, stirring halfway through. Toss together chicken and next 5 ingredients in a large bowl. Add vinaigrette; toss to coat. Sprinkle with pecans, and serve immediately.

*1 (8 ounce) can pineapple tidbits, drained, may be
 substituted.

Orange-Raspberry Vinaigrette

1/2 cup orange marmalade
1/4 cup white balsamic-raspberry blush vinegar
1 medium-size jalapeno pepper, seeded and
 minced
2 tablespoons fresh cilantro, chopped
2 tablespoons olive oil

Mix orange marmalade with next 4 ingredients in a bowl or shake in a sealed jar.

Jack-Mac Salad

4 cups uncooked elbow macaroni
1 cup mayonnaise
1/4 cup distilled white vinegar
2/3 cup white sugar
3 tablespoons prepared yellow mustard
1 1/2 teaspoons salt
1 teaspoon ground black pepper
1 sweet onion, chopped
3 stalks celery, chopped
1 green bell pepper, seeded and chopped
1/3 cup carrot, grated (optional)
1 small jar chopped pimentos (optional)

Cook macaroni according to directions. Drain and rinse with cold water. Drain and set aside. In a large bowl, mix the mayonnaise, vinegar, sugar, mustard, salt and pepper. Add in onion, celery, green pepper, carrot, pimentos and macaroni. Refrigerate 4 hours or overnight.

Fresh Spinach Salad

Combine the salad ingredients in a bowl:
1 bag fresh spinach
6 ounces fresh mushrooms, sliced
5 slices bacon, crisply fried and crumbled
4 ounces bleu cheese, crumbled
1 can French fried onion rings

DRESSING:
1 (10.75 ounce) can tomato soup
3/4 cup oil (canola, grape seed, etc.)
3/4 cup vinegar
3/4 cup sugar
1/2 teaspoon salt
1 teaspoon dry mustard
1/4 teaspoon paprika
1 medium onion, quartered

In large jar, mix dry ingredients together, then add liquid ingredients mixing well. Put onion quarters in for flavor, but remove before serving. Recipe makes enough dressing for 2 bags of spinach. Make ahead to have ready for the salad as the dressing needs to stay in refrigerator about 24 hours before using.

Mexican Corn Bread Salad

1 (1 ounce) package dry ranch dressing mix
1 cup sour cream
1 cup mayonnaise
6 corn bread muffins (16 ounces total)
2 (16 ounce) cans pinto beans, rinsed and drained
1 medium-sized green bell pepper, chopped
2 (15 1/4 ounce) cans whole-kernel corn, drained
3 large tomatoes, chopped
10 slices bacon, cooked and crumbled
2 cups shredded Mexican cheese blend
6 scallions, sliced

In a small bowl, combine dressing mix, sour cream, and mayonnaise; set aside. Crumble half of the corn muffins into a large glass bowl or trifle dish. Layer the beans over the muffins, then the bell pepper, sour cream mixture, corn, tomatoes, bacon, the remaining corn muffins, the cheese, and scallions. Cover and chill at least 2 hours before serving.

Axe 'em Jacks

Quinoa Salad

1 cup white quinoa, uncooked
1/2 teaspoon salt
1 cup diced, seeded, unpeeled cucumber
1 (14.5 ounce) can Hunt's Diced Tomatoes
 with Basil, Garlic and Oregano, drained
1 (2.25 ounce) can sliced ripe olives, drained
1/3 cup feta cheese, crumbled
1/4 cup red onion, chopped

Cook quinoa according to package directions, adding the salt. Meanwhile, combine cucumber, drained tomatoes, olives, cheese and onion in large bowl; set aside. Spread cooked quinoa in 13x9-inch baking dish. Cool slightly in refrigerator 5 minutes. Add quinoa to vegetable mixture; toss gently to combine. Serve immediately or refrigerate until cold.

Baked Jack Corn

2 large eggs, lightly beaten
1 1/2 cup sour cream
2 cup fresh corn kernels
8 ounces Monterey jack cheese, cut into cubes
1/2 cup soft bread crumbs
4 1/2 ounces chopped green chilies, drained
1 teaspoon salt
1/2 teaspoon ground black pepper
2/3 cup Cheddar cheese, shredded

Combine eggs and sour cream in a large bowl; stir in corn and next 5 ingredients. Pour into a greased 10 inch quiche dish or 2-quart baking dish.
Bake, uncovered, at 350 degrees for 35 minutes or until a knife inserted in center comes out clean. Sprinkle with Cheddar cheese, and bake 5 more minutes. Let stand 10 minutes before serving.

Secret Fruit Salad

makes 3-4 servings

1 small box of dry instant vanilla pudding mix
1 pound of strawberries, quartered
1/2 pint blueberries
1 (Red or Green) bunch Grapes
2 sliced bananas
1 can of peach slices (use 1/2 can of juice)
1 can of Mandarin oranges, undrained

Sprinkle pudding mix on the fruit and stir. Serve immediately or allow to sit overnight.

Smokey Corn and Tomato Bruschetta

ON THE GRILL
 1 large ear of yellow corn, husked
 1 small red onion (about 6 ounces), peeled,
 halved
 Olive oil (for grilling)
 1 1/2 pounds (about 5) medium tomatoes (such as
 vine-ripened. Do not use heirloom tomatoes.)
 1 small country bread loaf, sliced

FOR THE DISH
 1 garlic clove, minced
 1 tablespoon fresh lime juice
 1/8 teaspoon hot smoked Spanish paprika*
 2 tablespoons olive oil

Prepare barbecue (medium heat). Brush corn and onion with oil; sprinkle lightly with salt and pepper. Place corn, onion halves, and tomatoes on grill. Cook until corn is charred, onion is just tender, and tomato skins are blistered and loose, turning often, about 12 minutes for tomatoes and 15 minutes for corn and onion. Transfer to foil-lined baking sheet and cool. Brush bread with oil; sprinkle with salt and pepper. Grill until crisp, about 2 minutes per side. Core tomatoes and cut in half horizontally. Gently squeeze out or spoon out juices and seeds. Coarsely dice tomato flesh and place in medium bowl. Cut corn kernels from cob; add kernels to tomatoes. Chop onion; add to tomatoes. Mix in garlic, lime juice, paprika, and 1 tablespoon oil. Season to taste with salt and pepper. Can be made 3 hours ahead. Cover; let stand at room temperature. Serve with grilled bread.

*Spicy smoked paprika, sometimes labeled hot Pimentón or hot Pimentón de La Vera

Grilled Cedar Plank Salmon

1 cedar plank (6x14 inches)
2 salmon fillets (1 1/2 pounds total)
salt and freshly ground black pepper
6 tablespoons Dijon mustard
6 tablespoons brown sugar

Soak cedar plank in salted water for 2 hours and drain. Remove skin and any remaining bones from salmon fillet. Rinse the salmon under cold water and pat dry with paper towels. Generously season the salmon with salt and pepper. Position salmon (on what was skin-side down) on the plank and spread the mustard over the top and sides. Crumble brown sugar over the mustard.

Prepare grill for indirect heat. For gas, preheat to medium, then turn off the burners on one side. Turn the other burners to medium low. For charcoal, once the coals ash over, push them to one side.

Place the plank in the center of the hot grate, away from the heat. Cover the grill and cook around 20-30 minutes. The internal temperature should read 135 degrees. Transfer the salmon and plank to a platter and serve.

You may also grill the salmon over direct heat. Soak the cedar plank well. Spread mustard and brown sugar on the salmon, but do not put the salmon on the plank. Light the grill. When ready to cook, place the plank on the hot grate and leave it until there is a smell of smoke, about 3 to 4 minutes. Turn the plank over and place the fish on top. Cover the grill and cook until the fish is cooked through, reaching an internal temperature of 135 degrees. Check plank often, so the edges don't burn. If edges begin to catch fire, mist with water, or move the plank to a cooler part of the grill.

Grilled Salmon

1 1/2 pounds salmon fillets
lemon pepper to taste
garlic powder to taste
salt to taste
1/2 cup soy sauce
1/2 cup brown sugar
1/3 cup water
1/4 cup vegetable oil

Season salmon fillets with lemon pepper, garlic powder, and salt. In a small bowl, stir together soy sauce, brown sugar, water, and vegetable oil until sugar is dissolved. Place fish in a large resealable plastic bag with the soy sauce mixture, seal, and turn to coat. Refrigerate for at least 2 hours. Preheat grill for medium heat. Lightly oil grill grate. Place salmon on the preheated grill and discard marinade. Cook salmon for 6 to 8 minutes per side, or until the fish flakes easily with a fork.

Grilled Shrimp

1/2 cup olive oil
1/4 cup tomato sauce
2 1/2 tablespoons red wine vinegar
3 cloves garlic, minced
2 tablespoons chopped fresh basil
1 teaspoon salt
1/4 teaspoon cayenne pepper
2 pounds fresh shrimp, peeled and de-veined
wooden skewers soaked in water for 30 minutes

In a large bowl, mix the olive oil, tomato sauce, red wine vinegar, and the garlic. Add basil, salt, and cayenne pepper. Add shrimp to the marinade and stir to coat evenly. Cover and refrigerate for 1 hour, stirring occasionally.
Preheat grill for medium heat. Thread shrimp onto skewers, piercing both head and tail. Toss marinade. Lightly oil grill grate. Cook shrimp on for 2 - 3 minutes per side, or until opaque.

Skewered Chicken Fajitas

1 sweet onion, cut into 1 inch pieces
1 red bell pepper and green bell pepper, seeded and cut into 1 inch pieces
2 tablespoons vegetable oil
1 1/2 pounds of boneless skinless chicken breasts, cut into 1-inch cubes*
2 tablespoons fresh lime juice
2 tablespoons fajita seasoning mix (I use Old El Paso)
wooden skewers
toppings: sour cream, guacamole, shredded cheese, pico, salsa.

Preheat grill to medium heat. Brush grill with oil. Soak wooden skewers in water for 30 minutes to keep from burning. In a medium bowl, add the onion, red bell pepper, green bell pepper, and oil. Mix to coat.
In another bowl, add the chicken and remaining 2 tablespoons of oil. Sprinkle with lime juice and fajita seasoning mix. Gently stir to coat.
Thread the onion, bell peppers, and chicken onto the skewers. Use about 4-5 pieces of chicken per skewer, placing peppers and onions in between.
Grill for 4-6 minutes per side or until chicken is no longer pink. If chicken sticks to grill when you try to turn it, wait a couple of minutes. Chicken will not stick if it is ready to turn. Serve immediately in warmed tortillas and top with your favorite toppings.
*Sirloin or flank steak can be substituted for chicken. Grill steak to desired doneness.

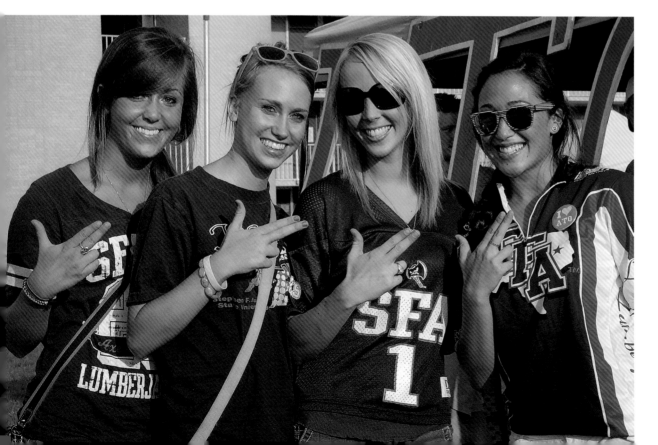

Axe 'em Jacks Spicy Ribs

2 tablespoons ground ginger
1 1/2 teaspoons salt
1 teaspoon black pepper
1/2 teaspoon dried crushed red pepper
3 slabs baby back pork ribs (about 5 1/2 lb.)
2 limes, halved
Hot-Sweet BBQ Sauce

In a small bowl, combine first 4 ingredients and mix well. Rinse and pat ribs dry. Remove thin membrane from back of ribs by slicing into it with a knife and then pulling it off. Rub ribs with cut limes, squeezing juice as you rub. Rub ginger mixture into meat, covering all sides. Place ribs in a 13x9 inch baking dish; cover and chill 8 hours. Let ribs stand at room temperature 30 minutes before grilling. Light 1 side of grill, heating to medium-high heat (350 to 400 degrees); leave other side unlit. Place rib slabs over unlit side, stacking 1 on top of the other and grill, covered with grill lid, 40 minutes. Reposition rib slabs, moving bottom slab to the top and grill 40 minutes. Reposition 1 more time, moving bottom slab to the top and grill 40 minutes. Lower grill temperature to (300 to 350 degrees); unstack rib slabs, and place side by side over unlit side of grill. Cook ribs 30 more minutes, basting with AXE 'EM JACKS HOT-SWEET BBQ SAUCE (Recipe Below).

2 (10 ounce) bottles sweet chili sauce
2 cups ketchup
1 teaspoon mustard
1/2 cup firmly packed dark brown sugar
1 teaspoon ground ginger
1 teaspoon pepper
1/2 teaspoon dried crushed red pepper flakes

Combine sweet chili sauce and remaining ingredients in a saucepan over medium-high heat. Bring mixture to a boil; reduce heat, and simmer 30 minutes.

Lumberjack Pork Chops

sea salt
1/2 cup packed dark brown sugar
4 (8-10 ounce) bone-in pork loin chops, trimmed
1/2 cup bourbon or apple cider
1/4 cup apple cider vinegar
3 teaspoons Worcestershire sauce
3 cloves garlic, minced
1 tablespoon ginger, peeled and minced
1 medium onion, cut into 1/2-inch-thick rounds
2 medium tomatoes, halved crosswise
1 1/2 tablespoon vegetable oil

Prepare grill for indirect heat: For gas, preheat to medium high, then turn off the burners on one side, and turn the other burners to medium low. For charcoal, once the coals ash over, push them to one side.

Whisk 1/4 cup salt, 1/4 cup brown sugar and 3 cups warm water in a large bowl. Add the pork and soak 10 minutes. Meanwhile, mix the bourbon, vinegar, Worcestershire sauce, the remaining 1/4 cup brown sugar, the garlic and ginger in an ovenproof saucepan. Put on the grill over direct heat; bring to a boil, then remove from the grill.

Grill the onion and tomatoes over direct heat until charred, about 3 minutes on each side for the tomato and 4 to 5 minutes on each side for the onion. Add to the saucepan, then return the pan to the grill and cook until the sauce is thickened, about 15 more minutes.

Remove the chops from the brine; pat dry. Brush chops with vegetable oil and grill over direct heat, 2-3 minutes per side. Transfer to the cooler side of the grill and cook 3-4 more minutes per side, basting with sauce.

Key Lime Chicken

4 tablespoons soy sauce
2 tablespoon honey
1 tablespoon vegetable oil
2 teaspoons key lime juice
1 teaspoon garlic, chopped
4 skinless, boneless chicken breast halves

In a bowl blend soy sauce, honey, vegetable oil, lime juice, and garlic. Coat and marinate chicken breast halves in the mixture and refrigerate at least 30 minutes. Preheat grill on high heat. Lightly oil the grill grate. Discard marinade, and grill chicken 6-8 minutes on each side, until juices run clear.

Firecracker Salmon

8 (4 ounce) salmon fillets
1/2 cup peanut or olive oil
6 tablespoons soy sauce
6 tablespoons balsamic vinegar
4 tablespoons green onions, chopped
4 teaspoons brown sugar
2 cloves garlic, minced
1 1/2 teaspoons ground ginger
2 teaspoons crushed red pepper flakes
1 teaspoon sesame oil
1/2 teaspoon salt

Place filets in a glass dish. In a separate bowl, combine the peanut oil, soy sauce, vinegar, green onions, brown sugar, garlic, ginger, red pepper flakes, sesame oil and salt. Whisk together, and pour over the fish. Cover and marinate the fish in the refrigerator 4-6 hours. Prepare an outdoor grill with coals about 5 inches from the grate, and lightly oil the grate. Grill the fillets 5 inches from coals for 10 minutes per inch of thickness, measured at the thickest part, or until fish just flakes with a fork. Turn over halfway through cooking.

Fluffy Pancakes

3/4 cup milk
2 tablespoons white vinegar
1 cup all-purpose flour
2 1/2 tablespoons white sugar
1 teaspoon baking powder
1/2 teaspoon baking soda
1 teaspoon salt
1 egg
3 tablespoons butter, melted
cooking spray

In a small bowl, combine milk with vinegar and set aside for 5 minutes to "sour."

In a large bowl, combine flour, sugar, baking powder, baking soda, and salt. Whisk egg and butter into "soured" milk. Add the flour mixture into the wet ingredients, stirring until lumps are gone.

Heat a large skillet over medium heat and coat with cooking spray. Pour 1/4 cupfuls of batter onto the skillet and cook until bubbles appear on the surface. Flip with a spatula and cook until browned on the other side.

Strawberry Syrup

1 cup water
1 cup white sugar
2 cups strawberries, quartered**
pinch of salt

Combine sugar and water in a saucepan and cook over medium to high heat, stirring constantly until sugar dissolves. Add strawberries and bring to boil. Add salt and cook 10 minutes and reduce heat, simmering until strawberries are soft, and the sauce is thick, about 10 minutes. You can strain to remove fruit or serve as is. Keep refrigerated.

**You can substitute blueberries, blackberries or raspberries for strawberries.

Buttermilk Pancakes

3 cups unbleached, all-purpose flour
3 tablespoons sugar
3 teaspoons baking powder
1 1/2 teaspoons baking soda
1 teaspoon salt
3 cups buttermilk
1/2 milk
3 large eggs
1/3 cup melted butter
Vegetable oil for the pan or griddle

Mix the flour, sugar, baking powder, baking soda, and salt together in a large bowl. In a medium bowl, thoroughly combine the buttermilk, milk, eggs, and butter.

Pour the wet ingredients into the dry ingredients, as opposed to dry into wet. Mix with just a few strokes until the batter is evenly moistened. (The batter will be lumpy.)

Let the batter rest for at least 5 minutes. Meanwhile, heat a griddle (preferably cast-iron) over medium heat. Oil the griddle lightly. The pan is ready when water droplets dance briefly on the surface before disappearing.

Pour the batter from the tip of a spoon. Use the spoon to gently spread this fairly thick batter. The pancakes need to be flipped when they're covered in bubbles. Also, check the underside to be sure it's browned. Flip and cook the other side until golden brown.

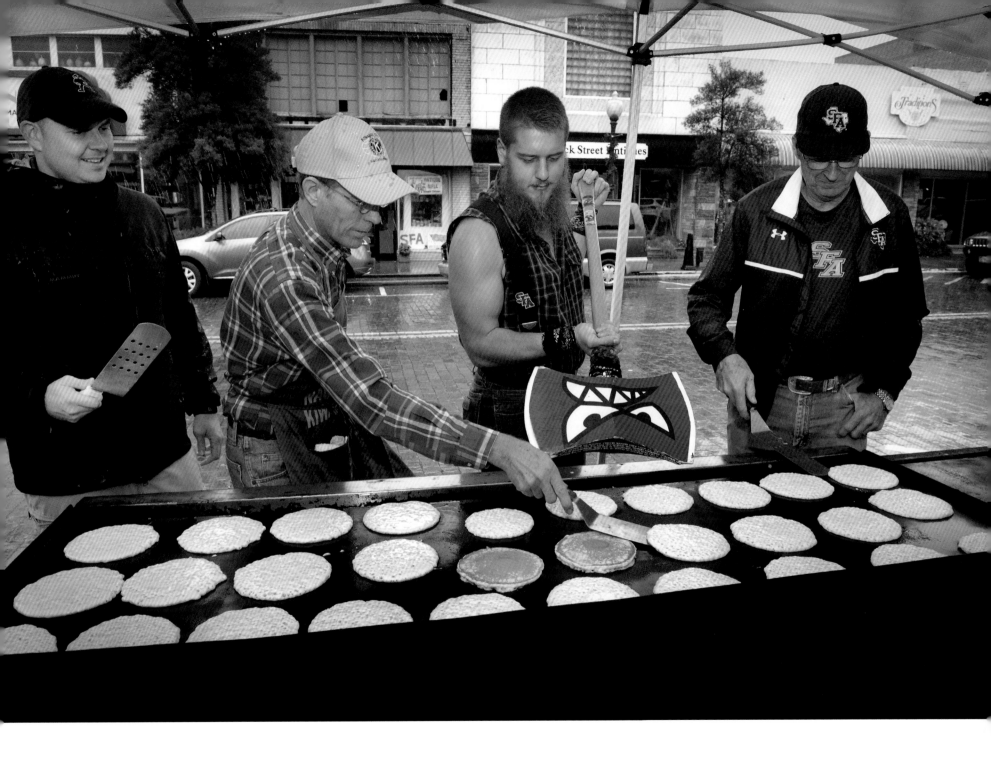

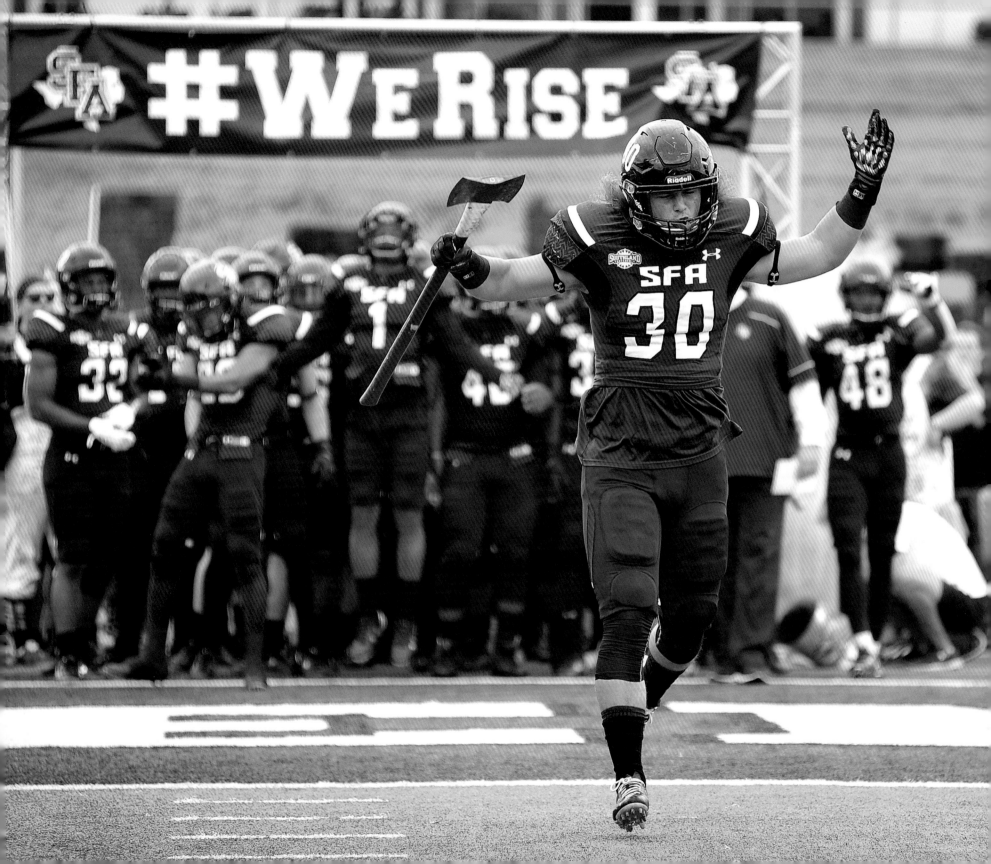

Mouthwatering Ribs

2 (2 pound) slabs baby back pork ribs
ground black pepper
1 tablespoon ground red chile pepper
2 1/4 tablespoons vegetable oil
1/2 cup chopped onion
1 1/2 cups water
1/2 cup tomato paste
1/2 cup white vinegar
1/2 cup brown sugar
3 tablespoons honey
3 tablespoons Worcestershire sauce
2 teaspoons salt
1/2 teaspoon coarsely ground black pepper
1 teaspoon liquid smoke flavoring
2 teaspoons garlic powder
1/2 teaspoon paprika
1/2 teaspoon onion powder
2 tablespoon dark molasses
1/2 tablespoon ground red chile pepper

Preheat oven to 300 degrees. Cut each rack of ribs in half, 4 half racks. Sprinkle salt and pepper and 1 tablespoon chile pepper over meat. Wrap each half rack in foil and back for 2-2 1/2 hours. Meanwhile, heat oil in a skillet over medium heat. Cook and stir the onions in oil until tender, 4-5 minutes. Add water, tomato paste, vinegar, brown sugar, honey, and Worcestershire sauce. Season with 2 teaspoons salt, 1/4 teaspoon black pepper, liquid smoke, whiskey, garlic powder, paprika, onion powder, dark molasses, and 1/2 tablespoon ground chile pepper. Bring mixture to a boil, then reduce heat. Simmer for 1 1/4 hours, uncovered, or until sauce thickens. Remove from heat, and set sauce aside.

Preheat an outdoor grill for high heat. Remove the ribs from the oven and let stand 10 minutes. Remove the racks from the foil and place on the grill. Grill the ribs for 3 to 4 minutes on each side. Brush sauce on the ribs while they're grilling, just before you serve them (adding it too early will burn it).

Mouthwatering Ribs II

2 slabs pork spareribs (about 4 lb.)
1 cup honey
1/3 cup soy sauce
3 tablespoons sherry (optional)
2 teaspoons garlic powder
1/2 teaspoon dried crushed red pepper
Garnish: thinly sliced green onions
JACKS' WINNING BBQ SAUCE

Rinse and pat ribs dry. If desired, remove thin membrane from back of ribs by slicing into it with a knife and then pulling it off. (This will make ribs more tender.)

Bring ribs and water to cover to a boil in a large Dutch oven over medium-high heat; reduce heat to medium, and simmer 30 minutes. Drain and pat dry. Place ribs in a 13x9 inch baking dish.

Stir together honey and next 4 ingredients; pour over ribs. Light 1 side of grill, heating to medium-high; leave other side unlit. Place ribs over unlit side of grill, reserving sauce in dish. Grill, covered with grill lid, 45 minutes. Reposition rib slabs, placing slab closest to heat source away from heat and moving other slab closer to heat.

Grill, covered with grill lid, 45 minutes to 1 hour or until tender, repositioning ribs and basting with reserved sauce every 20 minutes. Remove ribs from grill, and let stand 10 minutes. Cut ribs, slicing between bones. Serve with JACKS' WINNING BBQ SAUCE, if desired.

Jacks' Winning BBQ Sauce

1/4 cup of olive oil
1 yellow onion, chopped
4 celery stalks, chopped
1/2 cup ketchup
1/2 cup water
2 cups Worcestershire sauce
1/2 cup vinegar
2 1/2 teaspoons ground cumin
2 1/2 teaspoons chili powder
2 1/2 teaspoons hot sauce
2 1/2 teaspoons black pepper
2 1/2 teaspoons kosher salt
1/4 cup liquid smoke flavoring
2 tablespoons brown sugar
2 tablespoons Dijon mustard
1/2 cup, plus 2 tablespoons molasses

Sauté onions and celery in a large sauce pot and the remaining ingredients and simmer for 30 minutes.

Jumpin' Jack Pork Chops with Peach BBQ Sauce

3/4 cup firmly packed dark brown sugar
1/4 cup kosher salt
2 cups boiling water
4 cups ice cubes
4 bone-in pork loin chops (about 2 pounds)
1 medium-size sweet onion, finely chopped
2 tablespoons olive oil
1 garlic clove, minced
2 tablespoons ginger, peeled and grated
1 1/2 cups ketchup
1/2 cup peach preserves or jam
2 large peaches, peeled and diced
3 tablespoons apple cider vinegar
salt and freshly ground pepper to taste

Combine sugar and salt in a large bowl; add boiling water, stirring until sugar and salt dissolve. Stir in ice cubes to cool mixture. Add pork chops; cover and chill 30 minutes.

Meanwhile, sauté onion in hot oil in a medium saucepan over medium heat 2 minutes or until tender. Add garlic and ginger; cook, stirring constantly, 45 to 60 seconds or until fragrant. Add ketchup, peach preserves, and peaches. Reduce heat to low, and simmer, stirring occasionally, 30 minutes or until sauce thickens. Add vinegar; season with kosher salt and freshly ground pepper to taste. Remove from heat.

Remove pork from brine, discarding brine. Rinse pork and dry with paper towels. Preheat grill to 350-400 degrees (medium-high) heat. Pour half of peach mixture into a bowl; reserve remaining mixture. Season both sides of pork with desired amount of kosher salt and freshly ground pepper. Grill pork, covered with grill lid, 5 to 6 minutes on each side or until a meat thermometer inserted into thickest portion of each chop registers 145 degrees, basting pork occasionally with peach mixture in bowl. Remove pork from grill; let stand 5 minutes before serving. Serve with reserved peach mixture

Freezer Coleslaw

1 cup sugar
1 cup vinegar
1/2 teaspoon celery seeds
1 medium cabbage, shredded (about 8 cups)
1 large carrot, shredded
1/2 cup green pepper, chopped
1/2 cup sweet red pepper, chopped
1 medium-size sweet onion, finely chopped
1 teaspoon salt
1 teaspoon pepper

Stir together first 3 ingredients and 1 cup water in a saucepan; bring to a boil over high heat, stirring occasionally. Boil 1 minute. Cool completely (about 30 minutes).

Stir together shredded cabbage and next 6 ingredients in a large bowl. Pour dressing over cabbage mixture; toss gently. Divide coleslaw evenly among 4 (1-quart) heavy-duty zip-top plastic freezer bags. Seal and freeze 3 days. Store in freezer up to 1 month. Thaw coleslaw at room temperature 3 hours before serving.

Tailgate Chili

Adapted from Boilermaker Tailgate Chili Recipe

2 pounds ground beef chuck
1 pound bulk Italian sausage
1 (15 ounce) can seasoned black beans, drained
1 (15 ounce) can dark red kidney beans, drained
2 (15 ounce) cans chili beans, drained
1 (15 ounce) can chili beans in spicy sauce
2 (28 ounce) cans diced tomatoes with juice
1 (6 ounce) can tomato paste
1 can RoTel diced tomatoes and green chilies
1 large sweet onion, chopped
4 stalks celery, chopped
1 green bell pepper, seeded and chopped
1 red bell pepper, seeded and chopped
2 green chile peppers, seeded and chopped
2 tablespoons bacon bits
4 cubes beef bouillon
1/2 cup beer
1/3 cup chili powder
2 tablespoons Worcestershire sauce
1 tablespoon minced garlic
1 tablespoon dried oregano
2 teaspoons ground cumin
2 teaspoons hot pepper sauce (e.g. Tabasco)
1 teaspoon dried basil
2 teaspoons salt
1 teaspoon each ground black pepper and cayenned pepper
1 teaspoon paprika
2 teaspoons brown sugar
Toppings: Fritos, shredded cheese, sour cream, chopped tomatoes,
 and chopped onions

Brown ground chuck and sausage in a large stock pot over medium high heat. Cook thoroughly and drain off excess grease. Add the chili beans, spicy chili beans, diced tomatoes, and tomato paste. Add the onion, celery, green and red bell peppers, chile peppers, bacon bits, bouillon, and beer. Add the chili powder, Worcestershire sauce, garlic, oregano, cumin, hot pepper sauce, basil, salt, pepper, cayenne, paprika, and sugar. Stir to blend, then cover and simmer over low heat for at least 2 hours, stirring occasionally.

After 2 hours, taste, and adjust salt, pepper, and chili powder if necessary. The longer the chili simmers, the better it tastes. Serve in bowls over Fritos and garnish with desired toppings.

All Hail to SFA

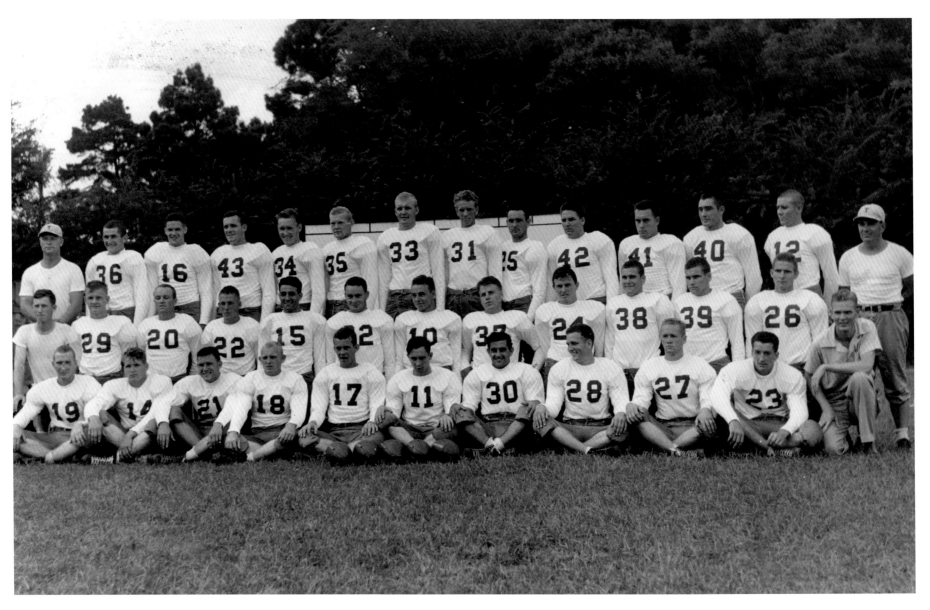

Lumberjack Football Team, 1942

Lumberjack Freshmen, 1943

SFA Band Drum Majorettes, 1943

F.E. Abernethy, student, 1940s

Aikman Gymnasium, 1940s

"The outbreak of World War II was to bring SFA and Nacogdoches even closer together. The desire for victory strengthened their sense of community as they organized the county's civil defense units, humanitarian relief organizations, educational awareness programs, and USO for the Home Front.... On the college campus, SFA's air raid warden, Jack Moore, patrolled for violators, yet he found none. At the Aikman gym, a basketball game between SFA and Oklahoma had just ended when the lights went out. Fortunately, everyone found the exits without incident. Although someone set off a few fireworks, by and large, and the students behaved according to the rules, and the campus betrayed little light. The next day, the Pine Log jokingly reported that 96 percent of the student body had a date during the drill."

—John Hunt, "Nacogdoches and SFA mobilize the home front"

"I do not remember much about the war in Europe before America's entry, but remember, I was only 16 when I entered college. The Birdwell assembly [in December of 1941] was my first war-time memory. I get goose-pimples just thinking about it. I personally had two close friends at Pearl Harbor. The guys started leaving immediately, some over the Christmas Holidays and even more once the semester was over."

Joyce Bright Swearingen

"Each year it became harder to get photographic supplies, such as film and good paper. In the meantime, Mr. Schluter [the local photographer] moved. Mr. Schluter had always taken the pictures for the annual. There was no film to take snapshots. That was a war product. We had to ask everyone to volunteer snapshots. Someway we found enough to make it work."

Joyce Bright Swearingen

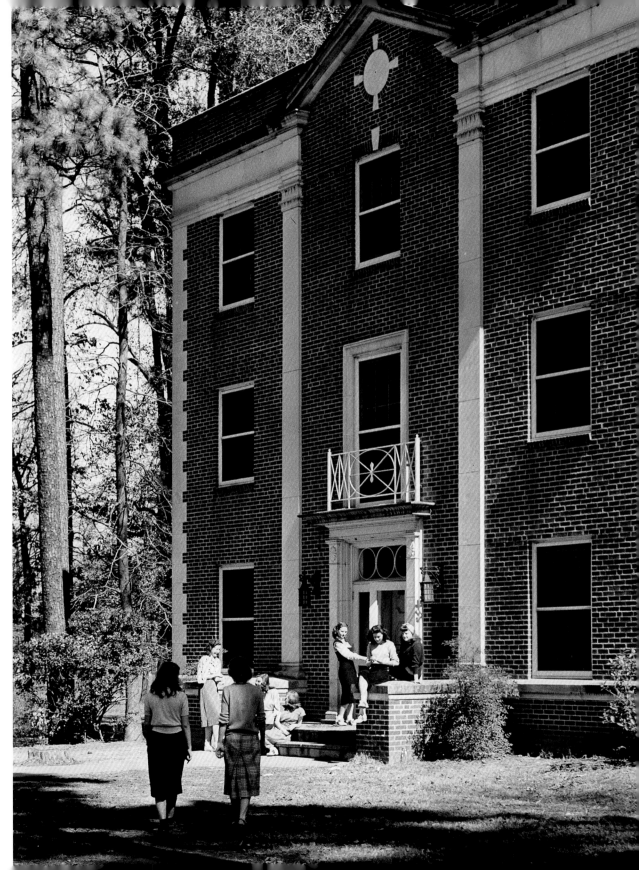

Gibbs Hall, 1947

SFA Coaching Staff, 1946. Left to Right: Stan McKewen, Bob Shelton, Bill Pierce, and Curly Roquemore.

Stone Fort Dedication, 1946

A Toast to Elegance

The holiday season – a wonderful, mystical time filled with family gatherings, parties and galas, lighting extravaganzas, cooking marathons and shopping sprees. The air feels fresher, people seem happier, lights are brighter, and schedules are busier! I have always loved the holiday season and look forward each year to making new memories. I enjoy spending time with family and friends and sharing special meals and moments. Starting with Thanksgiving and moving forward through Christmas and the New Year, the holiday season is about new beginnings, new life. Thanksgiving is a celebration of the founding of our great nation and Christmas, the celebration of the birth of our Savior. Rounding out the holiday season we welcome the arrival of a new year. With each celebration comes a time for both reflection and anticipation. We gather with family and friends to share our joys and our sorrows, our successes and our challenges. We laugh, cry, talk, sing, and enjoy time together. We decorate Christmas trees, sing beautiful carols, enjoy children's plays and concerts, and cook wonderful holiday foods. Nothing says "holiday" like turkey and dressing with all of the trimmings. We are thankful for life, freedom, and new beginnings.

During the holiday season I take time to reflect on the year and look forward with anticipation to the year ahead. I think about how fortunate I am to live in America. With all of our challenges, America remains the greatest nation on earth. We are a nation bound not by race or religion, but by the shared values of freedom, liberty, and equality. I am thankful for the freedom to worship as I choose and to vote as I am convicted. But with those rights come responsibilities as citizens to pledge our allegiance to this country and to uphold the constitution upon which it was founded. God bless America!

Thanksgiving is literally about giving thanks and the spirit of Thanksgiving leads us into the Christmas season. Christmas, a season of shopping, tree lighting, and many carefully planned celebrations. In the midst of the activity, we stop to remember the celebration – new life and new beginnings. Christmas is a season rich in traditions and full of memories. With many beautiful memories made and those yet to come, I can identify my favorite Christmas memory - 1982. Gary and I were expecting our second child and he was due on December 31. What a beautiful Christmas gift that year as he was born on December 19. We brought him home three days later and laid him in the cradle freshly prepared for him. My heart was happy and my spirit joyful. New life – God's gift to us. Each child is equally special and gratefully cherished. However, that day I had a unique sense of God's love as I watched my baby boy sleeping soundly in a cradle. God bless our homes!

New beginnings and new memories. I look forward to the years ahead. As we welcome in each new year, we must not ignore the puzzle pieces of our lives. Experiences of our past join with those of our present and future to create the unique story of our lives. May we always celebrate life!

– Kimberly M. Childs

The Most Amazing Gumbo for a Holiday Supper

This recipe is not for the faint of heart. Read ALL directions before beginning to make this dish. Pay very close attention when making the roux as it is easy to scorch.

1. Make the stock the day before you make the gumbo. You will need at least 1 gallon of liquid. I make a ham stock out of smoked ham hocks, which I simmer for a total of 4 hours; after the first 2 hours, I add 1 large yellow onion, two carrots, two stalks celery, parsley, peppercorns, a few whole allspice, and 2 bay leaves. After stock is sufficiently simmered, remove from heat and cool completely. Skim fat from top layer of stock (you don't want that fat in the gumbo). I also make a separate stock from the heads of the shrimp I have shelled (as I almost always put shrimp in my gumbo). This can be made in about 45 minutes the same day you make your gumbo. Add shrimp heads to water and boil. Add an onion, some celery, whole coriander seeds, black pepper corn, mustard seeds, bay leaf and reduce to low boil; I like to mix both stocks together—use your own judgment about how much water to put in to make these stocks, but overall you'll need 1 gallon of liquid.

2. Dice a large yellow onion, 1 large green bell pepper, 1 stick celery, 1 head garlic. Set aside.

3. Heat 1 cup oil (peanut, canola, or olive) for about 3 minutes over medium heat.

4. Make a roux by whisking 1 cup flour into the hot oil and constantly stirring over medium heat (this is important—if you use high heat, the flour will scorch) for about 20 minutes; flour should be the color of milk chocolate. If you start seeing dark flecks floating in the roux, you have burned the flour and must start over. NEVER use a burnt roux—it is bitter and will separate from your stock and float on top of the gumbo like an oil spill.

5. When roux is ready, add onions and stir for about 3-5 minutes over medium heat; then add the rest of the vegetables and stir for about 3 more minutes over medium heat.

6. Add about 1.5 pounds of good smoke sausage sliced into 1/4 inch rounds (for additional flavor, I like to put the sausage in my BBQ kettle and smoke them for about half an hour over indirect heat and then slice it up). If you've made a stock out of smoked ham hocks, you can add the hock meat too; if making a seafood gumbo, add gumbo crabs at this point as well; stir the meats/crabs in the roux-vegetable mixture for about 5 minutes over medium heat.

7. Now, add 1 gallon of good hot stock, 1 large ladle (about a 1 cup capacity) at a time to your roux-vegetable-meat mixture; it is important to incorporate this slowly, so that the roux won't break but instead mixes in smoothly, or else your flour will separate from the oil, and the gumbo will not be properly thickened; bring the mixture back up to a boil every time you add a ladle of stock to it before adding another ladle.

8. If you're using chicken, you want to add it to the pot as soon as you have incorporated all your stock and brought the gumbo to a low boil; I use only thighs, as they have the most flavor; I take the skin off and brown them up good in a hot skillet with a generous amount of oil; I salt and pepper them in the skillet on both sides; then I pour out the fat and throw in some white wine to deglaze and add the glazed liquid to the gumbo pot along with the browned chicken thighs; the idea is to get as much goodness into the pot as possible.

9. Now add your seasoning: 3 bay leaves, a good amount of thyme leaves (like a teaspoonful, but I never measure), cayenne to your taste, fresh cracked black pepper to your taste; salt to taste (be careful here because the ham hock stock is already salty from the cured hocks)—I usually find 2 -3 teaspoons of salt to be plenty, so add 1 at a time and taste accordingly.

10. Let boil/simmer for at least an hour and up to two; skim off any scum that rises to the top.

11. Now add your shrimp (about 2 pounds)—I like to devein and butterfly them; two packs of green onions chopped; and a big handful of parsley or cilantro chopped; let cook for 5 minutes on low boil-do not overcook or shrimp will become limp and greens will dissolve.

12. If using filé, it should be added to the individual bowls. Never cook it into the gumbo, as it will become bitter. I also like to add hot sauce to my bowl. Finally, if using okra, it should be incorporated into the gumbo 20 minutes before the stop cooking time. About a pound of chopped okra will do; frozen is fine if it has been defrosted.

Bourbon Glazed Ham

This recipe is for a fully cured/cook bone-in ham. It can be doubled for a full ham.

1/2 cup apple juice
1/4 cup bourbon
1 3/4 cups (packed) dark brown sugar
1 cup pecans, toasted, cooled, finely ground
1/4 cup mild-flavored (light) molasses
1/2 teaspoon ground cloves
1/2 teaspoon ground ginger
3 tablespoons dry mustard
1/2 bone-in ham (I use Cooks)

Combine juice and bourbon in saucepan and boil until reduced to 1/3 cup, about 6 minutes. In a bowl, mix sugar, pecans, molasses, cloves, ginger, and mustard. Add bourbon mixture; stir to form thick paste.

Position rack in bottom third of oven and preheat to 325 degrees. Line a large roasting pan with heavy-duty foil, leaving overhang on all sides (or better yet, purchase a large, disposable foil roasting pan because the glaze is really hard to scrub off). Place ham, fat side up, in prepared pan. Cover ham loosely with foil. Heat approximately 10-15 minutes per pound or until thermometer inserted into thickest part registers 130-135 degrees, about 10-15 minutes per pound. READ PACKAGE DIRECTIONS FOR THE HAM YOU PURCHASE.

Remove ham from oven and lightly score fat in crisscross or diamond pattern. Rub glaze thickly over top and sides of ham. Increase oven temperature to 400 degrees and return ham to oven (UNCOVERED) and roast until glaze is deep brown and bubbling, about 25 minutes. Remove ham from oven and let rest at least 20-25 minutes.

Duck L' Orange

1 tablespoon kosher salt
1 teaspoon ground coriander
1/2 teaspoon ground cumin
1 teaspoon black pepper
1 (5 to 6 pound) duck
1 juice orange, halved
1 tablespoon dried thyme
1 tablespoon marjoram
1 tablespoon dried parsley
1 small onion, cut into 8 wedges
1/2 cup dry white wine
1/2 cup chicken stock or broth
3 carrots
3 celery ribs

Place oven rack in middle and preheat over to 475 degrees. Mix first four ingredients together and pat inside and outside of duck with spice mix. Cut 1/2 of the orange into quarters (save the other half for juice) and place into small bowl. Add thyme, marjoram, parsley, and 4 onion wedges (set aside other onion wedges for roasting pan) and mix will. Place into duck cavity.

In a saucepan, combine white wine and chicken stock; squeeze in juice from 2nd half of orange and set aside.

Place the remaining 4 onion wedges in a roasting pan with carrots and celery. Place duck on top of vegetables and roast for 30 minutes.

After the duck has roasted for 30 minutes, reduce oven temperature to 350 degrees. Pour wine mixture into roasting pan and continue cooking until a thermometer (inserted into thigh but not touching the bone) registers 170 degrees, about 75-90 minutes. Do not overcook. (Make orange sauce while duck is roasting.)

ORANGE SAUCE
1/3 cup sugar
1/3 cup fresh orange juice (from 1 to 2 oranges)
2 tablespoons white-wine vinegar
1/8 teaspoon salt
tablespoons chicken stock or broth as needed
1 tablespoon unsalted butter, softened
1 tablespoon all-purpose flour
1 tablespoon orange zest, removed with a vegetable peeler

While duck roasts, cook sugar in a dry 1-quart heavy saucepan over moderate heat, stirring constantly, until it begins to melt. Continue to cook, stirring occasionally with a fork, until melted sugar turns a golden caramel (do not overcook). Carefully add orange juice, vinegar, and salt. Mixture will steam and bubble. Simmer the mixture over low heat, stirring occasionally, until caramel is dissolved. Remove syrup from heat and set aside to cool.

Once thermometer reaches 170 degrees, turn on broiler and broil 3 minutes until duck is golden brown. Remove from oven and tilt duck to drain juice from cavity and into pan. Remove vegetables from roasting pan and set aside to serve with duck. Pour pan juices through a fine-mesh sieve into a 1-quart glass bowl. Skim fat and discard. Add chicken stock or broth to pan drippings to equal 1 cup liquid.

In a small sauce pan, heat pan juices to a simmer. Stir together butter and flour to form a paste. Add flour paste to simmering juices, whisking constantly to prevent lumps. Add the orange syrup and 1 tablespoon orange zest (removed with vegetable peeler) and simmer until sauce thickens and zest becomes tender, about 5-7 minutes. Serve with duck and roasted vegetables.

.

Apricot-Glazed Cornish Hens

1 cup apricot preserves
3 teaspoons orange zest
3 tablespoons orange juice
1 teaspoon brown sugar
4 (1 to 1 1/4 pound) Cornish hens
1/4 teaspoon paprika
2/3 cup cashews (can substitute pistachios)
3 tablespoons melted butter
1/3 cup green onions, chopped
1 (6 ounce) package long-grain and wild rice mix
2 1/3 cups chicken stock

In a medium bowl, combine apricot preserves, orange rind, and orange juice; set aside to use later to baste hens.

Remove giblets from hens; reserve for another use. Rinse hens with cold water and pat dry. Close cavities and secure with wooden picks. Rub with olive oil. Sprinkle with paprika.

Preheat oven to 350 degrees. Place hens, breast side up, in a lightly greased roasting pan. Bake in preheated oven 1 1/4 to 1 1/2 hours, basting frequently with about 1/2 cup of the reserved apricot mixture during last 30 minutes of cooking.

While hens bake, prepare rice mixture.

In a large skillet, sauté cashews in the melted butter until golden, 1 - 2 minutes. Remove cashews from pan with slotted spoon and set aside, reserving any butter in the skillet.

To the skillet add onions and sauté until tender. Add rice and seasoning packet from box, and prepare according to package directions, substituting chicken broth for water and omitting salt. When done, stir in reserved cashews.

When hens are done, remove from oven and arrange on a serving platter; brush with remaining apricot glaze and serve over rice mixture.

Wild Rice Stuffed Turkey Breasts

1 (3-ounce) package dried cherries
2 cups port wine
3 1/2 cups chicken broth, divided
1/2 cup uncooked wild rice
1/2 cup uncooked long-grain rice
1 teaspoon freshly ground pepper
1 sweet onion, chopped
1/4 cup celery, diced
1/4 green pepper, chopped

2 cups soft whole wheat breadcrumbs
1/4 cup slivered almonds
1 (6-pound) turkey breast
2 teaspoons fresh rosemary, chopped
2 garlic cloves, minced
1 tablespoon sea salt
1 tablespoon freshly ground pepper
2 tablespoons butter
3 tablespoons all-purpose flour

Combine cherries and wine; let stand 1 hour. Drain, reserving wine in one container and cherries in another.

In a medium sauce pan, combine 2 cups chicken broth, wild rice, and next 4 ingredients. Bring to a boil. Cover and reduce heat, simmering 30 minutes or until liquid is absorbed and rice is tender. Cool. Stir in breadcrumbs, slivered almonds, and cherries.

Remove bone from turkey breast, leaving skin and meat intact. Place turkey between 2 sheets of heavy-duty plastic wrap, and flatten with mallet to 1-inch thickness. Rub skinless side of turkey breast with rosemary and garlic; spread with rice mixture. Roll the breast, starting at a long side, jellyroll fashion. Secure with toothpicks or kitchen string. Sprinkle with salt and tablespoon pepper and place on a lightly greased rack in a roasting pan.

Bake at 375 degrees for 2 hours or until a meat thermometer inserted into thickest portion registers 180 degrees. Remove from pan, reserving drippings; let stand 10 minutes.

Melt butter in a heavy saucepan over low heat; stir in reserved drippings. Whisk in flour until smooth. Cook, whisking constantly, 1 minute. Gradually add reserved wine and remaining 1 1/2 cups broth; cook over medium heat, whisking often, 5 minutes or until thickened. Serve with turkey.

Simple Prime Rib

1 bone-in prime rib (6 - 7 pounds)
7 cloves garlic, thinly sliced
salt and coarsely ground black pepper
2 cups red wine
4 cups beef stock
1 1/2 tablespoons fresh thyme leaves, chopped

Remove prime rib from refrigerator and let sit 30 minutes to come to room temperature before roasting. This is very important because if the meat is not room temperature when placed in the oven, it will take much longer to cook.

Preheat oven to 350 degrees.

Make small cuts/slits all over the meat and fill each slit with a sliver of garlic. Then, season the roast liberally with the salt and coarse pepper. Place roast on a rack set inside a roasting pan. Roast for approximately 2 hours for medium rare or until a meat thermometer inserted into the center of the roast reads 135 degrees. Remove the meat to serving platter, and tent with foil to keep warm.

Pour roast drippings into a large saucepan and heat on high. Add wine and cook over high until mixture reduces, stirring often so nothing sticks to pan. Add beef stock and cook until reduced by half. Stir in thyme and season with salt and pepper to taste.

Slice meat as desired and serve with au jus.

Beef Tenderloin with Balsamic Gravy

4 (6-ounce) beef tenderloin steaks
3 tablespoons coarse sea salt
2 tablespoons coarsely ground pepper
3 tablespoons olive oil

Preheat oven to 350 degrees. Rub steaks evenly with salt and pepper. Heat oil in large ovenproof skillet on high. Sear steaks 2-3 minutes on each side and then transfer skillet to preheated oven and cook 8-15 minutes for desired doneness. Serve with BALSAMIC GRAVY on the side and garnish with sprigs of parsley or thyme.

BALSAMIC GRAVY.
1/4 cup dry red wine
1/4 cup balsamic vinegar
2 tablespoons brown sugar
1 shallot, chopped
2 garlic cloves, minced
1 egg yolk
1/3 cup unsalted butter, melted

Combine wine, balsamic vinegar, brown sugar, shallot, and garlic in a small saucepan and bring to a boil, cooking 2 minutes. Cool.

After balsamic mixture has cooled, whisk egg yolk into mixture and cook over low heat, whisking constantly, until thickened. Slowly add butter and whisk until blended. Serve immediately.

Pork Tenderloin with Blackberry Wine Sauce

pork rub
1 1/2 pounds pork tenderloin
2 tablespoons olive oil

PORK RUB
3 teaspoons olive oil
1 teaspoon red wine vinegar
1 teaspoon dried thyme
1 teaspoon dried rosemary
1 tablespoon garlic, minced
1 teaspoon kosher salt
1/4 teaspoon fresh ground pepper

In a small bowl, combine all ingredients and mix well. Set aside. Remove skin and other excess fat from the pork tenderloin. Cut pork into 1 1/2 inch medallions. Liberally coat each medallion with the pork rub and place in a Ziploc baggie. Refrigerate and let marinate at least 2 hours up to all day.

Pre-heat a cast iron or other heavy skillet to high heat. Pre-heat the oven for 350 degrees. Add 2 tablespoons olive oil to the pan and coat the bottom. Sear medallions 2 minutes on each flat side. Remove from heat. If you sear the medallions in two batches, add another tablespoon of oil before starting the second batch.

Place seared medallions on a pan or leave in the cast iron skillet and place in the oven. Cook 8 - 15 minutes, removing medallions at 135 degrees. Tent medallions with foil and let them rest for 10 minutes before serving with BLACKBERRY WINE SAUCE.

BLACKBERRY WINE SAUCE
1/2 cup shallots, diced
2 teaspoons garlic, minced
2 cups red wine
1 1/2 cups blackberries
1/2 cup blackberry jam
2 tablespoons flour
3 tablespoons olive oil
1 tablespoon red wine vinegar
1 teaspoon salt
1/4 teaspoon cayenne pepper

Heat a saucepan to medium-high heat and place 2 tablespoons of olive oil in it to coat the bottom. Sauté the shallots for about 5 minutes until they begin to turn color and are extremely fragrant. Add the garlic and cook for about 2 minutes until it also begins to turn color. Pour in two cups of wine and increase heat to high. Stir well as the wine reduces by about half (10-20 minutes). Once the wine has reduced, lower heat to medium low and add blackberries and the jam. Using a fork, crush the blackberries, stirring frequently while the sauce simmers for about 5 minutes. Add salt. Add the flour slowly and stir in to thicken sauce slightly. Remove from heat. The sauce should thicken a little more as it cools. Put sauce back on low heat if it cools too fast. Spoon sauce over medallions.

Stuffed Tenderloin

1 whole fillet of beef
4 tablespoons butter
2 green onions, chopped
1 cup fresh mushrooms, chopped
5 cloves of garlic, thinly sliced
3 tablespoons bleu cheese
melted butter as needed

Sauté onions, mushrooms, and garlic in butter. Split tenderloin and add vegetables. Spread bleu cheese over stuffing. Close slit with toothpicks. Brush fillet with melted butter and bake at 350 degrees for 45 - 60 minutes or until desired doneness.

Chicken Marbella

1 garlic bulb, minced
1/4 cup dried oregano
1 tablespoon coarse sea salt
2 teaspoons pepper
1/2 cup red wine vinegar
1/2 cup olive oil
1 cup dried prunes or apricots
1/2 cup pimento-stuffed olives
1/4-1/2 cup capers with a bit of juice
6 bay leaves
2 chickens (3 1/2 to 4 pounds each) quartered, or
 you can use 8 pounds of leg quarters.**
1 cup brown sugar
1 cup dry white wine
1/4 cup fresh parsley or cilantro, chopped
**Do not use boneless chicken.

In a large dish, combine first 13 ingredients. Add chicken and coat each piece well. Cover. Refrigerate and let marinate for several hours or overnight. Turn chicken every so often in marinade.

Preheat oven to 350 degrees. Arrange chicken in a single layer in baking dishes and spoon marinade over. Sprinkle with brown sugar and pour white wine around chicken.

Bake 50 minutes to 1 hour, basting frequently. Chicken is done when juice runs clear. Transfer chicken, fruit, olives, and capers to a platter, moisten well with juices and sprinkle with parsley/cilantro. Serve chicken with remaining pan juices in a sauceboat.

Creamed Baby Spinach

2 (10-ounce) packages baby spinach, washed
1 sweet onion, finely chopped
3 tablespoons, plus one teaspoon all-purpose flour
2/3 cup grated Parmesan cheese
salt and pepper

3 tablespoons butter
2 garlic cloves, minced
2 cups milk
1/2 teaspoon white pepper
buttered bread crumbs

Bring 1 inch of water to a boil in a large saucepan. Add the spinach, cover, and steam until wilted, 3 to 5 minutes. Drain and rinse with cold water. After squeezing out all of the water, chop spinach and set aside. Melt the butter in a medium saucepan over medium heat. Add the onion and garlic and sauté until softened, about 4 minutes. Add in the flour, stirring constantly, to make a paste. Cook 1 minute. Slowly whisk in the milk and cook until slightly thickened. Stir in the Parmesan cheese.

Add spinach to cheese mixture. Salt and pepper to taste and cook until the spinach is heated, about 2 minutes. Pour into lightly butter baking dish and top with buttered bread crumbs. Refrigerate until 35-40 minutes before meal. Bake at 350 degrees until hot and bubbly.

Glazed Carrots

2 pounds carrots, sliced diagonally 1/4-inch slices
2/3 cup packed brown sugar
1 tablespoon molasses or maple syrup
1/4 cup butter
1 teaspoon orange zest
salt and pepper

In a medium to large saucepan, heat about one inch water to boiling. Add carrots and a dash of salt. Heat to boiling, then cover and reduce heat. Simmer about 12-15 minutes or until carrots are tender. As carrots simmer, heat brown sugar, molasses, butter, orange peel, and 1/2 teaspoon salt in medium-sized skillet over low to medium heat, stirring constantly, until sugar dissolves. Do not scorch. When carrots are cooked, drain liquid and stir carrots into sugar mixture. Cook over low heat 4-6 minutes, gently stirring. Salt and pepper to taste. Cook until carrots are glazed and hot.

Whipped Sweet Potatoes

4 pounds medium sweet potatoes
1 cup heavy cream
4 tablespoons unsalted butter
1/4 teaspoon cinnamon
1/2 vanilla bean, slit lengthwise, seeds scraped
sea salt and freshly ground pepper to taste
1/2 -1 cup sharp Cheddar cheese, grated

Preheat the oven to 400 degrees. Using a fork, poke holes in the sweet potatoes. Lightly oil potato skins and bake on cookie sheet for 35 minutes until tender. Let cool a little, then peel and put in mixing bowl. Whip until smooth.

In a small saucepan, combine the cream, butter, and vanilla bean and seeds. Bring to a simmer. Remove vanilla bean. Add about half of the vanilla cream mixture to the sweet potatoes and whip, adding more cream mixture to desired consistancy. Whip until smooth. Salt and pepper to taste. Transfer to a baking dish and top with desired amount of sharp Cheddar cheese. Return to oven until cheese melts. Serve warm.

Classic Parmesan Scalloped Potatoes
from Southern Living

1/4 cup butter
2 pounds Yukon gold potatoes, peeled and thinly sliced
3 cups whipping cream
2 garlic cloves, chopped
1 1/2 teaspoons salt
1/4 teaspoon freshly ground pepper
1/4 cup fresh flat-leaf parsley, chopped
1/2 cup (2 ounces) grated Parmesan cheese

Melt butter in a large Dutch oven over medium-high heat. Stir in potatoes and next 5 ingredients and bring to a boil. Reduce heat to medium-low and cook, stirring gently, 15 minutes or until potatoes are tender. Spoon mixture into a lightly greased 13 x 9 inch baking dish; sprinkle with cheese. Bake at 400 degrees for 25 to 30 minutes or until bubbly and golden brown. Remove to a wire rack and let stand 10 minutes before serving.

Butternut Squash Risotto

Makes 4-6 servings

1 large butternut squash
3 tablespoons olive oil
6 cups chicken broth
6 tablespoons butter
2 ounces pancetta, diced
1 1/3 cups finely chopped onion
2 cups Arborio rice (short-grain)
1/2 teaspoon dried rosemary or 1 teaspoon fresh
 rosemary, finely chopped
1/2 cup dry white wine
1 cup freshly grated Parmesan cheese
1/4 cup heavy cream
salt and pepper

Preheat oven to 400 degrees. Peel the butternut squash and remove all seeds. Cut the squash into 3/4-inch cubes. Cover baking sheet with foil. Place cubed squash onto baking sheet and toss with 3 tablespoons oil, 1 teaspoon salt, and 1/2 teaspoon pepper. Roast for 25-30 minutes or until the squash is tender.

Bring broth to a boil in a large saucepan over medium heat. Cover and simmer on low.

In a large Dutch oven, melt 3 tablespoons butter over medium heat and sauté onion and pancetta until onions are carmelized. Add rice and rosemary and mix well, coating the rice with butter. Stir in wine and cook for 2 minutes. Stir in 2 cups chicken stock, 1 teaspoon salt, and 1/2 teaspoon pepper. Simmer for 7-10 minutes, letting rice absorb the liquid. Add 2 more cups stock and simmer until liquid is absorbed. Repeat procedure with remaining stock and simmer until rice is al dente, approximately 30 minutes. Do not overcook. Remove from heat and add remaining 3 tablespoons butter, squash, and Parmesan cheese, mixing well. Add cream a little at a time to desired creaminess. Salt and pepper to taste. Transfer to a large bowl. Serve immediately.

Mimi's Wild Rice Dressing

Serves 15

4 boxes of Uncle Ben's wild rice & long-grain rice
 mixture
1/2-3/4 head of celery, diced
1 onion, diced
1 can of sliced water chestnuts

Sauté celery and onions until softened. Add water
chestnuts and sauté for a few more minutes. Add rice to
the mixture and cook per instructions on box.

For 4-5 servings, adjust the recipe to 1 box of rice,
1/2 cup onion, 2 stalks of celery and 1/4 can of water
chestnuts.

Nana's Bridgford Stuffed Bread

1/2 - 1 onion, diced
1/2 - 1 green bell pepper, diced
1 loaf of frozen French bread
2 pounds mild Owens sausage
8 ounces shredded Cheddar cheese
1 can whole kernel corn, drained
salt and pepper to taste

Brown the sausage and season with salt and pepper.
Add onion and bell pepper and let it cook down. Thaw
the bread. Knead it in the middle where you can make
a hole all down the middle. Layer meat mixture, then
corn and then cheese in the hole. Fold the flaps over
and pinch the dough together so it covers the mixture
inside. Use toothpicks to help it close if needed. Baste
the bread with milk or oil. Let rise for 2 hours then
bake at 350 degrees until bread is light brown.

Strawberry Bread

2 (10 ounce) packages frozen strawberries, thawed
2 cups sugar
1 1/2 cups vegetable oil
4 eggs, beaten
3 cups flour
3 teaspoons ground cinnamon
1 teaspoon baking soda
1 teaspoon salt
1 1/4 cups chopped pecans

Preheat oven to 350 degrees. Grease 2 (9x5-inch)
loaf pans. Beat together strawberries, sugar, oil, and
eggs; set aside. Combine flour, cinnamon, baking
soda and salt. Mix into strawberry mixture just until
combined. Stir in pecans. Divide batter between
prepared pans. Bake at 350 degrees for 1 hour.

Cinnamon Applesauce Jell-O

1 (3 ounce) package cherry Jell-O
1 1/4 cups water
1/3 cup Red Hots or red cinnamon candies
1 (16 ounce) jars applesauce

Combine water with candies and boil to melt
candies. Pour over Jello and dissolve. Add applesauce.
Chill until set.

Hot Spiced Tea

2 cups Tang
1 cup instant tea powder
1/2 cup lemonade mix
1 1/2 cups brown sugar
2 teaspoons ground cinnamon
2 teaspoons ground cloves
cinnamon stick (optional, for stirring)

Mix all ingredients in a large bowl and stir until well
blended. Store the mix in an air-tight container. When
ready to serve, place 3 teaspoons of the mix in a coffee
mug and add 1 cup of hot water. Stir with a whole
cinnamon stick, and serve while hot.

Waldorf Rice Salad

1 (15 ounce) can Mandarin oranges
1 red delicious apple, unpeeled and chopped
1 ripe pear, unpeeled and chopped
2 cups cooked long-grain and wild rice
1/2 cup celery, chopped
1/2 cup Craisins or golden raisins
1/2 cup mayonnaise
1/4 cup sour cream
1/2 cup walnuts, toasted and chopped

Cook rice according to package directions.

In a large bowl, combine first 6 ingredients. In
another bowl, combine mayonnaise and sour cream and
stir into fruit mixture. Toss well. Cover and chill. Serve
on individual red lettuce leaves or in individual bowls.

Red Ribbon Salad

2 (16-ounce) cans pitted dark sweet cherries
2 (3-ounce) packages cherry-flavored gelatin
1 envelope unflavored gelatin
2 cups boiling water
1/3 cup sugar
1/2 cup port or sweet red wine
1/4 cup lemon juice
1 (8-ounce) package cream cheese, softened
1/2 cup pecans, chopped and toasted
Garnishes: whipped cream

Drain cherries, reserving 1 cup juice. Chop cherries
and set aside.

Stir together gelatins and 2 cups boiling water until
dissolved. Stir in reserved juice, sugar, port, lemon
juice, and cherries. Pour half of gelatin mixture into a
lightly greased 13x9 glass dish. Chill 2 hours or until
almost set. Stir together remaining gelatin mixture,
cream cheese, and pecans, blending well. Pour over
slightly set gelatin mixture. Chill 6 hours or until firm.

Serve with whipped cream.

Holiday Lime Jell-O

1 cup milk
16 large marshmallows, each cut in half
1 (3ounce) box lime Jell-O
1 (3 ounce) package cream cheese
1 (15 1/2 ounce) crushed pineapple, drained
1/2 cup pecans, chopped and toasted
1 cup heavy cream

Combine milk and marshmallows in a saucepan and cook over low heat, stirring constantly. Add Jell-O and stir until dissolved.

In a large bowl, combine cream cheese, pineapple, and pecans. Add Jell-O mixture and blend well. Set aside to cool.

Whip heavy cream at medium speed of mixer until stiff peaks form. Fold whipped cream into cooled cream cheese/Jell-O mixture. Pour into 8x8 baking dish. Chill until firm.

Raspberry Christmas Salad

1 large package raspberry Jell-O
1 1/2 cups boiling water
2 (10 ounce) packages frozen raspberries in syrup, thawed and undrained
1 (15 1/2 ounce) can crushed pineapple, undrained
1/2 cup chopped pecans
2 cups sour cream

Dissolve gelatin in boiling water, stir in raspberries, pineapple, and chopped pecans. Blend well. Spoon 1 1/2 cups gelatin mixture into a lightly oiled 8-cup mold; chill until set. Spread sour cream over raspberry layer. Spoon remaining raspberry mixture over sour cream layer. Chill until set.

Nellie's Cranberry Jell-O Salad

1 (12 ounce) package fresh cranberries, ground
2 large red delicious apples, chopped
1 1/2 cups sugar
1/2 cup chopped nuts
1 (15 ounce) can crushed pineapple
2 small boxes raspberry Jell-O
2 cups boiling water

Mix ground cranberries and apples. Add sugar and set in refrigerator overnight. The next day, add nuts and crushed pineapple.

In a large bowl, combine boiling water and raspberry jello, stirring until Jell-O dissolves. Add cranberry mixture. Pour into glass dish and refrigerate until set.

Lemon Orange Jell-O Salad

2 cups boiling water
1 small package orange Jell-O
1 small package lemon Jell-O
2 cups Ginger Ale
1 large can crushed pineapple, drained. Reserve juice.
1 cup miniature marshmallows
2 large slice bananas
1 tablespoon flour
2 tablespoons butter
1 egg beaten
1/2 cup sugar
1 cup pineapple juice
1 small container whip topping
1/2 cup pecans, finely chopped

In a large bowl, dissolve both packages of Jell-O in 2 cups boiling water. After Jell-O is dissolved, add Ginger Ale. Pour into 9x13 glass dish and refrigerate until partially set. Add pineapple, marshmallows, and bananas to Jell-O mixture. Refrigerate until set and then add topping. Recipe follows.

TOPPING:

In a saucepan, combine flour, butter, egg, 1/2 cup sugar, and pineapple juice. Boil, stirring constantly until thickened. Cool. Fold in Cool Whip and spread topping over gelatin mixture. Sprinkle with chopped pecans.

Red, White, and Green Christmas Ribbon Salad

Read directions all the way through before beginning recipe.

1 (3 ounce) package lime Jell-O gelatin
1 (3 ounce) package raspberry Jell-O gelatin
1 (3 ounce) package lemon Jell-O gelatin
3 cups boiling water
1 cup mini marshmallows
1 1/2 cups cold water
1 (8 ounce) package cream cheese, softened
1/2 cup mayonnaise
1 cup cream, whipped
1 (20 1/2 ounce) can crushed pineapple, drained

DISSOLVE GELATIN FLAVORS SEPARATELY, USING 1 CUP BOILING WATER FOR EACH.

**For the lime Jell-O, add an additional 3/4 cup cold water and pour into a 13x9x2 pan. Chill until set, but not firm. This will be the bottom layer

**For the lemon Jell-O, stir in marshmallows and cream cheese; beat until blended. Chill until slightly thickened. While mixture is chilling, beat whip cream until stiff peaks form. Fold in whipped cream, mayonnaise, and crushed pineapple. Chill until very thick; spoon gently over lime gelatin. Chill until set, but not firm. This will be the middle layer.

**For the raspberry Jell-O, add 3/4 cup cold water to raspberry gelatin; set aside at room temperature. Chill raspberry gelatin until thickened; pour over lemon gelatin. Chill until firm. Cut into squares to serve.

Chocolate-Pecan Pie/Southern Living
Recipe from Ruben Ortega. Backstreet Cafe, Houston

CRUST

 2 cups (8 ounces) all-purpose flour
 1/2 teaspoon salt
 6 tablespoons powdered sugar
 1 1/2 sticks cold, unsalted butter, cut into 1/2-inch cubes
 1 1/2 to 2 tablespoons ice water

Preheat oven to 350 degrees. Sift together flour, salt, and sugar. Using a pastry blender, cut butter into flour mixture until it is the consistency of coarse cornmeal. Gradually add cold water, mixing until dough holds together. Do not overmix. Press into a disk about 5 inches in diameter, wrap in plastic, and refrigerate for at least an hour to firm up. Then roll out and line a 9-inch metal pie pan. Prick crust with a fork, then fill with uncooked beans or pie weights and bake until barely golden brown, about 30 minutes.

FILLING

 5 eggs
 3/4 cup dark brown sugar
 1 stick (8 tablespoons) unsalted butter, melted
 1/2 cup light corn syrup
 1/2 cup real maple syrup
 3 cups pecan halves or large pieces, toasted
 6 ounces good-quality semi-sweet chocolate, chopped to the size of chocolate chips

In a stainless-steel bowl, whisk together eggs and brown sugar. Add melted butter and whisk again. Add both syrups and whisk yet again. Let mixture rest for at least 10 minutes. Put pecans and chocolate chips in the partially baked pie shell and then pour in syrup mixture. Bake on a preheated cookie sheet at 350 degrees until pecans are a rich golden brown, about 40 minutes. Serve with orange-blossom-honey ice cream (for recipe, go to texasmonthly. com).

Stuffed Pears with Red Wine Reduction

6 firm Bosc or Bartlett pears
1 bottle Merlot wine
1 vanilla bean, whole
2 cinnamon sticks
2 bay leaves
2 cups sugar
2 (8 ounce) containers Mascarpone cheese, softened
1/2 cup heavy cream
1 1/4 teaspoon cinnamon
1/2 cup powdered sugar
2 tablespoons butter

There are two ways to serve these pears. One way is to cut the pears in halves, scooping out the seeds and core to create a small bowl that will hold the Marscapone filling. The other way is to keep the pears whole, removing only the top and core of the pears and piping the filling into the cavity. I suggest reading through the recipe before beginning to help you decide which way you would like to prepare this dish.

Peel pears, leaving stem intact. In a large, deep dish skillet, bring wine and an equal amount of cold water to a simmer. Split vanilla bean lengthwise and add to wine mixture. Add cinnamon sticks, bay leaves and sugar, to taste. Add pears to liquid and simmer for about 20 minutes or until tender. Cool pears in wine mixture to room temperature. Refrigerate overnight, turning occasionally so all sides of the pears will turn deep red.

Remove pears from refrigerator. Remove top of pear (with stem) about 1/2-1 inch down, keeping stems intact. The little cap of pear with its stem will function like a hat after filling the pear with cheese mixture. Core pears with an apple corer, leaving pear whole.

Blend together mascarpone cheese, heavy cream, 1/4 teaspoon cinnamon (more if desired) and powdered sugar, beating until smooth. Transfer to a pastry bag or a Ziploc sandwich bag. Snip one corner off of the sandwich bag and pipe filling into the cored pears. Put caps (with stems) gently into the Mascarpone filling on top of the pears. Set aside on platter.

Bring sauce up to a simmer and reduce by half. Remove bay leaves. Add butter to reduced sauce and stir until combined. Serve pears in individual, white bowls with reduction spooned generously over pears. Cool to room temperature before serving.

***If you choose to serve the pears in halves, carefully peel pears and cut the pears in half, lengthwise. Scoop out the seeds and core with a melon ball scoop. Remove enough of the core and flesh to create a small bowl in the pear half. Cook the pears in the wine mixture as directed in the recipe.*
To serve, place a dollop of the Marscapone filling on a dessert dish (to hold the pear in place) and gently position the pear on the filling. Fill the pear half with a liberal amount of Marscapone filling and drizzle with the wine reduction.

Perked Cranberry-Pineapple Punch
Makes 22 cups (Great Christmas Holidays hot punch)

Place in large coffee percolator
9 cups cranberry juice (not cocktail)
9 cups pineapple juice
4 1/2 cups water

In percolator basket add:
4 sticks cinnamon
2 tablespoons allspice
4 1/2 teaspoon whole cloves
1/4 teaspoon salt (dash)
1 cup brown sugar

Perk and serve hot.

Chocolate Layer Delight

1 1/2 cups semi-sweet chocolate morsels
2 (3-ounce) packages ladyfingers**
1 (13-ounce) jar hazelnut spread
20 individually wrapped caramel candies (Kraft)
2 1/3 cups whipping cream
1 1/2 cups chopped pecans
1/3 cup confectioners' sugar plus 2 tablespoons
1 (8-ounce) package cream cheese, softened
2 tablespoons crème de cacao
3 (1-ounce) semi-sweet chocolate baking squares

Put 9 inch springform pan in freezer for about 30 minutes, so it will be cold when you add ladyfingers to sides and bottom of pan.

Microwave chocolate morsels on high for 90 seconds or until melted, stirring at 30 second intervals; cool 5 minutes, and set aside.

Remove chilled springform pan. Working quickly so ladyfiners do not dry out, split ladyfingers and dip each in melted chocolate and stand halves, dipped end down, around edge of springform pan. Be sure to place rounded sides against pan; line bottom of pan with remaining halves. Spread hazelnut spread evenly over ladyfingers on bottom of pan.

Cook caramels and 1/3 cup whipping cream in a medium saucepan over low heat, stirring constantly, just until melted. Stir in pecans and mix well. Spoon caramel and pecans over hazelnut layer.

Beat 1/3 cup powdered sugar and cream cheese in a medium bowl at medium speed with an electric mixer until fluffy. Add crème de cacao and beat until well blended. Add melted chocolate and blend well.

In another bowl, whip remaining 2 cups whipping cream at medium speed until stiff peaks form. Gently fold into cream cheese mixture, and spoon evenly over the caramel layer. Shave chocolate over top and dust with powdered sugar.

**You can substitue Pepperidge Farm Milano cookies in place of lady fingers, or you can make your own shortbread crust.

Christmas Breakfast Casserole

Serves 10-12

1 pound bulk Italian sausage
1 cup onion, chopped
1 jar (7 ounces) roasted red peppers, drained,
 chopped, and divided
1 package (10 ounces) frozen chopped spinach,
 thawed and well drained
1 cup all-purpose flour
1/4 cup grated Parmesan cheese
1 teaspoon dried basil
1/2 teaspoon salt
8 eggs
2 cups milk
1 cup (4 ounces) shredded Provolone cheese
fresh rosemary sprigs, optional

Preheat oven to 425 degrees. In a skillet, cook sausage and onion over medium heat until sausage is no longer pink; drain. Transfer to a greased 3 quart baking dish. Sprinkle with half of the red peppers and all the spinach.

In a bowl, combine flour, Parmesan cheese, basil, and salt. Combine eggs and milk; add to dry ingredients and mix well. Pour over spinach.

Bake 20-25 minutes or until a knife inserted near center comes out clean. Sprinkle with Provolone cheese and remaining red peppers. Bake 2 minutes longer or until cheese is melted. Let stand 5 minutes before cutting. Garnish with rosemary if desired.

White Chocolate Bread Pudding with Salted Caramel Sauce

1 large loaf Challah, or other sweet bread*
1/2 cup butter, melted
16 ounces Ghiradelli white chocolate chips
2 cups milk
2 cups heavy cream
2/3 cups sugar
2 teaspoons good vanilla
8 large eggs

Preheat oven to 350 degrees. Cut the bread into 1 inch cubes and place in a large baking dish. **Drizzle bread cubes with melted butter. In a saucepan, combine milk, cream, and sugar and bring to a boil over medium heat, stirring until sugar is dissolved. Add vanilla and white chocolate chips, stirring until chips are melted.

In a large bowl, whisk eggs until smooth. Add slightly cooled milk mixture to eggs very slowly and stirring constantly. BE CAREFUL. (If milk mixture is too hot, it will cook the eggs.) Do not whisk, or egg mixture will have too much foam on the surface. Skim any foam from the egg mixture. Pour 1/2 egg mixture over bread and let stand 3-5 minutes. Press the bread into the egg mixture so the bread absorbs most of the liquid. Add remaining egg mixture. Let stand for 15 minutes to allow custard to soak into bread. Cover with foil and bake for about 45-50 minutes. Remove foil and bake for 15-30 minutes longer or until golden brown.

*Make sure you use a large loaf of bread or have enough on hand to absorb the liquid. I have used both Challah and King's Hawaiian rolls.

**Pay close attention to the oven. The cooking time will vary depending on the size of your pan. I often use a disposable foil roasting pan when I make this dessert.

SALTED CARAMEL SAUCE
 20 Kraft caramels
 1/4 cup half and half or heavy cream
 sea salt to taste

Unwrap caramels and place in top of double boiler. Add cream to caramels a little at a time, stirring constantly until caramels melt and the sauce's desired thickness is reached. You may have to add more cream. After caramels have melted, begin salting the mixture, tasting frequently. Add salt to desired taste.

Serve with white chocolate bread pudding. Store in refrigerator. You can heat this in the microwave for a few seconds when it's cold.

Nancy's Pumpkin Pie

1 tablespoon flour
1/2 cup white sugar
1/2 cup brown sugar
1 teaspoon ginger
1 teaspoon cinnamon
1/4 teaspoon black pepper
1/2 teaspoon salt
1/2 teaspoon nutmeg
1/8 teaspoon cloves
3 eggs
1 1/2 cups pumpkin
1 cup heavy cream
1 9 inch unbaked deep dish pie crust

In a large bowl, mix first 9 ingredients (flour-cloves). Add eggs one at a time and mix well. Stir in pumpkin and cream.

Pour into unbaked pie crust and bake at 400 degrees for 50 minutes or until knife comes out clean and center no longer seems liquid when the pie is gently shaken. Serve with whipped cream.

Cinnamon Apples

2 cups water
3/4 cup Red Hots candies
1/3 cup sugar
6 medium tart apples, peeled and quartered

In a large sauce pan over medium high heat, bring water, candies, and sugar to a boil. Reduce heat to medium low and simmer until candy has dissolved.

Add apples. Simmer uncovered until apples are tender, about 20-30 minutes. Remove apples from heat and allow to cool slightly before serving. For a deeper red color, let apples continue to soak in the syrup for a few hours.

Remove apples with a slotted spoon into serving dishes. Drizzle any remaining syrup over top.

Bourbon Ball Cookies

1 cup pecans
8 ounces vanilla wafers, enough to make 2 cups
1/2 cup unsweetened cocoa, divided
1/2 cup confectioners' sugar, divided
1/4 cup light corn syrup
1/4 cup bourbon

Preheat oven to 325 degrees.

Toast pecans on a cookie sheet for 5-6 minutes, occasionally turning tray in oven to ensure even toasting. You can also stir nuts with a spatula.

In a food processor, chop the vanilla wafers into crumbs. Add pecans and finely chop. In a medium bowl, combine the crumb-pecan mixture, 1/4 cup of the cocoa, and 1/4 cup of the confectioners' sugar. Add the corn syrup and bourbon. Mix thoroughly. Sift the remaining 1/4 cup cocoa and 1/4 cup confectioners' sugar onto a large plate. Form the crumb mixture into 3/4-inch balls and roll in cocoa-sugar to coat. Store in a sealed container for up to 5 days. Redust cookies with powdered sugar/cocoa mixture before serving.

Fresh Apple Cake

1 cup sugar
1 cup brown sugar
3 eggs, well beaten
1 1/2 cup vegetable oil
1/4 cup freshly squeezed orange juice
3 cups all-purpose flour
1 teaspoon baking soda
1 teaspoon salt
1 tablespoon cinnamon
1/2 teaspoon nutmeg
1 tablespoon orange zest
1 tablespoon vanilla
1 cup chopped nuts
3 cups peeled apples, FINELY chopped (If apples are
 not chopped finely enough, the cake will crumble)
butter to grease pan

Preheat oven to 325 degrees. In a large bowl, combine, sugars, eggs, oil, orange juice, flour, baking soda, salt, cinnamon, nutmeg, and vanilla; mix well by hand. Fold finely chopped apples and pecans into batter.

Pour the batter into a GENEROUSLY BUTTERED AND FLOURED tube cake pan or bundt pan and bake until a tester comes out clean, about 1 1/2 hours.

GLAZE
1 stick butter
1 cup sugar
1/2 cup buttermilk
1/2 teaspoon baking soda

Make glaze while cake is baking. Melt the butter in a large saucepan over medium heat. Stir in the sugar, buttermilk, and baking soda. Increase heat to medium high and bring ingredients to a rolling boil, stirring constantly. Boil for 1 minute. Pour the sauce over the hot cake in the pan as soon as you remove it from the oven. LET CAKE STAND 1 HOUR, then turn out onto a rack to cool completely.

Old-fashioned Molasses Cookies

3/4 cup butter
1 cup packed brown sugar
1/2 cup white sugar (reserved for coating raw
 dough balls)
1 large egg
1/2 cup molasses
2 1/2 cups all-purpose flour
1/2 teaspoon salt
2 teaspoons baking soda
1 teaspoon ground cinnamon
1 teaspoon ground ginger
1 teaspoon allspice
1 teaspoon nutmeg

With an electric mixer, cream the butter and brown sugar. Stir in molasses and egg and mix well. Combine all dry ingredients and stir into sugar and egg mixture. Wrap the dough in plastic and chill until firm, about 3 hours.

Heat the oven to 350 degrees. Measure the dough into tablespoon-size pieces and roll each piece between your palms to form 1 to 1 1/2 inch balls. Roll the balls in granulated sugar to coat. Put the balls 2 inches apart on lightly greased cookie sheets. Sprinkle the tops with more sugar and bake 9 to 10 minutes (don't overbake). Let cool on the sheets for 1 minute until set; transfer to a wire rack to cool completely.

Fudge Crinkles

1 box Betty Crocker Super Moist Devil's Food cake mix
1/2 cup vegetable oil
2 large eggs
confectioners' sugar or granulated sugar for rolling
 cookies

Preheat oven to 350 degrees. In a large bowl, combine dry cake mix, oil, and eggs. Mix by hand until dough forms. Dust hands with powdered sugar roll dough between palms to form 1 1/2 inch balls. Let cookie dough balls set for a minute or two before rolling in powdered sugar. Roll balls in powdered sugar and place 2-3 inches apart on ungreased cookie sheets. Bake for 8-10 minutes or until center is JUST SET. Remove from pans after a minute or so and cool on wire racks.

Peppermint Bark

1 cup crushed candy canes
2 pounds white chocolate
2 teaspoons peppermint extract (or to taste)

Place candy canes in a plastic bag and hammer into 1/4-inch chunks or smaller.

Melt the chocolate in a double boiler (or microwave), stirring every 20-30 seconds. Combine crushed candy canes with chocolate. Add peppermint extract. Pour mixture onto a cookie sheet layered with parchment or waxed paper and place in the refrigerator for 45 minutes or until firm. Break bark into pieces and share.

White Chocolate Dipped Coconut Macaroons

14 ounces sweetened flaked coconut
14 ounces sweetened condensed milk
1 teaspoon pure vanilla extract
2 extra large egg whites, at room temperature
1/4 teaspoon salt

Preheat the oven to 325 degrees. Combine the coconut, condensed milk, and vanilla in a large bowl.

Whip the egg whites and salt on high speed in the bowl of an electric mixer until they form stiff peaks. Carefully fold the egg whites into the coconut mixture. Drop the batter onto sheet pans lined with parchment paper and dusted with flour using either a 1 3/4-inch diameter ice cream scoop, or 2 teaspoons.

Bake for 25 to 30 minutes until golden brown. Cool on wire racks. Once macaroons have cooled, dip the bottom of each cookie in melted Ghiradelli White Melting Wafers and place on wax paper to dry.

Tiger Butter

1 pound vanilla almond bark (9 squares)
1/2 cup smooth peanut butter or 1/2 cup crunchy peanut butter
1 cup semi-sweet mini chocolate chips (more or less to taste)

Place almond bark and peanut butter in a microwave safe bowl. Microwave at 50% power for 4 minutes, stirring after 2 minutes. Add time in 30 second increments, until bark is melted and mixes well with peanut butter. Pour onto a foil lined cookie sheet, or into a foil lined 9 x 13 inch pan. Sprinkle chocolate chips over top of mixture. Let set until chips become glossy, indicating softness, or "meltness." Marble through mixture with a butter knife or rubber spatula, making certain not to mix in thoroughly. Let set until hard, or you can refrigerate until set.

Aunt Bill's Brown Candy reprinted from *THE OKLAHOMAN* late 1920s

3 pints white sugar, divided
1 pint half and half
1/4 pound butter (1/2 cup)
1 teaspoon soda
1 teaspoon vanilla
2 pounds pecans, finely chopped

You will find it much easier to manage if two of you are able to make the candy together, although of course this is not absolutely necessary for I've made loads of it alone.

First, pour one pint of the sugar into a heavy iron skillet and place it over low fire. Begin stirring with a wooden spoon and keep the sugar moving so that it will not scorch at all. (Melting sugar scorches VERY easily, so watch carefully). It will take almost half an hour to completely melt all of the sugar, and at no time should it smoke or cook so fast that it turns dark. It should be about the color of light brown sugar syrup.

As soon as you have the sugar started to heat in the skillet, pour the remaining two pints of sugar together with the pint of half and half into a deep heavy kettle and set it over a low fire to cook along slowly while you are melting the sugar in the skillet.

As soon as all the sugar is melted, begin pouring it into the kettle of simmering milk and sugar, keeping it on very slow heat and stirring constantly. Now the real secret of mixing these ingredients is to pour a very fine stream from the skillet into the pan. Aunt Bill always said to pour a stream no larger than a knitting needle, while stirring across the bottom of the kettle at the same time.

Continue cooking and stirring until the mixture forms a firm ball when dropped into cold water. After this test is made, turn out the fire and immediately add the soda, stirring hard as it foams up. Soon as the soda is mixed, add the butter, allowing it to melt as you stir. Now set the pan of candy off the stove, but not outdoors or in a cold place, for about 10 minutes, then add the vanilla and begin beating. Use a wooden spoon and beat until the mixture is thick and heavy, having a dull appearance instead of a glossy sheen. Add the broken pecan meats and mix. Turn into buttered tin

boxes or square pans, where it can be cut into squares when cooled. This candy stays moist and delicious indefinitely. Decorate the pieces of candy with halves of pecans, if desired

Christmas Trash

1 pound almond bark (white chocolate)
1/2 cup chunky peanut butter
1 cup dry roasted peanuts
1 cup miniature marshmallows
1 cup M&M's
1 1/2 cups Rice Krispies

In a large bowl melt the first two ingredients about 2 minutes on high in microwave, stirring every 30 seconds or so. When mixture is completely melted, add rest of ingredients. Stir to thoroughly coat. Drop by teaspoonfuls onto waxed paper and let cool until candy hardens.

Rum Balls

1 1/2 cups confectioners' sugar
2 tablespoons cocoa powder
1/2 teaspoon ground allspice
1/2 cup dark rum
2 tablespoons light corn syrup
2 1/2 cups vanilla wafers, finely crushed
1 cup walnuts, finely chopped and toasted

Into a large bowl, sift together 1 cup confectioners' sugar, the cocoa powder, and allspice. Stir in the rum and corn syrup. Stir in the vanilla wafers and walnuts and mix well. Place in the refrigerator to firm up slightly, about 30 minutes. (The mixture may appear crumbly and dry; this is okay.) Place remaining 1/2 cup confectioners' sugar in a shallow bowl or dish.

Using a tablespoon, scoop out portions of the chocolate mixture and roll into 1-inch balls. Roll the balls in the confectioners' sugar, coating evenly. Place on a baking sheet, cover with plastic wrap, and refrigerate overnight. Store in an airtight container in the refrigerator for up to 2 weeks, placing waxed paper between the layers.

Gingerbread Boys and Girls

1/3 cup shortening
1 cup packed brown sugar
1 1/2 cups dark molasses
2/3 cup cold water
7 cups all-purpose flour
2 teaspoons baking soda
1 teaspoon salt
1 teaspoon ground allspice
1 teaspoon ground ginger
1 teaspoon crushed cloves (optional)
1 teaspoon ground cinnamon

Cream shortening, brown sugar, and molasses. Mix in 2/3 cup water. In separate bowl, combine flour, soda, salt, and spices. Add to shortening mixture and mix well. Chill dough. Roll out very thick—1/2 inch thick. Cut with boy or girl cookie cutters. Transfer gingerbread to lightly greased baking sheet, using a thin spatula. Press raisins into dough for eyes and nose. Bake at 350 degrees for approximately 10-12 minutes, or until when toughed lightly with your finger, no imprint remains in the cookie. Cool before removing from baking sheet. Decorate with SIMPLE WHITE ICING

**You can also make old-fashioned gingerbread boy and girl patterns out of cardboard or heavy cardstock. Once you have the figure cut, grease the pattern and place on dough. Cut around the edges with a sharp knife.

SIMPLE WHITE ICING
Blend together 1 cup sifted confectioners' sugar, 1/4 teaspoon salt, 1/2 teaspoon vanilla, and enough milk to make easy to spread, about 1 1/2 tablespoons. Can add drop or two of food coloring if desired.

Lemon Cream Cheese Cookies

2 cups all-purpose flour
1 teaspoon baking powder
1 stick salted butter, softened
4 ounces cream cheese, room temperature
1 1/4 cups granulated sugar

1 large egg
2 tablespoons lemon juice
1/2 teaspoon lemon extract
1 tablespoon finely grated lemon zest

Preheat oven to 350 degrees. Line baking sheets with parchment paper. Combine the flour with the baking powder. Set aside. In a large mixing bowl cream butter and cream cheese until light, about 1 minute. Add sugar and beat until light and fluffy. Beat in the egg and 1 tablespoon lemon zest. Stir in the flour, 2 tablespoons of lemon juice, and lemon extract, mixing until well blended.

Drop the cookie dough onto the prepared baking sheets with a small cookie scoop or tablespoon. Slightly flatten each cookie with the bottom of a class that has been coated with sugar. Bake for 10 to 12 minutes or until the bottoms of the cookies are slightly browned.

LEMON ICING
1 1/2 cups powdered sugar
3 tablespoons fresh lemon juice
2 to 3 teaspoons finely grated lemon zest

Combine powdered sugar, 3 tablespoons lemon juice, and 2 to 3 teaspoons of lemon zest. Stir until well blended. Drizzle over lemon cookies.

Butter Cookies

1 cup butter
3/4 cup sugar
1 egg yolk
2 cups sifted flour
1/2 teaspoon salt
1 teaspoon vanilla

Cream the butter, sugar, and egg yolk. Sift flour with salt and stir in. Add the vanilla and mix well. Drop on cookie sheet; flatten with fork dipped in "foamy" egg white. Place pecan half on each. Bake at 350 degrees for 10 to 15 minutes.

Holiday Brownies

1/2 cup all-purpose flour, unbleached
1/4 teaspoon salt
2 eggs
1 cup nutella
1/2 cup brown sugar
1 teaspoon vanilla extract
1/2 cup unsalted butter, melted, room temperature

Move oven rack to center of oven and preheat oven to 325 degrees. Line the bottom of a 9x9 pan with parchment paper, letting the paper also line 2 opposite sides of the pan. Butter the remaining 2 sides.

Combine flour and salt in a small bowl and set aside. Using an electric mixer, beat eggs, Nutella, brown sugar, and vanilla until creamy and very well mixed, about 2-3 minutes. Reduce mixer speed to low. Add flour/salt mixture alternately with melted butter. Spread batter in prepared pan and bake 35-40 minutes or until a toothpick inserted in center comes out with lumps/crumbs (not completely clean). Remove brownies from oven and let cool until set, 1-2 hours.

Chocolate-Peanut Butter No-bakes

1/2 cup butter
1 1/2 cups white sugar
1/2 cup packed brown sugar
1/2 cup milk
4 tablespoons cocoa
1 pinch salt
3/4 cup creamy peanut butter
2 teaspoons vanilla
3 cups (uncooked) quick-cooking oats

Combine butter, sugars, milk, cocoa and salt in a saucepan and bring to a rolling boil over medium-high heat, stirring constantly. Boil for 1 minute and remove from heat. Stir in peanut butter and vanilla. Stir dry oats into chocolate mixture and continue stirring until the oats are completely coated with the chocolate mixutre. Drop cookies by tablespoonfuls onto wax paper. Let cool until set.

Everything but the Kitchen Sink Brownies

1 1/2 cups all-purpose flour
1 cup unsweetened cocoa
1/2 teaspoon baking powder
1/4 teaspoon baking soda
1/2 teaspoon salt
1 1/2 cups butter, melted
1 1/2 cups granulated sugar
1 1/2 cups firmly packed light brown sugar
4 large eggs
1/4 cup brewed very strong coffee
2 teaspoons vanilla extract
1 cup chopped Oreos, about 10 cookies
4 Hershey's (1.45 ounce) milk chocolate candy bars
 with almonds, chopped
1/2 cup Ghirardelli dark chocolate morsels
1/2 cup Ghirardelli white chocolate morsels
1 cup pecans, roughly chopped and toasted

Grease a 13x9 inch pan with cooking spray, and line the pan with aluminum foil, folding overlapping ends over short sides of pan. Coat foil with cooking spray and set pan aside.

Combine flour, cocoa, baking powder, soda, and salt in a small bowl and set aside. In a large bowl, cream butter and sugars at medium speed of electric mixer until smooth. Add eggs, coffee, and vanilla, mixing just until blended. Add flour mixture and beat at medium speed until blended. Fold in Oreos (or your favorite sandwich cookie crumbs), chopped Hershey bars, white and dark chocolate morsels, and pecans. Spoon batter into prepared pan, spreading evenly. Bake at 325 degrees for 55 to 58 minutes. Cool completely in pan on a wire rack. Cover and chill brownies at least 2 hours before inverting onto a cutting board and cutting into squares.

Spiced Nuts

1 pound pecan halves, lightly toasted
1/4 teaspoon ground cumin
1/4 teaspoon cayenne pepper
1 teaspoon kosher salt
1 teaspoon ground cinnamon
1 teaspoon dried ground orange peel
1/4 cup packed light brown sugar
2 tablespoons packed dark brown sugar
4 tablespoons unsalted butter
2 tablespoons water

Place pecan halves in a baking pan and bake in a 350 degree oven for a few minutes until golden brown, stirring often. Remove nuts from oven and set aside to cool.

Line a large jelly roll pan or 1/2 sheet pan with parchment paper and set aside. In a small bowl, combine cumin, cayenne pepper, salt, cinnamon, orange peel, and sugars and set aside.

Place the nuts in a 10-inch cast iron skillet and set over medium heat. Cook, stirring frequently, for 2 to 5 minutes until they smell toasted. Add the butter and stir until it melts. Add the spice mixture and stir to evenly distribute spices and sugars. Once combined, add water and keep stirring until the mixture thickens and coats the nuts, about 2-3 minutes. Transfer spiced nuts to the parchment lined pan(s), and use a fork or spatula to separate the spiced nuts. Let cool before storing.

Spice Cookies

1 box spice cake mix
1/2 cup vegetable oil
2 eggs
2 cups butterscotch chips

Preheat oven to 350 degrees. In a medium mixing bowl, combine cake mix, oil, and eggs. Stir in chips and nuts. Drop by teaspoonfuls onto ungreased cookie sheet and bake at 350 degrees for 8-10 minutes or until lightly browned. Cool. Remove cookies from baking sheets and cool completely on wire racks and frost with MAPLE FROSTING.

MAPLE FROSTING
1 1/4 cup powdered sugar
3 tablespoons maple syrup
1 tablespoon milk
2 teaspoons butter, softened
1/2 cup walnuts, finely chopped and toasted

In a medium bowl, combine all ingredients, whisking until smooth. Spread frosting evenly over cooled cookies and, working quickly, sprinkle cookies with nuts.

Divinity

2 1/2 cups sugar
1/2 cup light corn syrup
1/2 cup water
1/4 teaspoon salt
2 egg whites
1 teaspoon vanilla
1/2 cup chopped pecans (optional)

In a 2 quart saucepan combine sugar, corn syrup, water, and salt. Cook to hardball stage (260 degrees) stirring only until sugar dissolves. While you are waiting for the temperature of the syrup to reach 250 degrees, put egg whites in a mixing bowl and beat until stiff peaks form. Once the syrup reaches 260 degrees, very gradually add the syrup to egg whites, beating at high speed with electric mixer. Add vanilla and beat until candy holds its shape, 4-5 minutes. Stir in the chopped nuts.

Quickly drop candy from a teaspoon onto waxed paper, swirling the top of each piece.

**Hint: Have a cup of cold water ready and rinse your metal spoon in it—shake off excess water— to make candy easier to scoop and drop.

Mid Texas Pines we have
found peaceful shrines

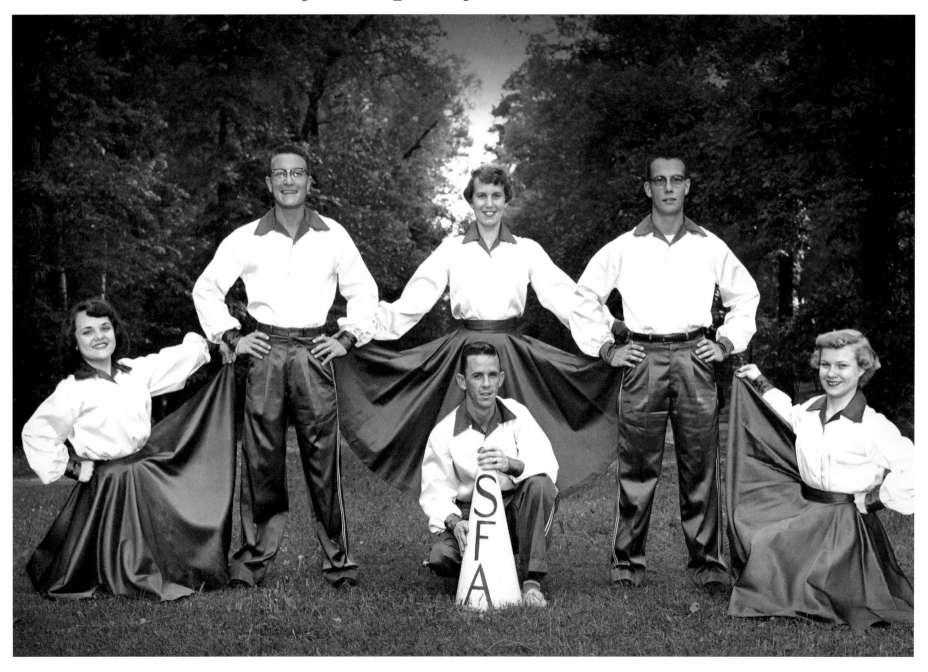

Cheerleaders, 1950

SFA CELEBRATES TURNING 35... "In praising the progress which had been made since Boynton had become president, the Chamber President J. Elbert Reese said there had been 'fifty-one new buildings and facility installations on the campus. ... The college plant now has a value in excess of five million dollars. Its budget this year is just short of two million dollars, of which $1,200,000 goes for salaries.' More important, Reese concluded, is the 'influence it is having throughout East Texas where there are some forty thousand ex-students who are better prepared for their places in life because of their attendance at the college.' The Chamber of Commerce gave Boynton a wall plaque inscribed with words of appreciation from the community and to the Boyntons he gave a silver tray with best wishes from the citizens. Boynton said what he often said: 'no state institution in Texas is located so fortunately as Stephen F. Austin State College. ... Nacogdoches is the best town in the state in which any institution of higher learning is located. ...You have as fine a group of people here as can be found in any city in America.'"

Dr. Jere Jackson, *The History of SFA*

"Dr. and Mrs. Boynton hosted their first big student reception on the lawn of the new president's house at the beginning of the summer term in June of 1958. The house and garden were elaborately decorated and Mrs. Maude Birdwell and her daughter Mrs. Jethro Meek of Indiana were there to help serve and greet the students.

One development in the town of Nacogdoches and one national item need to be mentioned in these years. The decision by local citizens to erect a community-owned hotel in the center of town was heralded by the headline in 1952: "NEW HOTEL BIGGEST STEP SINCE SFA FOUNDED."

The coming of the Fredonia Hotel did help SFA and quickly became an integral part of the memories of parents and students about their years and visits to Nacogdoches."

Dr. Jere Jackson, *The History of SFA*

Dr. and Mrs. Paul Boynton, 1951

Swimming, 1953

SFA Drum Major and Twirlers, 1954

Homecoming, 1956

Inauguration of Dr. Steen, 1959

STUDENT UNION BUILDING, 1956

BASKETBALL CONFERENCE PLAY, 1956

FRESHMEN, 1956

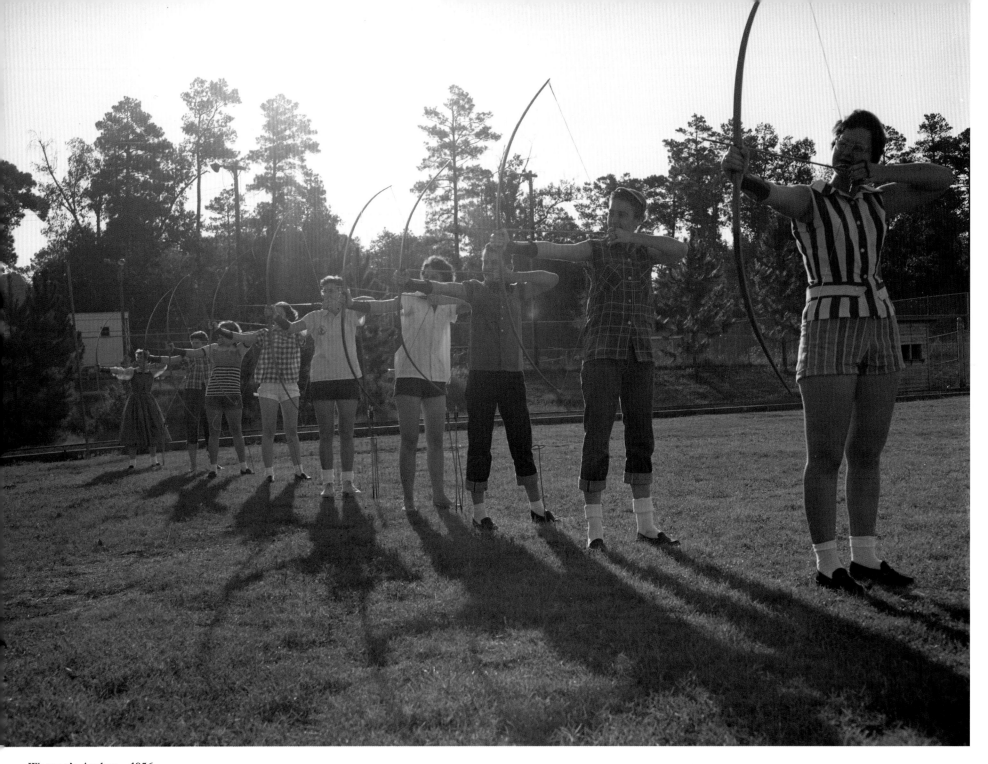

Women's Archery, 1956

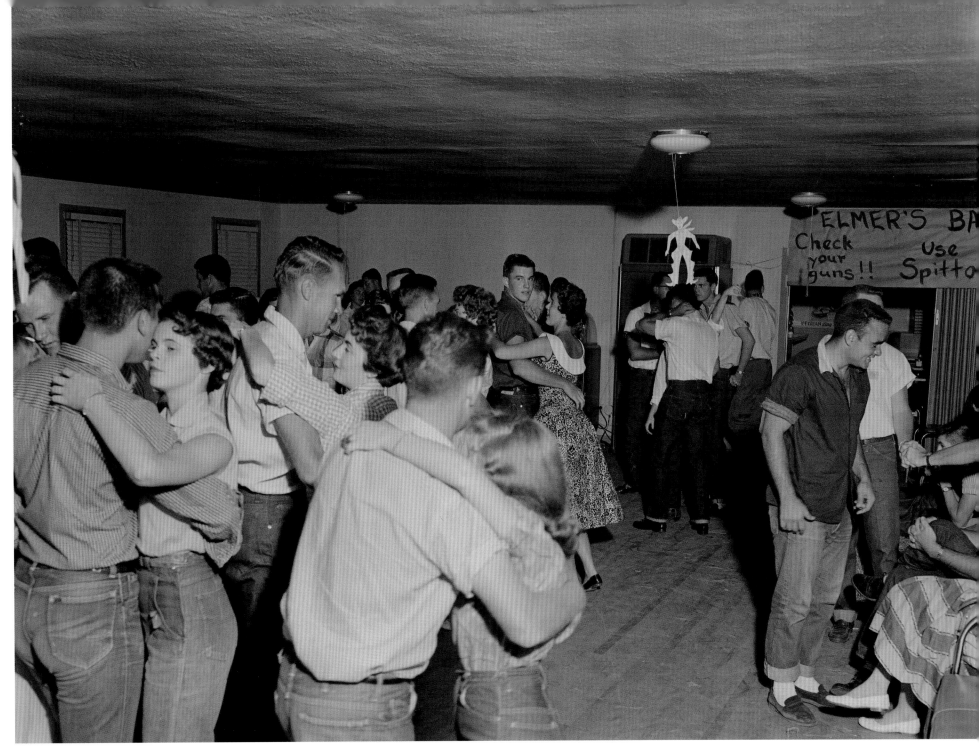

Pine Burr Dance, 1956

Celebrate the Seasons

Milky Way Cake

8 regular sized Milky Way candy bars
1 1/2 cups butter
2 cups sugar
1/2 cup butter, softened
4 eggs, beaten well
2 1/2 cups flour
1/2 teaspoon baking soda
1/4 teaspoon salt
1 1/4 cups buttermilk
1 cup pecans, chopped (optional)
1 teaspoon vanilla
Powdered sugar

FROSTING

2 1/2 cups sugar
1 cup evaporated milk
1/2 cup butter
1 cup marshmallow creme
1 (6 ounce) package semi-sweet chocolate chips
1 regular sized Milky Way candy bar, chopped
10 Kraft caramels, melted (if desired)

Combine candy bars and 1/2 cup butter in a saucepan and melt over low heat, stirring frequently. After candy bars have melted, remove mixture from heat and set aside. In a large mixing bowl, cream sugar and 1 cup of softened butter until light and fluffy. Add eggs and cooled chocolate mixture. Add the salt and baking soda to the buttermilk. Add buttermilk and flour alternately to the batter, blending well. Stir in vanilla and pecans. Pour batter into three 9 inch, greased and dusted with powdered sugar, cake pans. Bake at 325 degrees for 30-40 minutes or until cake is firm to touch. Cool cakes for 5 minutes before removing from pans and placing on wire cooling racks.

To make the frosting, combine the sugar, evaporated milk, and butter in a saucepan over medium heat-medium high heat. Cook to soft-ball stage (234-240 degrees) and then remove from heat. Add marshmallow cream and chocolate chips, stirring until melted. Add pecans. Frost layers and sides of cake. Top with chopped Milky Way pieces and drizzle with melted caramel.

Tiramisu
From Southern Living

8 ounces mascarpone cheese*
1/3 cup packed brown sugar
1/4 cup granulated sugar
2 1/2 cups whipping cream, divided
1 cup hot water
1 1/2 tablespoons instant coffee granules
1/4 cup Kahlúa
2 (3 ounce) packages ladyfingers, 24 total
3-4 teaspoons cocoa

In a mixing bowl, beat cheese, sugars, and 1/2 cup whipping cream at medium speed with an electric mixer until creamy. In another bowl, beat remaining 2 cups whipping cream until soft peaks form. Fold into cheese mixture.

Mix 1 cup hot water and coffee granules until dissolved. Add liqueur and mix well. Split ladyfingers in half, and brush cut sides of ladyfingers evenly with coffee mixture.

Dip 24 ladyfinger halves, flat sides down, into coffee mixture; place, dipped sides down, in the bottom of an 8-inch square baking dish, slightly overlapping. Spread half of cheese mixture over ladyfingers; dust with cocoa. Repeat procedure with remaining ladyfinger halves, coffee mixture, cheese mixture, and cocoa. Chill tiramisu at least 2 hours.

* May substitute cream cheese for mascarpone cheese.

FALL

Apple Salad with Candied Walnuts and Sweet Spiced Cider Vinaigrette

makes about 4 servings

2 bunches red leaf lettuce torn into bite-size pieces
4 cups arugula or fresh spinach
1 cup candied walnuts
2 large Honey Crisp apples, sliced into match sticks
SPICED CIDER VINAIGRETTE (recipe below)

In a large bowl, add the red leaf lettuce, arugula, walnuts, and half of the matchstick-sliced apples. Drizzle with some of the SPICED CIDER VINAIGRETTE. To serve, place portions of the salad in bowls or on plates and top each with the remaining matchstick-sliced apples and another drizzle of vinaigrette. Garnish with candied walnuts.

SPICED CIDER VINAIGRETTE
1/4 cup plus 2 tablespoons apple cider vinegar
3 tablespoons honey
2 tablespoons walnuts, lightly chopped
1/4 teaspoon cinnamon
1/4 teaspoon cayenne pepper
1/4 teaspoon salt or to taste
1/4 teaspoon dry mustard
pinch of cumin
pinch of curry powder
1/2 cup plus 2 tablespoons extra virgin olive oil

Combine all ingredients except olive oil in a food processor and blend until well blended and smooth. Slowly add olive oil and continue to blend until very well mixed. Add all ingredients through the curry powder into the bowl of a food processor and process until everything is well combined and smooth; with the processor running, slowly drizzle in the oil and continue to process until the vinaigrette is very well blended. Makes 1 cup. Refrigerate.

Couscous Salad

1 (5.8-ounce) box instant couscous
3/4 cup Craisins
1 tablespoon plus 1/4 teaspoon curry powder
1 teaspoon salt (or to taste)
1 1/2 teaspoons sugar
1/2 orange, juiced
2 to 3 tablespoons extra virgin olive oil
4 scallions, trimmed and thinly sliced into angles
3 tablespoons chopped fresh Italian parsley leaves
1/2 lemon, juiced
3/4 cup chopped walnuts, toasted
1/2 cup feta cheese (or to taste)
1 can garbanzo beans, drained
freshly ground pepper to taste

Add the couscous, cranberries, curry powder, salt, and sugar together in a mixing bowl. Boil water (amount will be listed on package directions) and pour over the couscous mixture. Add the orange juice and stir. Cover bowl with foil or sealed lid and let rest, stirring once or twice until the water is absorbed and the couscous is tender, about 5 minutes.

Fluff couscous with a fork. Add the olive oil, scallions, parsley, lemon juice, walnuts, feta cheese, and garbanzo beans. Mix gently until well mixed. Add salt and pepper to taste before serving.

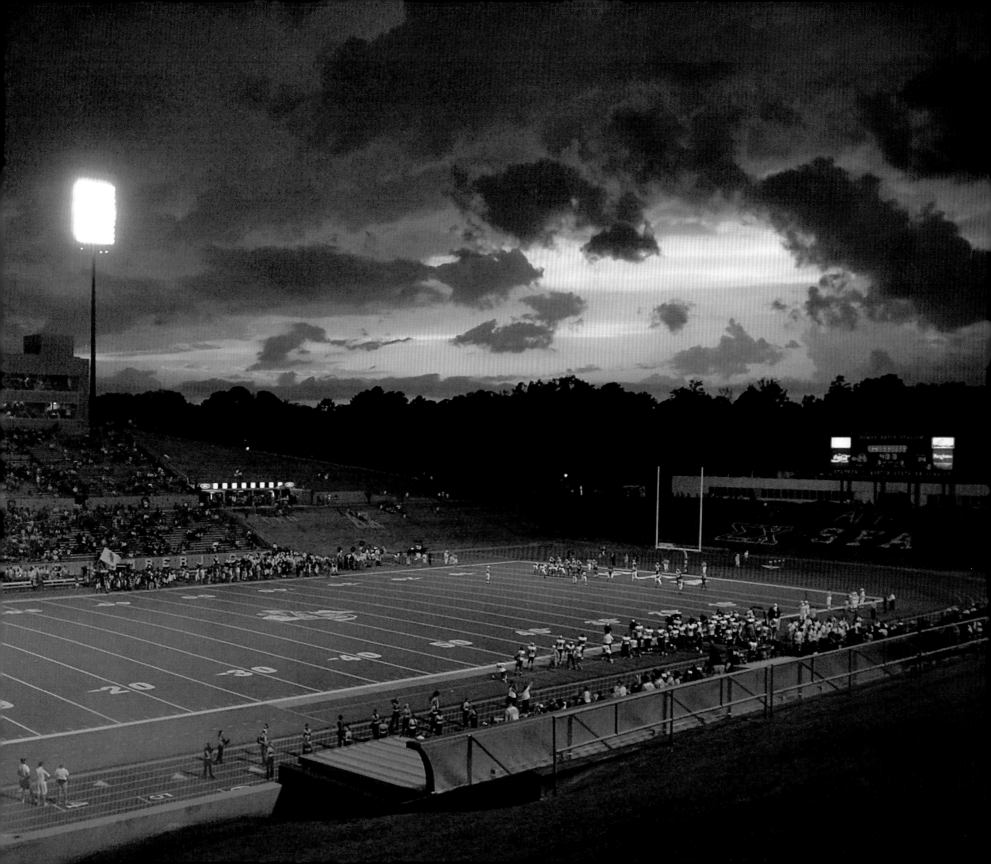

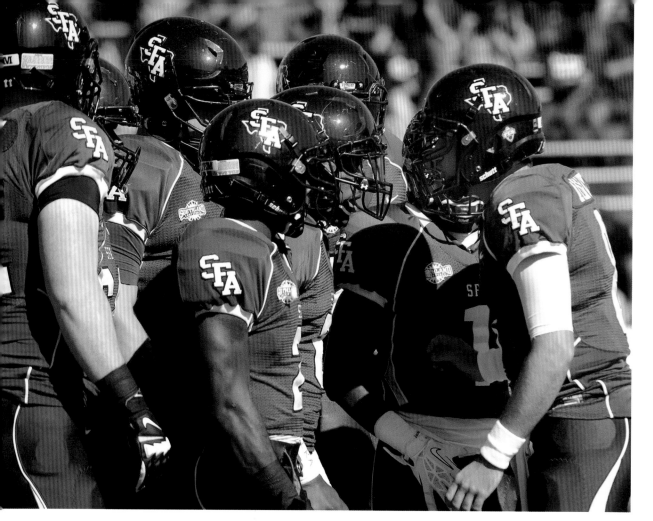

Fall Fruit Salad

HONEY-POPPY SEED DRESSING
- 1/4 cup vegetable oil
- 4-5 tablespoons honey
- 2 tablespoons lemon juice
- 1 1/2 teaspoons poppy seed

FRUITS
- 1 orange, peeled and sliced
- 1 pineapple, peeled, cored and cut into 1-inch pieces
- 2-3 cups seedless grapes, each cut in half
- 2 apples, cubed
- 2 teaspoons lemon juice

Add dressing ingredients to jar and shake well. Shake again before pouring over fruits.

In large bowl, combine orange slices, pineapple, grapes, apples, and lemon juice. Pour dressing over fruit. Mix well. Cover; refrigerate up to 24 hours.

Black and Blue Salad

1/2 head romaine lettuce, torn into bite sized pieces
1 1/2 cups fresh spinach, torn into bite sized pieces
1/2 red onion, thinly sliced
1/2 green pepper, thinly sliced
1/2 cucumber, thinly sliced
3 cups fresh baby arugula
16 cherry tomatoes, halved
toasted walnuts or pecans
1/2 cup black olives, chopped
4 ounces Gorgonzola, crumbled
salt and freshly ground black pepper
12 ounces tenderloin, pan-fried or grilled and chilled

To pan sear the filet, lightly coat a skillet with non-stick cooking spray or a couple tablespoons olive oil. Salt and pepper the steak. Preheat the skillet over medium-high until very hot. Add meat. Sear quickly on both sides, about 5-7 minutes per side for medium rare. You can cook longer to desired degree of doneness, but do not overcook. Let steak rest 5 minutes and then refrigerate for salad.

In a large bowl, combine the first 9 ingredients and 1/2 of the cheese. Toss lightly with just enough of the RED WINE VINAGRETTE (recipe follows) to coat the salad. Salt and pepper to taste. Slice cooked steak into very thin slices, crosswise. Arrange salad onto platter and top with steak slices. Sprinkle with remaining Gorgonzola.

Drizzle more vinaigrette over the steak slices and serve.

Red Wine Vinaigrette:

1/2 cup red wine vinegar
3 tablespoons lemon juice
3 teaspoons honey
2 teaspoons salt
freshly ground black pepper
1 cup olive oil

Combine all ingredients in a jar and shake until well mixed.

Pesto Rolls

Nana's Favorite

1/4 cup lukewarm water

2 teaspoons rapid rise yeast

1-1/2 cups lukewarm whole milk

1/2 cup butter, melted

1/4 cup sugar, divided

2-1/4 teaspoon salt

3 large eggs

3 cups bread flour

3 cups all-purpose flour

FOR INSIDE THE ROLLS:

1 cup pesto (homemade is better but not always easy to find)

1 cup freshly grated parmesan, divided

Place warm water in a small bowl with about a teaspoon of sugar. Sprinkle the yeast over the slightly warm (not too hot or yeast won't foam) water and let stand until foamy, about 5 minutes. Meanwhile, in the bowl of a stand mixer, stir together the milk, remaining sugar, salt, and eggs. Stir in the yeast mixture. With the mixer on low, mix in the 3 cups of bread flour. After mixed, switch to the dough hook. With the mixer on the lowest speed, add the all-purpose flour. The dough should pull away from the sides and bottom of the bowl. You may need more or less flour, depending on humidity.

Once the dough ball forms, let the dough rest for 10 minutes. Then, mix on medium speed for 6 minutes. Turn the dough out onto a lightly floured surface and form into a large ball. Grease a large bowl and place the dough ball inside, turning to coat. Cover with plastic wrap and let rise in a warm place for about an hour or until doubled in size. Butter two 9x13 inch pans. Deflate the dough by gently pushing down and turning it over in the bowl. Divide in half with a sharp knife. Roll out into a rectangle that is about 1/4 inch thick on a piece of lightly floured parchment paper.

Spread the pesto over the rectangle of dough and sprinkle with 2/3 cup of Parmesan. Roll up lengthwise, so you have a long log of dough and pinch the seams to seal. Roll the log over, so the seam is down. Cut into 1 inch thick slices. Place about 12 slices in each pan– don't overcrowd (about 9 rolls ift in an 8x8 pan). The rolls will need room to rise. Sprinkle the remaining 1/3 cup of Parmesan over the rolls. Cover with plastic wrap and let rise in a warm place for about an hour or until doubled in size. Preheat oven to 375 degrees. Bake the rolls, one pan at a time, for 40 minutes. Turn the pans halfway through to ensure even baking.

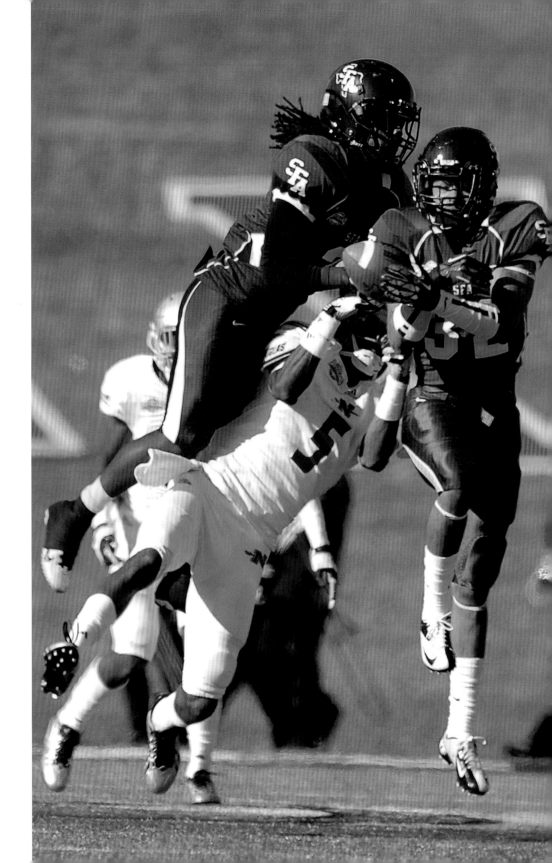

Kale Salad

4 cups kale, massaged and finely chopped
1 large red apple, such as Fuji or Honeycrisp,
 chopped, divided
1/2 sweet onion, thinly sliced
3/4 cup walnuts, toasted and chopped
1/3 cup Craisins or raisins
2 tablespoons Dijon mustard
3 tablespoons olive oil, more if needed
1 1/2 tablespoons red wine or apple cider vinegar
2 teaspoons honey
1/4 teaspoon sea salt

Massage kale before chopping. To massage kale, remove ribs and rub kale together between fingertips for 3-4 minutes. This technique removes the kale's natural bitterness, and turns the kale silky and sweet. After massaging, chop the kale and place it in a large bowl. Add the apple, onion, 1/2 cup walnuts (reserve 1/4 cup for dressing) and Craisins.

Put 1/4 cup walnuts, mustard, oil, vinegar, honey, and salt into a blender. Purée until well combined and slightly thick, adding oil if needed to thin. Pour dressing over kale salad and toss to combine.

Grilled Pear Salad

3 ripe Bartlett pears cut into 1/2-inch-thick wedges
1/4 cup red wine vinegar
1/2 cup seedless raspberry preserves
2 tablespoons chopped fresh basil
1 garlic clove, pressed
1/2 - 1 teaspoon salt
1/2 - 1 teaspoon seasoned pepper

1/3 cup olive oil
1 (5 ounce) package gourmet mixed salad greens
1/2 small red onion, thinly sliced
2 cups fresh raspberries
3/4 cup honey-roasted cashews
4 ounces crumbled goat cheese

Light grill and preheat to medium-high heat. Grill pear wedges, covered with grill lid, 1 to 2 minutes on each side or until golden. In a small bowl, whisk together red wine vinegar, preserves, basil, garlic, salt and seasoned pepper; slowly add olive oil, whisking constantly until smooth.

In a large bowl, combine salad greens, next 4 ingredients, and pears. Drizzle with desired amount of vinaigrette and toss to combine. Serve immediately with remaining vinaigrette.

Broccoli Salad

1 cup chopped pecans
1/2 (16 ounce) package farfalle pasta
1 pound fresh broccoli
1 cup mayonnaise
1/3 cup sugar
1/3 cup diced red onion
1/3 cup red wine vinegar
1 teaspoon salt
1/2 teaspoon black pepper
2 cups seedless red grapes, halved
8 cooked bacon slices, crumbled

Preheat oven to 350 degrees. Toast pecans in a single layer in a shallow pan 5 to 7 minutes or until lightly toasted and fragrant, stirring halfway through.

Prepare pasta according to package directions. Meanwhile, cut broccoli florets from stems, and separate florets into small pieces using tip of a paring knife. Peel away and discard tough outer layer of stems, and finely chop stems.

Whisk together mayonnaise and next 5 ingredients in a large bowl; add broccoli, hot cooked pasta, and grapes. Stir to coat. Cover and chill 3 hours. Stir bacon and pecans into salad just before serving.

Corn Casserole

6 ears sweet corn
1/2 cup milk
1/2 cup heavy cream
1/2 cup white cheddar cheese, shredded
1/2 teaspoon cayenne pepper
2 eggs, beaten
Salt and freshly ground black pepper

Preheat oven to 350 degrees. Grease casserole dish. Shuck the corn and cut all kernels off with a knife into a bowl, making sure to keep all of the runoff juice from the corn. Reserve. Mix together the milk, heavy cream, cheese, cayenne pepper and eggs. Pour mixture over reserved corn. Mix well. Pour into casserole dish and bake for 35 minutes or until set.

Grilled Chicken with Salsa

1 1/4 cups frozen corn kernels, thawed
1/3 cup chopped red onion
1/3 cup chopped red bell pepper
1/4 cup chopped fresh cilantro
2 tablespoons fresh lime juice
1/4 teaspoon garlic salt
2 teaspoons chopped seeded jalapeño chilie
1/2 cup dark beer
4 skinless boneless chicken breast halves

MARINADE
1 1/2 tablespoons soy sauce
1 tablespoon chopped fresh cilantro
2 teaspoons chopped seeded jalapeño chili
2 teaspoons fresh lime juice

To make salsa, combine corn, onion, bell pepper, cilantro, lime juice, garlic salt, and jalapeño in a small bowl. Season with salt and pepper. (Can be made ahead. Cover and chill.)

In a medium sized bowl or Ziploc bag, mix marinade. Combine beer, soy sauce, cilantro, jalapeño, and lime juice. Add chicken and coat well. Cover and refrigerate at least 1 hour.

Light barbecue (medium-high heat) or preheat broiler. Remove chicken from marinade and drain. Season with salt and pepper. Grill or broil chicken until just cooked through, about 4-5 minutes per side. Cut chicken into thin diagonal slices. Arrange chicken on plates. Top with salsa.

Artichoke Salad

1 box (8 ounce) Rice-a-Roni (chicken)
1/2 cup chopped onion
1/2 cup chopped green olives
1/2 cup chopped bell pepper
1/2 cup chopped celery
1 jar (4 ounce) marinated artichoke hearts
1 teaspoon curry powder
1/2 cup mayonnaise

Cook Rice-a-Roni according to directions on package. Let cool. Mix chopped vegetables with Rice-a-Roni. Reserve liquid of artichokes and combine with mayonnaise and curry powder; mix with Rice-a-Roni and artichoke hearts.
Serve chilled.

Pear Salad

1/2 cup pine nuts or chopped walnuts, toasted
1 (10 ounce) bag spinach, torn into bite-size pieces
1 (6 ounce) package Craisins
4 ounces crumbled bleu cheese
1 chopped pear and 1 sliced pear

DRESSING

2 tablespoons toasted sesame seeds
1/2 cup white sugar
2 teaspoons minced onion
1/4 teaspoon paprika
1/4 cup white wine vinegar
1/4 cup cider vinegar
1/2 cup olive oil

Combine salad ingredients in a large bowl.
In a medium bowl, whisk together the sesame seeds, sugar, onion, paprika, white wine vinegar, cider vinegar, and olive oil. Toss with spinach just before serving.

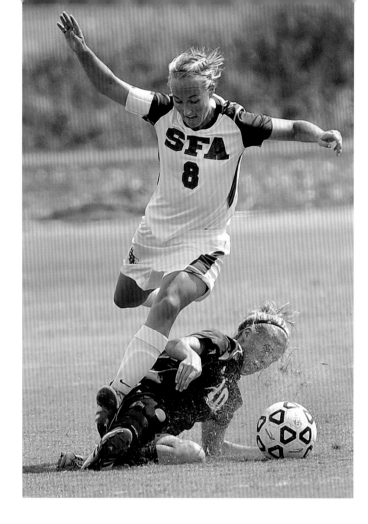

English Pea Salad

Serves 8

1 can (16 ounce) Le Sueur peas
1 egg, boiled and chopped
1/4 sweet onion, finely chopped
1/2 cup Cheddar cheese, shredded
sweet pickles, chopped
mayonnaise

Drain peas; add egg, onion, celery, and cheese. Add sweet pickles. Mix with mayonnaise. Chill at least an hour.

Another Yummy Layered Salad

2 heads Iceberg Lettuce, chopped
1 bunch green onions, chopped
1 cup celery, chopped
2 cups baby spinach
1 green bell pepper, chopped
1 can water chestnuts, chopped
8 hard boiled eggs, chopped
salt and pepper, to taste
1 bag (10 ounce) frozen peas, partially thawed
1 pound bacon, chopped and fried
2 cups cheddar cheese, grated

DRESSING:
2/3 cup Duke's mayonnaise
2/3 cup sour cream
1 1/2 tablespoon sugar (more to taste)
**You may have to make a little more dressing to cover your salad.

In a clear glass bowl or a 9x13 inch glass pan, layer lettuce, green onions, celery, spinach, pepper, chestnuts, and chopped eggs. Add salt and pepper to taste and cover with partially thawed peas.
Combine dressing ingredients in a separate bowl and mix well. Pour dressing over the top of the peas and spread to cover. Cover with grated cheese and sprinkle with chopped bacon.
Cover and refrigerate. Toss just before serving.

Cherry Cola Salad

1 (20 ounce) can of chilled crushed pineapple,
drained. Reserve juice. Do not use fresh
pineapple.
1 (14.5 ounce) can of chilled dark sweet cherries
in heavy syrup, drained. Reserve syrup.
1 large (8 serving size) cherry flavored Jell-O
1 (12 ounce) can of chilled Coca-Cola
1/2 cup of chopped pecans or walnuts, optional

Drain the cherry syrup and pineapple juices into a
saucepan. Set the fruit aside in the refrigerator to chill.
Bring fruit juices to a boil; remove from heat and whisk
in the Jell-O powder until fully dissolved. Pour into a
4 cup glass measuring cup and add enough Coca-Cola
to equal 4 cups of liquid. Transfer to a bowl and stir in
the pineapple, cherries, and nuts. Can pour into small,
prepared individual molds or a larger mold if desired.
Allow to set 3 to 5 hours or longer - do not stir!

TOPPING FOR CHERRY COLA SALAD
1 (8 ounce) package of cream cheese, room
temperature
1/2 cup of powdered sugar
2 cups of thawed Cool Whip or whipped
cream

Cream together the cream cheese and
sugar; stir in the Cool Whip or whipped
cream, until well combined.
To serve, turn out molds onto individual
lettuce leaves, or spoon servings into short
parfait glasses, or onto leaves of lettuce. Top
with a small dollop of the cream cheese
topping.

*IMPORTANT: You must use sweet cherries
in syrup for this recipe.*

Kale Salad II

1/2 cup pecans, toasted 5-10 minutes
8 ounces kale
1/2 cup radishes, sliced thin
1/2 cup dried cherries
2 ounces soft goat cheese, chilled

DRESSING
3 tablespoons olive oil
1 1/2 tablespoons white wine vinegar
1 tablespoon smooth Dijon mustard
2 teaspoons honey
sea salt and freshly ground black pepper to taste

Wash and dry kale. Remove ribs from each stalk.
Massage kale leaves (rub leaves between fingers,
massaging for 4-5 minutes to remove bitterness). Stack
kale leaves in small batches and roll tightly to cut,
crosswise. In a large salad bowl, add the kale ribbons,
pecans, radishes, cherries, and goat cheese.
In a small bowl, whisk dressing ingredients together
and pour the dressing over the salad.

Noodle Salad

2 large cucumbers
1 cup soy sauce
1/2 cup coconut milk
1/2 cup rice wine vinegar
1/2 cup chunky peanut butter
4 garlic cloves, minced
1 teaspoon sesame oil
1 teaspoon dried crushed red pepper
salt to taste
1 (16-ounce) package Soba noodles or angel hair
pasta, cooked according to package directions
1 cup shredded carrots
6 green onions, cut diagonally into 1 1/2-inch pieces

Peel cucumbers and halve lengthwise. Remove
and toss seeds. Slice cucumber into thin slices and set
aside. Combine soy sauce and next 7 ingredients in a
large bowl and whisk thoroughly; add cucumber, pasta,
carrot, and onions, tossing to coat. Cover and chill 4-8
hours.

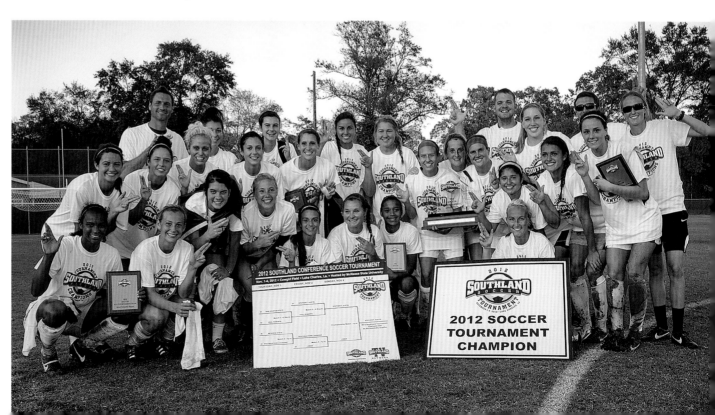

Best Potato Casserole

2 pounds of hash browns thawed
8 ounces of sour cream
8 ounces of onion dip
1 can of cream of chicken soup
1 large bag of shredded cheddar cheese

Mix all ingredients together and place in a greased 9 x 11 casserole pan.(Optional, melt 3/4 stick of butter add 2 cups of crushed corn flakes and cover with butter). Cook 1 1/2 hours at 350 degrees or until pototoes are done.

Ann's Chicken and Rice Casserole

1 stick margarine
1 1/2 cup rice
1 envelope onion soup mix
1 can cream of chicken soup
1 can chicken broth
1 can water
3-4 chicken breasts

Melt margarine in dish. Add rice on top. Remove skin from chicken. Put washed, salted, and peppered chicken on rice. Sprinkle onion soup mix over chicken. (Optional: Sprinkle a little Tony Cachere seasoning on top.) Pour water and broth over it. Cover with foil and put in 400 degrees oven for 20 minutes then turn the heat down to 350 and cook for almost an hour. (If your chicken is boneless, it doesn't take that long to cook.) I like to keep a little broth back and pour in on top after it is cooked too. Enjoy!

Baked Carrots

1 (16 ounce) package whole baby carrots
1/2 cup brown sugar
1/3 cup butter
1/3 cup boiling water
1 teaspoon salt
1/2 teaspoon ground cinnamon

Preheat oven to 350 degrees. Arrange carrots in an 8x8 inch pan. Combine sugar, butter, boiling water, salt, and cinnamon in a bowl; pour over carrots. Cover with aluminum foil and bake 1-1/2 hours, or until carrots are tender.

Macaroni and Cheese

4 tablespoons unsalted butter
2 teaspoons salt, divided
16 ounces elbow macaroni
5 tablespoons all-purpose flour
2 (12-ounce) cans evaporated milk
2 cups milk
2 teaspoons hot sauce
1/8 teaspoon ground nutmeg
1 teaspoon dry mustard
2 cups shredded extra-sharp Cheddar cheese
1 1/4 cups shredded American cheese
3/4 cup shredded Monterey Jack cheese

Adjust oven rack to middle position and heat oven to 350 degrees. Bring 4 quarts water to boil in large pot. Add 1 tablespoon salt and macaroni to boiling water and cook until al dente, about 6 minutes. Reserve 1/2 cup macaroni cooking water, then drain macaroni in colander. Set aside.

While pasta is cooking, melt 4 tablespoons butter in a large sauce pan over medium-high heat until foaming. Stir in flour and cook, stirring constantly, until mixture turns light brown, about 3-5 minutes. Slowly whisk in evaporated milk, milk, hot sauce, nutmeg, mustard, and 1 teaspoon salt and cook until mixture begins to simmer and is slightly thickened, about 4 minutes. Remove the mixture from the heat and cool slightly, whisk in 2 cups cheddar cheese (reserve 1 cup to sprinkle on top), the other cheeses and 1/2 cup reserved pasta water (for desired consistency) until cheese melts. Stir in macaroni until completely coated. Transfer mixture to 13x9 inch baking dish and top with remaining cup of cheddar cheese. Bake until cheese is bubbling around edges and top is golden brown, 20 to 25 minutes. Let sit for 5 to 10 minutes before serving.

Sweet Potato Casserole

3 cups of sweet potatoes, cooked and mashed
1/4 cup of milk
1/3 cup of butter, melted
1 teaspoon vanilla
2 eggs, beaten
1/2 teaspoon salt

TOPPING:
1 cup of chopped pecans
1 cup of brown sugar
3 tablespoons flour
1/3 cup of butter, melted
1 cup of coconut, optional

Mix mashed sweet potatoes, butter, vanilla, eggs, and salt. Spoon into a 1 1/2 quart oiled casserole dish. Combine topping ingredients and sprinkle over potatoes. Bake at 375 degrees for 25 minutes.

Heavenly Mushrooms

Makes 4 servings.

1 pound fresh mushrooms, sliced
1 tablespoon butter, melted
1/2 cup sour cream
1 tablespoon flour
dash of salt
1/8 teaspoon pepper (I use white pepper)
1/2 cup grated parmesan cheese
2 tablespoons fresh parsley, chopped

Sauté mushrooms in butter for 2 - 3 minutes; drain. Combine flour, sour cream, salt, and pepper in a small mixing bowl; stir well. Pour mixture over mushrooms and stir gently. Cook until thoroughly heated (do not boil). Spoon mixture into a lightly greased 1 quart casserole dish and sprinkle with cheese.

Bake mushrooms at 425 degrees for 10 to 15 minutes or until lightly browned. Remove from oven and sprinkle with chopped fresh parsley.

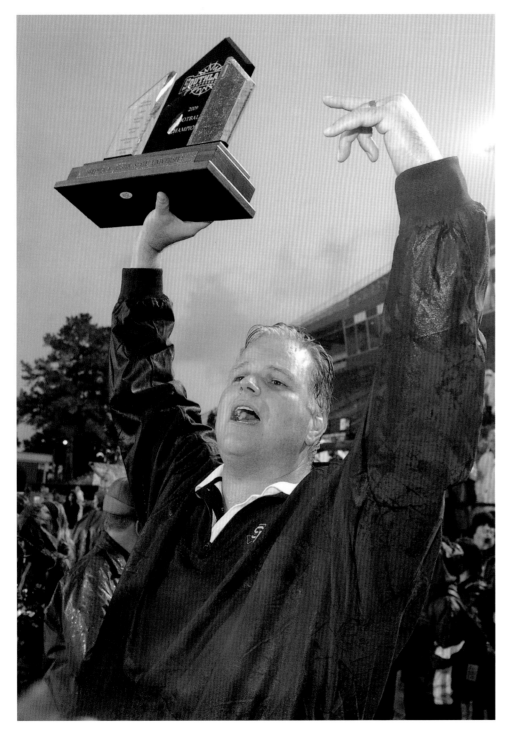

Baked Acorn Squash

1 acorn squash, halved 2 tablespoons brown sugar
2 tablespoons butter, softened freshly ground black pepper
salt

Preheat oven to 350 degrees. Slice acorn squash in half and scoop the seeds and pulp out of the squash. Place the squash, cut side up, in an 8x8 inch baking dish and add small amount of water to the dish, about one-half inch (the water bath helps steam the squash). Add 1 tablespoon of the butter and sugar to each squash half. Salt and pepper to taste. Cover with foil and bake in the preheated oven for about 1 hour until the squash is tender when pierced with a fork. Serve 1 half per person.

Mediterranean Style Spaghetti Squash

1 spaghetti squash, halved lengthwise and seeded
2 tablespoons olive oil
1 sweet onion, chopped
1 clove garlic, minced
1 1/2 cups tomatoes, chopped
3/4 cup crumbled feta cheese
1/2 cup sliced kalamata olives
2 1/2 tablespoons chopped fresh basil

Preheat oven to 375 degrees. Lightly grease a baking sheet.

Place spaghetti squash with cut sides down in a 9x13 inch casserole or baking dish. Pour 1/2 cup water into the dish and back until just tender 30-35 minutes. Remove squash from over and rake a fork back and forth across the squash to remove its flesh in strands—like spaghetti!

Meanwhile, heat oil in a skillet over medium heat. Cook and stir onion in oil until tender. Add garlic; cook and stir 2 to 3 minutes. Stir in tomatoes and cook until tomatoes are warmed through.

Use a large spoon to scoop the stringy pulp from the squash and place in a medium bowl. Toss with the vegetables, feta cheese, olives, and basil. Serve warm.

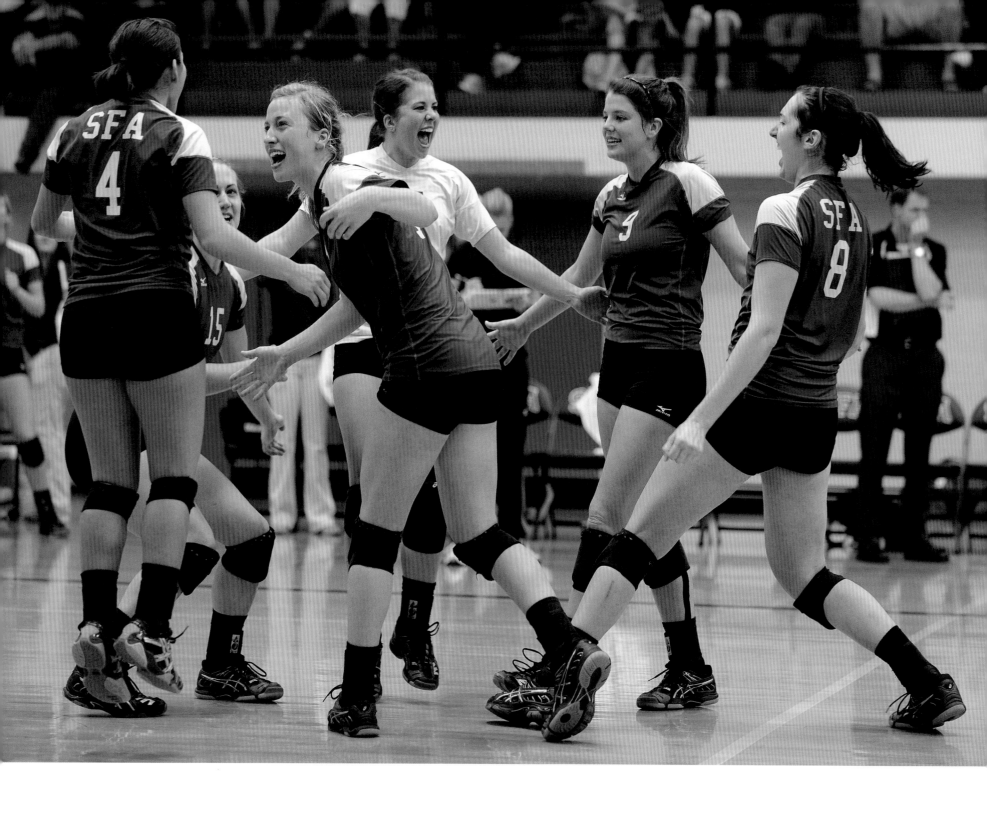

Baked Spaghetti Squash

1 spaghetti squash, halved lengthwise and seeded
6 tablespoons butter, softened
4 tablespoons cold butter
1/4 cup brown sugar
1/2 teaspoon cinnamon
salt and pepper to taste

Preheat an oven to 400 degrees. Cut squash into halves and remove seeds and pulp. Line a large baking dish with aluminum foil. Generously spread the softened butter over the outside of the squash; lay squash in the prepared baking dish with the cut sides facing down.

Bake in the preheated oven for 30 minutes. Flip the squash and put about half the butter, brown sugar, and cinnamon in each of the cavities of the squash halves. Return to the oven and continue baking until the outer shell is soft. While the squash is still in the shell, use a fork to scrape squash into strands. Add salt and pepper to taste and serve.

Mexican Brown Rice Salad

2 ears corn, husked
olive oil, for brushing
1 cup cooked brown rice
1 (15-ounce) cans pinto beans, drained and rinsed
1 (15-ounce) cans black beans, drained and rinsed
1 red bell pepper, seeded and finely chopped
1 bunch green onions, chopped.
1/2 red onion, chopped
1 small jalapeño, seeds and rib removed, diced
3 tablespoons olive oil
juice of 1 lime
1/2 teaspoon sugar
2 plus teaspoons cumin
1 clove garlic (or more to taste), finely chopped
1/4 cup cilantro, finely chopped
Kosher salt and freshly ground black pepper
1 cup crumbled queso fresco or feta cheese

Preheat the grill to medium-high heat. Brush corn with olive oil and season with salt and pepper. Grill for 5 to 6 minutes, rotating on all sides, until the corn has some nice charred spots. Let cool and remove corn kernels from the cob.

Add corn, brown rice, beans, bell pepper, jalapeno, and onions to a large bowl.

In a smaller bowl, whisk the olive oil, lime juice, sugar, cumin, garlic, cilantro, and salt and pepper. Fold dressing into the veggies and toss with crumbled cheese.

Seasoned Green Beans

2 (14 1/2 ounce) cans Italian cut green beans
1/2 sweet onion, chopped
4 slices thick-cut bacon, chopped
1/4 teaspoon garlic, minced
2 tablespoons sugar, or to taste
salt and pepper to taste

Fry bacon in a heavy sauce pan with chopped onion. Do not crisp the bacon, just cook enough to extract the drippings. Remove from heat. Empty the 2 cans of cut green beans into the sauce pan with the bacon and onion. Add salt and pepper to taste and then the 1/4 teaspoons of minced garlic. Stir well and return to heat. Bring to a boil over medium heat, then reduce heat to low. Cover and simmer for at least 1 hour.

Cabbage and Beef Casserole

1 pound ground beef
1 cup onion, chopped
1 medium head of cabbage, coarsley shredded
1/2 cup cooked rice
1 can diced tomatoes
1 can water
2 tablespoons sugar
1 tablespoon vinegar
Salt to taste

Brown beef with onion until beef loses its red color and onions are transparent. While beef is cooking, shred cabbage more coarsely than for slaw. Place in a greased baking dish. When beef is brown, stir in cooked rice. Place beef mixture in a layer over the cabbage. Mix tomatoes, water, sugar and vinegar together. Pour over beef and cabbage. Cover and bake at 350 degrees for 1 hour.

French Dip Sandwiches

2 tablespoons sea salt
3 tablespoons freshly ground black pepper
1 small boneless rib loin roast (4 to 5 pounds)
5 cloves garlic, minced
2 large onions, halved and sliced
1 packet French onion soup mix
1 teaspoon brown sugar
1 can beef consommé
1 can beef stock
2 tablespoons dry white wine
2 tablespoons Worcestershire sauce
1 tablespoon soy sauce
8 sandwich rolls
butter, softened, for toasting
8 slices provolone cheese, optional

Preheat the oven to 475 degrees. Salt and pepper roast and place on rack in a roasting pan and bake until medium-rare, 25 to 30 minutes (use a meat thermometer and keep an eye on it till it's medium-rare). Remove the meat and place on a cutting board.

Pour drippings from roast into saucepan and cook on medium-high heat. Add the garlic and sliced onions to the drippings, stirring around to cook until slightly tender, about 5 minutes. Add the soup mix and teaspoon of brown sugar.

Add consommé, stock, 1 cup water, the wine, Worcestershire sauce, soy sauce, and the remaining 1 tablespoon pepper and bring to a boil. Reduce heat and simmer for 1 hour. Pour through a fine mesh strainer and keep warm.

Slice the roast very, very thinly. Split the rolls and spread with butter. Then grill the rolls on a griddle or in a skillet until golden brown and crisp.

Using tongs, dip meat in au jus and pile into sandwich rolls, top with provolone cheese. Serve sandwiches with a dish of au jus.

Cheesey Chicken Lasagna

lasagna noodles
1/2 cup butter
1 sweet onion, chopped
2 cloves garlic, minced
1/2 cup all-purpose flour
1 1/2 teaspoons salt
1 1/2 cups chicken broth
1/2 cup white wine
1 1/2 cups milk
5 cups shredded mozzarella cheese, divided
1 cup grated Parmesan cheese, divided
1 teaspoon dried basil
1 teaspoon dried oregano
2 teaspoons ground black pepper
1 (30 ounce) carton ricotta cheese
2 cups chicken, cooked and cubed
1 1/2 (10 ounce) packages fresh spinach, destemmed
1 tablespoon chopped fresh parsley
1/4 cup grated Parmesan cheese for topping

Preheat oven to 350 degrees. Cook lasagna noodles according to package directions. Drain, and rinse with cold water. (You can also use no boil noodles and let them cook in the sauce.)

In a large saucepan, melt the butter over medium heat. Add onion, garlic, and saute until tender, stirring frequently. Stir in the flour and salt, and simmer until bubbly. Mix in the broth, wine, and milk. Bring to a boil, stirring constantly. Boil for 1 minute. Stir in 3 cups mozzarella cheese and 1/4 cup Parmesan cheese. Season with the basil, oregano, and ground black pepper. Remove from heat, and set aside.

In another skillet, saute spinach until wilted, add ricotta cheese, and chicken.

Lightly grease a 9x13 inch baking dish. Spread 1/3 of the sauce mixture in the dish. Layer with 1/3 of the noodles, and 1/3 of the ricotta mixture. Sprinkle with the remaining mozzarella cheese. Repeat layers. Sprinkle with cheese.

For the final layer, noodles, ricotta mixture, sauce, last 1/3 cup of mozarrella cheese. Sprinkle with parsley and 1/4 cup Parmesan cheese. Bake 35 to 40 minutes.

Slow Cooker Lasagna

1 pound ground beef
1 large onion, chopped
2 garlic cloves, minced
1 can (29 ounces) tomato sauce
1 cup water
1 can (6 ounces) tomato paste
1 teaspoon salt
1 teaspoon dried oregano
1 package (8 ounces) no-cook lasagna noodles
4 cups (16 ounces) shredded mozzarella cheese
1 1/2 cups (12 ounces) small-curd cottage cheese
1/2 cup grated Parmesan cheese

In a skillet, cook beef, onion, and garlic over medium heat until meat is no longer pink; drain. Add the tomato sauce, water, tomato paste, salt and oregano; mix well. Spread a fourth of the meat sauce in an ungreased 5 quart slow cooker. Arrange a third of the noodles over sauce (break noodles if necessary).

Combine the cheese; spoon a third of the mixture over noodles. Repeat layers twice. Top with remaining meat sauce. Cover and cook on low for 4-5 hours or until noodles are tender.

Black-eye Pea Soup

1 cans black-eye peas
1 can diced tomatoes
1 can diced tomatoes with green chilies or 1 cup salsa
chopped onion—to taste
link sausage—cut in small pieces

Mix all ingredients in pan. Simmer 30 - 40 minutes.

Chicken Pot Pie

1 pound skinless, boneless chicken breast halves cut into small cubes
1 cup carrots, sliced
1 cup frozen green peas
1/2 cup celery, thinly sliced
1/3 cup butter
1/3 cup onion, chopped
1/3 cup all-purpose flour
1/2 teaspoon salt
1/4 teaspoon black pepper
1/4 teaspoon celery seed
1 3/4 cups chicken broth
2/3 cup milk
2 (9 inch) unbaked pie crusts

Preheat oven to 425 degrees. Combine chicken, carrots, peas, and celery in a saucepan and cover with water. Boil for 15 minues and remove from heat. Drain chicken and vegetables and set aside on plate to cool.

In a saucepan over medium heat, cook onions in butter until soft and translucent. Stir in flour, salt, pepper, and celery seed. Slowly add chicken broth and milk, stirring constantly. Simmer over medium-low heat until thick. Remove from heat and add chicken vegetable mixture.

Place the chicken mixture in unbaked pie crust. Cover with top crust, seal edges, and cut away excess dough. Make several small slits in the top to allow steam to escape.

Bake in the preheated oven for 30 - 35 minutes, or until pastry is golden brown and filling is bubbly. Cool

Cheesy Chicken Tater Tot Casserole (Slow Cooker)

1 (32 ounce) bag frozen tater tots
1 (3 ounce) bag bacon pieces
1 pound boneless, skinless chicken breasts, diced
2 cups shredded Cheddar cheese
3/4 cup milk
salt and pepper, to taste

Spray slow cooker with nonstick cooking spray. Layer half of the frozen tater tots in the bottom of the slow cooker. Sprinkle with 1/3 of the bacon pieces. Now top with 1/3 of the shredded cheese.

Add diced chicken on top. Season with salt and pepper. Add 1/3 of the bacon pieces and another 1/3 of shredded cheese. Put the rest of the frozen tater tots on top. Finish with the remaining 1/3 Cheddar cheese and remaining 1/3 of bacon pieces. Pour 3/4 cup milk all over the top. Cover and cook on low about 4 – 6 hours.

Note: This recipe is designed to be made in a slow cooker. If your only choice is to make it in the oven, then you will need to partially thaw the tater tots first. Spray a 9x13 inch baking dish with nonstick spray. Layer ingredients into baking dish. Cover with aluminum foil and bake for about an hour to an hour and a half at 325 degrees.

Chicken Tetrazzini

1 (3 pound) chicken. Boil chicken with onion and celery. Debone and cut in fairly large pieces.

Cook 18 ounces thin spaghetti in 2 quarts chicken stock until tender.

CREAM SAUCE:
1/4 pound butter
1/2 cup flour
Add 3 cups milk slowly.
After sauce begins to thicken add: 1/2 pound Old English cheese and 1/2 pound American cheese (I only add 1/2 pound velveeta)

Season the sauce with salt and white pepper. Reserve juice from 2 (4 ounce) cans of mushrooms. Set mushrooms aside. Chop 1 onion and 1 green pepper. Cook onion and green pepper in in mushroom juice. Add chicken to spaghetti, then cream sauce, mushrooms, onion, and green pepper. Add also (optional) 1 cup toasted almonds and 1 small jar pimientos, chopped.

Place in buttered casserole pyrex. Bake 30 minutes in a 350 degree oven. Ten minutes before ready, sprinkle with buttered cracker crumbs. Continue baking until crackers are brown. The secret to this recipe is in the seasoning. Taste carefully for enough salt and pepper. We really use quite a bit. A real favorite. It freezes well.

Slow Cooker Taco Soup

1 pound ground beef
1 onion, chopped
16 ounces chili beans with liquid
15 ounces kidney beans with liquid
15 ounces whole kernel corn with liquid
8 ounces tomato sauce
2 cups water
2 (14.5 ounce) cans peeled and diced
 tomatoes
4 ounces diced green chile peppers
1.25-ounce package taco seasoning mix

In a medium skillet, cook the ground beef until browned over medium heat. Drain, and mix in slow cooker with remaining ingredients. Cook on low setting for 8 hours.

***Variations/options: Substitute chicken broth for water, add 1 can Ro Tel, add 1 packet Hidden Valley Ranch dressing mix, add 1/2 pound Velveeta.*

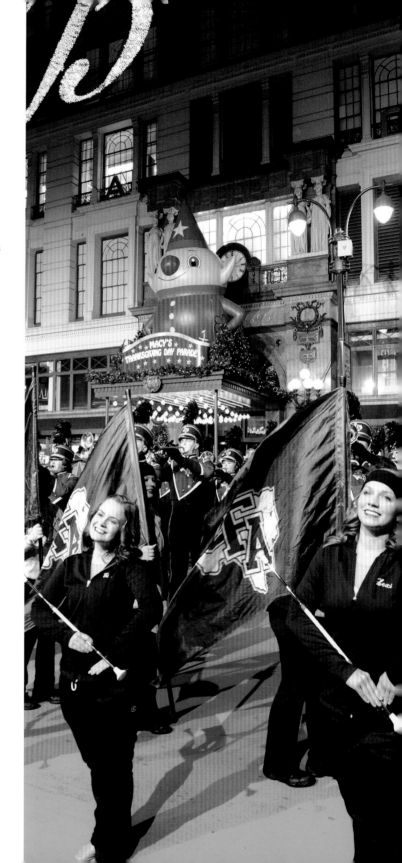

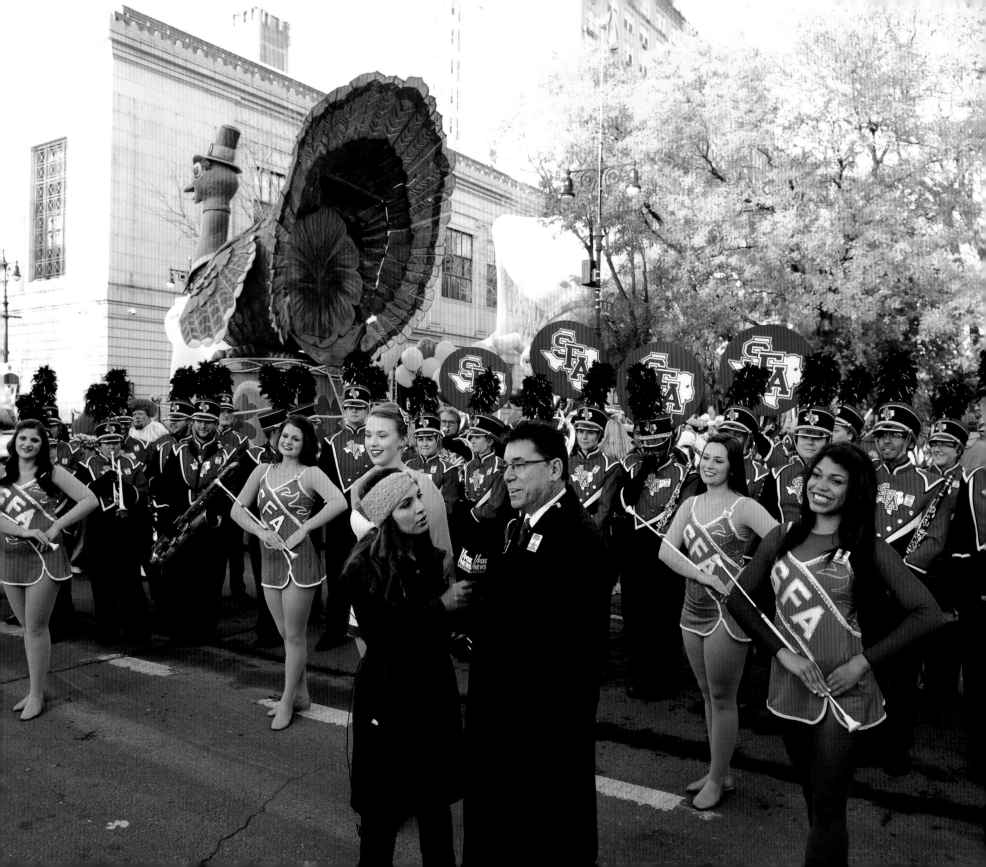

Unbelievable Cornbread Dressing

1 cup butter
2 cups all-purpose flour
2 cups yellow cornmeal
1 cup cup white sugar
2 teaspoons salt
1 teaspoon pepper
1 teaspoon sage (optional)
1 teaspoon baking soda
4 eggs
2 cups buttermilk
1 cup celery, thinly sliced
1 sweet onion, finely chopped
1 medium apple, finely chopped
6-8 slices light bread
4-6 cans chicken broth

Preheat oven to 375 degrees. Lightly grease a disposable foil pan (I usually buy one of the large roasting pans). Melt butter. In a large bowl, combine the melted butter, sugar, and eggs. Beat until well blended. Combine buttermilk with baking soda and stir into butter mixture. Stir in flour, cornmeal, salt, pepper, and sage (if desired) until a few lumps remain. Add celery, onion, and apple. Pour batter into prepared pan and bake in preheated oven for 20 to 40 minutes (depending on pan size and thickness of batter) or until a toothpick inserted into the center comes out clean. Let cool.

DRESSING

For the dressing, crumble cornbread in same pan as you baked it in. Taste to see if there is enough salt and pepper. Add more if needed. Tear 6 -8 slices of light bread into small pieces and mix into crumbled cornbread. Add enough chicken broth to thoroughly saturate the cornbread mix. If you like moist dressing, add a little more broth to where it is puddling on top of the cornbread. Cover with foil and return to 350 degree oven and bake until heated thoroughly. Remove foil and bake a few extra minutes to lightly brown.

Sweet Potato Casserole II

5 sweet potatoes
1/4 teaspoon salt
1/4 teaspoon black pepper
1/4 cup butter
2 eggs, beaten
1 teaspoon vanilla extract
1/2 teaspoon ground cinnamon
1/3 cup white sugar
2 tablespoons heavy cream
1/4 cup butter, softened
3 tablespoons all-purpose flour
2/3 cup packed light brown sugar
1/2 cup chopped pecans

Preheat oven to 350 degrees. Bake sweet potatoes 35 minutes, or until they begin to soften. Cool slightly, peel, and mash. In a large bowl, mix the mashed sweet potatoes, salt, pepper, 1/4 cup butter, eggs, vanilla extract, cinnamon, sugar, and heavy cream. Transfer to a lightly greased 9x13 inch baking dish. In a medium bowl, combine 1/4 cup butter, flour, brown sugar, and chopped pecans. Mix with a pastry blender or your fingers to the consistency of course meal. Sprinkle over the sweet potato mixture. Bake 30 minutes in the preheated oven until topping is crisp and lightly browned.

Pumpkin Pie

FILLING

1/2 cup granulated sugar
1/2 cup brown sugar
1 tablespoon unbleached all-purpose flour
1/2 teaspoon salt
1 teaspoon ground ginger
1 teaspoon ground cinnamon
1/2 teaspoon nutmeg
1/8 teaspoon ground cloves
1/4 teaspoon freshly ground black pepper (optional)
3 large eggs, beaten
2 cups (or one 15-ounce can) pumpkin
1 1/4 cups light cream (half and half) or evaporated milk

CRUST

Use your favorite single pie crust recipe.

In a large bowl, blend together the sugars, flour, salt, and spices. In a large measuring cup, beat the eggs, pumpkin, and cream or evaporated milk. Whisk into the dry ingredients. For best flavor, cover and refrigerate the filling overnight before baking, but do not remix—just pour into pie shell.

Lightly grease a 9 inch pie pan that's at least 1 1/2 inches deep. Roll the pie dough out to a 13 inch circle and transfer to the pan. Crimp the edges above the rim; this will give you a little extra headroom to hold the filling when it expands in the oven. Refrigerate the crust while the oven preheats to 400 degrees. When the oven is hot, place the pie pan on a baking sheet to catch any spillage. Pour the filling into the unbaked pie shell. Bake for 45 to 50 minutes until the filling is set 2 inch in from the edge. The center should still be wobbly. Remove the pie from the oven and cool on a rack; the center will finish cooking as the pie sits.

Dirty Cranberry Rice

Makes 6 servings

1 cup coarsely chopped pecans
1 package Zatarain's Dirty Rice
1/3 cup Craisins (or more to taste)
1/3 cup chopped green onions (or more to taste)
1 teaspoon orange zest
1/3 cup chopped green bell pepper (or more to taste)
2/3 cup mandarin oranges, drained.

Lightly toast pecans in small nonstick skillet over medium-low heat, stirring often, 5-7 minutes or until pecans are toasted and fragrant. Prepare rice according to package directions and add Craisins as rice is cooking. After rice has cooked, remove from heat and add chopped onion, orange zest, green pepper, and pecans. Salt and pepper to taste. Gently stir in mandarin oranges. Refridgerate until ready to serve.

East Texas Grape Salad

Makes 10-12 servings

1 can (20 ounces) pineapple tidbits (reserve
 3 tablespoons of juice)
1 package (8 ounces) cream cheese,
 softened
2 tablespoons mayonnaise
3 cups miniature marshmallows
2 1/2 cups seedless red grapes, halved
1 cup heavy whipping cream, whipped
1/2 cup pecans, chopped and toasted

Chop and lightly toast pecans. Drain the pineapple and set aside, reserving 2 tablespoons juice. In a mixing bowl, beat juice, cream cheese and mayonnaise until fluffy. Stir in pineapple, nuts, marshmallows, and grapes. Fold in whipped cream. Serve immediately or refrigerate.

Pumpkin Cheesecake

1 (9 inch) prepared graham cracker crust
2 (8 ounce) packages cream cheese, softened
1/2 cup sugar
1/2 teaspoon vanilla extract
2 eggs
1/2 cup pumpkin purée
1/2 teaspoon ground cinnamon
1 pinch ground cloves
1 pinch ground nutmeg
1/2 cup frozen whipped topping, thawed

Preheat oven to 325 degrees. Combine cream cheese, sugar, and vanilla in large mixing bowl and beat until smooth. Blend in eggs one at a time. Remove 1 cup of batter and spread into bottom of crust; set aside.

Add pumpkin, cinnamon, cloves, and nutmeg to the remaining batter and stir gently until well blended. Carefully spread over the batter in the crust.

Bake 35 to 40 minutes or until center is almost set. Cool and refrigerate at least 3 hours. Cover with whipped topping before serving.

Favorite Chocolate Icebox Pie

2/3 cup milk
3/4 cup semisweet chocolate morsels
1/4 cup cold water
2 tablespoons cornstarch
1 (14 ounce) can sweetened condensed milk
3 large eggs, beaten
1 1/2 teaspoon vanilla extract
3 tablespoons butter or margarine
1 (6 ounce) ready-made chocolate crumb pie
 crust
1 cup whipping cream
1/3 cup sugar
1/3 cup chopped pecans, toasted
1 (1.55 ounce) milk chocolate candy bar,
 chopped

Heat milk until it just begins to bubble around the edges in a 3 quart saucepan over medium heat (do not boil). Remove from heat, and whisk in chocolate morsels until melted. Cool slightly.

Stir together cold water and cornstarch until dissolved. Whisk cornstarch mixture, sweetened condensed milk, eggs, and vanilla into chocolate mixture. Bring to a boil over medium heat, whisking constantly. Boil 1 minute or until mixture thickens and is smooth. (Do not overcook.) Remove from heat, and whisk in butter. Spoon mixture into piecrust. Cover and chill at least 8 hours.

Beat whipping cream at high speed with an electric mixer until foamy; gradually add sugar, beating until soft peaks form. Spread whipped cream evenly over pie filling. Sprinkle with pecans and candy bar pieces.

Banana Cream Pie

1 (12 ounce) box Nilla Wafers, divided
1/2 cup butter, melted
2 large bananas, sliced
VANILLA CREAM FILLING
4 egg whites
1/2 cup sugar

Set aside 30 vanilla wafers; pulse remaining vanilla wafers in a food processor until coarsely crushed, about 2 1/2 cups. Combine butter with crushed wafers until blended and press firmly on bottom and up sides of 9 inch pieplate. Bake crust at 350 degrees for 10-12 minutes or until lightly browned. Let cool. Arrange banana slices evenly over bottom of crust.

Prepare VANILLA CREAM FILLING and spread half of hot filling over bananas; top with 20 vanilla wafers and then remaining filling. (Filling will be about 1/4 inch higher than top edge of crust.)

Beat egg whites at high speed with an electric mixer until foamy. Add sugar, 1 tablespoon at a time, beating until stiff peaks form and sugar dissolves. Spread meringue evenly over hot filling, sealing the edges.

Bake at 350 degrees for 10-12 minutes or until golden brown. Remove from oven and cool completely. Coarsely crush remaining vanilla wafers and sprinkle evenly over top of pie. Chill 4 hours.

VANILLA CREAM FILLING

3/4 cup sugar
1/3 cup all-purpose flour
2 large eggs
4 egg yolks
2 cups milk
2 teaspoons vanilla extract

Whisk together first 5 ingredients in a heavy saucepan and cook over medium-low heat, whisking constantly, 8 to 10 minutes or until mixture reaches the thickness of chilled pudding. (Mixture will just begin to bubble and will be thick enough to hold soft peaks when whisk is lifted.) Remove from heat, and stir in vanilla.

Apple Pie

1 recipe pastry for a 9 inch double crust pie
1/2 cup unsalted butter
1 teaspoon cinnamon
1/2 teaspoon nutmeg
3 tablespoons all-purpose flour
1 tablespoon vanilla
3 tablespoons water
1/2 cup white sugar
1/2 cup packed brown sugar
4 large red delicious apples—peeled and sliced

Preheat oven to 425 degrees. Melt butter in a saucepan add cinnamon and nutmeg. Stir in flour to form a paste. Add water, white sugar and brown sugar, and bring to a boil. Reduce temperature and let simmer. Add vanilla. Place the bottom crust in your pie pan. In a large bowl, combine sliced apples with 3/4 of the syrup mixture and mix well. Pour into pie shell, mounding slightly. Cover with a lattice work crust. Gently pour the remaining sugar and butter liquid over the crust. Pour slowly so that it does not run off.

Bake 15 minutes in the preheated oven. Reduce the temperature to 350 degrees and continue baking until apples are soft.

(Use a glass pie dish because it is larger and deeper. Also, place pan lined with foil under the pie just in case the pie boils over.)

Italian Cream Cake

1 stick (1/2 cup) butter
2 cups sugar
l/2 cup shortening
2 cups flour
1 teaspoon soda
1/8 teaspoon sal
5 eggs, separated (reserve egg whites)
1 teaspoon vanilla
1 cup buttermilk
1 cup flaked coconut
3/4 cup chopped nuts

Cream sugar, butter, and shortening; add egg yolks 1 at a time, beating thoroughly after each. Add vanilla and beat until blended

Mix dry ingredients and add alternately with buttermilk, mixing well after each addition. Stir in coconut and nuts. Beat egg whites until stiff and fold into batter. Pour into 3 greased and floured round cake pans and bake at 350 degrees for 20 minutes or until done. Cool before frosting.

FROSTING:
8 ounces cream cheese, softened
1 stick (1/2 cup) butter or margarine
1 pound powdered sugar
1 teaspoon vanilla
1/2 cup chopped nuts
Cream all ingredients and spread on cooled cake.

Not Neiman Marcus Cake

1 package yellow cake mix
1/4 cup oil
4 eggs
1 cup chopped nuts, divided
8 ounces cream cheese
1 pound powdered sugar

Mix cake mix, oil, 2 eggs, and 1/2 cup nuts by hand; press in ungreased 9x13 inch pan. Combine cream cheese, sugar, 2 eggs and remaining 1/2 cup nuts; pour over mixture in pan. Bake in preheated 300 degree oven for 1 hour and 15 minutes. Add scoop of ice cream or whipped cream when served.

East Texas Nut Cake

1 cup shortening
2 cups butter
1 2/3 cups sugar
3 eggs
2 teaspoons baking powder
1 teaspoon salt
1 cup milk
1 teaspoon vanilla
2 3/4 cups cake flour or 2 2/3 cups all-purpose
 flour
1 1/3 cups walnuts, chopped
walnut halves, for garnish

Cream together shortening, butter, and sugar. Add eggs and beat thoroughly. Sift together flour, baking powder, and salt; add flour mixture alternately with milk and vanilla, mixing well. Fold in walnuts. Pour into 2 greased and floured 9 inch layer pans or 13x9 inch oblong pan. Bake at 350 degrees until cake tests done, approximately 25 minutes. Cool. Ice with CREAMY CARAMEL ICING (recipe follows) and top with walnut halves.

CREAMY CARAMEL ICING
1 cup unsalted butter
2 cups firmly packed dark brown sugar
1/4 cup plus 2 tablespoons whipping cream
2 teaspoons vanilla extract
3 3/4 cups powdered sugar

Melt butter in a 3 quart saucepan over medium heat. Add brown sugar; bring to a boil, stirring constantly. Stir in whipping cream and vanilla; bring to a boil. Remove from heat, and let cool 1 hour. Pour into a mixing bowl. Sift powdered sugar into frosting. Beat at high speed with an electric mixer until creamy and spreading consistency.

Grandma's Banana Cake

1 cup shortening
2 cups sugar
3 eggs
2 bananas, mashed
2 1/2 cups flour
2 1/2 teaspoons baking powder
1/2 teaspoon salt
1 teaspoon soda (dissolve in buttermilk)
1 cup buttermilk
1 teaspoon vanilla

Cream shortening and sugar well; add eggs. Stir in mashed bananas, then add flour, baking powder, and salt that have been sifted together. Dissolve soda in buttermilk. Add buttermilk mixture and vanilla. Place in greased and floured loaf or tube pan. Bake at 350 degrees for 25 to 30 minutes.

WINTER

Winter Fruit Salad

1 can jellied cranberry sauce
2 cups applesauce (about same volume as
 cranberry sauce)
3/4 cup brown sugar, lightly packed
1/2 teaspoon cinnamon
1/3 cup butter, melted
1 large can peach slices
1 medium can pineapple tidbits
1 medium can pitted Bing cherries (dark, sweet
 cherries)
1 large can pears, sliced
1 cup coarsely chopped pecans
2 large bananas, sliced

Mix cranberry sauce, applesauce, brown sugar, cinnamon, and butter in a sauce pan and whisk over medium heat until the butter is melted and the cranberry sauce is smooth. Remove from heat and set aside. Drain all canned fruit well. Mix all fruit and nuts and place into a large casserole dish. Pour warm sauce over the fruit, making sure all the fruit is covered, especially the bananas (so they won't turn dark). Bake at 350 degrees about 30 minutes. Serve warm. Serves 20. It can be made ahead of time, but don't add bananas until ready to bake.

**Recipe Note: This is great served with ham, etc. at lunch or dinner, but it is exceptionally good served at brunch. It is always a special part of our family holiday brunches, along with an egg casserole and hot biscuits. You can vary the fruits according to the ones you like and add them in whatever proportion you enjoy.

Chicken and Dumplings

3 1/2 boneless skinless chicken thighs
2 celery ribs, sliced
4 carrots, peeled and sliced
1 medium onion, diced
1 (14 1/2 ounce) cans chicken broth
2 tablespoons dried parsley
2 teaspoons chicken bouillon granules
1 1/2 teaspoons salt
2 teaspoons pepper
water (as needed)

DUMPLINGS
2 cups flour
3 teaspoons baking powder
1 teaspoon salt
3/4 cup milk
4 tablespoons unsalted butter, melted

Combine chicken, celery, carrots, onion, chicken broth, parsley, chicken bouillon granules, salt, and pepper in a large stock pot; add enough water to cover chicken. Bring to a boil; reduce heat, cover, and simmer 2 hours or until chicken is done. Remove chicken and cool. Skin and debone chicken. Return meat to soup; discard skin and bones. Add more salt and pepper to taste, if desired. Return soup to a simmer.

In a mixing bowl, combine dumpling ingredients and mix well to form a stiff dough. You m ay have to adjust milk or flour to reach desired stiffness. Drop by tablespoonfuls into simmering soup. Cover and simmer for 15 to 20 minutes.

Strawberry Jell-O Salad

2 packages strawherry Jell-O
1 package frozen strawberries
1 carton sour cream
1 small can crushed pineapple
2 bananas (mashed)
1 cup pecans, chopped
2 cup boiling water

Combine water and Jell-O, pineapple, stawberries, bananas, and pecans. Put half of Jell-O mixture into an oblong pan. When jelled, put sour cream on top, then add the rest of the Jell-O. Chill until set.

Cherry Salad

1 can cherry pie filling
1 can sweetened condensed milk
1 carton Cool Whip
1 can crushed or chunk pineapple, drained
1/4 to 1 cup coconut (optional)
1/4 to 1 cup pecans, toasted and chopped
1 cup miniature marshmallows

Mix ingredients together and chill.

Christmas Cheer

1/2 pound raw cranberries
1 package cherry gelatin
1/2 cup sugar
1 1/2 cup hot water
1 cup miniature marshmallows
1/2 cup chopped nuts
1 cup crushed pineapple
1 cup heavy cream, whipped

Put cranberries through food chopper. Add sugar, marshmallows, and pineapple. Stir to dissolve sugar; chill. Add hot water to gelatin, stir until gelatin dissolves. Chill until it begins to set. Combine with cranberry mixture. Stir in chopped nuts. Fold in whipped cream. Chill.

Cherry Salad Supreme

Serves 12.

1 box raspberry gelatin
1/3 cup mayonnaise
1 can cherry pie filling
1 cup crushed pineapple
1 box lemon Jell-O
l/2 cup whipped cream
4 ounces cream cheese
1 cup small marshmallows

Dissolve raspberry gelatin in 1 cup boiling water; stir in pie filling. Put into a 9x9x2 inch baking dish; chill until partially set. Dissolve lemon gelatin in 1 cup boiling water. Beat the cream cheese and mayonnaise together; gradually add the lemon qelatin. Stir in undrained pineapnle; add whipped cream to lemon mixture. Fold in marshmallows. Spread over raspberry mixture; chill until set.

Cranberry Salad Mold

Makes 6 to 8 servings

1 (8 ounce) can crushed pineapple in syrup
boiling water (as needed)
1 (3 ounce) package raspberry-flavored gelatin
1 (14 ounce) can whole-berry cranberry sauce
1 cup drained mandarin oranges
1 teaspoon orange zest

Drain syrup from pineapple into a 2-cup measuring cup. Add boiling water to equal 1 1/4 cups. Transfer to a large bowl. Dissolve gelatin in hot syrup mixture; chill 1 hour and 30 minutes or until partially set. Fold in cranberry sauce, oranges, zest, and crushed pineapple. Pour into 1 (4-cup) mold and chill 2 hours or until set.

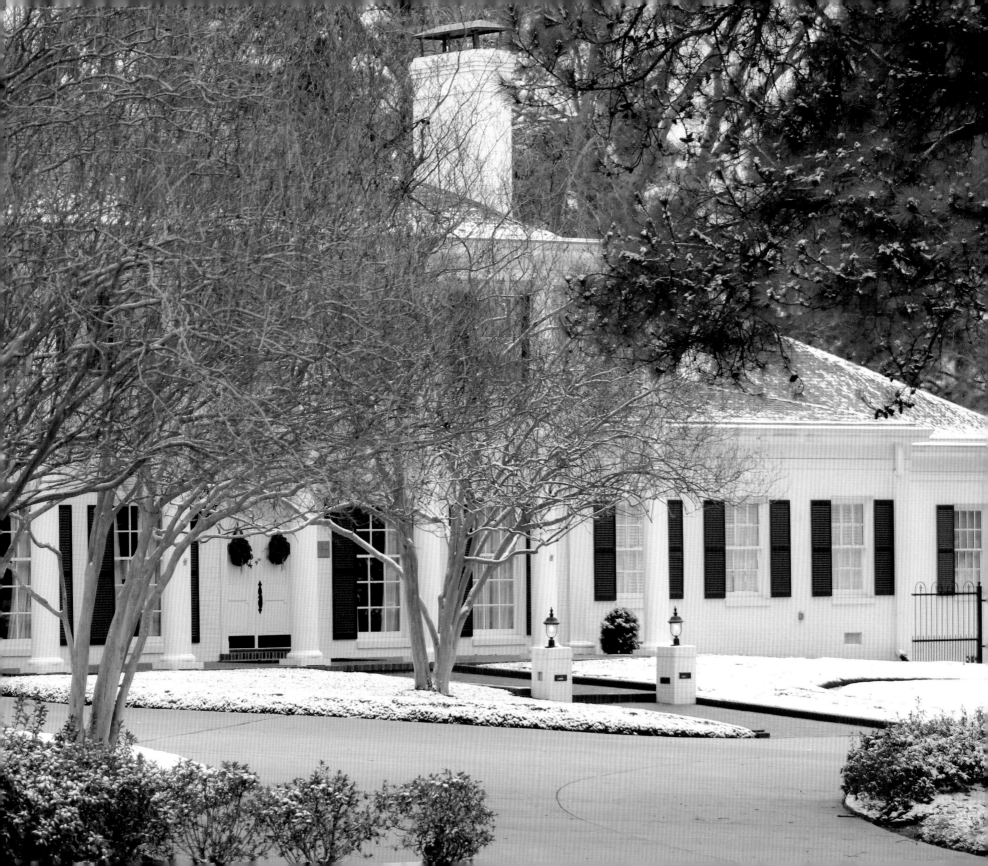

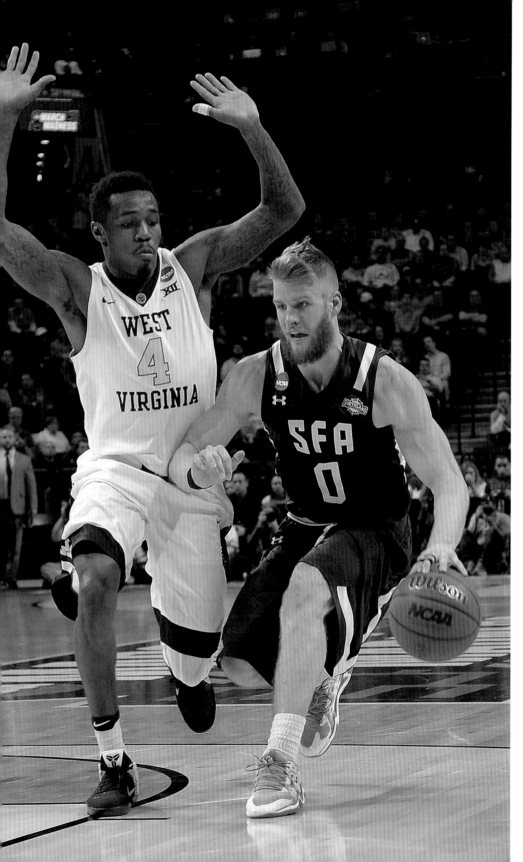

Cheesy Sour Cream Chicken Enchiladas

Makes 6 servings

1 stewed chicken, boned and chopped (a rotisserie chicken also works)
2 (10 3/4 ounce) cans cream of mushroom soup, undiluted
1 (8 ounce) carton sour cream
1 (4 ounce) can chopped green chilies
1/4 teaspoon salt
1/2 teaspoon pepper
1/4 teaspoon garlic powder
2 cups shredded Cheddar cheese
1 sweet onion, chopped
1 dozen corn tortillas
hot oil for heating tortillas.

Combine soup, sour cream, green chilies, salt, pepper, and garlic powder in a medium saucepan. Mix well. Cook over medium heat, stirring often, just until hot. In a separate bowl, combine cheese and onion. Cook each tortilla in hot oil for a few seconds or just until softened. Drain on paper towels. Immediately spoon about 1 1/2 tablespoons of cheese and onion mixture, chicken, and about 2 tablespoons of soup mixture onto center of each tortilla. Roll up tightly, and place in greased 13x9 inch baking dish. Spoon remaining soup mixture over top of enchiladas; sprinkle some chicken and remaining cheese and onion on top. Bake at 350 for 20-30 minutes.

Layered Chicken Enchiladas

2 tablespoons butter
1 green pepper, chopped
1 sweet onion, chopped
3 cups chicken, cooked and cubed
1 can cream of chicken soup
1 can cream of mushroom soup
1 (8 ounce) package cream cheese
1/2 ground pepper

1 can original Rotel, drained
1 teaspoon chili powder
1/2 teaspoon garlic powder
1/2 pound Velveeta, cubed
12 corn tortillas, cut in half
1 cup Cheddar cheese, shredded

Heat oven to 350 degrees. Melt butter in large skillet on medium heat. Add peppers and onions; cook until crisp-tender. Add chicken, soups, cream cheese, pepper, RoTel, chili powder, garlic powder, and the VELVEETA; mix well. Spread 1 cup chicken mixture onto bottom of 13x9-inch baking dish; cover with 6 tortilla halves. Repeat layers 3 times. Cover. Bake 45 minutes or until heated through. Uncover and spread cheddar cheese on top.

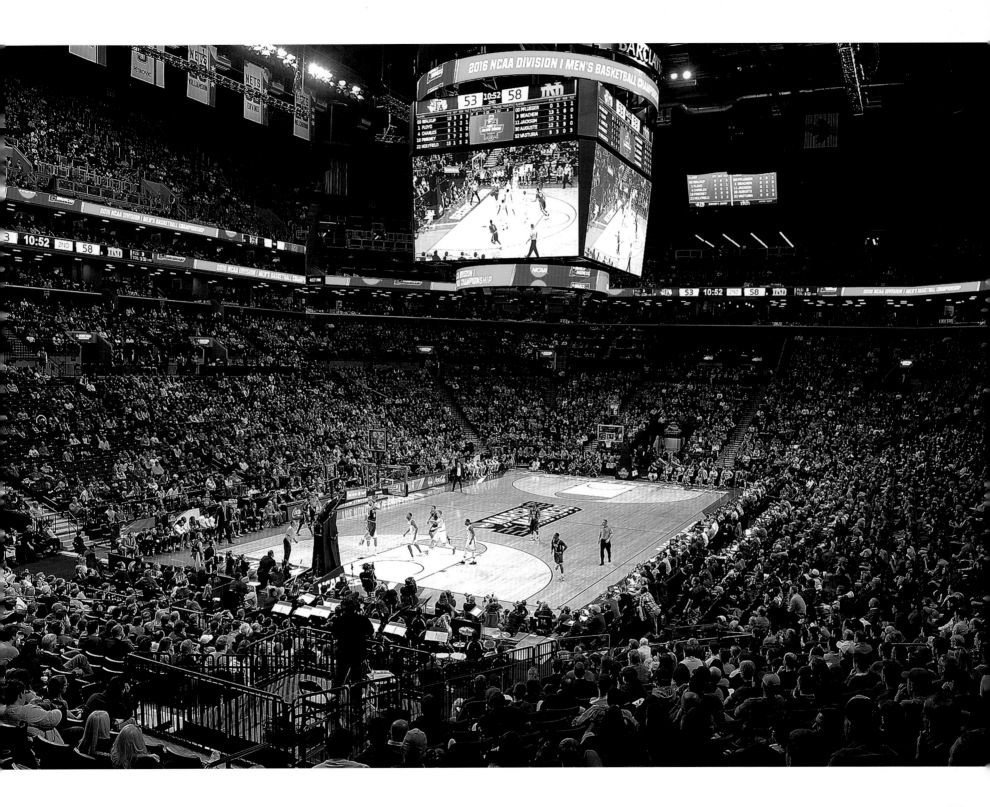

125

Tamale and Corn Bake

3/4 cup finely crushed corn chips
1 large (15.25 ounce) can whole kernel corn,
 drained
1/4 teaspoon salt
2 teaspoons chili powder
1/2 cup chopped ripe olives
1 (17 ounce) can tamales, drained and cut
 into 1-inch pieces
2 cups grated cheddar cheese
3/4 cup crushed corn chips (for topping)
1 (15 ounce) can tomato sauce
picante sauce

Arrange in baking dish step by step as given above.
Bake at 350 degrees for 25 minutes or until bubbly.
Serve with picante sauce.

Mexican Corn Bread

1 1/2 cups corn meal
3/4 cup buttermilk
3/4 cup vegetable oil
2 eggs
1 medium can (15 ounces) cream style corn
1 teaspoon salt
2 tablespoons sugar
3 teaspoons baking powder
3 jalapeño peppers, chopped
1 cup Cheddar cheese, grated

Make batter of all ingredients except cheese; mix
well. Pour half of batter into baking dish; sprinkle
on half of cheese. Add remaining batter and top with
cheese. Bake about 1 hour at 350 degrees.

Frijoles

1 pound dry pinto beans
1 tablespoon olive oil
1/4 pound salt pork, rind removed or 1/4 pound
 sliced bacon, finely chopped
1 cup onion, chopped
1 serrano chili or 1 jalapeno pepper, finely chopped
1 tablespoon finely chopped garlic
6 cups water
1/4 teaspoon cumin seed
2 1/2 teaspoons salt

Soak beans according to package directions; drain.
Heat oil in stock pot or dutch oven over medium-
high heat. Add salt pork; cook 2 minutes, until
browned. Reduce heat to medium; add onions and
chilies and cook 4 minutes. Add garlic and cook 1
minute. Add drained beans, water, and cumin seed.
Bring to a boil; reduce heat to medium-low. Cover and
simmer 30 minutes. Add salt and continue to cook until
beans are tender.

Chicken Enchiladas Verde

*** To speed things up, use a broasted chicken, jarred
verde sauce, and salsa.*

8 bone in chicken breast halves, skinned
2 quarts water
1 tablespon ground cayenne
2 teaspoons salt, divided
23 fresh tomatillos, husks removed
1 medium onion, chopped
2 garlic cloves, minced
1 tablespoon vegetable oil
2 tablespoons fresh cilantro, chopped
2 cups Monterey Jack cheese, divided
1 tablespoon water
10 corn tortillas
1 (4 ounce) package crumbled feta
VERDE SAUCE (RECIPE FOLLOWS)
RED PEPPER SAUCE (RECIPE FOLLOWS)

Bring first 3 ingredients and 1 1/2 teaspoons salt to
a boil in a Dutch oven. Cover, reduce heat, and simmer
30 minutes. Add tomatillos and cook 5 more minutes.
Remove chicken and tomatillos, reserving broth for
Verde Sauce. Bone and shred chicken.

Chop 7 tomatillos, reserving remaining tomatillos
for VERDE SAUCE. Sauté onion and garlic in hot oil in
a Dutch oven over medium-high heat until tender. Add
chopped tomatillos and remaining 1/2 teaspoon salt.
Cook 5 minutes. Add chicken and cook 5 minutes. Stir
in cilantro and 1 cup Monterey Jack cheese. Sprinkle
1 tablespoon water in tortilla package. Microwave on
high for 1 minute. Dip each tortilla in VERDE SAUCE.
Place 1/2 cup chicken mixture down center of each
tortilla; roll up. Place in a lightly greased 13x9 baking
dish; top with remaining sauce, spreading to ends of
tortillas.Sprinkle with remaining Monterey Jack cheese
and feta cheese. Bake covered at 425 degrees for 25
minutes or until heated thoroughly. Serve with RED
PEPPER SAUCE.

VERDE SAUCE

4 pablano chile peppers
16 reserved cooked tomatillos
1 1/2 cups reserved chicken broth, divided
1 sweet onion, chopped
2 cloves garlic, minced
3 romaine lettuce leaves, torn
1/3 cup fresh cilantro, chopped
1 teaspoon salt (more to taste)

Broil pepeprs on foil-lined baking sheet until
blistered, about 5 minutes per side. Place broiled
peppers in Ziploc bag and let rest about 10 minutes.
Peel peppers and remove and discard seeds. Add
peppers, cooked tomatillos, 1 cup chicken broth, and
rest of ingredients to blender or processor and blend
until mixture is smooth. Be sure to scrape down sides.
Pour mixutre into a saucepan and cook over medium
heat 5 minutes. Sirt in remaining 1/2 cup chicken
broth and cook about 10 minutes or until sauce
thickens.

RED PEPPER SAUCE

2 (7 ounce) jars roasted red bell peppers, drained
1/4 teaspoon salt and pepper (more to taste)
1 tablespoon fresh cilantro, chopped

Process all ingredients in blender or food processor
until smooth. Be sure to scrape down sides. Cover and
chill if desired.

Ranch Beans (Crock Pot)

1-2 pounds hamburger
1/2 pound bacon
1 sweet onion, chopped
1 large (53 ounce) can pork and beans
1 can black beans
1 can red kidney beans
1 can cannellini beans
1 teaspoon salt and pepper (or to taste)
1 1/3 cup catsup
1/2 cup brown sugar
1 1/2 teaspoon mustard
1 tablespoon liquid smoke
2 tablespoons vinegar

Fry bacon, remove when crisp. Then brown hamburger and onion. Drain grease and add all ingredients to meat, draining all beans except pork and beans. Cook in crock pot. When it boils, turn on low for approximately 2 hours.

Jambalaya

1 tablespoon vegetable shortening
1 tablespoon all-purpose flour
1/4 pound ham, cubed
1/4 cup chopped green pepper
1 bay leaf
1/2 teaspoon parsley
1/2 teaspoon dried thyme
1 onion, sliced
1 clove garlic, minced
salt and pepper to taste
2 cups tomato juice
1 cup rice, uncooked
1 pound shrimp, peeled

Melt shortening in large heavy saucepan over medium heat. Stir in flour and mix well. Add ham and green pepper. Simmer 5 minutes, stirring constantly. Add bay leaf, parsley, thyme, onion, garlic, salt, pepper, and tomato juice. Bring to a boil. Mix rice into liquid, cover and simmer over low heat for 40 minutes, stirring occasionally. Add shrimp and simmer another 5 minutes.

Lumberjack Stew

1 tablespoon oil
2 cloves garlic, minced
1 cup gluten product (or meat) of your choice
3 cups potatoes, chopped
3 tablespoons Better than Bouillon no-beef base
 (or beef bullion)

1 medium onion, chopped
1 cup celery, diced
2 cups carrots, sliced
6 cups water
1 1/2 cups green beans
1 cup instant mashed potatoes

In a large soup pot, sauté onion in oil until clear, then add garlic, celery, and gluten (or meat of your choice.) When celery is tender, add water, bouillon, carrots, and green beans. Bring to a boil, then turn down low to maintain a slow simmer for 45 minutes. Add potatoes and continue cooking another 15 minutes or until potatoes are tender. Add instant mashed potatoes and cook another 5 minutes, until stew is slightly thickened.

Vanilla Cream Pie

2/3 cup sugar
2 1/2 tablespoons cornstarch
3 egg yolks, slightly beaten
9 inch pastry shell
1/2 teaspoon salt
1 tablespoon flour
3 cups milk
1 tablespoon butter
1 1/2 teaspoon vanilla

Mix sugar, salt, cornstarch, flour, and milk in a saucepan. Stir in 3 cups milk gradually. Cook over moderate heat, stirring constantly, until mixture thickens and boils. Boil 1 minute. Remove from heat. Stir at least 1 cup of the hot mixture slowly into the egg yolks. Blend into hot mixture and boil 1 minute more, stirring constantly. Remove from heat. Blend in butter and vanilla. Cool, stirring occasionally. Pour into a baked pie shell. Chill thoroughly. Top with whipped cream or spread meringue lightly on filling, sealing it onto edges or crust to prevent shrinking. Bake 8-10 minutes at 400 degrees.

BANANA CREAM PIE:
Use Vanilla Cream Pie filling. Arrange a layer of sliced bananas 1/2 inch deep in pie shell before pouring in the filling. Top with whipped cream or meringue and a ring of banana slices
Garnish with whipped cream or NO-WEEP MERINGUE with a ring of banana slices.

Double Chocolate Coca-Cola Cake

1 cup Coca-Cola (real thing, not diet)
1/2 cup oil
1 stick butter
3 tablespoons cocoa
2 cups sugar
2 cups flour
1/2 teaspoon salt
2 eggs
1/2 cup buttermilk
1 teaspoon baking soda
1 teaspoon vanilla

FROSTING:
1 stick butter
3 tablespoons cocoa
6 tablespoons of cream or milk
1 teaspoon vanilla extract
3 3/4 cups confectioner's sugar

In a saucepan, mix Coca-Cola, oil, butter, and cocoa and bring to a boil. In another bowl, combine the sugar, flour, and salt. Pour the boiling Cola mixture over the flour mixture and beat well. Add the eggs, buttermilk, soda, and vanilla and beat well. Pour mixture into a greased and floured 13x9 inch baking pan and bake at 350 degrees for 20-25 minutes. Remove pan and cool before frosting.

No-weep Meringue

1/2 cup water
1 tablespoon cornstarch
1/4 cup sugar
1/2 teaspoon vanilla
pinch of salt
3 egg whites

Combine above ingredients except egg whites and cook over low heat until clear or translucent. Cool. Beat 3 egg whites very stiff; fold in cooled mixture. Spread on pie. Bake in a 350 degree oven until golden brown.

Chocolate Chip Cookie Cheesecake

3 (8 ounce) packages cream cheese, softened
3 eggs
3/4 cup sugar
1 teaspoon vanilla extract
2 (16.5 ounce) rolls refrigerator chocolate chip cookie dough (keep refrigerated until needed)

Preheat oven to 350 degrees. In a large bowl, beat together cream cheese, eggs, sugar, and vanilla extract until well mixed; set aside.
Slice cookie dough rolls into 1/4-inch slices. Arrange slices from one roll on bottom of a greased 9x13 inch glass baking dish; press together so there are no holes in dough. Spoon cream cheese mixture evenly over dough; top with remaining slices of cookie dough.
Bake 45-50 minutes, or until golden and center is slightly firm. Remove from oven, let cool, then refrigerate. Cut into slices when well chilled.
If desired top with ice cream or whipped cream.

Cherry-O-Cream Cheese Pie

1 crumb crust or baked pastry shell
1 (3 ounce) package cream cheese
1/3 cup lemon juice
1 teaspoon vanilla
1 1/3 cup sweetened condensed milk
1 can prepared cherry pie filling

Soften cream cheese to room temperature; whip until fluffy. Gradually add milk while continuing to beat until well blended. Add lemon juice and vanilla; blend well. Pour into crust. Chill 2-3 hours before garnishing top of pie with pie filling.

Flame Cake

2 ounces red food coloring
1 teaspoon white vinegar
1/2 cup shortening
1 teaspoon salt
2 1/4 cup cake flour
1 cup buttermilk
1 teaspoon baking soda
1 1/2 cup sugar
2 eggs
1 teaspoon vanilla
2 teaspoons cocoa

Dissolve the soda in the vinegar and set aside. Cream the sugar, shortening, eggs, salt, and vanilla until fluffy. Add the food coloring. Add the flour, buttermilk, and cocoa. Mix well. Fold in the soda and vinegar mixture. Put in 2 9x9 inch cake pans. Bake 30 minutes at 350 degrees or until inserted toothpick comes out clean.

FROSTING
1 cup milk
1 cup butter
1 cup sugar
3 teaspoons flour
1 teaspoons vanilla

Cook the milk and flour until it coats the spoon. Cream the butter, sugar, and vanilla until fluffy. Add milk mixture, a spoonful at a time. Beat well. Spread between layers and on top of cake. Keep cake in refrigerator.

Heavenly Spice Cake

1 teaspoon cinnamon
1 teaspoon salt
2 cups buttermilk
1 teaspoon vanilla
3 cups flour
1 cup butter
2 1/2 cups sugar
2 eggs, unbeaten
2 tablespoons cocoa
2 teaspoons soda
1 teaspoon cloves

Cream the shortening and 1 1/2 cups sugar. Add eggs, one at a time; beat well after each addition. Mix the rest of the sugar with the cocoa and spices, and add to the mixture alternately with the buttermilk and the flour. Bake in a loaf pan at 350 degrees until an inserted toothpick comes out clean.

Red Velvet Pound Cake

1 (1 ounce) bottle red food color
3 cups cake flour
1/4 teaspoon salt
1 cup milk
I cup butter, softened
1/2 cup shortening
3 cups sugar
7 eggs
2 teaspoons vanilla

Combine butter, shortening, and sugar; cream until light and fluffy. Add eggs, one at a time, beating well after each addition. Stir in vanilla and food coloring. Combine flour and salt and add to creamed mixture, alternating with milk, beating well. Pour into a greased and floured 10 inch tube pan. Bake at 325 degrees for about 1 hour and 20 minutes or until a toothpick inserted in center comes out clean. Cool cake completely. Frost with cream cheese frosting.

CREAM CHEESE FROSTING:
1/2 cup butter
1 teaspoon vanilla
3-4 cups powdered sugar,
1 (8 ounce) package cream cheese, softened
1/2 tablespoon milk

Combine butter and cream cheese, blend until smooth. Stir in vanilla, mixing well. Stir in powdered sugar. Beat frosting until creamy, adding enough milk to make frosting of spreading consistency.

CARROT CAKE

2 cups flour
2 cups sugar
2 teaspoons cinnamon
1/2 teaspoon salt
1 teaspoon baking powder
2 teaspoons soda
1 1/2 cups oil
4 eggs
1 teaspoon vanilla
3 cups grated carrots

Mix all dry ingredients together. Add oil, eggs, vanilla and blend well. Add carrots and mix. Bake in 3 greased and floured (9 inch) pans or a 9x13 inch pan. Bake at 350 degrees for 30 minutes or until done.

FROSTING FOR CAKE:
1 (8 ounce) package cream cheese
1 stick butter
1 teaspoon vanilla
1 box powdered sugar
1 cup chopped pecans

Cream the cheese, butter, and vanilla. Add powdered sugar, mixing until smooth. Stir in pecans. Add a little milk to thin if necessary.

Cream Cheese Braid

DOUGH:

- 1 cup sour cream
- 1/2 cup sugar
- 1 teaspoon salt
- 1/2 cup butter
- 1/2 cup warm water
- 2 envelopes dry yeast
- 2 eggs
- 4 cups bread flour

Scald sour cream in a small saucepan. Remove from heat and stir in sugar, salt, and butter. Stir until butter is melted and let cool until the mixture is lukewarm. Put the warm water in a large, warmed bowl. (I use the bowl to my mixer with the dough hook attached.) Sprinkle in the yeast and stir until the yeast is dissolved. Add the lukewarm sour cream mixture and eggs; mix well. Add flour 1 cup at a time, blending between each addition. This dough will be very sticky. Put into an airtight container with plenty of room for expansion and refrigerate it overnight (or at least 4 to 5 hours). The next day, punch the dough down and divide it into six equal parts. On a floured surface, roll out each part into a rectangle about 8x12 inches. (Work fast since the dough gets very sticky when it warms up.) It is a good idea to leave each of the six parts in the refrigerator until you get ready to work with it. Spread the rectangle with the CREAM CHEESE FILLING. Spread 1/6 of the filling on each rectangle, keeping it away from the edges. Roll up like a jelly roll, beginning on the long sides. Pinch the edges together and fold the ends under slightly. Lay on a greased, aluminum foil-lined cookie sheet. With a sharp knife or scissors, make 6 equally spaced x-shaped cuts across the top of each loaf, about 1/2 inch deep. Cover with a clean cloth and allow to rise until doubled (about an hour). Bake at 350 degrees until light brown. Do not overbake. Spread with SUGAR GLAZE while hot. When the loaves are cooled, wrap to store in aluminum foil. They freeze beautifully. Each roll will yield about a dozen slices.

CREAM CHEESE FILLING:

- 1 pound cream cheese, softened
- 1 well-beaten egg
- 2 teaspoons good-quality vanilla extract
- 3/4 cup sugar
- 1/8 teaspoon salt

SUGAR GLAZE:

- 2 cups powdered sugar
- 2 tablespoons milk
- 2 teaspoons vanilla

***Recipe Note: This is absolutely my most famous recipe. I have made this every Christmas for more than 30 years, and everyone always wants the recipe. It's not hard to make, even though it takes planning ahead since you have to let the dough rise.*

Chocolate Chip Cookies

- 1 cup butter (2 sticks)
- 1 cup shortening
- 1 1/2 cups sugar
- 1 1/2 cups brown sugar

*** Cream together, then add:*
- 3 eggs
- 3 teaspoons vanilla

*** Mix well, then add:*
- 4 1/2 cups flour
- 6 teaspoons baking powder
- 1 1/2 teaspoons baking soda
- 1 teaspoon salt

*** Mix well, then add:*
- 1 (12 ounce) package chocolate chips (semi-sweet or milk chocolate)
- 1 1/2 cups chopped nuts (optional)

Drop by rounded teaspoon on baking sheet. Bake at 375 degrees for 8-10 minutes.

SPRING

Tex-Mex Mac and Cheese

2 poblano peppers
2 ears fresh corn, husks removed
8 ounces uncooked rotini or fusilli pasta
1/2 cup chopped cooked Mexican-style chorizo
3 tablespoons butter
3 tablespoons all-purpose flour
3 cups milk
3 cups (12 ounce) shredded pepper jack cheese
1 1/2 teaspoons salt
1/2 teaspoon freshly ground pepper
1 cup crushed tortilla chips
3 tablespoons melted butter

Broil peppers and corn at the same time on an foil-lined jelly-roll pan. Broil peppers 10 minutes or until blistered, turning after 5 minutes. Broil corn 20 minutes or until charred, turning every 5 minutes. Place peppers in a zip-top plastic freezer bag; seal and let stand 10 minutes. Peel peppers; remove and discard seeds. Chop peppers. Cut corn kernels from cobs. Reduce oven temperature to 400 degrees. Cook pasta according to package directions until al dente. Drain.

Cook chorizo in LARGE skillet over medium heat, stirring often until crisp; remove chorizo and drain on paper towels. Discard drippings. Using the same LARGE skillet, melt 3 tablespoons butter over medium heat; stir in flour until smooth and cook, stirring constantly until golden brown, about 2 minutes. Slowly add milk and cook, stirring often until thickened, about 10-12 minutes. Remove from heat, and gradually add cheese, stirring until smooth. Add chopped peppers, corn kernels, chorizo, salt, and pepper. In a large bowl, gently stir together cheese mixture and pasta. Spoon into large baking dish or disposable foil baking pan.

Combine tortilla chips and 3 tablespoons melted butter and sprinkle over pasta. Bake at 400 degrees for 12 to 15 minutes or until golden and bubbly. Let stand 5 minutes before serving.

Curried Chicken Salad

4 cups finely chopped cooked chicken
3 (8 ounce) packages cream cheese, softened
3/4 cup golden raisins
1/2 cup coconut, toasted
1 cup medium-diced celery
6 green onions, minced
1 (2.25 ounce) package slivered almonds, toasted
1 1/2 tablespoons curry powder
1/2 teaspoon salt
1/2 teaspoon black pepper
1 tablespoon ginger

In a large bowl, combine all ingredients and chill for 8 hours. Serve with your favorite crackers.

Broccoli and Cauliflower Salad

1 cup mayonnaise
2 tablespoons white wine vinegar
1 garlic clove, pressed
1 tablespoon sugar
1/4 cup sunflower seeds
1/2 sweet onion, finely chopped
1 cucumber, peeled and thinly sliced
1/2 cup raisins
1 bunch broccoli, cut into florets
1 small head cauliflower, cut into florets
1 can (8 ounces) sliced water chestnuts, drained
2/3 cup slivered almonds, toasted

Whisk together first 4 ingredients. Add remaining ingredients, tossing well. Add salt and pepper to taste. Chill 4 hours and serve.

Spicy Southwest Potato Salad

1 1/2 cups mayonnaise
1/4 cup sweet chili ranch salad dressing
2 tablespoons fresh lime juice
2 tablespoons chipotle pepper puree
1 large ripe tomato, seeded and diced
1/2 cup chopped cilantro leaves
3 green onions, chopped, white and green parts
1 medium red onion, thinly sliced
1 pound of bacon, fried and crumbled
1/4 teaspoon cayenne
3 cloves garlic, finely chopped
salt and pepper
14-16 new potatoes, cooked and cubed

In a large bowl, combine all ingredients except the potatoes and mix well. Place potatoes in a large bowl. Pour dressing mixture over potatoes and mix well. Add salt and pepper to taste.

Chopped Corn Salad

3 cups iceberg lettuce, chopped
2 (8-3/4 ounce) cans whole kernel corn, drained
1 (15 ounce) can whole black beans, drained, rinsed
1 (10 ounce) can RoTel
2 tablespoons olive oil
1 cup shredded sharp Cheddar cheese

Toss together all ingredients in large bowl until combined. Add your favorite shredded cheese to make this salad more hearty.

Wooden Bowl Salad

1/2 head lettuce, shredded
1 cup water chestnuts, thinly sliced
2 1/2 cups cooked, diced chicken
1 cup celery, chopped
1/2 cup green pepper, chopped
1/2 red onion, minced
1 package (10 ounce) frozen peas, uncooked
1 pint mayonnaise
3 tablespoons sugar
6 ounces (1 1/2 cups) Cheddar cheese, grated
8 slices crisp bacon, crumbled
3 hard-cooked eggs, sliced

Layer in large bowl lettuce, water chestnuts, and chicken. Mix other vegetables and spread as next layer. Over entire salad, spread mayonnaise and sprinkle with 3 tablespoons of sugar, completely covering all the vegetables. Cover (sealing edges) and refrigerate 8 hours. Before serving, top with cheese, bacon, and sliced eggs.

Apricot Salad
Serves 12

2/3 cup water, boiling
2/3 cup sugar
2 (3 ounce) packages apricot Jell-O
1 (8 ounce) package cream cheese, softened
2 (4 1/2 ounce) jars apricot baby food
1 (20 ounce) can crushed pineapple, with juice
1 (14 ounce) can sweetened condensed milk
l 1/2 cups chopped pecans

Dissolve Jell-O in hot water. Add baby food and pineapple. Cool; add rest of ingredients. Refrigerate until firm; cut in squares.

Blueberry Salad

1 package (6 ounce) blackberry Jell-O
8 ounces sour cream
6 ounces cream cheese, softened
1 cup boiling water
1 cup cold water
1/2 cup sugar
1 can (21 ounce) blueberry pie filling mix
1/2 teaspoon vanilla
1/2 cup chopped pecans
1 can (8 ounce) crushed pineapple, drained

Dissolve Jell-O in 1 cup hot water. Add 1 cup cold water. Add pie filling mix and drained pineapple. Pour into 13x9 inch dish and refrigerate until firm. Mix sour cream, cream cheese, and sugar until well blended. Add vanilla and nuts. Spread over top of set Jell-O and chill until ready to serve.

Buttermilk Salad

1 (20 ounce) can crushed pineapple, undrained
1 (6 ounce) package lemon gelatin
2 cups buttermilk
2 cups chopped pecans
1 (12 ounce) container frozen whipped topping, thawed

Mix together pineapple and gelatin; heat until gelatin is dissolved. Cool. Add buttermilk and pecans. Fold in whipped topping. Pour into 13x9 inch (or any oblong) casserole dish and chill.

Black Cherry Fruit Salad

Serves 10

2 envelopes unflavored gelatin
1/2 can (16 ounce) black cherries, drained; reserve juice
1 can (16 ounce) fruit salad, drained
1/2 cup sliced blanched almonds
1/2 cup mayonnaise
1 cup whipping cream
mayonnaise (optional) for topping

Soak gelatin in enough black cherry juice to dissolve. Bring remainder of cherry juice to a boil, let cool, then add soaked gelatin. Add fruit, almonds, and mayonnaise. Fold in whipping cream and pour in mold. Allow to congeal. Serve with additional mayonnaise on top.

Pretzel Congealed Salad

1 (10 ounce) box regular sized pretzels
1 1/4 sticks butter
8 ounces frozen whipped topping
3 ounces cream cheese
1 cup sugar

FIRST LAYER:
1 (6 ounce) package strawberry-banana Jell-O
2 cups boiling water
2 (10 ounce) packages frozen strawberries, partially thawed
Break pretzels into nut-sized pieces to cover bottom of 9x13 inch baking dish. Mix with melted margarine. Bake at 350 degrees for 10 minutes. Stir after 1-2 minutes of baking. Let cool.
SECOND LAYER:
Mix whipped topping, cream cheese, and sugar. Spread over cooled first layer. Be careful to cover the entire surface and "seal" the edges.
THIRD LAYER:
Mix Jell-O with boiling water. Add strawberries.
Pour over second layer and chill until set. This is an easy, delicious salad that is sure to be a hit every time.

Easy Fruit Salad

1 (21 ounce) can peach pie filling
1 (20 ounce) can pineapple chunks, drained
1 (11 ounce) can mandarin oranges, drained
1 banana, sliced
fresh or frozen strawberries (optional)

Mix fruits together and chill before serving.

Spring Green Salad

1 (5 ounce) bag mixed spring salad greens
2 ounces blue cheese, crumbled
1 orange, peeled and sectioned
1/2 red onion, thinly sliced
1 green pepper, thinly sliced
1/2 pint fresh strawberries, quartered
SWEET-AND-SPICY PECANS
SHAKEN BALSAMIC VINAIGRETTE

In a large bowl, combine first 5 ingredients. Drizzle with 1/2 cup Balsamic Vinaigrette. Toss to coat. Serve with remaining vinaigrette.

SWEET-AND-SPICY PECANS
1/4 cup sugar
1 cup warm water
1 cup pecan halves
2 tablespoons sugar
1 tablespoon chili powder
1/4 teaspoon cayenne pepper

Stir together sugar and warm water until sugar dissolves. Add pecans; soak 10 minutes. Drain; discard liquid.
Combine 2 tablespoons sugar, chili powder, and cayenne. Add pecans; toss to coat. Place pecans in a single layer on a lightly greased baking sheet. Bake at 350 degrees for 10 minutes or until pecans are lightly toasted, stirring once.

SHAKEN BALSAMIC VINAIGRETTE
1/4 cup balsamic vinegar
2 tablespoons dark brown sugar
1 garlic clove, minced
2 tablespoons sweet onion, finely chopped
1/4 teaspoon salt (more to taste)
1/4 teaspoon pepper (more to taste)
3/4 cup olive oil

Combine all ingredients in jar. Cover and shake until blended.

Lentil Vegetable Soup

Serves 6

2 small onions, finely chopped
2 carrots, finely chopped
6 small white potatoes, finely chopped
1 (16-ounce) bag brown lentils
1 (15.5-ounce) can fire roasted tomatoes, diced
8 cups vegetable broth or water
1-2 cups finely chopped spinach
salt and pepper to taste

This lentil vegetable soup is a favorite of my boys and so easy to make. I think one of the reasons they like it is because I chop all of the vegetables really small. And, like most of the soups I make, if you don't have an ingredient, such as carrot or spinach, leave it out or substitute another favorite ingredient.
Combine all ingredients, except the spinach, and cook on low for 2 hours. Add the spinach about 5 minutes before the soup is done. Season to taste with salt and pepper.

Potato Salad

Serves 8

6 large new potatoes
2 hard cooked eggs, chopped
1/2 cup celery, diced
1/4 cup onion, diced
2 tablespoons sweet pickle relish
1/2 cup bell pepper, diced
2 tablespoons parsley, chopped
1 1/2 tablespoon mustard
3 tablespoons salad oil
1 tablespoon Worcestershire sauce
1 tablespoon seasoning salt
mayonnaise to desired moistness
aalt and pepper to taste

Boil potatoes with skins on until tender; cut into cubes. Mix all ingredients while potatoes and eggs are still warm. Refrigerate until chilled.

Tri-color Pasta Salad

1 pound package of tri-color rotini pasta
1/2 of a medium red onion, chopped
1 stalk of celery, chopped
1/2 green bell pepper, chopped
1/2 red bell pepper, chopped
1 can of pitted black olives, sliced
1 cup Italian dressing
1 tomato, seeded and chopped
Parmesan cheese, to garnish

Boil the pasta al dente according to package directions. Drain and rinse well. To the drained pasta, add all of the chopped vegetables, except the tomatoes. Stir in the Italian dressing and mix well. Cover and refrigerate 6 hours or overnight. Just before serving, add the chopped tomato, toss, and sprinkle the top with Parmesan cheese and crumbled bacon. Store leftovers in the fridge.

French Country Bread

SPONGE

 1 cup water, preferably spring water
 1/2 teaspoon dry yeast
 1 1/4 cups unbleached bread flour
 2 tablespoons whole-wheat flour
 2 tablespoons rye flour

The night before or up to 16 hours before:
 In a small bowl, stir together the water and yeast and let dissolve by briskly whisking.
 With a whisk then switching to a medium wooden spoon, stir in bread flour, whole wheat flour, and rye flour to make a thick mixture.
 Cover bowl lightly with plastic wrap (leaving a small air space) and let stand 8-16 hours at room temperature.

DOUGH

 All of sponge
 1 cup water, preferably spring water
 2 1/2 teaspoons salt
 1 tablespoon sugar
 1/2 teaspoon yeast
 3 3/4 - 4 cups unbleached bread flour

Stir down the sponge. Add remaining ingredients holding back about 1/2 cup of the flour to add when kneading. Knead until dough is smooth and resilient. Shape dough into a ball and place in a lightly greased bowl. Cover lightly and let rise about 45 minutes.
 Gently deflate dough and form into two balls (three if smaller loaves desired). Gently place dough, seam side down, on doubled-up baking sheets. The top sheet should be lined with parchment paper. Spray dough lightly with a non-stick vegetable spray, cover lightly, and let rise until approximately 50 percent larger.
 Preheat oven to 475 degrees. Slash top of loaf only about 1/4 inch deep with a sharp knife, spray with water, and dust with flour.
 Spray water into oven, place sheets on lowest rack of oven, spray oven with water every five minutes or so. After 15 minutes at 475 degrees (13 minutes for three smaller loaves), reduce heat to 425 degrees and bake an additional 15 minutes (13 minutes for three smaller loaves). Cover bread in oven with foil if tops are getting too browned.
 Remove from oven when loaves sound hollow when tapped on bottom. Cool well on wire rack before slicing.

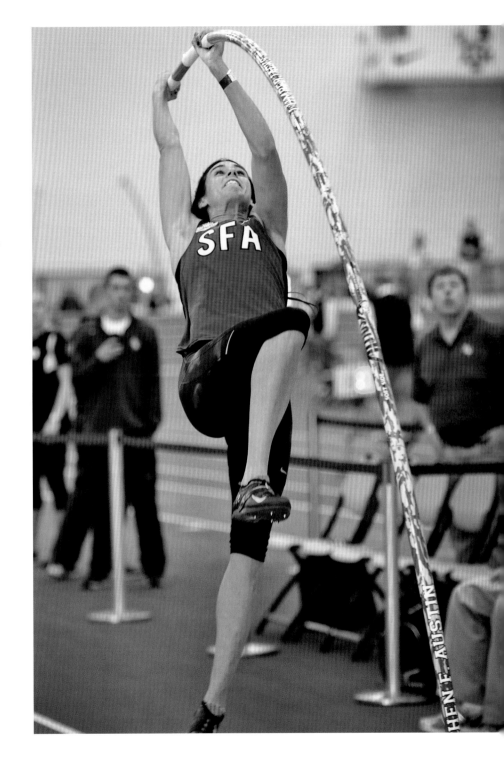

Country Style Pork Ribs

1 cup brown sugar
1 can Dr. Pepper
1 can (5 ounces) chipotle peppers packed in adobo
1/4 cup brown mustard
1 tablespoon white vinegar
3 cloves garlic, minced
1 teaspoon salt
1/4 teaspoon cayenne pepper (more to taste)
2 pounds pork loin country style ribs

In a medium saucepan, combine the first 6 ingredients and bring to a boil. Reduce heat and simmer until sauce is reduced and thick, about 20 minutes. Allow to cool completely. Divide into two containers and refrigerate one container for later.

Place ribs in a large baking dish, lined with heavy foil. Brush half the marinade over ribs, coating both sides. Cover with foil and refrigerate for 8 hours.

Preheat the oven to 275 degrees. Place the pan, still covered in foil, into the oven for 2 hours. Remove the foil and increase the temperature to 300 degrees. Using the other half of the sauce, brush another generous layer all over the ribs. Return the pan to the oven and continue cooking for another 30 to 40 minutes, brushing on another layer of sauce as it cooks. Remove the ribs when they are easily pulled apart with a fork.

Apple Baked Beans

3 to 4 slices bacon, diced
1 medium onion, diced
1/2 green pepper, diced
1 (16 ounce) can Bush's Original Maple Baked Beans
1 (16 ounce) can Campbell's Pork and Beans
1/2 cup Blues Hog Barbecue Sauce (or of choice)
1 pound crumbled pork sausage, cooked and drained
1 (21 ounces) can apple pie filling, chunked
1/2 cup brown sugar, firmly packed
2 tablespoons Worcestershire sauce
2 tablespoons prepared mustard
1 teaspoon chipotle or cayenne powder (optional)
1 teaspoon Blues Hog Barbecue Rub (or of choice)

Brown bacon and remove from skillet, leaving the rendered grease. Sauté onion and green pepper in the remaining bacon grease. Put bacon, onion, and green pepper in a large mixing bowl. Mix in all the remaining ingredients. Pour into a greased 9x13x2 inch baking dish. Bake uncovered at 325 degrees for 1 hour.

"These are without a doubt the best baked beans in the history of the free world. People have been known to kill for this recipe." This is a quote from the friend who gave me the recipe, Pat Spence, former SFA director of student publications. I couldn't agree more! I order the Blues Hog ingredients online; but, if you have a favorite rub and sauce, it will probably do almost as well.

Baked Sweet Onions

6 tablespoons butter, divided
1 small jar diced pimentos, drained
3/4 cup saltine, finely crushed
2 cups sweet onions, chopped
8 ounces Swiss cheese, shredded
2 eggs

Melt 4 tablespoons butter in a skillet. Add the onions and sauté until golden brown, 15-20 minutes. Layer half of the onions in an 8x8 lightly greased baking dish. Sprinkle with half of the cheese and pimentos and 1/4 cup cracker crumbs. Top with remaining onions, pimentos, and cheese. Whisk eggs and next 4 ingredients and pour over onion mixture. Melt remaining butter (2 tablespoons), and add the remaining 1/2 cup cracker crumbs. Cook over medium heat, stirring often, until crumbs are lightly browned. Sprinkle crumbs evenly over the onion mixture and bake at 350 degrees until lightly browned and set, about 20-25 minutes.

Crockpot Orange Chicken

2 large carrots, peeled and sliced 1/2-inch thick
2 large red or green bell peppers, cut into chunks
3 cloves garlic, finely minced
4 boneless skinless chicken breasts
2 teaspoons ground ginger
1 teaspoon salt
1/2 teaspoon pepper
8 ounces orange juice concentrate
2 cups Mandarin or fresh orange segments
2 green onions, chopped
hot cooked rice

Put carrots, peppers, garlic, chicken, ginger, salt, pepper and frozen orange juice in crockpot. Cover and cook on LOW 4-6 hours. Serve chicken on hot cooked rice on platter. Top with orange segments and green onions. Serve chicken liquid in gravy boat, if desired.

Butter and Lemon Shrimp

1/2 pound shrimp that has been shelled and
 deveined (can be frozen or fresh)
1 1/2 sticks of butter
1 lemon, sliced thin
1/2 package of dry Italian seasoning packet

Preheat oven to 350 degrees. Line cookie sheets and sides with foil. Melt butter in oven on lined cookie sheet. Place lemon slices on melted butter. Lay shrimp on top of butter and lemons. Sprinkle the dry Italian dressing mix on top of shrimp. Bake at 350 degrees for 15 minutes, until light golden brown.

This is great alone or served on pasta or rice, using melted butter/lemon juice drizzled on top. It is hard to say how many shrimp to use since shrimp come in different weights and sizes. Just use your own judgment. I use a medium shrimp, and I can lay around 36 on a cookie sheet.

Pepper Steak Supreme

1 (16 ounce) can drained bean sprouts
1 medium sweet onion, thinly sliced
2 medium sized tomatoes, cut into wedges
2 teaspoon cornstarch
2 tablespoons sugar
1 pound tenderloin tips or sirloin, cut into chunks
3 tablespoons oil
1 teaspoon salt
1 teaspoon pepper
1/2 teaspoon ginger
1/4 cup soy sauce
1-2 green peppers, cut in squares

Slice the steak into 1/2-inch thick slices across the grain. In a bowl, blend the soy sauce, sugar, cornstarch, and ginger in a bowl until the sugar has dissolved and the mixture is smooth.

Place the steak slices into the marinade, and stir until well-coated. Heat 1 tablespoon of vegetable oil in a large skillet over medium-high heat, and place 1/3 of the steak strips into the hot oil. Cook and stir until the beef is well-browned, about 3 minutes, and remove the beef from the skillet to a bowl. Repeat twice more, with the remaining beef, and set the cooked beef aside.

Return all cooked beef to the skillet and stir in the salt, pepper, and onion. Sauté the beef and onion together until the onion becomes tender, about 2 minutes. Add green pepper. Cook and stir the mixture until the pepper becomes tender, about 2 minutes. Add the tomatoes and stir everything together. Serve over rice.

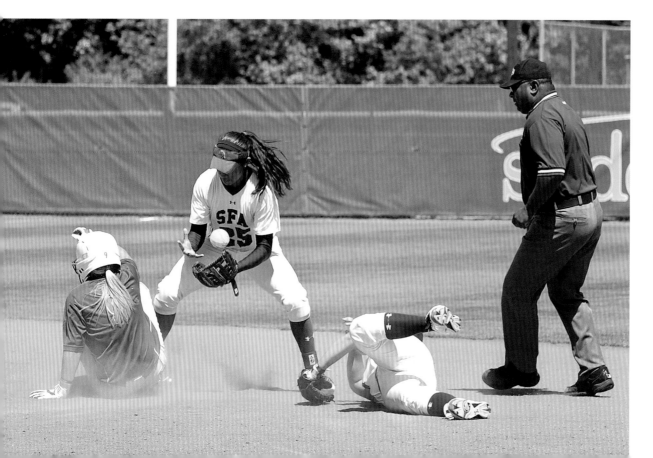

Salisbury Steak

2 tablespoons canola oil
1 medium onion, chopped
1 1/2 pounds 80/20 ground beef
1 cup seasoned bread crumbs
1 tablespoon dry mustard
1 tablespoon seasoned salt
1 tablespoon Worcestershire sauce
1 large egg
1/2 (8 ounce) package sliced baby
 portobello mushrooms
salt and black pepper
1/4 cup all-purpose flour
2 (14 ounce) cans beef broth

In a large skillet, sauté onion in 1 tablespoon of the oil until soft, about 6 minutes. Put 1/2 of the onion in a large bowl; add the beef, bread crumbs, grill seasoning, Worcestershire sauce, and egg. Mix well and form into 5 patties. Heat the remaining tablespoon of oil in the same skillet over medium-high heat. Cook the patties until well browned, about 4-5 minutes on each side. Remove the steaks and discard all but 2 tablespoons of the grease. (The patties will not be cooked through and will finish cooking in the gravy.)

Return pan to heat. Add the mushrooms and cook 5 minutes, stirring occasionally. Add remaining onions. Sprinkle in the flour and cook for 2 minutes. Add the beef broth and bring to a boil. Return the patties to the pan. Reduce heat and simmer, cooking until the sauce has thickened, and the steaks are cooked through, about 10 minutes.

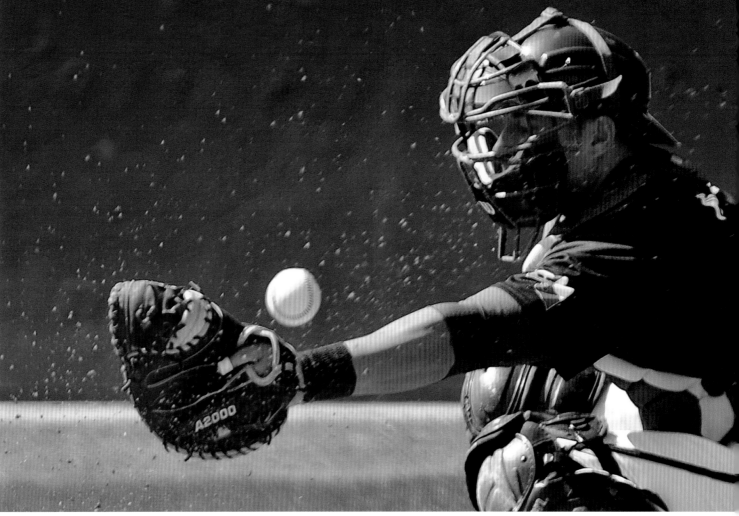

Cheesy Gold Potatoes

5 pounds Yukon Gold Potatoes
1 1/2 sticks Butter
1 package (8 ounces) cream cheese, softened
1/2 cup (to 3/4 cups) half-and-half
1 teaspoon seasoned salt
1 teaspoon black pepper
1 cup shredded Cheddar cheese (optional)

Bring a large pot of water to a simmer and add peeled and chunked potatoes. Bring to a boil and cook for 30-35 minutes or until fork slides in easily. Drain potatoes and mash. Add butter, cream cheese, 1/2 cup half and half, seasoned salt, and pepper. Mash well. You may have to add more half and half. After mashing, pour potatoes into baking dish and top with shredded cheese (optional). Bake at 350 degrees until cheese melts and potatoes are warmed.

Fresh Strawberry Pie

Graham cracker crust or baked pie shell
1 cup water
1 cup sugar
7 teaspoons cornstarch
1 box strawberry Jell-O
1 pint fresh strawberries, no sugar added or no sugar
 added frozen strawberries
red food coloring (optional)

Mix Jell-O and cornstarch together well; add sugar and then water. Bring to a boil, cook 1 minute; cool and then add strawberries. Refrigerate until set. Top with Cool Whip.

Snickerdoodles

1 cup butter
1 1/2 cups sugar
2 large eggs
2 3/4 cups flour
2 teaspoons cream of tartar
1 teaspoon baking soda
1/4 teaspoon salt
3 tablespoons sugar
3 teaspoons cinnamon

Preheat oven to 350 degrees.

Beat together butter, sugar, and eggs in a large bowl until light and fluffy. Combine flour, cream of tartar, soda, and salt in a separate bowl. Slowly add flour mixture into butter mixture. Chill dough for about 30 minutes. In a small bowl, combine 4 tablespoons of sugar and 4 tablespoons of cinnamon. Roll dough into 1 inch balls and coat in sugar mixture. Place on ungreased cookie sheet and flatten gently with your hand. Bake for ten minutes or until bottom of cookies are slightly browned.

Ruth Ivy's Sheet Cake

1/2 cup buttermilk
2 eggs
1 teaspoon vanilla
1 teaspoon baking soda
2 cups flour
2 cups granulated sugar
1 1/2 teaspoon cinnamon
1/2 teaspoon salt
1 stick butter
1/2 cup Crisco
6 tablespoons cocoa
1 cup water

In a mixing bowl combine buttermilk, eggs, vanilla, and baking soda. Whisk until smooth and set aside.

In a large mixing bowl, sift together flour, sugar, cinnamon, and salt. Set aside.

In a saucepan combine 1 stick unsalted butter, 1/2 cup vegetable shortening, 6 tablespoons cocoa, and 1 cup water. Bring to a boil.

Pour hot mixture over flour mixture and stir vigorously with a wooden spoon. Add buttermilk mixture and stir to thoroughly incorporate.

Pour batter in buttered and floured half-sheet-cake pan (about 15x10 inches) and bake at 400 degrees for 20 minutes or until edges of cake pull away from the pan and the cake springs back when you touch it.

ICING
1 stick butter
6 tablespoons buttermilk
6 tablespoons cocoa
1 teaspoon vanilla
4 cups powdered sugar
1 cup pecans, chopped

About 10 minutes before the cake is done, bring to a boil 1 stick unsalted butter, 6 tablespoons buttermilk, and 6 tablespoons cocoa. Quickly remove from heat and add 1 teaspoon vanilla and 4 cups powdered sugar; beat with an electric mixer until smooth. Stir in 1 cup pecan pieces. Can thin icing with milk if needed.

Lemon Ricotta Bars

THE CRUST
 1 3/4 cups unbleached all-purpose flour
 2/3 cup confectioners' sugar
 1/4 cup cornstarch
 1 tablespoon lemon zest
 3/4 teaspoon salt
 12 tablespoons unsalted butter (1 1/2 sticks), cut into 1 inch pieces, slightly softened plus extra for greasing pan

Put oven rack in middle position. Preheat oven to 350 degrees. Lightly butter a 13x9 inch baking dish and line with one sheet parchment paper. Butter paper, then lay second sheet crosswise over it.

Mix flour, confectioner's sugar, cornstarch, lemon zest, and salt in food processor. Add butter and blend until mixture is pale yellow and resembles coarse meal. (You can also do this by hand.)

Sprinkle mixture into lined pan and press firmly into pan bottom and about 1/2-inch up sides. Refrigerate for 30 minutes and then bake until light golden brown, about 20 minutes.

LEMON-RICOTTA FILLING
 8 ounces (1 cup) fresh whole milk ricotta, drained
 4 large eggs, beaten
 1 1/3 cups granulated sugar
 3 tablespoons unbleached all-purpose flour
 2 1/2 tablespoons lemon zest
 2/3 cup lemon juice (3-4 lemons), strained
 1/4 teaspoon salt

Whisk ricotta, eggs, sugar, and flour in medium bowl, then stir in lemon zest, juice, and salt to blend well. Reduce oven temperature to 325 degrees.

Stir filling once more before pouring into warm crust. Bake until filling feels firm when touched lightly, about 30 minutes. Transfer pan to wire rack; cool to room temperature, at least 2 hours. Transfer to cutting board, fold paper down, and cut into bars, cleaning knife or pizza cutter between cuts. Dust with powdered sugar.

Mud Pie

 1 1/2 cups margarine
 2 cups flour
 2 cups nuts, chopped
FIRST LAYER
 1 pound confectioners' sugar
 1 (12 ounce) container Cool Whip, divided
 12 ounces cream cheese, softened
SECOND LAYER
 1 (6 ounce) box instant chocolate pudding mix
 1 (3 1/2 ounce) box instant vanilla pudding
 5 1/2 cups milk
 chocolate, shaved

Combine margarine, flour, and nuts; pat into a 13x9 inch pan. Bake at 350 degrees 15-20 minutes until lightly browned.
FIRST LAYER:
 Blend confectioners' sugar, Cool Whip, and cream cheese until smooth. Spread over cooled crust.
SECOND LAYER:
 Beat instant chocolate pudding, instant vanilla pudding, and milk until thickened. Carefully spread over first layer. Cool until set in refrigerator. Top with remaining Cool Whip. Sprinkle shaved chocolate on top for decoration.

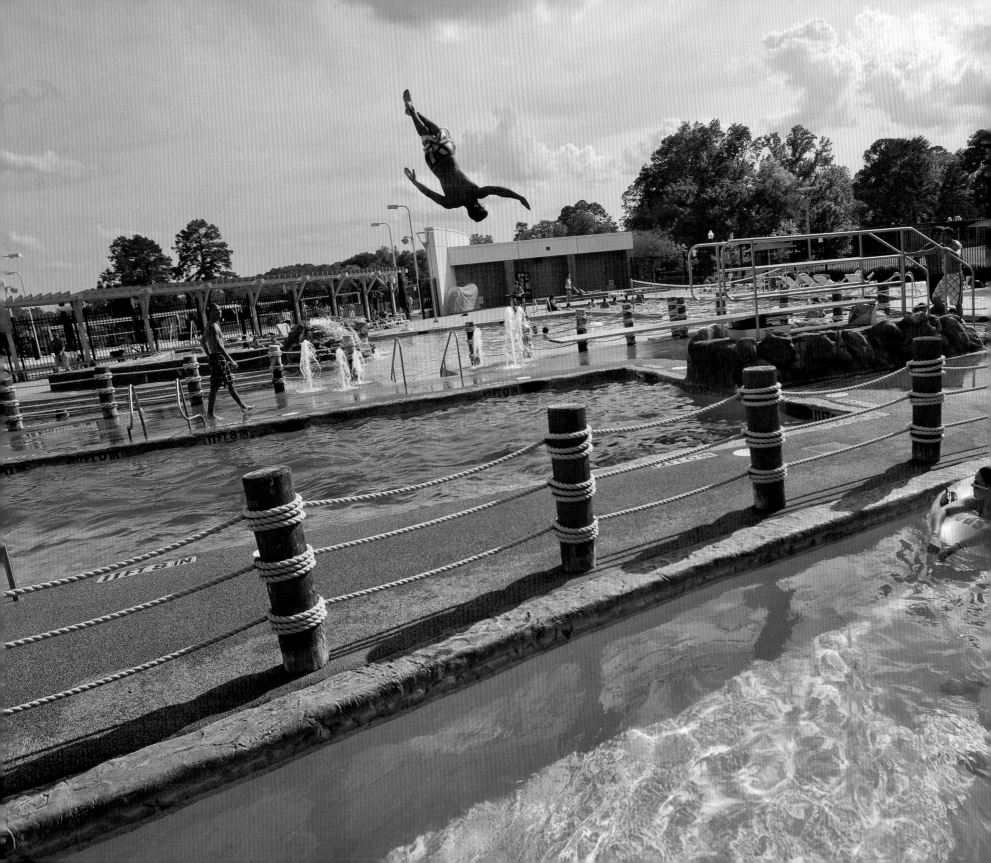

SUMMER

Grilled Flank Steak

1/2 cup soy sauce
1/2 cup olive oil
5 tablespoons honey
4 garlic cloves, minced
1 tablespoon dried rosemary
1/4 teaspoon cayenne pepper
2 tablespoons ground black pepper
1 1/2 teaspoons salt
2 pounds flank steak

Combine all ingredients except steak in 13x9 baking dish. Add steak to marinade and coat generously. Cover and refrigerate 2-4 hours.

Light grill to medium high heat. Grill steaks 4-5 minutes on each side for medium rare. Do not overcook.

Olive Salad

Good with small toasted pieces of sour dough bread as a condiment.

1 cup pimento stuffed green olives, chopped
3 celery hearts with leaves, diced
1 teaspoon good quality red wine vinegar
1 tablespoon extra virgin olive oil
4 fresh garlic cloves, minced

Combine all in small bowl and cover and refrigerate overnight, stirring occasionally. Serve at room temperature.

Fried Strawberry Pies

2 cups fresh strawberries, mashed
3/4 cup sugar
1/4 cup cornstarch
1 package refrigerated pie crusts
vegetable oil
powdered sugar

In a saucepan over medium heat, combine first 3 ingredients in a saucepan and bring to a boil, stirring constantly. Boil for 1 minute or until thickened. Cool completely.

Roll 1 pie crust on lightly flowered surface. Using a 3 inch cookie cutter, cut crust into circles and roll each to 3 1/2 inches. Lightly moisten the edges of the circles with water so dough will stick together. Place 2 teaspoons of strawberry filling in the center of the circles and fold circles in half, pressing edges together, so filling won't leak out. Place pies on a baking sheet and freeze at least 1 hour.

In a large skillet add enough vegetable oil to be at least 1 inch deep. Heat oil to 350 degrees. Fry pies about a minute on each side or until lightly browned. Drain pies on paper towels and dust with powdered sugar.

Taco Salad

8-10 cups romaine or iceberg lettuce, chopped
1 pound lean ground beef
1 packet taco seasoning mix
1/3 cup picante sauce (I use Old El Paso)
1 can red, black or pinto beans, drained
1 cup corn
1/2 cup sliced black olives
1 cup diced tomatoes
4 green onions, sliced
2 cups grated sharp Cheddar cheese
1 bag Fritos corn chips
Catalina dressing (to taste)

Brown the ground beef; add the taco seasoning to beef and mix well (drain if needed). Add picante sauce in towards the end. Remove from heat and add beans and corn to the meat; mix well.

In a large bowl, mix everything together, adding the the Fritos and dressing last. Combine well to make sure everything is coated. Serve immediately.

Rees' Family Jell-O Salad

Jell-O salads are sort of like that uncle that shows up to reunions still wearing polyester pantsuits. You love him, but you are sort of embarrassed to be seen next to him. This Jell-O salad recipe is at least 80 years old, and is served at every Thanksgiving in our family.

2 large boxes black cherry gelatin or 4 small boxes
2 cans black cherries (pitted) juice reserved
1 box cream cheese
1/4 cup pecan pieces (optional)
1/2 cup mayonnaise (optional)

Stuff black cherries with cream cheese, reserving juice in a measuring cup. Prepare gelatin as directed on boxes using boiling water. Use a 9x13 inch glass casserole dish. As the directions for gelatin call for cold water, use cherry juice plus cold water to make correct amount called for. Once gelatin is dissolved in boiling water, add cherry juice and cold water. Gelatin will begin to set. Add cream cheese stuffed cherries and pecans if desired. Place in refrigerator to cool at least 4 hours. Serve with mayonnaise if desired.

Strawberry Spinach Salad

2 tablespoons sesame seeds
1/4 cup white sugar
1/2 cup olive oil
1/4 cup balsamic vinegar
1/2 teaspoon paprika
1/4 teaspoon Worcestershire sauce
2 tablespoons onion, minced
10 ounces fresh spinach, rinsed and torn into
 bite-size pieces
1 quart strawberries, cleaned and sliced
1 container blue cheese
fried and crumbled bacon
1/4 red onion thinly sliced
1/4 cup slivered almonds

In a medium bowl, whisk together the sesame seeds, sugar, olive oil, vinegar, paprika, Worcestershire sauce, and onion. Cover and chill.

In a large bowl, combine the spinach, strawberries, onions, bleu cheese, bacon, and almonds. Pour dressing over salad, and toss. Refrigerate before serving.

Mandarin Orange Salad

Combine the salad ingredients in a bowl:
1 bag fresh spinach
1 bunch red leaf lettuce, washed and chopped
2 avocados, sliced
1 (21 ounce) can Mandarin oranges, reserve syrup
1 red onion, sliced
1 cucumber, peeled and sliced
1/3 slivered almonds
1/3 cup crispy chow mein noodles

DRESSING:
1/2 cup olive oil
4 tablespoons white wine vinegar
4 tablespoons syrup from Mandarin oranges
2 tablespoons soy sauce
3 teaspoons sugar
1 teaspoon sesame oil
1/2 teaspoon crushed red pepper.

Combine all ingredients in a small jar and shake until well mixed.

Strawberry Lime Salad

1/3 cup extra-virgin olive oil
3 teaspoons lime zest
3 tablespoons lime juice
4 tablespoons honey
sea salt
ground black pepper
1 head romaine lettuce, torn
2 chicken breasts, grilled and sliced
2 cups sliced strawberries
4 ounces feta cheese, crumbled
1 cup frozen peas, thawed
1 avocado, sliced
1/2 cup red onion, sliced

Whisk together olive oil, lime zest, lime juice, and honey. Season with salt and pepper and set aside.

Place romaine in a large bowl and top with chicken, strawberries, feta, peas, avocado, and red onion. Season with salt and pepper, and drizzle with dressing. Toss and serve immediately.

Broccoli and Raisin Salad

5 cups small broccoli florets, chopped finely
1/3 cup chopped onion
3/4 cup raisins
1/2 cup sunflower kernels
1 cup mayonnaise
1 1/2 tablespoon cider vinegar
1/4 cup sugar
salt and pepper to taste
fried bacon, crumbled (optional)

In a large bowl, add broccoli, onion, raisins, sunflower seeds, and bacon if desired. Whisk together mayonnaise, cider vinegar, and sugar. Pour over broccoli mixture and toss, coating evenly. Add salt and pepper to taste. Cover and chill 2 hours before serving.

5-Cup Bean Salad

1 can garbanzo beans
1 can pinto beans
1 can black beans
1 can cannellini beans
1 can black-eyed peas
1 can sweet corn
1 red onion, finely chopped
1 bunch fresh cilantro, chopped
sea salt
pepper
juice from 1 lime

Drain each can of beans and corn. Pour into large bowl. Add the chopped onion, cilantro, sea salt, and pepper. Squeeze in lime juice and toss until everything is well coated.

May be eaten as a salad or as a dip with blue corn chips.

Spicy Pimento Cheese

2 cups extra-sharp Cheddar cheese, shredded
1 (8 ounce) package cream cheese, softened
1/2 cup mayonnaise, not salad dressing
1/4 teaspoon garlic powder
1/2 teaspoon ground cayenne pepper
1/4 teaspoon onion powder
1 jalapeño pepper, seeded and finely chopped
1 (4 ounce) jar diced pimento, drained
salt and black pepper to taste

Combine cheeses, mayonnaise, garlic powder, cayenne pepper, onion powder, jalapeño, and pimento in mixing bowl. Beat at medium speed, with paddle if possible, until thoroughly combined. Season to taste with salt and pepper.

Linguine with Tomatoes and Olives

1/2 teaspoon sea salt
2 cloves garlic, minced
Parmesan cheese, grated
1/2 teaspoon sugar
1 red onion, finely chopped
1 teaspoon red wine vinegar
1 (16 ounce) package linguine
3 tablespoons olive oil
1 cup kalamata olives, sliced
2 sprigs fresh oregano, chopped
1/2 teaspoon freshly ground black pepper
3 cups halved cherry tomatoes

Prepare linguine as directed on package. Sauté onion and garlic for about 5 minutes. Add chopped tomatoes and olives. Cover and simmer for about 8 minutes.

Remove the oregano leaves from the stems and chop. Add the oregano to the tomato sauce along with the salt, sugar, wine vinegar, and pepper. Simmer for 2 minutes. Toss sauce together with linguine and sprinkle with grated Parmesan.

Red Pepper and Tomato Soup

1/4 cup water
1 (28 ounce) can whole tomatoes
1 (12 ounce) jar roasted red peppers, drained
1/4 cup half-and-half
1 1/2 teaspoons salt
2 teaspoons sugar
1/2 teaspoon freshly ground black pepper
2 garlic cloves
1/4 teaspoon cayenne pepper

Combine all ingredients in a blender or food processor and purée until smooth, scraping down sides as needed. Pour into a medium-size saucepan and cook over medium-high heat, stirring often, 8 minutes or until hot. Serve immediately.

Asian Grilled Salmon

3 pounds fresh salmon, boned but skin on
2 tablespoons Dijon mustard
3 1/2 tablespoons good soy sauce
7 tablespoons good olive oil
1/2 teaspoon minced garlic
1/4 teaspoon cayenne pepper

Light charcoal briquettes or light gas grill, and brush the grilling rack with oil to keep the salmon from sticking.

Whisk together the mustard, soy sauce, olive oil, garlic, and pepper in a small bowl.

While the grill is heating, skin side down, cut the salmon crosswise into 4 equal pieces. Drizzle half of the marinade onto the salmon and allow it to sit for 10 minutes. Discard used marinade. Place the salmon, skin side down, on grill. Grill for 4-5 minutes, depending on the thickness of the fish. Use a heavy, wide spatula to carefully turn salmon. Grill an additional 4-5 minutes. The salmon will be slightly raw in the center, but don't worry; it will keep cooking as it sits.

Transfer the fish, skin down, to a serving plate, and drizzle the reserved marinade on top. Allow the fish to rest for 10 minutes. Remove the skin and serve.

Black Bean Burgers

Makes 8

3 (14.5 ounce) cans black beans, rinsed
 and drained
1 1/2 cups seasoned breadcrumbs (or plain oatmeal)
1/2 sweet onion, finely chopped or grated
1 jalapeño pepper, seeded and diced
3/4 cup chopped fresh cilantro
1 clove garlic, minced
2 large eggs, beaten
1 teaspoon salt
1/8 teaspoon cumin
1/3 cup all-purpose flour
1/3 cup cornmeal
2 tablespoon oil, vegetable or olive
hamburger buns

Mash the beans with a fork. Combine mashed beans with breadcrumbs (or oatmeal) and next 7 ingredients. Shape mixture into 8 patties. Combine flour and cornmeal; dredge patties in flour mixture.

Heat oil in large non-stick skillet over medium-high heat; cook the patties for 5 minutes on each side or until lightly browned; drain on paper towels. Serve on lightly buttered and toasted hamburger buns.

Fajitas

1/4 cup olive oil
1 lime, juiced
4 tablespoons chopped fresh cilantro
4 tablespoons finely chopped onion
3 cloves garlic, finely chopped
1 1/2 teaspoons ground cumin
1 teaspoon salt
1 teaspoon cayenne pepper
1 pound flank steak
8 (6 inch) corn tortillas, or more as needed
2 avocados, peeled and sliced
2 tomatoes, diced
1 (8 ounce) jar salsa
1 (8 ounce) package shredded Mexican cheese blend

Combine first eight ingredients in a sauce pan, and simmer over medium heat 4-5 minutes. Let cool, and pour into a Ziploc bag. Add steak and marinate in the refrigerator for 6 hours to overnight.

Grill steak for about 7 minutes on each side for medium rare. Let steak rest before slicing into thin slices. Serve with avocado, tomatoes, salsa, cheese, and sour cream.

Chicken Crepes

CREPE BATTER:
- 2/3 cup flour
- 1/8 teaspoon salt
- 2 eggs, slightly beaten
- 3 tablespoons margarine, melted and cooled
- 1 cup milk

Sift flour with salt; add remaining ingredients and beat until batter is smooth. Cover and chill for several hours or overnight. Cook crepes, cool, and cover for later use. I use electric crepe maker.

FILLING:
- 1/4 cup (1/2 stick) margarine
- 1 can (8 ounce) sliced mushrooms, drained
- 1/2 cup green pepper, chopped
- 1/2 cup green onions, chopped
- 1/2 cup celery, chopped
- 3 cups chicken breasts, cooked and diced
- 1/2 cup chicken broth
- 3 to 4 chicken bouillon cubes, dissolved in broth
- 1 can (8 ounce) water chestnuts, drained and sliced
- salt and pepper to taste
- lemon juice to taste
- cayenne to taste
- garlic salt to taste

Sauté mushrooms and vegetables in margarine in heavy skillet until onions are clear. Add remaining ingredients and cook over moderate heat until mixture becomes thick with no liquid remaining. Remove from heat and set aside.

SAUCE:
- 1/4 cup flour
- 1 cup chicken broth
- 2 cups light cream
- 1/2 teaspoon salt
- 1/8 teaspoon white pepper
- 1/2 cup Swiss cheese, grated
- slivered almonds for topping

Blend flour with chicken broth in heavy saucepan; add cream, salt, and pepper. Heat over moderate heat, stirring constantly, until mixture boils. Reduce heat and simmer for 2 minutes, stirring occasionally. Add about 1 cup of sauce to chicken filling and mix well. Mixture should be moist but not soupy. Reserve remainder of sauce to pour over filled crepes. Sauce will be thin and light in color.

ASSEMBLING CREPES:
Place about 1/4 cup filling on crepe. Roll each crepe individually and place, seam side down, in single layer in shallow buttered baking dish. Pour remaining sauce over crepes and sprinkle with grated cheese. Bake at 425 degrees for approximately 15 minutes until crepes are lightly browned and cheese is bubbly. Remove from heat, top with slivered almonds, and return to oven for 3 to 5 minutes until almonds are delicately toasted. Serve hot. Makes approximately 1 dozen large crepes. These are a lot of trouble but are well worth the effort. Especially good with fresh fruit salad, tangy green beans, and a light dessert.

Stuffed East Texas Summer Squash

makes 2 servings

- 1 yellow summer squash
- 1 egg
- 1 teaspoon fresh onion
- 5-8 crackers (or toasted bread or stuffing)
- favorite cheese, grated
- salt and pepper to taste

Boil squash in large saucepan. Cook 6-8 minutes or until tender. Remove from water and cool. Cut squash in half lengthwise. Scoop out each half and reserve pulp. Combine egg, onion, salt, reserve pulp, and either crumbled crackers, toasted bread, or stuffing. Spoon the mixture into the squash shells and top with your favorite grated cheese. Place in baking dish sprayed with cooking spray. Cover and bake for 20 minutes at 375 degrees. Uncover and bake 5-10 minutes longer until lightly brown.

Lumberjack Chicken

- 3 cups of your favorite BBQ sauce
- 1/2 cup peach preserves
- 1 clove garlic
- 3 tablespoons jalapeño, finely chopped
- 12 whole chicken thighs with skin and bones
- olive oil

Combine first 4 ingredients in a medium saucepan. Cook 5-10 minutes on medium-high heat. Let cool.
Preheat oven to 400 degrees. Line a jelly roll pan with foil. Coat foiled pan with olive oil. Place chicken thighs skin side down in the pans and roast for 25-30 minutes. Coat chicken with peach BBQ sauce, and turn thighs over to cook other side. Brush with more peach sauce and cook 7-10 more minutes. Remove from oven and turn thighs over again and brush with more of the sauce. Cook 5-7 more minutes. Flip chicken and coat once more with sauce. Increase oven temperature to 425 and bake another 5 minutes or more until the thighs are completely cooked. Remove from oven and cover with foil and let chicken rest.

Buffalo Wing Pizza

- vegetable cooking spray
- 1/2 cup Frank's Red Hot Buffalo Sauce
- 1 (10 ounce) Boboli pizza crust
- 2 cups chopped deli-roasted whole chicken
- 1 cup shredded provolone cheese
- 1/4 cup crumbled bleu cheese

Spread hot sauce over crust, and layer with next 3 ingredients. Bake according to package directions for pizza crust until thoroughly heated. Serve immediately.

Nellie's Company Chicken

Serves 4

1 (3 ounce) package dried beef, in slices
4 whole boneless skinless chicken breasts
8 slices bacon
1/2 (8 ounce) package cream cheese
1/2 cup sour cream
1 can cream of undiluted mushroom soup
paprika

Place breasts, one at a time, between Saran wrap and pound to 1/4 inch thick. Sprinkle each with salt and pepper. Place a couple of dried beef slices on top of each breast. Roll up each breast (begin at the shortest end); wrap the rolled chicken with a slice or two of bacon and secure with a toothpick.

In a saucepan, heat together the cream cheese, sour cream, and undiluted mushroom soup. Heat through until cream cheese is partially melted. Pour sauce over chicken. Sprinkle each breast with paprika. Cover and bake at 350 degrees for 45-60 minutes (or longer) until chicken is cooked through. When serving, spoon gravy mixture over each chicken breast, and serve extra gravy with the meal.

Eggplant Parmesan

2 Eggplants—washed and sliced (1/2' inch slices, skin on)
Italian breadcrumbs
1 egg
Arrabiata sauce (two-three jars). You can use any sauce; I just prefer this one.
1 onion, diced
tomatoes, diced
mozzarella cheese, shredded
Cheddar cheese, shredded
feta cheese, crumbled
goat cheese, crumbled
marinated artichokes (optional)
sea salt to taste
pepper to taste

Preheat oven to 350 degrees Rub olive oil on the eggplant. Salt and pepper each slice; dip in egg and then breadcrumbs (I do this twice). Fry in pan on both sides until a nice golden brown. In large casserole dish, pour enough sauce to cover bottom of dish. Start with one layer of fried eggplant, onion, tomatoes, artichokes, and then cheeses. Pour enough sauce to cover cheese and then begin layering again with eggplant, onion, tomatoes, artichokes, and cheeses until you've used all the ingredients. Top off with cheese. Bake for about 30-40 minutes.

I usually make two dishes with the above

Summer Creamed Corn

7 slices bacon cut into 1/2 inch pieces
1/2 sweet onion, chopped
3 cups fresh corn cut from the cob (5-6 ears) (or frozen corn, thawed)
1/2 teaspoon black pepper
1/4 teaspoon of cayenne pepper
1/3 cup cream
3 ounces cream cheese cut into cubes
1 chopped green onion (blades and all)

Fry the bacon in a deep skillet over medium high heat; when crispy remove from skillet and drain on paper towels. Remove all but 2 tablespoons of the bacon fat from the skillet and add the onion to the skillet, browning lightly, about 2-3 minutes.

Reduce the heat to medium. Add the corn and all but a couple of tablespoons of the bacon, which will be used for garnish. Add black pepper, cayenne pepper, and cream to the skillet. Bring to a simmer and cook for approximately 4 minutes or until the corn is just tender. Add the cream cheese pieces and continue cooking until the cheese has thoroughly melted. Remove heat and pour into a serving bowl, garnish with chopped green onion and bacon.

White Bean Wraps

2 tablespoons cider vinegar
1 tablespoon canola oil
2 teaspoons finely chopped canned chipotle chile in adobo sauce **
1/4 teaspoon salt
2 cups shredded red cabbage
1 medium carrot, shredded
1/4 cup chopped fresh cilantro
1 15-ounce can white beans, rinsed
1 ripe avocado
1/2 cup shredded sharp Cheddar cheese
2 tablespoons minced red onion
4 8-10 inch whole-wheat wraps or tortillas

Whisk vinegar, oil, chipotle chile, and salt in a medium bowl. Add cabbage, carrot, and cilantro; toss to combine.

Mash beans and avocado in another medium bowl with a potato masher or fork. Stir in cheese and onion.

To assemble the wraps, spread about 1/2 cup of the bean-avocado mixture onto a wrap (or tortilla) and top with about 2/3 cup of the cabbage-carrot slaw. Roll up. Repeat with remaining ingredients. Cut the wraps in half to serve, if desired.

**Chipotle chiles in adobo sauce are smoked jalapeños packed in a flavorful sauce. Look for the small cans in the Mexican foods' section in large supermarkets. Once opened, they'll keep at least 2 weeks in the refrigerator or 6 months in the freezer.

Berry Light Dessert

1 cup part-skim ricotta cheese
1/2 teaspoon lemon extract
3 packets sugar substitute (more or less to taste)
1/2 to 1 cup light (Greek or regular) lemon yogurt
sliced berries (raspberries, blueberries, blackberries)
2 tablespoons slivered almonds.

Mix first 4 ingredients in a small bowl. Cover and chill. To serve, top with sliced berries and sprinkle with slivered almonds.

Pound Cake with Strawberries

1 pint fresh strawberries, sliced
3 tablespoons sugar
1 cup butter, softened
1 (8 ounce) package cream cheese, softened
2 1/2 cups sugar
6 large eggs
3 cups sifted cake flour
1/4 teaspoon salt
1 1/2 teaspoons vanilla extract
1 cup whipping cream
3 tablespoons sugar
strawberry syrup (recipe below)
whole strawberries for garnish

Sprinkle sliced strawberries with 3 tablespoons sugar; cover and chill until ready to serve. Cream butter at medium speed. Add cream cheese and beat at medium speed with an electric mixer until creamy; gradually add 2 1/2 cups sugar, beating well.

Add eggs, 1 at a time, beating until combined. Stop using mixer and stir in flour by hand just until combined. Stir in salt and vanilla. Pour batter into a greased and floured 10-inch tube pan.

Bake at 300 degrees for 1 hour and 50 minutes or until a wooden pick inserted in center comes out clean. Cool cake in pan on a wire rack 10 to 15 minutes; remove from pan, and let cool completely on wire rack.

Meanwhile, beat whipping cream and 3 tablespoons sugar at high speed with an electric mixer until stiff peaks form. Cut cake into slices and serve with strawberry mixture and a dollop of whipped cream. Drizzle with STRAWBERRY SYRUP.

STRAWBERRY SYRUP—MAKE ONE DAY AHEAD
2 (16 ounce) packages frozen sweetened
 strawberries, thawed
1/2 cup orange juice

Purée berries and juice in a blender. I purée the syrup in batches, 1 package strawberries, 1/4 cup juice at a time to make sure the syrup is well puréed. Store in refrigerator.

Best and Easiest Apple Pie Cake

1 box spice cake mix
1 can applie pie filling
3 eggs

Take apple pie filling and chop apples slightly, making smaller apple pieces; mix all ingredients in bowl. You can use a small mixer if lumpy. Flour a bundt pan (use Bakers Joy spray) Bake at 350 degrees for 35-40 minutes. Ice with cream cheese icing.

CREAM CHEESE ICING
1 (8 ounce) cream cheese softned
1 stick oleo, softened
1 box powdered sugar (can sift)
1 teaspoon vanilla

Mix with mixer and apply to a cooled cake.

Hershey Bar Cake

2 sticks (1 cup) butter
8 small Hershey bars (1.45 ounces each)
2 cups sugar
4 eggs
1 cup buttermilk
1/2 teaspoon soda
2 1/2 cups flour
1/2 teaspoon vanilla
1 cup chopped nuts

Melt together butter and Hershey bars. Add sugar and eggs, 1 at a time, beating well after each addition. Mix buttermilk and soda and stir in. Add flour, flavoring, and nuts. Beat well and bake in greased tube cake pan at 300 degrees for 1 1/2 hours or until cake tests done.

Pineapple Turnovers

CRUST:
3 cups flour
1 cup shortening
1 teaspoon salt
1/2 cup cold tap water

Stir the salt into the flour and cut the shortening into the mixture; add water. Form into small balls. Roll out to desired thickness. Place 1 teaspoon filling in the middle of each round of rolled dough; fold the dough over, and pinch edges together with the tines of a fork. Roll turnovers in a mixture of sugar and cinnamon. Bake at 350 degrees until golden brown, or about 20 minutes.

FILLING:
1 can (20 ounce) crushed pineapple, drained
1 1/2 cups sugar
2 tablespoons cornstarch
1 stick (1/2 cup) butter
1 cup water

Mix pineapple and sugar. Bring to a boil. Mix cornstarch and water to make a paste; add to first mixture and stir rapidly. When mixture thickens, remove from heat and add butter. Let cool before using in turnovers.

Millionaire Pie

1 can (14 ounce) sweetened condensed milk
1 can (8 ounce) drained pineapple
1 cup flaked coconut
5 tablespoons fresh lemon juice
1 carton (8 or 9 ounce) frozen whipped topping
1/2 cup pecans, chopped

Combine all ingredients in a large bowl and mix well. Pour into baked pie crust. Keep refrigerated.

Maw Maw's Sweet Potato Pie

2 cups sweet potatoes, cooked and mashed
1 1/2 cups sugar
1 stick (1/2 cup) margarine
1 cup evaporated milk
4 eggs, beaten
1 teaspoon vanilla
1 teaspoon nutmeg
2 unbaked (8 inch) pie shells

Combine ingredients in order listed. Blend well. Pour in pastry lined pie plates. Bake at 350 degrees for 45 minutes or until knife inserted in the center comes out clean.

Blueberry Tarts

2 (8 ounce) packages cream cheese, softened
1 cup sugar
1 1/4 teaspoon pure vanilla extract
1/4 teaspoon cinnamon
2 eggs
vanilla wafers
1 (21 ounce) cans blueberry pie filling**

Preheat oven to 350 degrees. Fill a 12 count muffin tin with cupcake liners. Place a vanilla wafer in each liner.

Beat cream cheese with mixer until fluffy. Add sugar, vanilla, and cinnamon with a handheld electric mixer until fluffy. Add sugar and vanilla, beating well. Add eggs, 1 at a time, beating well after each.

Spoon cream cheese mixture over wafers and bake for 20 minutes. Cool. Spoon blueberry filling over each tart.

**Can use other pie fillling flavors.

Blueberry Desert

If fresh blueberries aren't available, you can use blueberry pie filling.

1 cup all-purpose flour
3/4 cup chopped pecans
1/2 cup margarine, melted
4 cups blueberries
1 cup white sugar
2 tablespoons cornstarch
1 teaspoon lemon juice
1 (8 ounce) package cream cheese, softened
1 (14 ounce) can sweetened condensed milk
1/3 cup lemon juice

Preheat oven to 300 degrees. Combine flour, pecans, and butter in a large bowl and mix until crumbly. Press into a 9x13 baking dish and bake 20-30 minutes until golden brown. Cool.

Combine blueberries, sugar, cornstarch, and 1 teaspoon lemon lemon juice in a saucepan. Cook 10-13 minutes over medium high heat until berries burst and syrup thickens. Cool.

Beat cream cheese with mixer until fluffy. Add sweetened condensed milk and blend well. Stir in lemon juice. Pour cream cheese filling onto cooled crust. Spread blueberry filling over cream cheese mixture. Chill until firm, about 2-3 hours.

Salted Turtle Cake

1 box German chocolate cake mix
1 1/2 sticks butter
1 cup chocolate chips
1 package (11 ounces) caramels
2/3 cup evaporated milk (divided)
2 cups chopped pecans

Cut softened butter into cake mix. Add 1/3 cup evaporated milk; mix well (makes a stiff batter). Place half of batter in a well-buttered 13x9x2 inch pan. Bake at 350 degrees for 6 minutes. Cover with chocolate chips and all but 1/2 cup pecans. Melt caramels in double boiler or microwave with 1/3 cup milk. Pour 3/4 of melted caramel over chips and pecans. Next add remainder of cake batter. Bake at 350 degrees for 15-17 minutes or until done. Do not overbake. Top with remaining caramel, nuts, and sprinkle with sea salt.

Apricot Delight

1 large can apricots, drained and chopped (reserve juice)
1 large can crushed pineapple, drained (reserve juice)
2 (3 ounce) packages orange Jell-O
2 cups hot water
3/4 cup miniature marshmallows

DRESSING:
1/2 cup sugar
3 tablespoons flour
1 egg, beaten
2 tablespoons butter
1 cup combined apricot and pineapple juices
1 cup cream, whipped
grated cheese and nutmeats

Drain and chill fruit, reserving juice for use. Dissolve gelatin in boiling water and add 1 cup of fruit juice. Pour into 9x13 pan. Chill until partially set. Fold in fruit and marshmallows, spread with topping.

To prepare topping, combine sugar, flour, and beaten egg. Stir and flour in top of double boiler, blend in beaten egg, and stir in 1 cup remaining juice. Cook over low heat, stirring constantly until thickened. Add butter and cool. Beat with mixer until fluffy and fold in whipped cream. Spread on top of congealed Jell-O and fruit. Top with grated cheese and nuts. Makes a large salad.

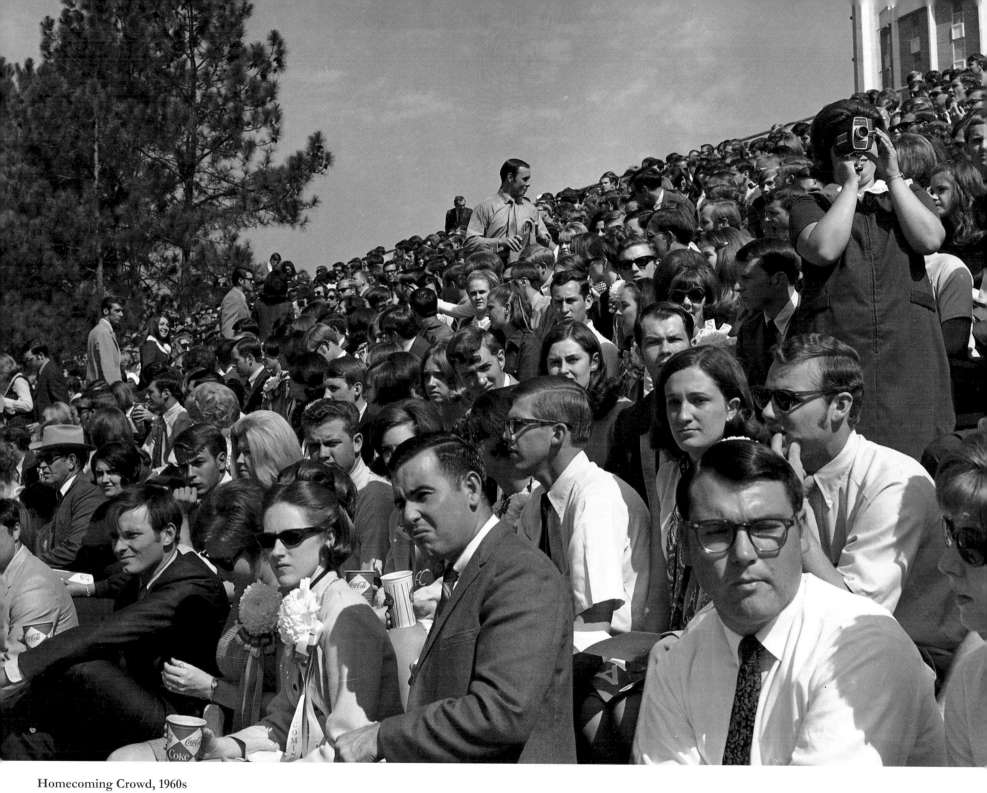

Homecoming Crowd, 1960s

Where ev'ry month is May
Long live our Alma Mater,

Attending SFA was one of the most challenging yet rewarding times of my life. One of my greatest memories was winning first place in the discus throw at an intramural track meet. I hurled that wooden saucer 146 feet. Of course, I had asked two or three fraternities if I could represent them; however, they decided they didn't need my assistance.

The result of my education, a triple major in history, science, and HPE as well as an M.Ed. in 1970, led me to a lifelong career of teaching and coaching. I became the Associate Athletic Director for SFA from 1984-1990, Athletic Director from 1990-2005, and eventually I wound up serving on the SFA Board of Regents as both a member and, eventually, a Chairman. I consider my time spent at SFA to have been the best years of my life.

—Steve McCarty, Athletic Director Emeritus

Lumberjack Mascot, 1969

Homecoming Queen, 1969

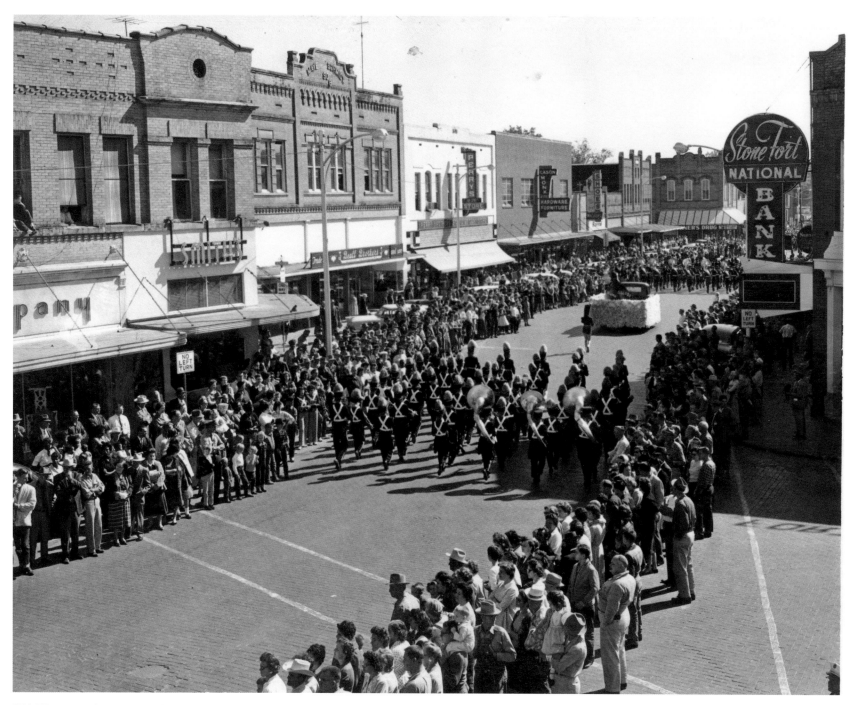

SFA Homecoming Parade, 1960

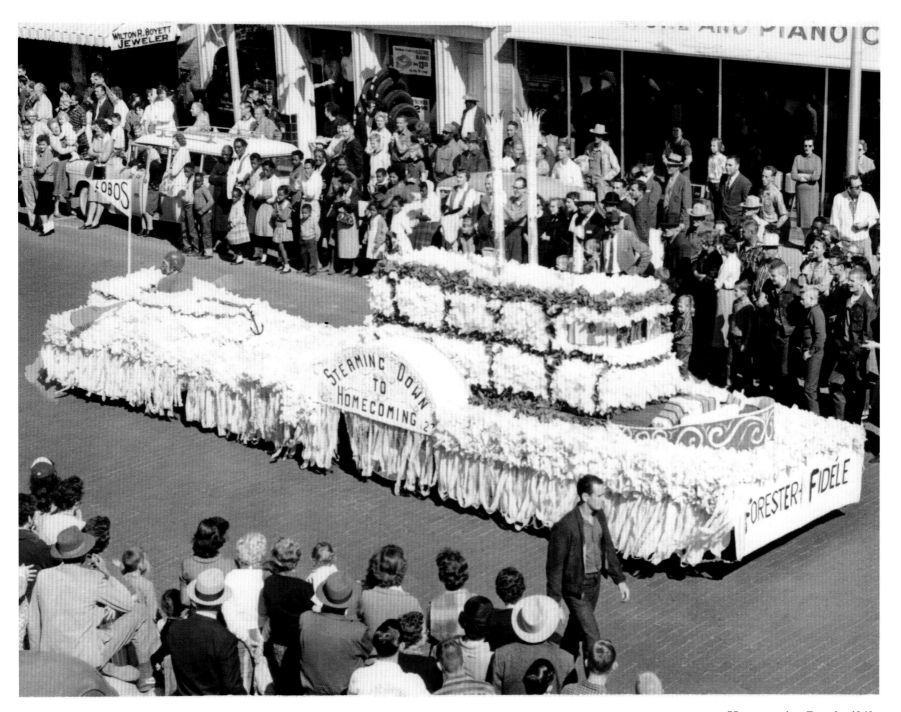

Homecoming Parade, 1960s

Dr. and Mrs. Ralph Steen, 1964

Steen Hall, 1965

Kennedy Auditorium, 1960s

Drum Major and Twirl-O-Jacks, 1969-70

Bon Appétit!

Food and travel have the power to transform us as well as to shape our understanding of the world and those who live in it. When we sit around the table with others over a leisurely meal, we share so much more than mere nourishment.

I've had the good fortune of taking students on field experiences in the United States and abroad. In most instances, we've eaten like locals. From gooey deep-dish pizza in Chicago to meatballs served with tart lingonberry sauce in Sweden, food gives us a "sense of place" or genus loci. By sampling homegrown specialties, we are reminded that the world is bigger than barbeque and Tex-Mex.

One of my favorite food and travel memories happened in Sweden. The late afternoon was misty and cool, and our hosts had prepared a special outing at small Nordic lake. The idea was for us to fish and then grill our catch over an open fire. The Swedish students assisting us were experts. In fact, our little fishing expedition was their final exam. They patiently helped us bait our hooks, cast our reels, and encouraged us even when no fish were biting. After about an hour and a half, both the Swedes and the Texans knew that a fish dinner was not to be had that evening. No matter how badly we wanted it, the fish were just not biting. At this point, I was thinking that sandwiches and coffee might be on the evening's menu since fresh fish definitely wasn't. But our hosts, the ever gracious and welcoming Swedes, had something else in mind. When we returned to the little camp cabin on the lake, we found a blazing fire with succulent skewers of reindeer roasting. I'm not sure I've ever had a better meal – roasted reindeer, flat bread, saft (a drink made from lingonberries) and soft cinnamon buns. We shared laughter over our failed fishing attempt and enjoyed campfire tales from both Texas and Sweden. There in the flickering firelight, we weren't people from two very different cultures, we were just friends, sharing a special meal.

I get to see a lot of friends sharing special meals at the Culinary Café at SFA. Some are regulars, and some are visiting our campus culinary lab for the first time. Chef Todd Barrios and our culinary students work hard to create memorable meals – three courses planned and perfected by young professionals. The menus often push the envelope, especially for East Texas. We've served mango haberñero sorbet, pork belly nachos with wasabi cream, and smoked peach cobbler, just to name a few of the interesting items that have been on the menu. Something special happens at the Culinary Café. Our students, many who have never worked in a restaurant, get to interact with the public in a unique way. Our guests get to sample creations they can't find anywhere else. The best part for me happens after the guests leave, and the students sit together family style and sample the meal. I love to just listen to them talk about the day's events and how much fun they had serving our guests. In that moment, all of our differences are put aside, and we are simply Lumberjacks, sharing a meal.

Bon Appétit!
Chay Runnels

Pork Medallions with Mushroom Dill Sauce

1 1/2 to 2 pounds pork tenderloin, sliced into 6 to 8 pieces, 1/2 inch thick
4 tablespoons butter
12 ounces sliced mushrooms
1 small chopped yellow or sweet onion
salt and freshly ground pepper to taste
1 1/2 cups beef broth (if canned, low salt)
1 tablespoon flour
1/2 cup sour cream
1 teaspoon chopped fresh dill or 1/2 teaspoon dried dill
1 cup uncooked rice

In a large skillet over medium heat, melt 2 tablespoons of butter and cook the mushrooms for 6-8 minutes. Using a slotted spoon, transfer mushrooms to a bowl and set aside. Pour off liquid.

Over medium high heat, melt the other 2 tablespoons of butter in the same skillet. Add the pork and cook for 3-4 minutes on each side or until browned. Add onion and cook 3-4 minutes until the onion is softened but not browned. Sprinkle lightly with salt and pepper. Pour in 1 cup beef broth. Cover and lower heat to medium-low and cook for 15 minutes or until meat is tender.

While meat is cooking, make the rice. In medium saucepan bring 2 cups of water to boil. Add rice; reduce to simmer; cover and cook for 20 minutes.

Transfer pork (retain drippings) to serving dish and keep warm. Stir flour into the skillet drippings and blend. Turn heat to medium and add rest of beef broth, stirring constantly until you have a smooth gravy. Taste and adjust seasoning. Let sauce cool. Add sour cream and dill and blend. Add mushrooms. Heat sauce through but do not boil as the sour cream will curdle. Pour sauce over pork medallions and serve with rice.

Cream of Tomato Soup

2 tablespoons butter
1/2 of a medium onion, chopped
1/2 of a small carrot, peeled and finely diced
2 tablespoons flour
1 (14.5 ounce) can crushed tomatoes, juice reserved
1 cup chicken broth
1/2 tablespoon tomato paste
1/2 tablespoon fresh basil (or 1/4 teaspoon dried basil)
1 teaspoon fresh thyme (or 1/4 teaspoon dried thyme)
1 bay leaf
1/2 cup heavy cream
salt and pepper to taste

In a large saucepan, melt butter over medium heat. Add onion and carrot and cook, stirring frequently until softened, 3-5 minutes. Add flour and cook, stirring constantly 1 to 2 minutes without allowing to color. Add tomatoes with their juices, broth, tomato paste, basil, thyme, and bay leaf. Bring to a boil. Reduce heat to low and simmer, stirring frequently until mixture reaches desired consistency. Remove and discard bay leaf. Let soup cool slightly before adding to blender or food processor.

In a food processor or blender, purée soup in batches until smooth. Return to pan and stir in cream. Season with salt and pepper to taste. Simmer until heated through.

Pavlova

4 egg whites at room temperature
2/3 cup finely granulated white sugar
4 teaspoons cornstarch
1/2 teaspoon white vinegar
1 teaspoon vanilla extract
1 cup heavy whipping cream
approximately 1 cup strawberries, mashed or cut into very small pieces
a baking sheet
a bowl (glass, stainless steel, or copper is best)
a mixer, an egg beater, or a wire whisk

Set your oven to 250 degrees. Put the egg whites in the bowl. Add the vinegar. Beat the egg whites until fluffy.

Once the egg whites are fluffy, slowly add sugar.

When the egg whites are very stiff, add the cornstarch and the vanilla, whisking a few more turns. Do not overwhisk here!

Spray baking sheet with Pam. Make approximately 12-25 bowls with the meringue. (Use a spoon to mound the meringue on the baking sheet and make a well in the middle, creating a bowl-shaped shell.)

Put the meringue in the oven. When the meringue starts to brown, it is done (around 30-45 minutes).

While the meringue is in the oven, cut up your fruit.

Remove the meringue bowl from the oven. Lift the bowls of the baking sheet with a spatula. Make sure they are nice and cool—if they're still warm, wait and try again in a little while.

Whisk the cream until it is stiff. Add 1 tablespoon powdered sugar when peaks start to form. Fill the meringue bowl with whipped cream and put the fruit on top for a delicate, airy treat.

Serve promptly, so the meringue does not get soggy from the cream.

Creamy Tuscan White Bean Soup

2 tablespoons extra-virgin olive oil
1 cup yellow onion, chopped (about 1 medium
 onion)
1 cup carrots, diced (about 2 medium carrots)
1 cup celery, sliced (about 3 celery ribs)
1/4 teaspoon dried red pepper flakes
4 cloves garlic, pressed
1/2 teaspoon dried rosemary
1/4 teaspoon dried thyme
2 bay leaves
1 quart low-sodium chicken broth
3 (15 ounce) cans Cannellini beans with liquid, 1
 can reserved
3 to 4 cups roughly chopped kale leaves
kosher salt and freshly ground black pepper
shaved Parmesan cheese (optional for serving)

Sauté the carrots, celery and onions in extra-virgin olive oil until softened, about 5 minutes. Add the hot pepper flakes and pressed garlic, and stir constantly for an additional minute.

Add two cans of the cannellini beans (liquid and all), the chicken broth, rosemary, thyme, and bay leaves to the sautéd veggies. Bring to a boil. Stir in the chopped kale leaves and then turn down to a simmer for about l0 minutes

Puré the remaining can of cannellini beans in a food processor or blender. Stir the purée into the soup and simmer for an additional 5 minutes. Season to taste with kosher salt and pepper.

Serve topped with shaved Parmesan cheese and a loaf of crusty French bread.

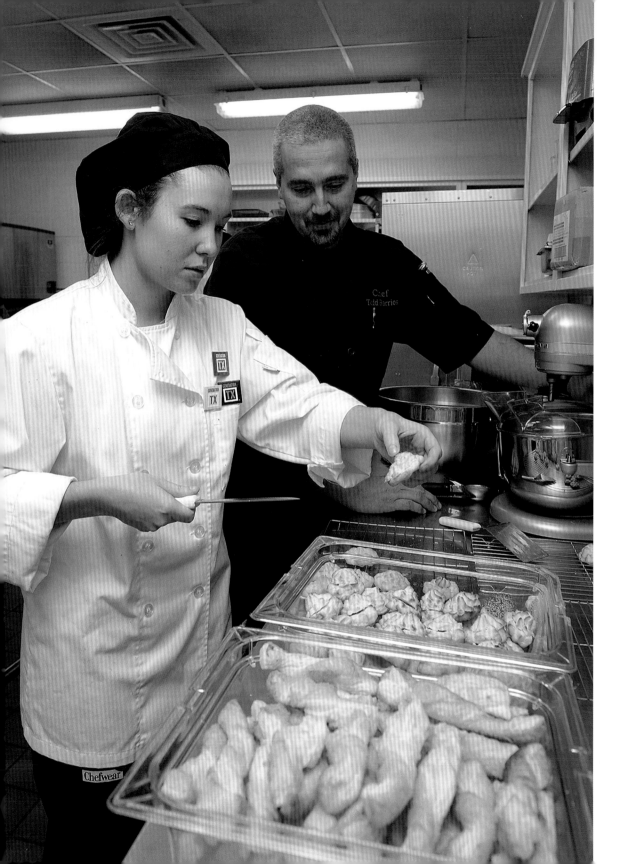

Creole Oyster Stew

2 tablespoons olive oil
1 cup yellow onions, diced
1/2 cup green bell peppers, diced
1/2 cup celery, diced
2 tablespoons garlic, minced
1 quart oysters with liquid
1 quart heavy cream
Creole seasoning to taste
tabasco to taste

Sauté "trinity" [onions, bell pepper, celery] in sauce pan until they begin to sweat. Add oysters and liquid and cook until oysters begin to curl. Add heavy cream, spice, and tabasco and reduce until thickened.

Potato Salad
Serves 8

6 large new potatoes
2 hard cooked eggs, chopped
1/2 cup celery, diced
1/2 cup onion, diced
2 tablespoons sweet pickle relish
1/2 cup bell pepper, diced
2 tablespoons parsley, chopped
1 1/2 tablespoons mustard
3 tablespoons salad oil
1 tablespoon Worcestershire sauce
1 tablespoon seasoning salt
add mayonnaise to desired moistness
salt and pepper to taste

Boil potatoes with skins on until tender; cut into cubes. Mix all ingredients while potatoes and eggs are still warm. Refrigerate until chilled.

Quinoa Tabbouleh Salad (gluten-free)

Makes 5-6 servings.

2 tablespoons olive oil, divided
3/4 cup uncooked quinoa
1 cup unsalted chicken broth or stock
1/2 teaspoon salt, divided
2 tablespoons freshly squeezed lemon juice
1/4 teaspoon pepper
dash sugar
1 clove garlic, minced
2 cups baby arugula
1 cup peeled, seeded, diced cucumber
1/2 cup diced red onion
1 cup grape tomato halves or diced tomoto
3/4 cup fresh parlsey, minced

Heat small saucepan over medium high heat; add 1 teaspoon oil. Stir in quinoa; cook 2 minutes until lightly toasted, stirring frequently. Gradually add broth; bring to a boil. Cover, reduce heat, and simmer 13 minutes or until tender. Remove from heat. Add 1/4 teaspoon salt. Cool to room temperature.

In small bowl, whisk remaining 5 teaspoon oil, remaining 1/4 teaspoon salt, lemon juice, pepper, sugar, and garlic. Set aside.

In medium bowl, combine cooled cooked quinoa and remaining ingredients. Add vinaigrette and toss gently.

Sugar Cane Shrimp

2 tablespoons of olive oil
1 pound jumbo shrimp, peeled
1/2 cup corn
1/2 cup red bell pepper, diced
1/4 cup green onions, diced
Creole seasoning to taste
1/4 cup cane syrup (as needed to glaze)

Sauté shrimp in skillet with olive oil. Add corn and peppers and cook until peppers begin to sweat. Add Creole spice and green onions. Toss and add cane syrup. Reduce until syrup is glazed on shrimp.

Creamy Butternut Squash Linguini

1 medium butternut squash, peeled and diced
3 tablespoons olive oil
8 sage leaves
1 pound linguini
1 1/2 cups pasta water
1 tablespoon olive oil
1/4 cup diced yellow onion
2 cloves garlic, minced
1/8 teaspoon ground nutmeg
1/4 cup freshly grated Parmesan cheese
salt and freshly ground black pepper, to taste

Bring a large pot of water to a boil. Salt the water and add the butternut squash. Cook until soft, about 12-15 minutes.

While the squash is cooking, fry the sage leaves. Heat 3 tablespoons olive oil in a small skillet over medium-high heat until surface is shimmering slightly. Add a few leaves at a time and cook until crisp, but still bright green, about 30 seconds. Transfer to a paper towel to drain. Season with salt. Set aside.

Using a large slotted spoon, carefully remove the squash from the water and place in a large bowl. Add the pasta to the boiling water and cook according to package instructions. Reserve water for squash purée.

Place the cooked butternut squash in a large food processor or blender. Puré the squash until smooth. Add pasta water and puree until the sauce reaches your desired consistency. You may need a little more or a little less pasta water depending on the size of your squash.

In a large deep skillet, heat 1 tablespoon of olive oil over medium-high heat. Add onion and garlic and sauté until soft, 3-5 minutes. Add puréd butternut squash. Stir in the Parmesan cheese. Season with nutmeg, salt, and pepper. Add the pasta and stir until pasta is well coated. Chop two of the sage leaves and stir them into the pasta. Serve.

Tomato Basil Soup

8 servings.

4 cups canned whole tomatoes crushed
4 cups V-8 Juice
12-14 washed, fresh basil leaves
1 cup heavy cream
1/4 pound sweet, unsalted butter
salt to taste

Combine tomatoes and juice; simmer for 30 minutes. Purée, adding basil leaves in blender. Return to cooking pot, add cream and butter while stirring over low heat.

Rosemary Chicken and Potatoes

Serves 6

4 tablespoons olive oil
2 tablespoons paprika
1 tablespoon dried rosemary
2 teaspoons salt
1 teaspoon black pepper
1 teaspoon garlic powder
1 1/2 pounds small red potatoes, halved
6 chicken breasts
non-stick cooking spray

Preheat oven to 425 degrees. Mix olive oil, paprika, rosemary, salt, black pepper, and garlic powder in large bowl. Add chicken and potatoes; toss to coat well.

Arrange potatoes in single layer on foil-lined baking pan sprayed with non-stick cooking spray.**

Bake 15 minutes.

Push potatoes to one side of the baking pan and place chicken on pan. Bake 30-35 minutes longer or until chicken is cook through and potatoes are tender.

**Stir potatoes occasionally.

90-Minute Cinnamon Rolls

3 1/4 cups all-purpose flour, divided
1 envelope yeast rapid rise yeast rapid rise
1/4 cup sugar
1/2 teaspoon salt
3/4 cup milk
1/4 cup water
1/4 cup butter
1 egg
1 cup firmly packed brown sugar
1 tablespoon cinnamon
1/2 cup butter, softened

Set aside 1 cup all purpose flour from total amount. Mix remaining flour, yeast, sugar, and salt in large bowl.

Heat milk, water, and 1/4 cup butter until hot to the touch, 125-130 degrees. Stir hot liquid into dry ingredients. Mix in egg. Mix in enough reserved flour to make a soft dough, so that it does not stick to the bowl. Turn out onto floured board and knead 5 minutes. Cover dough and let rest 10 minutes.

Mix brown sugar, cinnamon, and remaining butter together. Roll dough into 12x9 inch rectangle. Spread with brown sugar, cinnamon, butter mixture. Roll from long side, jelly-roll style; pinch to seal the seam.

Cut into 12 equal slices with a sharp knife. Place cut side up into large greased muffin cups or pyrex dish. Put on top of your oven where it is warm. Cover dough with a dish cloth and let rise 20 minutes.

Put a cookie sheet under your muffins to catch sugar syrup spills.

Bake at 375 degrees for 15 minutes or until browned. Remove from muffin cups to cool. Serve warm.

If you would like to make icing, measure 1/2 cup of powdered sugar. Add enough milk to make a gravy consistency.

FOR GLUTEN FREE CINNAMON ROLLS

Replace all-purpose wheat flour with equal parts of this
 mixture:
1 cup brown rice flour
1 cup sorghum flour
1 cup tapioca flour
1 cup cornstarch
3/4 cup white rice flour
1/3 cup instant mashed potato flakes

Then measure 3 1/4 cups of this mixture and add 2
 teaspoons xanthum gum.

Creamed Broccoli Soup

The recipe comes from Allrecipes.

3 tablespoons butter
1 onion, chopped
4 large carrots, chopped
1 clove garlic, chopped
4 cups water
4 tablespoons chicken bouillon powder
1 pound fresh broccoli florets
2 cups half-and-half
3 tablespoons all-purpose flour
1/4 cup ice water
1 tablespoon soy sauce
1/2 teaspoon ground black pepper
1/4 cup chopped parsley

Melt butter in a saucepan over medium heat; add chopped onions, carrots, and garlic, and cook for 5 minutes, stirring occasionally until softened.

In a medium-sized cooking pot, add 4 cups water and chicken bouillon granules and bring to boil. Add precooked onion mixture to soup pot. Add broccoli florets, reserving a few pieces to be added near the end of cooking time. Reduce heat and simmer, covered, for 15-20 minutes or until broccoli is just tender.

In a blender or food processor, purée soup in batches and return to pot. Stir in half and half cream and remaining broccoli florets.

In a cup, mix flour with 1/4 cup cold water to form a thin liquid.

Bring soup to boil; add flour mixture slowly, stirring constantly to thicken soup as desired. Add soy sauce and black pepper and stir well. Garnish with chopped parsley (or carrot curls) when serving. Serve soup hot or cold.

Peanut Butter Cookies

1 1/4 cup flour
3/4 teaspoon baking powder
1/2 cup butter
1/2 cup sugar
1/2 cup brown sugar
1/2 cup peanut butter
1 egg

Cream together butter and sugars; add peanut butter and egg. Combine flour and baking powder and mix with creamed mixture.

Roll dough into waxed paper and refrigerate. Once firm, unroll dough and slice. Bake at 300 degrees for 10–12 minutes.

Bert Rees' Pralines

Bert Rees was a long time Assistant Professor in the SFA Art Department. Bert was known in Nacogdoches for his Christmas lighting displays at his home. Every year, he would make pralines for his family to enjoy at Christmas time.

2 cups granulated white sugar
1 cup brown sugar
3 tablespoons butter
1 teaspoon vanilla
2 1/2 cups broken pieces of pecans
1 cup milk
dash of salt

Mix sugar, milk, and salt in medium sauce pan. Cook over medium heat. Let sugar dissolve. Add pecans. Cook until candy forms a soft ball. Add 2 tablespoons butter and turn off heat. Let stand 5 minutes without stirring. Add vanilla and beat until it looks cloudy. Drop in heaping teaspoons onto wax paper. Let candy cool, then you can remove easily from paper.

Wonderful Peach Cobbler

FILLING:
3 1/2 cups fresh peaches (sweetened to taste)
3 tablespoons butter
2 tablespoons flour
2 tablespoons sugar

Mix flour and sugar together and add to peach/butter mixture. Stew peaches until tender and thickened. Pour into a large pie dish and top with crust.

CRUST:
1 cup flour
1/2 teaspoon salt
2 tablespoons sugar
1 teaspoon baking powder
1/2 cup shortening
4-5 tablespoons cold water

Roll dough to 1/4 inch thick.

TOPPING:
3 tablespoons butter
1 tablespoon flour
3 tablespoons sugar

Dot the crust with butter. Mix flour and sugar together and sprinkle over butter. Bake at 325 degrees for 30 minutes or until golden brown. This cobbler crust stays firm so it is even good cold.

Chicken Tikka Masala

Serves 6-8

2 cups yogurt
2 tablespoons lemon juice
1 1/2 tablespoons ground cumin
2 teaspoons ground cinnamon
1 1/2 tablespoons cayenne pepper
1 1/2 tablespoons black pepper
2 tablespoons ginger
2 1/2 tablespoons salt (or to taste)
6 boneless, skinless chicken breasts cut into bite-
 sized pieces

2 tablespoons butter
2 cloves garlic
2 jalepeño peppers, finely chopped
1 1/2 tablespoon ground cumin
1 1/2 tablespoon paprika
2 tablespoons salt, or to taste
2 (8 ounce) cans tomato sauce
2 cups heavy cream

In a large bowl, combine yogurt, lemon juice, cumin, cinnamon, cayenne pepper, black pepper, ginger, and salt. Stir in chicken. Heat large skillet over medium-high heat and add chicken mixture.

After chicken has been cooked, add butter to skillet over medium heat. Sauté garlic and jalepeños. Season with cumin, paprika, and salt. Stir in tomato sauce and cream. Simmer on low heat until sauce thickens (about 20 minutes). Serve over MEDITERRANEAN RICE.

Mediterranean Rice

2 tablespoons olive oil
1 large onion, finely chopped
1 garlic clove
2 cups rice
3/4 cup water
2 tablespoons lemon rind, grated (recipe is fine
 without it, just adds a hint of lemon)
1/4 cup parsley
black pepper

Heat olive oil and sauté onion and garlic. Stir in rice and 3/4 cup of water. Once cooked, add lemon rind, parsley, and pepper. Stir well to combine. Serve with CHICKEN TIKKA MASALA.

You gotta love the 70s!

I was a very "happy to be here student" at SFASU in the 70's. In the second semester of my freshmen year, 1973 spring semester, dorms opened and everyone was returning to SFA. Then, it started to snow hard and for a long time. Snow and ice were abundant, and everyone loved playing in the snow. Classes were delayed because of the iced over roads into Nacogdoches. I will always remember that week as I had never seen snow before. We wore low-cut hip hugger jeans from the army/navy store, wide belts, and crop tops. I saw my fair share of streaking students which was popular in the early 1970s.

—Norma Doan

Slow-cooked Boston Butt Pork Roast

3-4 pound pork butt roast
1-2 cloves slivered garlic (depending on taste)
1 package onion soup mix
1 cup Coca-Cola
salt and pepper to taste

Rub the butt roast with salt and pepper. Using the tip of a sharp knife, make holes in the roast and insert a sliver of garlic into each hole. Place roast in the crockpot. Add the onion soup mix and 1 cup of Coca Cola. Cook for 8 hours on low (you can also cook for 4 hours on high). When roast has reached desired doneness, remove it from the crockpot and pour the liquid into a saucepan. Skim fat. To thicken gravy, remove 1 cup of liquid and add cornstarch to make a slurry. **

Heat the gravy mixture on medium high and stir in cornstarch mixture. Bring to a boil and simmer. Keep adding cornstarch (make a slurry each time) until you reach the desired consistency. Salt and pepper to taste.

**If you are cooking the roast in the oven, your roast will need to reach an internal temperature of 195 degrees. Prepare roast as directed above, but add the onion soup and Coke to the roasting pan and mix them together before adding the roast. Place the roast fat side up and cover with foil. Bake the roast at 350 degrees for 4 hours or until a meat thermometer reaches 195 degrees. Let stand 15-20 minutes and shred with 2 forks.

Honor to thee for aye.

Jack Cheerleaders, 1970

Above left: Order of the AX, 1970
Left: Mel Montgomery Practice, 1974

Watermelon Bash, 1970s

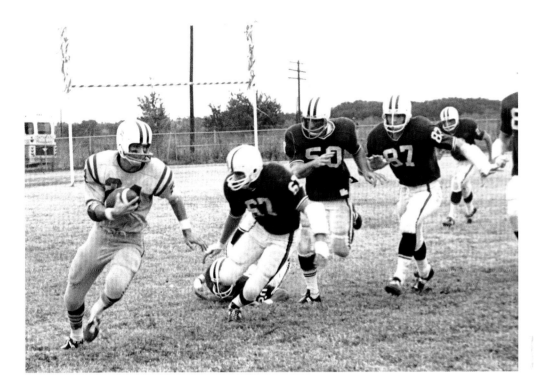

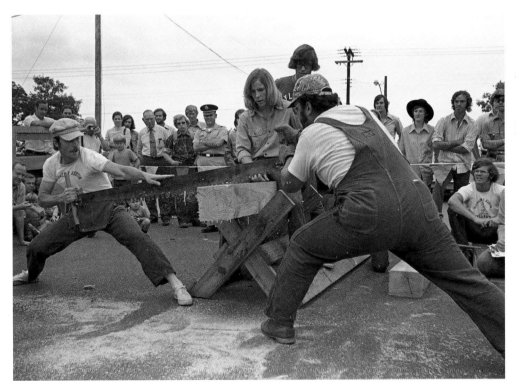

Above right: Homecoming Game, 1971
Right: Lumberjack Day, 1974

Leah Daniels, Feature Twirler, 1974

Above left: SFA Homecoming Parade, 1974
Left: Twirl-O-Jacks, 1978

Baker Pattillo, Dean of Student services, 1977

Above right: Abernathy Award, 1970
Right: Ralph W. Steen Library, 1972

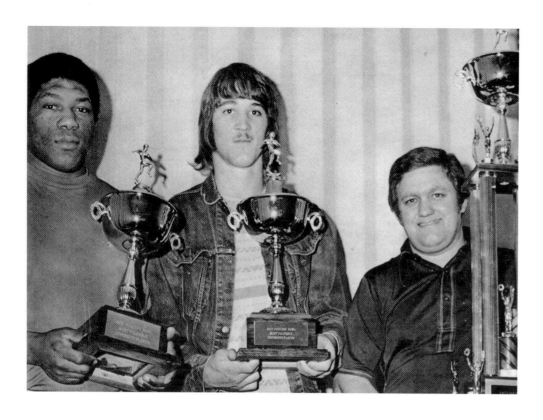

SFA Students, 1971

Above left: Poultry Bowl MVPs, 1974
Left: Alumni Golden Anniversary, Mrs. Lera Thomas, 1973

Dr. Johnson, SFA President, 1976-1990

Above right: Bob Sitton, Alumni, 1972
Right: Homecoming, 1972

Healthy & Lean

Having moved to East Texas almost ten years ago, I have come to absolutely love the beautiful geography and tall trees of this area. One of my favorite pastimes is to walk on Raguet Street or around the university and simply take in the colorful landscape that makes up Nacogdoches. It is hard to imagine teaching at another university, or living in another college town, that is more beautiful. Visitors to Stephen F. Austin State University often comment on the beauty of the campus, the towering trees, the landscaped plazas. Admittedly, I find myself making any number of excuses to get out of the office and run an errand to somewhere across the university just to get out and enjoy a nice walk. These are particularly enjoyable experiences when the sounds of the band practicing echoes through the wind on a crisp fall morning or when the ROTC students are running through the heart of campus and chanting their call-and-response songs in the afternoon.

So many people, both on and off campus, take advantage of the loveliness of our university on a daily basis, which creates wonderful opportunities to incorporate health and wellness into our everyday lives. The salad bar and fruits and vegetables at the Student Center cafeteria are delicious, especially since I did not have to wash or cut it up! The Employee Wellness program through the Campus Recreation Center provides ample opportunities for SFA employees to incorporate snippets of workout time into the workday or organize group walks on campus. I cannot even begin to count the number of people I have run into on campus walking in the mornings, taking in a quick yoga class on their lunch break, biking with the kids at the duck pond, or swimming laps at the Rec in the evenings. What a great environment to work in and raise children with an awareness of health and fitness! A better university atmosphere that supports and promotes health and wellness would be difficult to find.

Now, don't get wrong . . . I love sweets and treats just as much as the next Lumberjack! As one of my many, many spatulas explains, "Life's short . . . eat cookies!" I couldn't agree more. But after a fresh stack of homemade pancakes on a Saturday morning (with whole wheat flour, of course!) or a batch of my grandmother's awesome chocolate chip cookies, a walk down Raguet or across campus is just a few steps away.

—Dana Cooper

When my daughter started preschool, I was determined to prepare healthy lunches for her. I tried every variation of healthful muffins you can imagine--wild rice muffins, mini couscous cakes, vegetable bran, whole wheat peach, chickpea . . . you name it, I made it! But she wasn't having it at all. Day after day, the lunches came home without mommy's healthy muffins being touched. But as my son was four months old when that semester began, I met with a group of students taking an individual studies class via group method that fall. We had class at my dining room table with tea every Tuesday afternoon, and they (unlike my daughter) loved the muffins! One student loved to put sriracha sauce on the spinach and pine nut muffins (recipe on page 189). As he devoured muffin after muffin, week after week, all I could think was, "Wow . . . dorm life must be rough!" I love college students!

—Dana Cooper

Mediterranean Salmon Salad

8 tablespoons extra-virgin olive oil
1 tablespoon plus 1 teaspoon red wine vinegar
1 tablespoon honey
1/4 teaspoon cayenne pepper
1 teaspoon sea salt (or to taste)
4 (6-ounce) salmon fillets (about 1 1/4 inches)
1 clove garlic, minced
1/2 cup kalamata olives, pitted and chopped
14 cherry tomatoes, halved
1 cup sliced celery (inner stalks with leaves)
1/4 cup fresh mint, roughly chopped
1/4 cup walnut, finely chopped

Turn on broiler. Line a pan with foil and lightly brush with olive oil. Whisk 2 tablespoons olive oil, 1 teaspoon vinegar, the honey, red pepper flakes, and 1 teaspoon sea salt in a small bowl. Put the salmon, skin-side down, on the prepared pan and brush the tops and sides of the salmon with the honey glaze. Broil until golden brown and cooked through, 4-6 minutes.

Heat 3 tablespoons olive oil and 1 tablespoon vinegar, olives, pinch of salt, and minced garlic in a small saucepan over medium-high heat until bubbling, about 3 minutes. In a bowl, combine tomatoes, celery and mint. Add heated garlic mixture. Season with salt and walnuts and toss to combine. Serve with the salmon.

Spinach Salad II

3/4 cup pine nuts or chopped walnuts, toasted
1 pound spinach, rinsed and torn into bite-
 size pieces
1 (6 ounce) package Craisins
4 ounces crumbled bleu cheese
1/2 cup pear, chopped

DRESSING
2 tablespoons toasted sesame seeds
1 tablespoon poppy seeds
1/2 cup white sugar
2 teaspoons onion, minced

1/4 teaspoon paprika
1/4 cup white wine vinegar
1/4 cup cider vinegar
1/2 cup olive oil

In a large bowl, combine the spinach with the toasted nuts, blue cheese, Craisins, and chopped pear.

In a medium bowl, whisk together the sesame seeds, poppy seeds, sugar, onion, paprika, white wine vinegar, cider vinegar, and vegetable oil. Toss with spinach just before serving.

Apple Cider Vinaigrette

1/3 cup apple cider vinegar
1/3 cup Dijon mustard
1/3 cup honey
1/3 cup Duke's or Kraft mayonnaise
1 teaspoon sugar
1 teaspoon salt
ground pepper to taste

Shake ingredients in mason jar until well blended.

Mediterranean Quinoa Salad

1 cup white quinoa, uncooked
1/2 teaspoon salt
1 cup cucumber, diced, seeded, and unpeeled
1 can (14.5 oz each) Hunt's diced tomatoes with
 basil, garlic, and oregano, drained
1/3 cup kalamata olives, chopped
1/3 cup crumbled feta cheese
1/4 cup red onion, chopped

Cook quinoa according to package directions, adding the salt. Combine cucumber, drained tomatoes, olives, cheese, and onion in large bowl; set aside.

Spread cooked quinoa in 13x9-inch baking dish. Cool slightly in refrigerator 5 minutes. Add quinoa to vegetable mixture; toss gently to combine. Serve immediately or chill before serving.

Pinto & Black Bean Wraps

Makes approximately 5 wraps

quinoa
water
1 (15 ounce) can black beans
1 (16 ounce) can Bush pinto beans
1 avocado
MANGO SALSA (RECIPE BELOW)
balsamic vinegar (optional) or balsamic reduction*
whole wheat or corn tortillas

Prepare quinoa in a pot with 1 part quinoa, 2 parts water. Bring water to a boil. Place a lid over pot and set to a low heat until all of the water has been absorbed by the quinoa.

Fill tortillas with quinoa, black beans, sliced avocado (if there isn't any already in the salsa), and mango salsa. Lightly drizzle with balsamic vinegar/reduction.

I made balsamic reduction by pouring balsamic vinegar into a small pan over heat for 3 minutes and setting it aside once it began to boil. It will thicken as it cools down. Be careful not to burn it!

Mango Salsa

1 large mango, peeled and diced
1/2 cucumber, (about 1 cup) diced
1/2 cup chopped sweet onion
1/4 cup packed fresh cilantro, chopped
1 large tomato, diced
1 avocado, diced
2 teaspoons lemon juice

If you can't find the mango, add extra tomato and avocado. Mix all together – eat with chips or do the PINTO & BLACK BEAN WRAP.

Greek Pasta

1 cup dry elbow macaroni
3/4 cup chickpeas, drained and rinsed
1 (6 ounce) jar quartered artichoke hearts
1/2 cup olives, chopped
1 can water chestnuts, sliced
1 teaspoon dried oregano
4 sundried tomatoes, chopped
1/2 cup feta cheese, crumbled
1/8 teaspoon red pepper flakes
1/8 teaspoon black pepper
pinch of sea salt

Cook pasta in boiling salted water until al dente. Drain and set aside. In a large bowl, combine the chickpeas, artichoke hearts (with oil from the jar), olives, chestnuts, sundried tomatoes, oregano, feta, and red pepper flakes. Toss to combine. Add the cooled macaroni and toss again. Season with a pinch of salt and pepper to taste. Serve immediately or keep in the fridge for up to five days.

Jicama Slaw

3 carrots, peeled and julienned
1 small jicama, peeled and julienned
1 large red bell pepper, cored and very thinly sliced
1/4 head red cabbage, cored and very thinly sliced
1/2 red onion, thinly sliced lengthwise
6 tablespoons olive oil
6 tablespoons rice wine vinegar
3 tablespoons fresh lime juice
2 tablespoons honey
3 tablespoons cilantro leaves, minced
1 teaspoon salt
1 teaspoon freshly ground black pepper
1 teaspoon sugar
1/2 teaspoon chili powder
1/2 teaspoon red chile flakes

Prepare vegetables in a large bowl. In a jar, combine oil, vinegar, lime juice, honey, minced cilantro, salt, pepper, sugar, chili powder, and chile flakes. Shake well to mix. Pour dressing over vegetables and garnish with cilantro.

Gazpacho

1/2 pounds vine-ripened tomatoes, peeled and chopped
1 cup tomato juice
1 cup cucumber, peeled, seeded, and chopped
1/2 cup red bell pepper, chopped
1/2 cup red onion, chopped
1 small jalapeño, seeded and minced
1 medium garlic clove, minced
1/4 cup extra-virgin olive oil
1 lime, juiced
3 teaspoons balsamic vinegar
2 teaspoons Worcestershire sauce
1/2 teaspoon ground cumin
1 teaspoon sea salt
1/2 teaspoon freshly ground black pepper
2 tablespoons fresh basil leaves, rolled and chopped

Fill a large pot halfway full of water and bring to a boil. Make an X with a paring knife on the bottom of the tomatoes. Spear tomatoes with a fork and dip into the boiling water for 15 seconds, remove, and set on plate to cool. Rinse tomatoes with cold water. Peel tomatoes and chop (You can remove seeds if you like).

Place the tomatoes and 1 cup tomato juice into a large mixing bowl. Add the remaining ingredients and mix well to combine. Transfer 1 1/2 cups of the mixture to a blender and puré for 15 to 20 seconds on high speed. Return the purée to the bowl and stir to combine. Cover and chill for 2 hours and up to overnight.

Turkey Mole Soup

1 teaspoon olive oil
1 1/2 pounds ground turkey
1 cup onion, chopped
1 cup green bell pepper, chopped
3 tablespoons chili powder
4 garlic cloves minced
1/4 bottled mole
2 (14 ounce) cans of chicken broth
1/2 cup raisins
1 can black beans, drained
1 can diced tomatoes, undrained
1 can chopped green chilies, undrained

Brown turkey in olive oil. Add onion, bell pepper, chili powder and garlic. Cook 5 minutes then combine mole and chicken broth stirring with a whisk. Add raisins, beans, tomatoes, and green chilies to mixture and simmer for 20 minutes.

Lentil Vegetable Soup

Serves 6

2 small onions, finely chopped
2 carrots, finely chopped
6 small white potatoes, finely chopped
1 (16 ounce) bag brown lentils
1 (15.5 ounce) can fire roasted tomatoes, diced
8 cups vegetable broth or water
1-2 cups spinach, finely chopped
salt and pepper to taste

Combine all ingredients except the spinach and cook on low for 2 hours. Add the spinach about 5 minutes before the soup is done. Season to taste with salt and pepper.

This lentil vegetable soup is a favorite and so easy to make. I chop all of the vegetables really small. And, like most soups, if you don't have an ingredient, such as carrot or spinach, leave it out or substitute another favorite ingredient.

Chocolate Pudding with Avocado

Taken from the Jessica Seinfeld's Deceptively Delicious book, published in 2007.

1/2 cup organic butter, softened
1 cup avocado, pureed
1 cup powdered sugar
1/2 cup cocoa powder, unsweetened
1 generous teaspoon of pure vanilla extract
1/4 cup cornstarch

In a medium saucepan (or large if you are messy like me) melt the butter over low heat. Gently stir in the avocado puree, cocoa powder, sugar, and vanilla. Cook slowly, mashing and mixing the ingredients with a spatula to smooth out any lumps. The mixture will thicken in about three minutes. Move the pan off the heat, and slowly mix in the cornstarch. Serve warm with milk.

Healthful Chicken Casserole

1 pound of organic chicken, cooked, skinned, and chopped
1 package (10 ounces) frozen spinach
1/4 cup onion, finely chopped and sautéed
1/2 teaspoon garlic powder, divided
8 ounces of fresh mushrooms, sliced and sautéed
2 tablespoons butter, melted
1 cup organic skim milk
1 cup mozzarella cheese

Cook spinach according to package directions and drain very well with paper towels. Otherwise, dinner will be soggy! Mix onion with spinach. Arrange spinach in bottom of 1.5 quart baking dish. Sprinkle with 1/4 teaspoon of garlic power. Spoon mushrooms on spinach and drizzle with melted butter. Arrange chicken on mushrooms and sprinkle with remaining 1/4 teaspoon of garlic powder. Top with mozzarella cheese. Place in oven at 350 degrees for 30 minutes. Makes approximately six servings . . . or less if you are a college athlete!

Spinach & Pine Nut Muffins

Taken from the 500 Cupcakes book, 2005.

2 1/3 cups flour (if you want to go really healthy, use one cup of whole wheat flour and the rest white flour)
1 tablespoon of baking power
2 tablespoons of sugar
1/4 teaspoon of nutmeg
a dash of salt
1 1/4 cups of organic skim milk
3 tablespoons of extra virgin olive oil
1 egg, beaten
1 cup of cooked spinach, chopped
1/2 cup of pine nuts

Preheat the over to 350 degrees, and grease a large six-cup muffin pan. Mix dry ingredients in a medium bowl.

In a larger bowl, mix the egg, milk, and oil. Gently fold in the flour mixture, and stir until just combined. Stir in the pine nuts and spinach, but just barely.

Spoon the batter into the prepared pan, and bake for approximately twenty minutes. Remove from oven, and cool for roughly five minutes. Move muffins to cool on a rack. If you your heart desires, serve with sriracha sauce!

Bean Salad

2 tablespoons extra virgin olive oil
2 tablespoons white wine vinegar
1/4 teaspoon sea salt
1/8 teaspoon ground black pepper
1 (15 ounce) can cannellini beans, drained and rinsed
1 (15 ounce) can kidney beans, drained and rinsed
1/4 cup chopped fresh flat-leaf parsley
1 stalk celery, finely diced
1 green onion, thinly sliced on the diagonal
1/4 small red onion, minced

In a medium bowl, combine oil, vinegar, 1/4 teaspoon salt and 1/8 teaspoon pepper. Add the beans, parsley, celery, and onions, stirring until combined.

Simple Zucchini and Tomatoes

2 tablespoons extra virgin olive oil
1 small red onion, diced
2-3 medium zucchini, cut into 1/2-inch chunks
1 pint cherry or grape tomatoes, halved
2 cloves garlic, minced
1 teaspoon salt
1/4 teaspoon freshly ground black pepper
1 tablespoon fresh basil, chopped
Parmesan cheese (optional)

In a large skillet or sauté pan, heat the olive oil over medium heat. Add the red onions and cook, stirring frequently, until onions are soft and pale purple in color, 7-8 minutes. Do not brown. Add the zucchini, tomatoes, garlic, salt, and pepper. Cook for 3-5 minutes, stirring frequently, or until the zucchini are cooked but still crisp and the tomatoes have started to collapse, creating a little sauce. Stir in the fresh basil. Add salt and pepper to taste. Serve with grated Parmesan cheese.

Thai Beef Salad

1 pound top-round London broil or flank steak, about 1 to 1 1/2-inches thick
3 tablespoons lime juice, divided into thirds
3 tablespoons low-sodium soy sauce
3 tablespoons canola oil
2 tablespoon brown sugar
1 teaspoon garlic, minced
1 1/2 teaspoons ginger, minced
1 1/4 teaspoons red curry paste or chili-garlic sauce
1/2 head red-leaf lettuce, torn (about 6 cups)
3 shallots, thinly sliced (about 1/2 cup)
1/2 cup cilantro leaves, rinsed and dried
1 cup basil leaves, sliced into ribbons
peanuts for a little crunch if desired

Pat the meat dry and place in a sealable plastic bag or small glass dish. In a medium bowl, combine 1 tablespoon of the lime juice with the next 6 ingredients. Add 1/2 of the lime mixture into the bag with the meat. Add the remaining 2 tablespoons lime juice to the marinade in the bag. Seal tightly, and marinate meat in refrigerator at least 4 hours or overnight, turning occasionally. Refrigerate the rest of the unused marinade for salad dressing.

After meat has been in marinade for atleast 4 hours, spray grill or grill pan with cooking spray and preheat. Grill steak until medium-rare, about 5 minutes per side. When steak reaches desired doneness, remove it from heat and let rest until cooled. Slice steak, against the grain, into thin slices.

Combine lettuce, sliced shallot, cilantro, basil, and beef in a salad bowl, reserving a few shallots for garnish. Add the reserved dressing (and peanuts if desired) and toss to coat.

Roasted Chicken

1/2 cup butter, softened
2 garlic cloves, minced
2 tablespoons fresh oregano, chopped
1 tablespoons fresh flat-leaf parsley, chopped
2 tablespoons fresh chives, sliced
1 1/2 teaspoons sea salt
1 teaspoon lemon zest
ground black pepper
8 bone-in, skin-on chicken thighs
1 tablespoon olive oil

Preheat oven to 425 degrees. Line a jelly roll pan with foil. Combine first 8 ingredients in a small bowl and mix well. Loosen skin on each chicken thigh but do not detach. Spread butter mixture under skin and pat skin back into place. Brush thighs with oil and sprinkle with desired amount of salt and pepper. Place thighs on a lightly greased (with cooking spray) wire rack in foil-lined jelly-roll pan. Bake for 50 minutes or until a meat thermometer inserted into thickest portion of a chicken thigh registers 165 degrees. Remove from oven and let chicken rest 8-10 minutes.

Roasted Red Pepper Hummus

2 cups chickpeas
1 cup roasted red bell pepper, sliced and seeded
2 tablespoons white sesame seeds
1 tablespoon lemon juice
1 tablespoon olive oil
1 1/4 teaspoons cumin
1 teaspoon onion powder
1 teaspoon garlic powder
1 teaspoon sea salt
1/4 -1/2 teaspoon cayenne pepper

In a food processor, process all ingredients until smooth.

Blackened Tilapia Tacos

(Serves 2-4) You can whip these up in like 10 minutes.

> 1/2 teaspoon paprika
> 1/4 teaspoon salt
> 1/4 teaspoon pepper
> dash of cayenne pepper
> 1/4 teaspoon onion Powder
> 1/4 teaspoon cumin
> 3 Tilapia filets
> 1 1/2 tablespoons olive oil
> 1 avocado, mashed
> 4 whole wheat tacos

Combine the dry seasonings in a small mixing bowl. Whisk to combine. Lightly dust each side of the tilapia filets with the seasoning blend.

Heat the olive oil in a large skillet over medium heat. Add the tilapia to the pan and cook the tilapia for five minutes on each side.

Warm the tortillas. Smash a little bit of avocado on each tortilla. Place half of a tilapia filet on to each taco. Break the filet apart a little bit. Serve with a little bit of fresh pico de gallo or salsa and some jalapeño slices.

Grilled Salmon with Rosemary Honey Sauce

> 24 ounces wild caught salmon, with skin
> 2 tablespoons honey
> 2 tablespoons fresh rosemary, chopped
> 2 tablespoons olive oil
> 2 tablespoons Dijon mustard
> 1/4 - 1/2 teaspoon salt and pepper

Pat the salmon dry. Mix honey, rosemary, olive oil, Dijon mustard, salt, and pepper in a small bowl.

Brush the salmon with the honey mixture. Let marinate for 20 minutes. Grill the salmon, skin side down for approximately 12-15 minutes (until it flakes easily with a fork).

Chicken a la Calabrese

3 large boneless, skinless chicken breasts
olive oil (for sautéeing)
2 large white onions, peeled and sliced
2 jalepeños, de-seeded and chopped finely
(2 large bell peppers if spice (jalapeño) isn't your thing)
3 cloves garlic, smashed
2 (28 ounces) cans of crushed tomatoes
1 (28 ounces) can of tomato sauce
1 teaspoon salt (or to taste)
1/2 teaspoon of black pepper
1/2 teaspoon red pepper flakes
1/2 cup fresh parsley leaves
1/2 cup fresh mint leaves
few dashes of oregano seasoning
whole grain penne pasta
Parmesan cheese

Pre-heat oven to 450 degrees. Cut chicken breasts into bite-sized pieces and lay them in a lightly greased casserole dish. Season with a dash of salt and a dash of black pepper. Put in oven for 15 minutes. While chicken is cooking, heat olive oil in large pot over medium-high heat. Add sliced onions, peppers, and garlic and cook about 5 minutes (or until onions are tender). Add crushed tomatoes, tomato sauce, salt, pepper, and red pepper flakes. Simmer for about 10 minutes. Stir in parsley, mint, and oregano. Take chicken out of oven and reduce oven to 350 degrees. Pour tomato mixture over chicken. Cover and bake for an additional 15 minutes. Prepare pasta according to package directions. Serve chicken and tomato mixture over pasta. Garnish with Parmesan cheese.

Salmon Spread

8 ounces cream cheese, at room temperature
1 tablespoon freshly squeezed lemon juice
1 teaspoon prepared horseradish, drained
1/4 teaspoon ground black pepper

1/2 cup sour cream
1 tablespoon fresh dill, minced
1/2 teaspoon sea salt
1/4 pound smoked salmon, minced

In a mixing bowl, beat cream cheese until just smooth. Stir in the sour cream, lemon juice, dill, horseradish, salt, and pepper. Mix well. Gently stir in the smoked salmon until well mixed. Chill and serve with crackers or fresh veggies.

Mongolian Beef

2 teaspoons vegetable oil
1/2 teaspoon ginger, minced
1 tablespoon garlic, chopped
1/2 cup soy sauce
1/2 cup water
3/4 cup dark brown sugar
vegetable oil, for frying (about 1 cup)
1 pound flank steak, sliced into 1/4 inch thick slices
1/4 cup cornstarch
2 large green onions, sliced on the diagonal into one-inch lengths

Make the sauce by heating 2 teaspoons of vegetable oil in a medium saucepan over low to medium high heat. Add ginger and garlic to the pan and quickly add the soy sauce and water before the garlic scorches.

Add brown sugar to the sauce and increase heat to about medium. Boil 2-3 minutes or until the sauce thickens. Remove sauce from heat. Slice the flank steak against the grain into 1/4 inch thick bite-size slices. Drag the steak slices through the cornstarch, dusting both sides. Let the beef sit for 10 minutes. While the beef rests, heat one cup of oil in a skillet over medium heat until it's nice and hot, but not smoking.

Add the beef to the oil and sauté for two minutes or until the beef just begins to darken on the edges. Stir the meat to ensure even cooking. After a couple minutes, use a large slotted spoon to remove meat from skillet. Drain on paper towels. Discard oil. Place skillet back over the heat and return meat to skillet, simmering for 1 minute. Add the sauce and cook for 1 minute while stirring, and then add all the green onions. Cook for 1 more minute, then remove the beef and onions with tongs or a slotted spoon to a serving plate. Serve over rice.

Crab Cakes

1 (16 ounce) can or pouch crab meat	2 egg whites
3 tablespoons reduced-fat mayonnaise	1 tablespoon lemon juice
2 teaspoons Dijon mustard	2 teaspoons fresh dill
1/2 teaspoon Old Bay seasoning	1/2 cup whole-wheat Panko bread crumbs

Heat the oven to 350 degrees. In a large bowl, combine the crab meat, egg whites, mayonnaise, lemon juice, mustard, dill, and seasoning; mix well, forming little cakes. In a separate bowl, toss each cake in Panko crumbs to form crust. Place crab cakes on baking sheet. Bake in oven for 20 minutes or until cakes are browned on top.

Hopping John

1 cup celery, sliced
2/3 cup onion, chopped
1 clove garlic, minced
1 tablespoon vegetable oil or bacon drippings
4 cups water
2 (10 3/4 ounce) cans Campbell's condensed chicken broth, undiluted
1 (16 ounce) package frozen black-eyed peas
1/2 pound cooked ham, cubed
1/4 teaspoon cayenne pepper (more to taste)
1 bay leaf
3 cups long-grain rice, cooked

Sauté celery, onion, and garlic in vegetable oil in a large Dutch oven until tender. Add water and remaining ingredients except rice. Bring to a boil; cover, reduce heat, and simmer 40 minutes or until peas are tender. Remove and discard bay leaf, and serve mixture over rice. Note: To cook rice with black-eyed peas, stir 1 cup uncooked long-grain rice into peas after 40 minutes, and simmer an additional 35 minutes.

Southern Rice

Makes 6 to 8 servings

cooking spray
1 cup celery, sliced
3/4 cup green onions, sliced
3/4 cup green pepper, chopped
2 3/4 cups chicken broth
1 teaspoon poultry seasoning
1/2 teaspoon salt
1/8 teaspoon pepper
1 1/2 cups long-grain rice, uncooked
1/4 cups chopped pecans, toasted

Coat a large nonstick skillet with cooking spray; place over medium-high heat until hot. Add celery, green onions, and green pepper; sauté until crisp-tender. Stir in broth and next 3 ingredients; bring to a boil. Spoon rice into a shallow 2-quart baking dish; add hot broth to mixture. Cover and bake at 350 degrees for 30 minutes or until rice is tender and liquid is absorbed. Sprinkle with pecans.

Mex–Tex Soup

Makes 4 servings

1 cup onion, chopped	1 cup green pepper, chopped
1 cup tomato, chopped	1/2 cup fresh parsley, chopped
2 (14.5 ounce) cans chicken broth	1 teaspoon dried whole oregano
1 1/2 teaspoon chili powder	3/4 teaspoon ground cumin
1/2 teaspoon salt	1/2 teaspoon pepper
1 bay leaf	1 teaspoon brown sugar

1 teaspoon garlic powder
1 cup diced cooked chicken breast, skinned before cooking
1/2 cup shredded sharp cheddar cheese
tortilla chips

Combine all ingredients (except chicken, cheese, and tortilla chips) in a Dutch oven. Bring to a boil; cover, reduce heat, and simmer 30 minutes. Remove bay leaf, and stir in diced chicken; cook until soup is thoroughly heated. Pour soup into individual serving bowls. Top each serving with shredded cheese and tortilla chips.

White Bean Dip

1 can (15 ounces) cannellini beans, rinsed and drained
8 garlic cloves, roasted
2 tablespoons olive oil
2 tablespoons lemon juice

In a blender or food processor, add the beans, roasted garlic, olive oil, and lemon juice. Blend until smooth. Serve with pita triangles or fresh veggies.

White Chili

If you are tired of the same old beef chili, this is a great alternative.

2 tablespoons olive oil
2 boneless chicken breast halves, diced
12 to 16 ounces chicken or turkey sausage
1 cup onion, chopped
4 cloves garlic, minced
2 cans (16 ounces) Great Northern beans, drained and rinsed
1 1/2 cups tomatillo salsa
1 cup chicken broth
1 can (14.5 ounce) diced tomatoes with juice, fire-roasted or chili-style
1 cup frozen corn kernels
2 tablespoons finely chopped jalapeno peppers, or mild chile peppers (or a combination!)
1 1/2 teaspoons ground cumin
1/2 teaspoon salt
1/4 teaspoon ground black pepper
dash of cayenne pepper, optional (just do it)

In a large skillet, heat olive oil over medium heat. Add the onions, diced chicken, and sliced sausage. Sauté until onions are tender and chicken is cooked through. Put the drained beans in a 4 to 6-quart slow cooker; add the skillet mixture and all remaining ingredients. Cover and cook on high for 3-4 hours or 6-8 hours on low.

Kale Soup

1/2 cup yellow split peas
1 1/2 pounds kale
1 onion, chopped
1 cup of mushrooms, sliced
2 cups carrot juice
1 (46 ounce) can tomato juice

Cook 1/2 cup yellow split peas until soft. Cook 1 and 1/2 pound of Kale until soft (bite size pieces). Add one onion, 1 cup of mushrooms, 2 cups of carrot juice, and a can of tomato juice. Cook until all ingredients are done and hot. Serves about 4.

Cream of Cilantro Soup

1 bunch fresh cilantro, reserve few sprigs for garnish
1 (32 ounce) cans low-sodium low-fat chicken broth
2 tablespoons butter
2 tablespoons flour
1 (8 ounce) package fat free cream cheese
1 (8 ounce) container light sour cream
1 cloves garlic, minced
1/2 teaspoon salt
1/2 teaspoon cayenne pepper
1/2 teaspoon cumin
6 teaspoons chopped cilantro for garnish
red pepper flakes for garnish

Reserve a couple of cilantro sprigs for garnish. Remove stems from rest of cilantro and finely chop leaves. Add 1 cup broth and chopped cilantro to food processor or blender. Puré until smooth, stopping to scrape down sides. In a large saucepan melt the butter over medium heat and whisk in the flour. Slowly add the remaining broth, whisking to smooth.

Boil, while whisking, for 1 minute. Stir in the cream cheese, cilantro mixture, sour cream, garlic, salt, pepper, and cumin. Reduce heat and simmer for 15 minutes. Ladle into bowls and garnish if desired.

Cucumber Dip

1 cup low-fat plain yogurt
4 ounces low-fat cream cheese
1/2 cup cucumber, seeded and diced
1 clove garlic, minced
2 tablespoons fresh dill, chopped
1 teaspoon lemon zest
salt and pepper to taste

Blend yogurt and cream cheese until smooth. Add remaining ingredients and mix well. Serve with your favorite vegetables.

Healthy Ranch Dip

1/2 cup buttermilk, low fat or non fat
1/3 cup low fat real mayonnaise
2 teaspoons dried dill
1 tablespoon lemon juice
1 teaspoon Dijon mustard
1 teaspoon honey
1/2 teaspoon garlic powder
salt and pepper to taste

Whisk all ingredients together and serve with baby carrots, sliced red bell peppers, snap peas, broccoli and cauliflower florets, cucumber spears, and grape tomatoes.

Avocado Boats with Tuna

2 avocados, halved and pitted
1 1/2 (4.5 ounces) cans tuna, drained
1/2 red bell pepper, diced
1/2 jalapeño, minced
1/2 cup cilantro leaves, finely chopped
1/2 lime, juiced
1/4 teaspoon cayenne pepper
salt to taste

Cut avocado in half and remove pit. Scoop out some of the avocado to widen the "bowl" area. Place scooped avocado into a medium-size bowl and mash avocado with a fork. Stir in next 4 ingredients. Add lime juice and cayenne; mix well. Spoon tuna into the avocado bowls. Season with salt and serve.

Curried Chicken Salad

1/2 cup low-fat mayonnaise
2 tablespoons lemon juice
2-3 teaspoons curry powder
2 cups deli rotisserie chicken, diced
1 small red delicious apple, chopped
1 cup seedless red grapes, halved
1 cup celery, diced
1/4 cup almonds, slivered
1/4 cup tablespoons raisins
1/2 teaspoon salt and pepper

In a large bowl, combine, mayonnaise, lemon juice and curry powder. Gently stir in chicken apple, grapes, celery, almonds, and raisins. Salt and pepper to taste. Chill before serving, if desired.

Blueberry Bran Muffins

6 cups original All-Bran cereal
3 cups sugar
4 eggs
1 quart buttermilk
5 cups King Arthur whole wheat flour
5 teaspoons baking soda
2 teaspoons salt
1 cup canola oil
4 cups frozen blueberries
1 cup finely chopped pecans (optional)

Preheat oven to 400 degrees. In a small bowl, pour 2 cups of water over 2 cups of bran cereal and let set while assembling the rest of the ingredients. In a very large mixing bowl, whisk the eggs, buttermilk, and sugar. In a large mixing bowl, whisk the flour, soda, and salt. Gradually stir the dry ingredients into the wet ingredients. Stir in the oil, all of the wet and dry cereal, the blueberries, and the nuts. Pour batter into pre-sprayed muffin tin and bake 15-20 minutes until just done. (This batter may be saved in the refrigerator for up to 6 weeks.)

Peppermint Cookies

2 egg whites
1/8 teaspoon salt
1/8 teaspoon cream of tartar
1/2 cup white sugar
2 peppermint candy canes, crushed

Preheat oven to 225 degrees. Line 2 cookie sheets with foil. In a large mixing bowl, beat egg whites, salt, and cream of tartar to soft peaks. Gradually add sugar, continuing to beat until whites form stiff peaks. Drop by spoonfuls 1 inch apart on the prepared cookie sheets. Sprinkle crushed peppermint candy over the cookies. Bake for 1 1/2 hours in preheated oven. Meringues should be completely dry on the inside. Do not allow them to brown. Turn off oven. Keep oven door ajar, and let meringues sit in the oven until completely cool. Loosen from foil with metal spatula. Store loosely covered in cool dry place for up to 2 months.

Coconut and Chocolate Cookies

1 cup flaked sweetened coconut
1 cup all-purpose flour
1/2 teaspoon baking powder
1/4 teaspoon baking soda
1/8 teaspoon salt
3/4 cup packed brown sugar
1/4 cup unsalted butter, softened
1 teaspoon vanilla extract
1 large egg
2 ounces dark chocolate (70% cacao), chopped
cooking spray

Preheat oven to 350 degrees. Arrange coconut in a single layer in a small baking pan. Bake for 7 minutes or until lightly toasted, stirring once. Set aside to cool. Lightly spoon flour into a dry measuring cup; level with a knife. Combine flour, baking powder, baking soda, and salt in a medium bowl; stir with a whisk until blended. Place sugar and butter in a large bowl; beat with a mixer at medium speed until well blended. Beat in vanilla and egg. Add flour mixture, beating at low speed just until combined. Stir in toasted coconut and chocolate. Drop by level tablespoons 2 inches apart onto baking sheets coated with cooking spray. Bake at 350 degrees for 10 minutes or until bottoms of cookies just begin to brown. Remove from pan and cool completely on wire racks.

Berry Filled Cinnamon Crepes

1/2 cup fresh raspberries
1/2 cup fresh blueberries
1/2 cup fresh blackberries
1/2 cup small strawberries, quartered
2 tablespoon granulated sugar
2 bananas, cut into 1/2-inch slices
4 CINNAMON CREPES RECIPE FOLLOWS
powdered sugar (optional)

Combine first 6 ingredients in a saucepan over medium-low heat. Cook 4 minutes or until thoroughly heated, stirring occasionally.

Place 1 CINNAMON CREPE on each of the 2 plates; spoon about 1/2 cup fruit mixture in center of each crepe. Fold bottom edge of crepe (closest to you) over fruit; fold in both sides of crepe over fruit. Arrange, seam sides down, on plates. Sprinkle with powdered sugar if desired.

CINNAMON CREPES
3/4 cup all-purpose flour
3/4 cup half-and-half
1/4 cup whole milk
1/4 cup granulated sugar
1/2 teaspoon ground cinnamon
1/4 teaspoon vanilla extract
dash of salt
2 large eggs
cooking spray

Combine flour and next 7 ingredients (through eggs) in a food processor or blender and blend until smooth. Pour batter into a bowl; cover and chill for at least 1 hour.

Heat a medium nonstick skillet over medium-high heat. Coat pan with cooking spray; remove pan from heat. Pour 1/4 cup batter into pan; quickly tilt pan in all directions so batter covers pan with a thin film. Cook 1 minute or until surface of crepe begins to look dry.

Carefully lift edge of crepe with a spatula to test for doneness. Turn crepe over when the underside is lightly browned; cook crepe 20 seconds on the other side.

Place crepe on a paper towel and cool. Repeat the procedure until all of the batter is used. Stack the crepes between single layers of wax paper or paper towels to prevent them from sticking.

Apple Dumplings

1 1/2 tablespoon butter

1 1/2 teaspoon honey

1 1/2 cups whole-wheat flour

3 tablespoons buckwheat flour

3 tablespoons rolled oats

3 tablespoons brandy or apple liquor

8 large tart apples, thinly sliced

1 1/2 teaspoons cinnamon

1 1/2 teaspoon nutmeg

3 tablespoons honey

zest of one lemon

Combine butter, honey, flours, and oats in food processor. Pulse until mixture looks like a fine meal. Add brandy or apple liquor and pulse until mixture forms a ball. Remove dough from food processor, wrap tightly in plastic, and refrigerate for two hours.

Preheat the oven to 350 degrees. Mix apples, cinnamon, nutmeg, and honey. Add lemon zest. Set aside. Roll out refrigerated dough with extra flour to 1/4-inch thickness. Cut into 8 or 9 inch circles. Use an 8-cup muffin tin and lightly coat the muffin tin with cooking spray. Lay a circle of dough over each lightly sprayed cup. Push dough in gently. Fill with apple mixture. Fold over sides and pinch at top to seal. Bake for 30 minutes at 350 degrees until golden brown.

Mocha Ricotta Cheese with Strawberries

1 cup Friggo ricotta cheese

3 packages sugar substitute

1 teaspoon Hershey's cocoa

1/2 teaspoon instant coffee or espresso powder

1/2 teaspoon vanilla extract

Combine all ingredients in a small bowl and whisk to mix evenly. Cover and chill for several hours. Serve with fresh strawberries.

Apple Cupcakes with Cinnamon Frosting

1 1/2 cups apples, peeled and shredded

1/2 cup dried apples, diced

3 tablespoons light brown sugar, plus 3/4 cup, divided

1 teaspoon ground cinnamon, divided

1/3 cup canola oil

2 large eggs

1 teaspoon vanilla extract

3/4 cup whole-wheat pastry flour

3/4 cup cake flour

3/4 teaspoon baking soda

1/4 teaspoon salt

1/2 cup nonfat buttermilk

FROSTING

1 cup light brown sugar

1/4 cup water

4 teaspoons dried egg whites reconstituted according to package directions

1/4 teaspoon cream of tartar

1/4 teaspoon salt

1 teaspoon vanilla extract

1/2 teaspoon ground cinnamon

Preheat oven to 350 degrees. Line 12 muffin cups with cupcake liners or coat with cooking spray. Combine shredded and dried apples in a bowl with 3 tablespoons brown sugar and 1/4 teaspoon cinnamon. Set aside. Beat oil and the remaining 3/4 cup brown sugar in a large mixing bowl with an electric mixer on medium speed until well combined. Beat in eggs one at a time until combined. Add vanilla, increase speed to high, and beat for 1 minute.

Whisk whole-wheat flour, cake flour, baking soda, salt, and the remaining 3/4 teaspoon cinnamon in a medium bowl.

With the mixer on low speed, alternately add the dry ingredients and buttermilk to the batter, starting and ending with dry ingredients and scraping the sides

of the bowl as needed, until just combined. Stir in the reserved apple mixture until just combined. Divide the batter among the prepared muffin cups. (The cups will be full.)

Bake the cupcakes until a toothpick inserted into the center of a cake comes out clean, 20-22 minutes. Let cool for at least 1 hour before frosting.

For frosting, bring 2 inches of water to a simmer in the bottom of a double boiler. Combine 1 cup brown sugar and 1/4 cup water in the top of the double boiler. Heat over the simmering water, stirring, until the sugar has dissolved, 2-3 minutes. Add reconstituted egg whites, cream of tartar, and pinch of salt. Beat with an electric mixer on high speed until the mixture is glossy and thick, 5-7 minutes. Remove from heat and continue beating 1 minute more to cool. Add vanilla and 1/2 teaspoon cinnamon and beat on low until mixed. Spread or pipe the frosting onto the cooled cupcakes and sprinkle cinnamon on top.

Healthy Fruit Cookies

3 ripe bananas

3 diced apples

1/4 cup walnuts, chopped

3 cups rolled oats

1 cup dates, pitted and chopped

1/4 cup shredded coconut

1/4 cup wheat germ

1/3 cup applesauce (or more if needed)

1 teaspoon vanilla extract

1 teaspoon cinnamon

1 teaspoon nutmeg

Preheat oven to 325 degrees. In a large bowl, mash the bananas. Stir in rest of ingredients. Mix well and allow to sit for 15 minutes. Drop by teaspoonfuls onto a parchment lined cookie sheet. (Don't forget parchment paper; these cookies can stick to cookie sheet.)

Bake for 15- 20 minutes in the preheated oven, or until lightly brown.

As years unfold, happy Mem'ries we'll hold,

Left: Dr. and Mrs. Archie P. McDonald, 1980s

President Jimmy Carter, 1988

Stephen F. Austin Statue Dedication, 1986

Homer Bryce Doctoral, 1993

LIEUTENANT GENERAL ORREN RAY "COTTON" WHIDDON graduated from Stephen F. Austin University in 1955, was drafted into the US Army as a Buck Private and upon completion of OCS in 1956, he was commissioned a 2nd Lieutenant, Field Artillery. General Whiddon served two tours in Vietnam, including G2, 101st Airborne and in a variety of career building assignments, including Ft. Sill, OK; Vicenza, Italy; Ft. Leavenworth, KS; The Pentagon (numerous); Giessen, Germany (twice); SHAPE, Mons, Belgium; Ft. Polk, LA; and Ft. Eustis, VA. Other key assignments include AFCENT, The Netherlands; and Commanding Gen., 8th ID, Bad Krueznach, Germany. Gen. Whiddon retired in 1990 as Commanding Gen., Second United States Army, Ft. Gillem, GA. Awards and decorations Gen. Whiddon received include the Distinguished Service Medal (2 Oak Leaf Clusters), Defense Superior Service Medal (1 Oak Leaf Cluster), Legion of Merit (3 Oak Leaf Clusters), Bronze Star Medal (two Oak Leaf Clusters), Meritorious Service Medal (4 Oak Leaf Clusters), Air Medal (5 Oak Leaf Clusters), Army Commendation Medal (2 Oak Leaf Clusters), Army Good Conduct Medal (1 Oak Leaf Cluster), National Defense Service Medal (1 Oak Leaf Cluster), Vietnam Service Medal (3 Oak Leaf Clusters), Army Service Ribbon (1 Oak Leaf Cluster) and Overseas Service Ribbon (Oak Leaf Clusters). Gen Whiddon is authorized to wear the Combat Infantry Badge, Parachutist Badge, Joint Chiefs of Staff ID Badge, and Army Gen. Staff ID Badge. General Whiddon was inducted into Stephen F. Austin University's Alumni Hall of Fame in 1988.

Ol' Cotton

A M-1A 75-millimeter howitzer was brought to SFA in October of 1994. This cannon is used at football games to signal when SFA scores. The retired gun sits in front of the Military Science building on East College Street when not at the football games. The cannon was first fired at a football game on November 19, 1994, after President Dan Angel approved the firing because of student requests. Prior to each firing, safety precautions are taken to ensure no injuries occur.

Ol' Cotton

Duck Dash

The Duck Dash started on November 16, 1991. Sponsored by the Alumni Association, the proceeds benefit the organization and a scholarship fundraiser. Rubber ducks can be purchased, one for $5 or six for $25, and are entered into a race. Multiple heats are run with the finalists racing to determine prizes. In 1999 the Duck Dash was moved to Lumberjack Alley, but has since moved back to the Ag Pond.

The Oldest Town in Texas has it Cooking

The president's home at SFA has always been a lively and desirable place for parties and receptions. When the house was officially dedicated and renamed the Juanita Curry Boynton house in 2003 and when the house was remodeled in 2010, the enhancements to the home made entertaining easier and more efficient for hosting larger groups of supporters.

The events hosted in the house during a president's tenure are a reflection of his own personality and preferences. During President Boynton's presidency, picnics in the yard were frequent events. The Steens enjoyed having students over for sing-alongs. After Mrs. Steen died, Dr. Steen entertained at the University Center. Each year at Christmas time, he invited the faculty to a Sunday afternoon reception in the ballroom. These were formal events; the ladies wore long dresses, and sparkling grape juice was served with the bottles wrapped in cloth like champagne. Guests may or may not have been aware of the content of the bottles. Occasionally a person left the reception claiming to feel a bit "tipsy," but I suppose that was just the Christmas spirit they were feeling.

During the William R. Johnson presidency, Baker became a vice president, and we were invited to many dinners honoring our Board of Regents, who meet on campus at least four times each year. Freida Johnson was an excellent cook and prepared the dinners herself, often working all night in order to prepare the meal. The tables were set beautifully for these very formal dinners, and the conversations were always interesting and enjoyable.

Baker and I have continued the Johnsons' tradition of serving dinner to the Board of Regents, and we also host picnics for the SFA faculty and staff and for the Lumberjack Marching Band, as well as dinners for the dignitaries who speak at SFA's commencement ceremonies. We host dinners and receptions for student groups and for special university guests, alumni and donors. Thanks to Aramark, I have lots of help and no "all-night" cooking marathons, but I am always on the search for new recipes, table settings and arrangements.

Since my retirement as chair of the Department of Elementary Education, I have enjoyed devoting much more of my time to making sure that the university is represented at each event in the best possible manner and in a way that reflects the spirit of SFA. It is an honor to live in this historic home. Baker and I work every day to ensure that future generations of Lumberjacks will feel the same pride in this university that we do.

—Janice Pattillo

DR. ALTON BIRDWELL was the first President of the University, then Stephen F. Austin State Teachers' College. He served in this capacity from 1923 to 1942. His First Lady, Maude, was active in carrying out her responsibilities as the President's wife. The Birdwells lived in a white frame home located on the corner of Starr and Clark Boulevard, the site of the present President's home. The Birdwell Building on campus provides a lasting recognition of the contributions of the first President.

Mrs. Sidney Orton was a friend of Anne Birdwell (Dr. and Mrs. Birdwell's daughter). She often ate with the Birdwells and remembers that two favorite dishes were Stuffed White Patty Squash and Hot Spoon Bread (the bread usually was served for supper). She says that all the Birdwells loved coffee.

Miss Sugene Spears became Dr. Birdwell's secretary in 1930. She remembers that roast was a favorite food of the Birdwells. Receptions at that time were all-college affairs for both students and faculty. Miss Spears recalls the punch and cookies that had been prepared by the college dietitian were served at all the receptions.

Mrs. Ruth Fouts Pochmann was a student-assistant and member of the first graduating class. She related that Mrs. Birdwell often asked her to help greet guests at the many parties she and Dr. Birdwell gave for students and faculty, and occasionally for townspeople, too. Mrs. Pochmann shared a recipe for Schaum Torte with Mrs. Birdwell. She recalls that Dr. Birdwell declared it to be the best dessert he had ever eaten, so Mrs. Birdwell had the cook prepare the torte for a small dinner party for eight. When the cook and her assistant had cleared the table for the dessert, Mrs. Birdwell herself went to the kitchen and brought in the beautiful torte, with 2 small candles aflame in the center. She set it down in front of her husband saying, "Make a wish out loud, Alton, before you blow them out." Dr. Birdwell gave his distinctive, throaty laugh as he said, "May the next 2 years be easier than the first two have been, but every bit as happy." Then he asked Mrs. Birdwell to serve it! The recipe is provided by Ruth Pochmann who was a member of the first graduating class in 1925.

**Mrs. Paul L. Boynton (second First Lady) remembers that this Birdwell menu was a favorite.

Fried Chicken
Mashed Potatoes
String Beans
Corn on the Cob
Apple Pie
Iced Tea

Schaum Torte

7 egg whites
2 cups of sugar
2 talbespoons vinegar
1 teaspoon vanilla
1 carton (1/2 pint) whipping cream, whipped and sweetened
1 cup pineapple chunks
12 maraschino cherries

Whip egg whites until they peak. Gradually add the sugar while beating. Fold in the vinegar and vanilla. Pour into a spring-form pan. Cook for 1 hour at 150 to 200 degrees. It should be slightly browned. Remove from oven and cool. Then remove the sides of the pan. Also take off the fallen top in pieces and lay them on a plate, not touching one another. Into the whipped cream, fold the drained pineapple, and pour onto the base of the torte. Cut up the cherries and sprinkle over the top. Then stick the pieces of crust (that are on the plate) into the topping in vertical position. This torte is spectacular when served whole at table, but is just as delicious served in individual portions and brought to the table. Mrs. Birdwell added small lighted candles for dinner parties! (Two to six small candles may be used.)

—Reprinted from: THE BEST OF SFA *Diamond Anniversary Edition*, 1998

DR. PAUL BOYNTON was President of the college from 1942 to 1958. He and his First Lady, Juanita, came to Nacogdoches with their two children, Edwin and Paula. Both children graduated from the University. Dr. Boynton provided strong leadership during the course of the war and postwar era. The Boynton Building on campus is named in his memory.

Dignity and protocol were readily evident in the Boynton era. Dr. Boynton is remembered by many as a "courtly gentleman" who was a stimulating conversationalist with a keen wit. A tall and slender man, he was always well groomed, had rather formal manners, and was a friend to students. First Lady, Juanita, established a reputation for being a gracious hostess who met the public well and who entertained effortlessly. She is credited with bringing the townspeople and college personnel together on numerous occasions.

The Boyntons entertained a great deal. Although Mrs. Boynton planned many of the parties alone or with Dr. Boynton, she also was a good sport about impromptu guests.

For example, Dr. Boynton was in Washington when the moving van arrived at the President's home with their furniture. Mrs. Boynton had been working for two days straightening the house when Dr. Boynton arrived home with the news that he had secured a WAAC unit for SFA and needed to hold a conference with his top administrators at home. Weary though she was, Mrs. Boynton cheerfully put the coffee pot on and prepared to serve refreshments.

President and Mrs. Boynton entertained new faculty each year at a dinner in their home. They also hosted the President's annual reception, graduation receptions, and other special occasions in their home, and often in the midst of their beautifully landscaped garden. The present President's home was built during the Boynton era. Mrs. Boynton survives her husband and makes her home in Nacogdoches. The former First Lady maintains her loyalty to the University and, in addition, is very active in social activities in the city. Juanita and Freida (present First Lady) have developed a close personal friendship. Favorite family menus were provided by Mrs. Boynton, who also served as a valuable member of the Cookbook Advisory Committee. Mrs. Boynton comments, "Angel Food Cake was the only thing I could cook when we married! We often got 'old' hams from Kentucky and Tennessee where we formerly lived. The Orange-Pecan Muffins were a family favorite."

—Reprinted from: THE BEST OF SFA *Diamond Anniversary Edition*, 1998

Swedish Pound Cake

1 cup (2 sticks) margarine
2 cups sugar
5 eggs
2 cups sifted flour
1 teaspoon vanilla
6 ounces chocolate chips
1 cup flaked coconut
1 cup chopped nuts

Cream margarine and sugar. Add eggs and beat well. Stir in 2 cups sifted flour, vanilla, chocolate chips, coconut, and nuts. Pour into greased and floured bundt pan. Bake 1 hour at 325 degrees. Allow to cool slightly and remove from pan. Spread topping over cake while still warm.

TOPPING:
In small saucepan, combine 3/4 cup sugar and 3/4 cup water. Boil 3 minutes. Remove and add 1/2 stick margarine and 1 teaspoon almond extract; blend. Spread over cake while warm.

Ham Loaf or Ham Balls

1 1/2 pounds lean fresh pork ham
1 1/2 pounds lean cured ham
1/2 teaspoon salt
1/2 teaspoon pepper
1 teaspoon dry mustard
1 cup milk
1 cup cracker crumbs
1 egg

SAUCE:
1 1/2 cups brown sugar
1/4 cup water
1/2 cup vinegar

Grind together fresh pork and cured ham; add rest of the ingredients and form into loaf or balls. Bake, uncovered, at 350 degrees for 1 1/2 hours for loaf (less for balls). Baste often with sauce while cooking. For sauce, combine all ingredients and cook slowly for five minutes. Serve with ham.

Garlic Grits

2 cups grits
1 1/2 quarts water
1/2 cup milk
2 rolls (6 ounce) garlic cheese
4 beaten eggs
1 stick (1/2 cup) butter
Salt and Pepper

Cook grits in water until done. Add remaining ingredients and mix. Pour into casserole. Sprinkle top with Parmesan cheese and paprika. Bake 30 minutes at 300 degrees.

Sausage Balls

1 pound pan sausage
3 cups packaged biscuit mix
1 cup grated cheese

Mix all ingredients together thoroughly. Form into desired-sized balls. Bake 20 minutes at 300 degrees.

Quick Raspberry Salad

3 packages (3 ounce) raspberry Jello
2 cups boiling water
1 can (16 ounce) whole cranberry sauce
1/2 pint (1 cup) sour cream

Combine Jello and boiling water and stir until Jello is completely dissolved. Stir in cranberry sauce. Refrigerate. When mixtures starts to jell, add sour cream and blend. Pour into individual molds and allow to congeal.

Cranberry Surprise Corn Muffins

1 cup cornmeal
1 cup flour
1/4 cup sugar
4 teaspoons baking powder
1/2 teaspoon salt
1 cup milk
1 egg, beaten
1/2 cup vegetable oil
1/2 cup orange-cranberry relish

Heat oven to 400 degrees. Combine cornmeal, flour, sugar, baking powder, and salt. Combine milk, egg, and oil and add to dry ingredients. Mix until dry ingredients are moistened. Fill greased muffin cups 2/3 full. Place 1 /2 teaspoons of relish into center of each cup. Press lightly into batter. Bake 15 to 20 minutes. Cool 5 minutes in muffin pan. Remove to wire cooling rack. Makes one dozen muffins.

Orange-Pecan Muffins

1 egg, slightly beaten
1/2 cup sugar
1/2 cup orange juice
2 tablespoons salad [vegetable] oil
2 cups biscuit mix
1/2 cup orange marmalade
1/2 cup chopped pecans
1/4 cup sugar
1 1/2 tablespoons flour
1/2 teaspoon cinnamon
1/4 teaspoon nutmeg
2 tablespoons butter

Combine first four ingredients. Add to biscuit mix and beat vigorously for 30 seconds. Stir in marmalade and pecans. Grease muffin pans or line with paper baking cups; fill 1/4 full. Combine 1/4 cup sugar, flour, cinnamon, and nutmeg; cut in butter until crumbly. Sprinkle over batter. Bake at 375 degrees for 20 to 25 minutes.

Creamy Lemon Meringue Pie

3 eggs, separated
1 can (14 ounce) sweetened Condensed milk
1/2 cup lemon juice
1 teaspoon lemon rind
1 prepared graham cracker crust
1/4 teaspoon cream of tartar
1/3 cup sugar

Preheat oven to 350 degrees. Beat egg yolks; stir in sweetened condensed milk, lemon juice and rind. Pour into crust. In small bowl, beat egg whites with cream of tartar until foamy. Gradually add sugar, beating until stiff. Spread on top of pie. Bake until light brown, about 15 minutes. Chill before serving.

Angel Food Cake

1 1/2 cups sugar
1 cup sifted cake flour
1/2 teaspoon salt
1 1/4 cups egg whites (10 to 12)
1 1/4 teaspoons cream of tartar
1 1/2 teaspoons almond extract

Add 1/2 cup of the sugar to flour. Sift together 4 times. Add salt to egg whites and beat with rotary beater until foamy. Sprinkle cream of tartar over eggs and continue beating to soft-peak stage. Add the remaining cup of sugar by sprinkling 3/4 cup at a time over egg whites and blending carefully, about 20 strokes each time. Fold in extract. Sift flour-sugar mixture over egg whites about 1/4 at a time and fold in lightly, about 10 strokes each time. Pour into 10 inch tube pan which has been lightly floured but not greased. Bake at 350 degrees for 35 to 40 minutes. Remove from oven and invert pan on cooling rack a minimum of one hour before removing and slicing.

Forgotten Cookies

1 1/2 cup egg whites
1 1/4 cups sugar
1/4 teaspoon salt
1 teaspoon vanilla
2 1/2 cups moist shredded coconut

Preheat oven to 375 degrees. Beat egg whites until stiff. Beat in sugar, salt, and vanilla. Blend in coconut. Drop one teaspoonful at a time, 2 inches apart, on greased baking sheet. Place in preheated 375 degree oven. Turn off oven and leave overnight.

Plum Cake

2 cups self-rising flour
2 cups sugar
1 teaspoon cinnamon
1 teaspoon cloves
1 cup vegetable oil
3 eggs
2 small jars (4 1/2 ounces each) plum baby food
1 cup chopped pecans or walnuts

Combine ingredients in a large bowl and mix well. Bake in a greased and floured bundt pan for 1 hour and 15 minutes, at 350 degrees. Glaze with plum jelly while hot. This freezes well.

Sally Lunn Bread

1 package (.25 ounce) dry yeast
1 teaspoon warm water
1 cup milk, scalded
1/2 cup sugar
1 stick margarine
3 eggs, beaten
4 cups flour
2 teaspoons salt.

Mix yeast, 1 teaspoon sugar, and warm water. Scald milk. Add 1/2 cup sugar and margarine, and stir to melt margarine. Cool, then add yeast mixture. Add beaten eggs and salt. Using mixer, beat in 4 cups flour. Let rise 2 hours. Beat down and pour into greased bundt pan. Let rise. Bake at 325 degrees for 45 minutes. This tastes like bread but looks like a cake. Freezes well.

Center. Mr. Elmer Childers, Director of Food Service for the University, recalls that Dr. Steen preferred beef to chicken and especially favored steaks, fruit pies, and frozen desserts on the menu. Mr. Childers related that Dr. Steen was very particular about table settings and was concerned if the same fork was used for salad, main course, and dessert. He admired attractive table settings and service and always expressed his appreciation to the food service staff immediately following an entertainment function.

The Steens' love for Early American cut glass was well known to their friends and associates. The Gladys E. Steen Early American Cut Glass Collection was contributed to the Department of Home Economics by Dr. Steen prior to his retirement and is on permanent display in the foyer of the Home Economics Building. Dr. and Mrs. Steen were held in high esteem by the University community. The Gladys E. Steen Dormitory and the Ralph W. Steen Library are fitting tributes to an outstanding University First Family.

—Reprinted from: THE BEST OF SFA *Diamond Anniversary Edition*, 1998

DR. RALPH W. STEEN became SFA's third president in 1958. During his term of office, the college became a University. Dr. and Mrs. Steen (Gladys) entertained both in their home and in the new University Center. Mrs. Steen's recipe collection was given to her friend, Mrs. William Turner (Frances). Mrs Turner has shared Mrs. Steen's recipes with us, as well as her own memories of some of Mrs. Steen's favorites. Many of the recipes have Mrs. Steen's own comments written on them, and her comments have been included.

Mrs. Steen was the first President's wife to serve sparkling Katawba grape juice (nonalcoholic champagne) at the President's reception in the early 1960s. Everyone thought it was alcoholic champagne, and many were shocked that it was served on campus! It became a tradition and is still served frequently.

Tiny crescent mince meat pies brushed with butter and sugar became a traditional food for receptions while Mrs. Steen was first Lady. She often served bite-sized squares of cheese on a platter with the crescents arranged around the outer edge. She served all kinds of sandwiches, often including ribbon sandwiches made with brown and white bread and various fillings. Tiny cream puffs stuffed with savory fillings, such as chicken or ham salad, were served frequently. Miniature chocolate cake squares with pale pink frosting were a favorite for receptions, often served on a table with red candles, making a beautiful color combination. Fruits of various kinds were included. Fruit punch, as well as Katawba grape juice, was a part of the reception menu. Mrs. Steen always included enormous black olives, very large stuffed olives, and large mixed nuts. After Mrs. Steen's death in September of 1965, the University was without a First Lady until Dr. Steen retired in June of 1976. During this time, Dr. Steen entertained at the University

Stuffed Squash

1 tablespoon butter
4 large white or yellow squash
1 tablespoon chopped onion
1 tablespoon chopped green pepper
1 tablespoon chopped celery
1 cup shredded sharp cheese
1 cup soft bread crumbs
parsley
salt and pepper

Cook green pepper and onion in butter about 10 minutes. Scoop out centers of squash; leave shells about 1/4 inch thick. Combine vegetables, cheese, crumbs, and seasonings (and squash pulp, if any). Stuff; bake until done, about 45 minutes in moderate oven (350 degrees). Garnish with parsley. Chip celery and pepper, but not onion-grate it. Try chicken broth for liquid. I combine the two (squashes). Good.

Perfection Salad

1 tablespoon (1 envelope) Unflavored gelatin
1/4 cup cold water
1 cup hot water
1/4 cup sugar
1/2 teaspoon salt
1/4 cup vinegar
1 tablespoon lemon juice (fresh, frozen, or canned)
1/2 cup finely shredded cabbage
1 cup chopped celery
2 teaspoons chopped pimentos

Soften gelatin in cold water. Dissolve in hot water. Add sugar and salt. Stir until dissolved. Add vinegar and lemon juice. When mixture begins to thicken, add remaining ingredients. Turn into individual oiled molds. Unmold on cool crisp lettuce. (6 servings) Old-fashioned favorite.

Cabbage Salad

10 tablespoons sugar
2 teaspoons dry mustard
1 teaspoon salt
1 cup salad oil
1 small green onion, chopped finely
1/2 cup vinegar
1 tablespoon celery seed or poppy seed
cabbage

Put sugar, mustard, and salt in oil and beat until thick. Add onion, vinegar, and seeds. Fix ahead. Shred cabbage and use anytime needed.

Chocolate Nut Pie

3 squares (1 ounce each) bitter [unsweetened] chocolate
1 cup evaporated milk
1 cup sugar
1/4 cup flour
1/8 teaspoon salt
1 cup boiling water
3 eggs, separated
1 teaspoon vanilla
9 inch pastry shell, baked
1/2 cup chopped walnuts

Melt 3 squares bitter chocolate in 1 cup evaporated milk in top of double boiler. Mix sugar, flour and salt; add 1 cup boiling water and stir into chocolate mixture. Cover and cook 15 minutes, stirring frequently. Beat 3 egg yolks. Add hot chocolate mixture slowly to eggs, stirring constantly. Return to double boiler and cook until thick, about 3 minutes. Remove from heat. Add vanilla, cool, and pour into baked pastry shell. Sprinkle with chopped walnuts. Use 3 egg whites for meringue; or use 2 whole eggs, and serve with whipped cream. I add 1 heaping tablespoon of cornstarch for a thicker pie. A lump of butter is very good. Our favorite always.

Rice Krispie Cookies

1 cup fat [butter or crisco]
1 cup sugar
1 cup brown sugar
2 eggs
1 teaspoon vanilla
2 cups flour
1 teaspoon soda
1/2 teaspoon baking powder
1/2 teaspoon salt
2 cups oatmeal
1 cup coconut
2 cups Rice Krispies

Cream fat and sugars. Add eggs and vanilla. Sift dry ingredients together and then add oatmeal and coconut. Add to creamed mixture. Add rice krispies and mix. Form into tiny balls and put in ungreased pan. Bake slowly until brown at 350 degrees.
Good. Easy and good for Joe Ralph (Dr. and Mrs. Steen's son).

Mrs. Gossett's Grits Recipe

4 cups water
1 teaspoon salt
1 cup quick grits
1 roll (6 ounce) nippy garlic cheese
1 stick (1/2 cup) margarine
2 eggs
Milk

Let water and salt come to boil. Add grits. Cook 5 minutes. Turn off heat. Add cheese and margarine. Put eggs in a measuring cup and fill the cup with milk. Pour out in bowl and beat until well mixed. Add this to grits mixture. Grease casserole; pour in grits and bake about 40 minutes at 325 or until golden brown. Delicious. Try putting some chopped parsley in. (Mrs. Gossett was Mrs. William Turner's mother.)

My Roast and Gravy

Select a good roast, preferably prime rib. Put a little butter in heavy pan and heat. Put meat in and brown quickly, turning often. Turn heat to low and cook until very tender. Add a little hot water if necessary. Put sliced onions on top of roast as it cooks; remove onions when very tender, and discard. Salt and season about 20 minutes before done.

GRAVY:

Pour off all fat from liquid in roast pan. This liquid must cool long enough to skim fat off when it coines to top. Measure 2 tablespoons fat for every cup of gravy. Put in pan over low heat. Add 2 tablespoons flour for every 2 tablespoons fat. Brown. Add 1 cup cold water for every 2 tablespoons fat and flour. Stir. Cook until smooth and bubbly. Season well; a hot sauce is grand for seasoning! Add brown juices to gravy and stir until smooth. Keep roast hot.

Cabbage Rolls

2 or 3 pounds cabbage
1 large onion, chopped
2 tablespoons butter
1 pound ground veal
1/2 pound ground pork
3/4 cup wheat germ
1 3/4 teaspoon salt
1/2 teaspoon pepper
1/2 teaspoon seasoned salt
2 cups cooked rice

SAUCE:
1 can (10 3/4 ounce) cream of mushroom soup
2 1/2 cups tomato juice
1/4 teaspoon salt
1/8 teaspoon pepper

Core cabbage and set in large pan. Scald with boiling water to loosen leaves. Separate leaves and soak about 5 minutes to soften. Pare down heavy veins. Saute onion in butter. Mix meat, wheat germ, seasonings, and onion. Add rice and blend well. Fill each leaf with 2 or 3 tablespoons of meat mixture. Roll leaves, tucking in ends. Place rolls, lapped end down, in roasting pan. Blend together mushroom soup, tomato juice, and seasonings. Pour over cabbage rolls. Cover and bake at 350 degrees for 1 1/2 to 2 hours.

Apricot Sticks

1 package (1 pound) dried apricots, ground
1 cup sugar
1/2 cup orange juice
1/2 of an orange rind, ground, if desired

Combine the above and cook for 10 minutes. Stir or it will stick. Cool until ingredients can be rolled into smaller sticks. Roll in powered sugar. Very good. *I got* [this recipe] *from Frances Tuner in August 1962. Used every Christmas at President's reception.*

The Steen Cut Glass Collection

This beautiful and important collection of American Brilliant Period Cut Glass, which dates from 1876 to 1916, was presented to Stephen F. Austin State University by Dr. Ralph W. Steen, the third president of the university, in memory of his wife, Gladys E. Steen. Dr. Steen and his wife collected the crystal throughout their marriage and enjoyed using it during their years in the university president's home.

This extensive collection of more than 100 pieces of antique cut glass was accepted by the Department of Home Economics on behalf of the university from Dr. Steen when he retired in 1976. The collection was carefully preserved for more than 30 years by the faculty of that department, which later became the Department of Human Sciences, and then the SFA School of Human Sciences.

In 2008, the faculty of the School of Human Sciences generously allowed the collection to be moved to this display space, so that it may be seen and appreciated by students, faculty and staff, members of the community, and visitors to the university.

Left: SFA First Lady, Gladys E. Steen, 1964
Right: SFA First Lady, Dr. Janice Pattillo, 2016

JOHNSON FAMILY FAVORITES

DR. WILLIAM R. JOHNSON became the fourth President of Stephen F. Austin State University in the summer of 1976. Mrs. Johnson (Freida) and their teen-aged children, Scott and Alison, along with the family dogs, Elsa and Grindl, accompanied the President. Almost immediately, a flurry of activity began with the renovation of the house and the numerous activities of a busy family. Mrs. Johnson devotes much time and energy to her responsibilities as First Lady. She is known throughout the area as a gracious hostess and already is famous for the luncheons and parties held in their home. The newly renovated University Center provides an appropriate setting for the larger receptions and other special functions hosted by the President and First Lady.

In the renovation of the University Center, a small entertainment area was set aside as the First Ladies' Room. Thus, First Ladies at Stephen F. Austin State University were officially recognized with this tribute during the 1980's. The area is furnished and appointed in a manner that provides an appropriate setting for small intimate dinner parties. Mrs. Johnson, with her

quiet dignity and graciousness, deserves a great deal of credit for having inspired other to recognize the contributions made by the First Ladies of Stephen F. Austin State University. As an on-going project, Mrs. Johnson is researching the history of the First Families and recording the University's heritage for future generations.

Mrs. Johnson has been supportive of the cookbook project since its beginning. She collected recipes from the Birdwell Family members, members of the Board of Regents, and friends of the University. In addition, she tested many of the recipes in her own kitchen, where Dr. Johnson passed judgment on the results. Dr. Johnson likes a wide variety of dishes, from such traditional American ones as roast beef and turkey and dressing, to ethnic foods (such as Chinese, Mexican, Italian, and French). He has always encouraged Mrs. Johnson's culinary efforts. Dr. Johnson, an energetic man with man interests, is never idle. Though many evenings and weekends are filled with University events or civic affairs, there are also occasionally times when he does woodworking and plays the

guitar. Each January he travels to Guerrero, Mexico, for a week of bass fishing. Every summer he and Mrs. Johnson spend two or three days at the beach, his favorite vacation spot.

A fond father, Dr. Johnson has encouraged his children to pursue their own special interests. Alison, a slender, attractive, and vivacious brunette, is a social worker who graduated from SFA in December of 1982. Alison began cooking family meals (once a week) at the age of twelve, and catered a cocktail buffet for seventy during her sophomore year of college. Scott, a May, 1982, graduate of the University of Texas at Austin, anticipates finishing a Master's degree in Computer Science at SFA in May of 1984. Scott, gregarious and athletic, plays tennis and racquet ball, and lifts weights.

Dr. Johnson, known to his many friends as Bill, has provided effective leadership for the University. He has strong faculty, student, and community support. The growth of Stephen F. Austin State University has continued in an era of difficult economic conditions and declining national enrollments. Dr. Johnson has reorganized and strengthened the administrative and academic practices and policies of the University, which in many cases had lagged behind the rapid growth of SFA.

—Reprinted from: THE BEST OF SFA *Diamond Anniversary Edition,* 1998

Lace Cookies

2 eggs
1 cup sugar
2 tablespoons melted butter
2 teaspoons vanilla
1 cup oatmeal
1 cup nuts, chopped
1 cup shredded coconut
1/4 teaspoon salt

Beat eggs until light. Beat in sugar gradually, adding butter and vanilla afterward, and mixing well. Add remaining ingredients. Drop on greased baking sheet, using a heaping teaspoon batter for each cookie. Bake at 375 degrees until cookies are a delicate brown.

Beef Burgundy

2 pounds beef round tenderized, or sirloin
1 package (10 ounces) thin noodles
1 medium onion, finely chopped
4 tablespoons margarine
1 garlic clove, pressed
2 cans beef gravy
1/2 pint sour cream
salt and pepper, to taste
1/2 cup Burgundy wine

Cut beef into 1-inch cubes. Cook noodles. Sauté onions in margarine slowly until lightly browned. Remove onions from pan. Brown beef cubes slowly in drippings left in pan; add garlic, gravy, sour ream, salt, pepper, and onions. Line casserole dish with noodles; pour meat mixture over noodles. Bake in 325 degree oven for 1 hour and 30 minutes or until meat is tender. Add wine; bake 15 minutes longer. Yield: 6 servings.

Cornbread Sticks

1/2 cup sifted flour
2 1/2 teaspoons baking powder
1 tablespoons sugar
1/2 teaspoon salt
1 1/2 cups cornmeal
1 egg
2 tablespoons butter, melted
3/4 cup milk

Sift flour, baking powder, sugar, and salt. Add cornmeal and mix well. In separate bowl, mix egg and butter well. Then beat in the milk. Pour the liquid into the dry ingredients. Combine with a few rapid strokes. In oven preheated to 425 degrees, place well-greased cornbread stick pan. When the pan is quite hot, pour in the batter. Bake for 20 to 25 minutes. Makes 7 sticks.

Broccoli Soubise

1 bunch fresh broccoli
2 medium sized onions
2 tablespoons flour
3/4 cup plus 2 tablespoons chicken stock
6 tablespoons water
3 1/2 tablespoons butter
2 tablespoons flour
1/4 teaspoon salt
Pinch of white pepper
Pinch of nutmeg
Pinch of crumbled leaf thyme
1/2 cup milk

FIRST MAKE THE SAUCE SOUBISE:
1. Chip the onions into a heavy saucepan; add 6 tablespoons of the chicken stock, all the water, and 1 1/2 tablespoons butter.
2. Cover and simmer about 45 minutes. (Now skip to step 5).
3. Uncover, raise heat and boil vigorously until liquid is reduced to about 1/2 cup.
4. Pour into blender and puree. Set aside.
5. In top of double boiler, melt the remaining 2 tablespoons butter. Blend in flour, salt, pepper, nutmeg and thyme.
6. Whisk in the milk and the remaining 1/2 cup of stock and heat, stirring all the while, until thickened and smooth.
7. Set double boiler top over simmering water, cover and simmer about 45 minutes, stirring occasionally.
8. Blend in pureed mixture from Step 4.

Now: Wash the broccoli. Remover the large leaves and the tough part of the stalks. Steam until barely tender. Drain. Serve at once with the Sauce Soubise.

Velvet Cream Chocolate Pie

8 ounce softened cream cheese
1/4 cup sugar
1 teaspoon vanilla
2 eggs, separated
6 ounces chocolate chips
2 teaspoons margarine
1 cup whipped cream
3/4 cup chopped pecans
baked pic shell, 9 or 10 inch
pecan halves
whipped cream for garnish

Combine cream cheese, sugar, and vanilla; mix until well blended. Melt the chocolate chips with 2 teaspoons margarine in double boiler. Add the 2 egg yolks and the melted chocolate. Beat the egg whites until stiff. Gradually beat in the sugar and cream cheese mixture; fold into chocolate mixture.

Fold in whipped cream and chopped pecans.

Pour into baked pie shell. Chill until set. (May be frozen for several days). When ready to serve, arrange pecan halves on top in an attractive pattern and add a dollop of whipped cream. Slice into 6 or 8 pieces.

Fried Bread

1 1/2 cup cornmeal
1/4 teaspoon salt
boiling water
liquid shortening

Measure cornmeal into a bowl. Add salt and stir well. Pour enough boiling water into the cornmeal to make a stiff paste. Form into patties about 3 inches long and 1/2 inch thick. Preheat liquid shortening and fry patties until golden brown

JANICE AND BAKER PATTILLO NAMED CITIZENS OF THE YEAR 2011

by Archie P. McDonald

He wrestled a bear at his school's assembly.

She babysat children and worked with children in the church and that led her to want to become a teacher.

He lettered in high school football for three years, served his Tiger team at Arp High School as co-captain, earned appointment to all-district and all-East Texas teams—and classmates elected him "most likely to succeed."

First "car" date, Senior Prom, 1960

She served as president of Future Homemakers of America—and made sure the club selected him as its "beau." Both Baker and Janice have been honored for lifetime achievement by being named to the Arp High School Wall of Fame.

They can't remember when they met but know for certain that it occurred in Arp's Emanuel Baptist Church, where his pastor-father preached—active and emeritus—for 47 years. At the time of his retirement, the church named the sanctuary, where he had preached all those years, the Pattillo Education Center.

Janice and Baker Pattillo have been Nacogdoches and SFA bound nearly all their lives, and bound to the community and the school for the past 48 years.

Baker's involvement with SFA began when Dr. Ralph W. Steen delivered the commencement address at Arp High School in 1961, and the two developed a special bond soon afterward.

While Janice completed high school, Baker attended Tyler Junior College, then transferred to SFA in 1963 to study English and history, earning a bachelor's degree in 1965 and master's in guidance and counseling in 1966. During summers he mowed yards and worked for a company that installed oil well tanks.

After graduation from high school, Janice followed Baker's path to Tyler Junior College, then finished her degree at Baylor University. They married in 1966. She taught in the public schools in Tyler and also in Woden while Baker worked at SFA.

While still in graduate school, Baker spoke with Dr. Steen of his hope for future employment at SFA and Dr. Steen arranged for his appointment as assistant director of placement and financial aid. "We processed every application by hand in those days," Baker said, "and I made $1.25 an hour—lots less than Janice earned as a teacher."

When Baker enrolled in Texas A&M University's doctoral program in guidance and counseling, he spent four days each week in College Station and three days working in Nacogdoches at SFA. Dr. Steen let Baker write his dissertation in a room located on the third floor of the Austin Building—exactly the same room that is now Baker's office as president of the University.

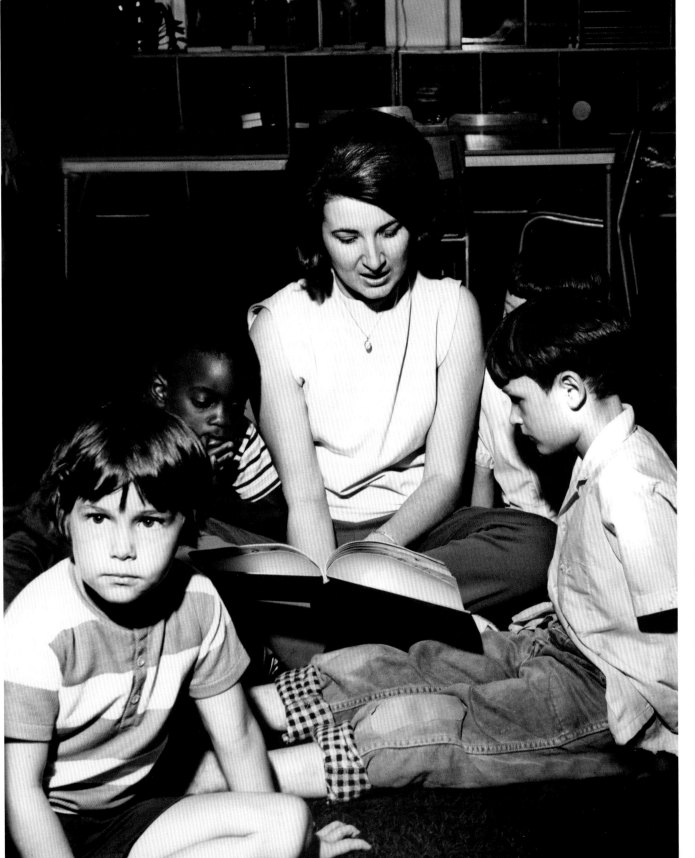

Janice and Baker Pattillo have been part of the Nacogdoches and SFA family for more than four decades.

Janice began teaching at SFA in 1969 and was the school's first kindergarten instructor. "I taught the children in the morning and college students in the afternoon," she remembers.

Over the years Janice advanced to coordinator of early childhood education and then chair of the Department of Elementary Education. She retired in August after 42 years at SFA, and SFA's Board of Regents voted to name the Early Childhood Research Center in her honor.

Dr. Ralph W. Steen named Baker assistant director of placement and financial aid in 1966; he became director of placement and financial aid in 1970 and advanced to dean of student services in 1972. Dr. William R. Johnson named Baker vice president for student affairs in 1979 and later changed the title to vice president for university affairs. He became interim president of the university in July 2006. Regents removed the "interim" part of his title January 2007 and also affixed his name to the Baker Pattillo Student Center on April 24, 2007.

Janice and Baker are the proud parents of Paige Pattillo Brown, who never considered attending any university except SFA for her undergraduate degree. She earned a doctor of jurisprudence at the University of Texas School of Law and is the assistant county attorney for Nacogdoches County. Paige is married to Dr. Todd Brown, assistant professor of economics and finance in the Nelson Rusche College of Business.

Janice and Baker Pattillo and Paige and Todd Brown consider Susan Williams, who has worked as Special Assistant to President Baker Pattillo for 31 years, "a member of the family." In fact Paige refers to Susan as her second mom.

The Pattillo family has included a succession of pet dachshunds, Heidi, Noel, and now Doches. Doches walks the campus quite often with Baker, wearing her purple Go Jacks vest.

Janice and Baker are a team that has been good for SFA and for Nacogdoches. Here are notable achievements: SFA's highest enrollment, fall semester of 2010; student center reconstructed and parking garages and new residence halls built; new facilities for instruction in nursing and early childhood development; and general improvement in campus appearance.

While Janice settles into a busy retirement, Baker promises to resume walking Doches on campus "when the weather cools off."

—Reprinted with permission from *The Daily Sentinel*

Above left: Dr. Baker Pattillo and O.A. "Bum" Phillips, 1982
Left: Baker and Janice Pattillo with Doches, 2011
Right: Baker and Janice Pattillo, Jackson Baker Brown, Paige Pattillo-Brown, and Todd Brown, 2016

Champagne Tea

Austrian Jam Cookies

1/2 cup butter
1/2 cup sugar
1 teaspoon vanilla
1 egg, separated
1 1/4 cup flour sifted
2/3 cup chopped almonds
1 cup raspberry jam

Beat butter, sugar, egg yolk, and vanilla in a medium bowl. Stir in flour; gather dough into a ball. Chill several hours. Remove and roll level teaspoons of dough into balls and dip in egg white. Roll each ball in almonds. On cookie sheet, place 1 inch apart. Press indentation in center of each cookie and fill with jam.

Bake at 300 degrees for 20 minutes until golden.

Pecan Praline Bars

1 1/2 cup flour
2 cups + 3 tablespoons brown sugar, divided
1 1/3 cups pecan halves, divided
1/2 cup half and half
1 1/2 cups powdered sugar
1 teaspoon vanilla

Preheat oven to 325 degrees. Spray a 9x13 inch pan with non-stick spray and set aside. In a mixing bowl, cream together 1/2 cup butter (softened, not melted) and 1/2 cup brown sugar. Add 1 1/2 cups flour and 1/2 cup chopped pecans. Press mixture into pan, and bake at 325 degrees for 22-25 minutes. Set aside to cool for 30 minutes.

Adjust oven temperature to 225 degrees. While crust cools, melt 3 tablespoons butter with 3 tablespoons brown sugar in small skillet. When melted, add 1 1/2 cup pecan halves. Coat pecans with sugar mixture and sauté for about 3-5 minutes on medium-low heat. Transfer the coated pecans to a baking sheet and toast in a 225 degree oven for 20 minutes. When done, set aside to cool.

In a saucepan, add 1/2 cup cream, 1/3 cup butter, and 1 1/2 cups brown sugar. Bring to a low boil over medium heat while stirring. Boil for 1 minute and remove from heat. Whisk in powdered sugar and vanilla until smooth. Pour over pecan crust and top with toasted pecans. Let stand for 30-45 minutes to set up. Store in refrigerator.

Butternut Squash Bisque

3 tablespoons olive oil
1 medium onion, diced
3 cups vegetable stock
1/4 teaspoon ground pepper
1/2 cup heavy cream
1 whole butternut squash
2 carrots, diced
1/2 teaspoon kosher salt
1/8 teaspoon ground nutmeg

Heat oven to 350 degrees.

Cut the squash in half and remove the seeds using a spoon. Line a baking sheet with aluminum foil and place the squash, cut side up, on the baking sheet. Drizzle with olive oil. Place in oven and roast for 60-90 minutes until the flesh of the squash is softened. Remove from the oven and allow to cool. Once cool, use a spoon to remove the flesh and discard the skin.

In a medium sized stockpot, add the remaining 2 tablespoons of oil and heat over medium heat. Add the onion, carrots, salt, pepper, and nutmeg; sauté until the onions are tender, about 8-10 minutes. Then, add the squash and cook an additional 5 minutes.

Add the vegetable stock and bring the mixture to a boil. Once boiling, reduce heat to a low-medium and simmer until the carrots are tender, about 8-10 minutes.

Beef Bourguignon

Julia Childs Modification (ala Janice and Tammy)

ONIONS

 18-20 peeled white broiler onions at least 1 inch in diameter
 1 1/2 tablespoons butter
 1 1/2 tablespoons olive oil
 1/2 cup beef stock or white or red wine
 salt and pepper

MEDIUM HERB BOUQUET TIED INTO CHEESE CLOTH

 4 parsley sprigs
 1 bay leaf
 1/4 teaspoon thyme

SAUTÉED MUSHROOM INGREDIENTS

 2 tablespoons butter
 1 tablespoons olive oil
 1/2 pound fresh sliced mushrooms (portobello)
 2 tablespoons minced shallots or green onions
 salt and pepper to taste

BEEF MIXTURE INGREDIENTS

 large covered casserole fireproof, at least 3 inches deep
 5 slices of bacon
 1 tablespoon olive oil
 3-5 pounds rump roast trimmed of all fat; cut 1 ½-2 inch cubes
 1 1/2 pounds baby carrots
 1 sliced yellow onion
 3 cups red wine (cabernet sauvignon)

PREPARE MIXTURE SALT/PEPPER/FLOUR AND SET ASIDE:

 1 teaspoon salt
 1/4 teaspoon pepper
 2 tablespoons flour

BEEF STOCK-HERB MIXTURE:

 2 cups beef stock
 1 tablespoon tomato paste
 2 cloves of garlic minced
 1/2 teaspoon thyme
 2 crumpled bay leaves (dried)

Preheat oven to 450 degrees.

In large covered casserole, fry 5 slices of bacon in 1 tablespoon olive oil over moderate hear for 3-4 minutes. Remove bacon, crumble, and set aside. Reheat casserole until fat is almost smoking. Dry beef in paper towels, squeezing each piece until dry. Wet meat will not brown. Braise meet in hot oil turning until all sides are browned. Do not crowd meat in pan. Remove meat and set aside with bacon.

In the same fat brown sliced onion and carrots, stirring. May add additional olive oil if needed. Cook, stirring 10-15 minutes.

Return beef and bacon to casserole and toss with 1/2 of salt/pepper/flour mixture. Set casserole uncovered in pre-heated oven and cook for 4 minutes. Toss meat and sprinkle the remaining salt/pepper/flour mixture and cook for 4 more minutes.

Turn the oven down to 325 degrees. Pour in wine, beef broth, tomato paste, herbs, and garlic and cook. Stir. Cook 2 1/2 to 4-hours. The meat is done when a fork pierces the meat easily.

Prepare onions and mushrooms while meat is cooking.

ONIONS

In skillet on top of stove sauté onions in 1 1/2 tablespoons olive oil and 1 1/2 tablespoon butter for ten minutes, rolling the onions so that they brown evenly. Pour in beef stock or wine. Salt and pepper to taste. Add herb bouquet. Cover and simmer slowly for 40 minutes. Use glass lid on pot to make sure they do not burn. Remove herb bouquet when done and trash bouquet. Set aside until meat mixture is finished. Add onions and mushrooms to meat mixture when ready to be served.

MUSHROOMS

Place a very large skillet over high heat with 2 tablespoons butter and 1 tablespoon olive oil. As soon as butter foam has begun to subside, add mushrooms. Toss and brown mushrooms for 4-5 minutes. During the sauté, the mushrooms will first absorb the fat. In 2-3 minutes the fat will reappear on the surface and the mushrooms will begin to brown. As soon as they have lightly browned, remove from heat. Toss in green onions. Sauté for 2 more minutes on moderate heat. Set aside until meat mixture is finished. Add onions and mushrooms to meat mixture when ready to be served.

Serve over buttered noodles, mashed potatoes, rice, or boiled potatoes.

Glazed Carrots

Julia Childs / Tammy modification

1 1/2 pounds baby carrots
1 1/2 cups beef broth (14 ounce can)
6 tablespoons butter
2 tablespoons brown sugar (+ 1 tablespoon if using
 14 ounce can)
dried parsley

In large skillet with lid, bring above ingredients to a boil and reduce heat to medium. Add lid. Cook 30-40 minutes on simmer.

When carrots are tender and a little juice is in the pan, boil down. Add dried parsley. Serves 4.

Harvest Salad

1 tablespoon unsalted butter
1 1/2 tablespoons packed light brown sugar
1/2 cup raw pecans
1 small shallot, finely diced
1 teaspoon Dijon mustard
2 teaspoons balsamic vinegar
1/4 cup extra-virgin olive oil
2 teaspoons maple syrup
salt and pepper
mixed greens
1 red pear, sliced thinly
1/4 cup shaved Parmesan

Candied Pecans: Head a nonstick pan over medium heat. Add the butter and sugar and stir until melted. Add the pecans to the pan and stir for about a minute. Pour them onto a cookie sheet lined with wax paper. Separate the pecans with two forks and let cool.

Salad: Combine the shallot, Dijon, and balsamic vinegar in a small bowl. Slowly drizzle in the olive oil and whisk continually to emulsify the dressing. Stir in the maple syrup and season with salt and pepper.

Toss the greens with enough dressing to lightly coat the leaves. Add the pears, pecans, and Parmesan. Toss again and serve. Serves 4-6

Bacon Braised Brussels Sprouts

2 slices bacon
3/4 pound Brussels sprouts, trimmed and quartered
1/4 cup water
salt and pepper to taste

Cook bacon in a 10-inch heavy skillet over moderately low heat, turning until crisp. Transfer to paper towels to drain. Add Brussels sprouts and a pinch each of salt and pepper to fat in skillet and cook over moderate heat, stirring occasionally until browned, about 3 minutes. Add water, then simmer, covered, until tender, about 5 minutes. Crumble bacon over Brussels sprouts and toss with salt and pepper to taste.

Butternut Squash and Bacon Pizza

2 cups cubed butternut squash (1/2-inch pieces)
1 tablespoon plus 1 teaspoon olive oil, divided
1/4 teaspoon salt
1/4 teaspoon freshly ground black pepper
1 small red onion, halved and thinly sliced
2 cups chopped fresh baby spinach
1 -2 store bought Naan Bread or Boboli crust
4 ounces fontina cheese, shredded
2 ounces crumbled goat cheese
6 slices of bacon, cooked and crumbled
1/2 teaspoon dried thyme
2 tablespoons cornmeal

Toss squash with 1 teaspoon oil, salt, and pepper. On a baking sheet, cook squash until soft and lightly browned, 25 minutes, stirring halfway through; set aside. In a large skillet over medium-high heat, heat remaining 1 tablespoon oil. Cook onion (season with salt and pepper), stirring until light brown. Remove from heat.

Take store bought Naan bread. Top with squash, onion, spinach, bacon, both cheeses, and thyme. Dust stone (or inverted sheet) with cornmeal; place pizza on it and bake until crust is crispy and cheese melts, 10 to 12 minutes.

Red Velvet Cake with Mascarpone Mousse

1 Box Red Velvet Cake (prepare according to directions)
3/4 cup heavy whipping cream
1 tablespoon granulated sugar
4 ounces mascarpone cheese
2 ounces cream cheese
1/8 teaspoon pure vanilla extract
3 tablespoons powdered sugar
1 bar white chocolate
1 bar dark chocolate

CAKE DIRECTIONS:

Prepare according to box. Bake as directed in rimmed cookie sheet or sheet pan lined with parchment paper. Let cool.

MASCARPONE MOUSSE DIRECTIONS:

In a small chilled metal bowl, whisk heavy cream in a figure eight motion. Just as soft peaks are forming, add the granulated sugar gradually. Continue whipping the cream until stiff peaks form.

Cover the bowl and chill in an ice bath. Combine room temperature mascarpone and cream cheese with a rubber scraper. Add vanilla and powdered sugar. When cheese mixture reaches a smooth consistency, set aside, keeping the mixture at room temperature. Just before serving, lightly fold whipped cream into the cheese mixture.

To assemble: Cut cooled red velvet cake into squares or circles using a biscuit cutter or glass. Place cake in small soufflé dish or bowl. Layer mousse on top of cake. Garnish with shaved white and dark chocolate and red velvet cake crumbles.

Brussels Sprouts Braised in Butter

From Julia Childs / Adapted by Janice Pattillo

Preparation: Trim base of Brussels sprouts; cut small cross in stem part for quick cooking. Remove wilted, yellow, dark and brown leaves. Wash in colander or bowl.

Blanching sprouts: In very large pot bring 7 to 8 quarts of salted water to rapid boil. (1 1/2 teaspoon salt per quart of water.) Boil Brussels sprouts for 10-12 minutes. They are done when a knife pierces the stem easily. Drain immediately.

Cooking sprouts: Use a 2 1/2 quart, fireproof, covered casserole or baking dish (that can go on range or oven) large enough to hold sprouts in 1 or 2 layers. Butter generously (leave small clumps) Arrange sprouts with heads up, stems down.

Sprinkle lightly with salt and pepper and 2-4 tablespoons melted butter. Cook on top of stove until butter sizzles.

**Cooking sprouts in oven: Cut waxed paper the size of the top of the baking dish. Butter waxed paper leaving large clumps on the paper. Place buttered paper, butter-side down on the sprouts and bake for 20 minutes in middle of preheated 350 degree oven.

OPTION:
 Mix: 1/2 cup Swiss cheese grated and 1/2 cup grated Parmesan
 2 tablespoons melted butter

Follow recipe above. When they have been in oven for 10 minutes, place in bowl and place aside. Reset oven to 425 degrees; sprinkle 3 tablespoons of grated cheese, coating bottom and sides of casserole dish. Then return Brussel sprouts, spreading the rest of the cheese over the top layer. Pour on melted butter. Place uncovered in upper part of oven for 10-15 minutes to brown the cheese.

**You can use the same recipe for cauliflower or broccoli.

Chopped Salad

From Janice Pattillo

2-3 large stalks romaine lettuce, shredded
about 9 (2 inch) carrots, shredded
3 tablespoons red onion, finely chopped
2 (Gala) apples, chopped very small
frozen corn (do not thaw)
2 cans black beans, washed and drained
Cheddar cheese, shredded

*Place in 2 gallon bag and refrigerate; will stay fresh about a week.

TOPPINGS:
 honey mustard dressing; Kraft
 nuts, chopped coarsely and toasted
 French's fried onions, extra crispy
 **Can add chicken and avocado slices on the side.

Gayla Mize's Cornbread Dressing

Aunt Jemima cornmeal mix
1 onion, chopped
1 bunch green onions, chopped
4 eggs (hold until cook time)
2 teaspoons poultry seasoning
1 1/2 teaspoons sage
2 teaspoons salt
1 teaspoon pepper
celery salt
1 box chicken broth
1 cooked and deboned chicken
6 pieces of toasted white bread
1/2 cup butter

Cook cornbread without sugar and crumble with toast in very large 9x15 inch baking dish. Sauté' onion in butter. Add all ingredients. (Hold eggs until cook time) Mix until moist. Add chicken broth until standing. Cook 1.5 hours at 350 degrees.

Spinach Lasagna

From a recipe in Southern Living 1979 Annual Recipes)

1 (16 ounce) carton ricotta or small-curd cottage cheese
1 1/2 cups shredded mozzarella cheese, divided
1/4-1/2 cup shredded Parmesan cheese or Romano cheese
1 egg or 2 egg whites
1 (10 ounce) package frozen chopped spinach, thawed and drained (squeeze to almost dry)
1 teaspoon salt
1/8 teaspoon pepper
3/4 teaspoon whole oregano
2 15 1/2 ounce jars spaghetti sauce
1 8 ounce package lasagna noodles**
1 cup water

Combine ricotta cheese, 1 cup mozzarella cheese, 1/2 of the parmesan cheese, egg, spinach, salt, pepper, and oregano in a large mixing bowl; stir well.

Spread 1/2 cup of spaghetti sauce in a greased 13x9x2-inch baking dish. Place 1/3 of the lasagna noodles over sauce, and spread with ½ of the cheese mixture. Repeat layers. Top with remaining noodles, spaghetti sauce, and the remaining cheese (1/2 cup mozzarella and the remaining parmesan cheeses). Pour water around the edges.

Cover securely with aluminum foil, and bake at 350 degrees for 1 1/4 hours. Let stand 15 minutes before serving. Yield: 8 servings.

**Could use whole-wheat noodles or zucchini slices.

Cous-Cous Miriam

Onion, medium or large, chopped
Winter vegetables
 Rutabaga, pealed & chunked
 Turnips, pealed & chunked
 Carrots, scrubbed & chunked
 Acorn squash, seeded & chunked
1 (15 ounce) can garbanzo beans, drained
1 (15 ounce) can diced tomatoes, drained
1/2 cup parsley, chopped or 1/2 cup cilantro,
 chopped
1/8-1/4 teaspoon saffron
1-2 tablespoon(s) oil, olive or corn
1-2 teaspoon(s) black pepper
1 bay leaf
1 teaspoon salt (more, if desired)
3-4 cups (or more) water or chicken broth
1/4-1/2 cup cream or evaporated milk, optional

BASE INGREDIENTS COOKING DIRECTIONS

In a large soup pot, sauté in oil over medium heat onions, saffron, and black pepper until onions are nearly clear. Add chunked winter vegetables, garbanzo beans, tomatoes, parsley or cilantro, bay leaf, salt, and water; put the acorn squash on top to steam (it is softer and will cook much more quickly than the harder root vegetables; you could even add it during the last 20-25 minutes); cover and simmer for 45-60 minutes (until vegetables are tender, but not mushy). Drain broth, set aside and cool a bit; optional—to the drained broth, add cream or evaporated milk to taste.

GARNISH INGREDIENTS

1/4 cup butter (or margarine)
onion, medium or large, thinly sliced
1/2 cup brown sugar
1/4 cup water
1/2-1 cup raisins (soak in hot water before using)
2-4 teaspoons cinnamon (or more if desired)

GARNISH COOKING DIRECTIONS

In a small sauce pan or a small skillet, saute thinly sliced onions in butter until nearly clear. Add the drained, plumped raisins, the 1/4 cup water, cinnamon, and brown sugar; stir well; simmer for about 10 minutes.

COUS-COUS, 1-2 BOXES

Prepare as directed on the box

SERVING

Put the veggies on top of the cous-cous; spoon a bit of the separated broth over the veggies and cous-cous; garnish on the side or on top of everything. Enjoy!

**This recipe makes a lot; it keeps well in the refrigerator and is good as left-overs; you can use nearly any winter vegetables that you like; if you don't like some of the vegetables listed above, leave them out and/or add others; the same is true for the garbanzo beans and tomatoes. This is a very forgiving recipe!

Broccoli Cornbread

adapted from 1st Baptist, Bryan cookbook

1 (10 ounce) package frozen chopped broccoli,
 thawed and drained
5 eggs, beaten
1 chopped onion
1 stick melted butter (or margarine)
1/2 cup milk
2 cups cottage cheese
2 packages Jiffy corn bread mix

Mix all ingredients in a large bowl. Bake in greased 9x13 inch baking dish at 350 degrees for 45 min.
** One large bunch of fresh broccoli, cooked and chopped, may be substituted for the frozen.

White Chile

8 servings

1 pound dried great northern white beans,
 rinsed, picked over
2 pounds boneless chicken breasts
1 tablespoon olive oil
2 medium onions, chopped
4 cloves of garlic, minced
2 (4 ounce) cans chopped mild green chilies
2 teaspoons cumin, ground
1 1/2 teaspoon dried oregano, crumbled
1/4 teaspoon ground cloves
1/4 teaspoon cayenne pepper
6 cups chicken tock
3 cups grated Monterey Jack cheese
sour cream
salsa
chopped fresh cilantro

Place beans in heavy large pot. Add enough cold water to cover by at least 3 inches and soak overnight.
Place chicken in heavy large saucepan. Add cold water to cover and simmer. Cook until just tender about 15 minutes. Drain and cool. Remove skin. Cut chicken into cubes.
Drain beans. Heat oil in same pot over medium-high heat. Add onions and saute until translucent, about 10 minutes. Stir in garlic, then chilies, cumin, oregano, cloves, and chayenne and saute 2 minutes. Add beans and stock and bring to boil. Reduce heat and simmer until beans are very tender, stirring occasionally about 2 hours. NOTE: Can be prepared 1 day ahead. Cover and refrigerate. Bring to summer before continuing.
Add chicken and 1 cup cheese to chili and stir until cheese melts. Season to taste with salt and pepper. Ladle chili into bowls. Serve with remaining cheese, sour cream, salsa, and cilantro. Could also add chopped avocado.

Salmon Dill Scones

2 1/2 cups flour
2 tablespoons granulated sugar
1 tablespoon baking powder
1 teaspoon kosher salt
1/2 cup butter
3 large eggs (2 for scones and 1 egg for egg wash)
2/3 cup buttermilk
1/4 cup dill, chopped
2 tablespoons half and half
8 ounces cured or smoked salmon, chopped
1/4 cup capers, chopped

Preheat oven to 375 degrees. In a large bowl, whisk together the flour, sugar, baking powder, and salt. Cut the butter into the flour using a pastry cutter or food processor.

Whisk 2 eggs and combine with the buttermilk. Add to the flour mixture and stir until just moist.

Stir in the dill, capers, salmon and mix lightly. The dough will be sticky. Turn the sticky dough out onto a well-floured board and knead lightly. Cut dough in half and roll each half into a circle about 3/4 inch thick. Cut each circle into 4 wedges.

Whisk remaining egg in a small dish and brush on top of the scones. Let the scones rest for about 10 minutes before baking. (You will get a higher scone as the baking powder activates). Bake for 20 minutes or until golden.

Homemade Cornbread

1 1/2 cup of meal
1 cup flour
3 teaspoon baking powder
1/2 teaspoon soda
2 1/2 tablespoon sugar
2 eggs
2 1/2 tablespoon oil

Take iron skillet and heat in oven after you have poured 2 tablespoons of oil in bottom. Swirl and get oil over all its sides.

Combine all ingredients in a large bowl and mix well. Remove hot skillet from oven. Pour batter into skillet and return skillet to oven, baking 20-25 minutes on 400 degrees or until light brown on top.

Broccoli with Rice
Favorite holiday dish. Serves 6

1 stick butter
1 onion, chopped
1 rib celery, chopped
1 package frozen chopped broccoli
1 can cream of chicken soup
1 cup grated cheese or 1 small jar cheese whiz
1 1/2 cups cooked rice
Tabasco
salt and peper to taste
optional bread crumps (slices of bread in 1/2 inch cubes or smaller)

In a large skillet sauté onions and celery in butter until vegetables are clear. Cook broccoli according to the package directions; drain well. Mix broccoli with soup and cheese; add to celery and onions. Stir in cooked rice; season; add bread crumps.

Bake at 350 degrees for 45 minutes.

**This can be mixed ahead and frozen. (If frozen, thaw in referigerator before cooking)

Chicken Cacciatore

4 chicken thighs
2 chicken breasts with skin and backbone, halved crosswise
1 teaspoon salt, plus more to taste
1 1/2 teaspoon freshly ground black pepper, plus more to taste
1/2 cup all-purpose flour, for dredging
3 tablespoons olive oil
1 large red bell pepper, chopped
1 sweet onion, chopped
3 garlic cloves, finely chopped
3/4 cup dry white wine
1 (28-ounce) can diced tomatoes with juice
3/4 cup reduced-sodium chicken broth
3 tablespoons drained capers
1 1/2 teaspoons dried oregano leaves
1/4 cup coarsely chopped fresh basil leaves

Sprinkle the chicken with 1 teaspoon of each salt and pepper. Coat the chicken pieces with the flour.

Heat oil over medium in a large heavy saute pan. Add the chicken pieces to the pan and brown lightly on each side, about 4-5 minutes per side. You may need to cook the chicken in two batches if your skillet is too full. When chicken is browned, transfer it to a plate and cover with foil. Add the bell pepper, onion, and garlic to the chicken drippings and cook over medium heat until the onion is tender. Season with salt and pepper. Add the wine and simmer until reduced by half. Add the can of tomatoes, including juice, chicken broth, capers, and oregano. Return the chicken pieces to the pan and turn them to coat in the sauce. Bring the sauce to a simmer over medium low heat and cook about 20-30 minutes (20 minutes for thighs and 30 for the breasts.)

Transfer the chicken to a platter. Thicken sauce if needed and spoon off excess fat. Ladle sauce over the chicken, sprinkle with 1/4 cup basil and serve.

Chicken Parmesan

1/4 cup extra-virgin olive oil, plus 3 tablespoons
2 garlic cloves, minced
1/2 cup Kalamata olives, sliced
2 (28 ounce) cans whole peeled tomatoes, drained and hand-crushed
1 tablespoon sugar
1/2 cup all-purpose flour
1 tablespoon water
1 (8 ounce) ball fresh mozzarella, drained
1 (16 ounce) package spaghetti pasta, cooked al denté

1 medium sweet onion, chopped
2 bay leaves
1/3 cup fresh basil leaves, torn, plus 1/4 cup torn basil
sea salt and freshly ground black pepper
4 skinless, boneless, chicken breasts
2 large eggs, lightly beaten
1 cup dried bread crumbs
freshly grated Parmesan

Place a pan coated with olive oil over medium heat. When oil is hot, add onions, garlic, and bay leaves; cook and stir for 5 minutes until soft. Add the olives and 1/2 cup basil. Carefully add the tomatoes and, stirring constantly; cook the tomatoes until the liquid is cooked down and the sauce is thick, about 15 minutes; season with 1 tablespoon of sugar; add salt and pepper to taste. Lower the heat, cover, and keep warm.

Preheat the oven to 450 degrees.

Pound the chicken breasts with a flat mallet until they are about 1/2 inch thick. Put the flour in a pie pan and season with salt and pepper, mixing well. In a large bowl, combine the eggs and water, beating until frothy. Put the bread crumbs on a plate, season with salt and pepper.

In a large oven-proof skillet, heat 3 tablespoons of olive oil over medium high heat. Lightly coat both sides of the chicken cutlets in the seasoned flour; dip them in the egg mixture, coating completely and letting excess drip off, and then coat the chicken with bread crumbs. When oil is hot, add the chicken and fry for 4 minutes on each side until golden and crusty, turning once.

Spoon tomato-olive sauce over chicken and sprinkle with mozzarella, grated Parmesan, and a little basil. Bake for 15 minutes or until the cheese is bubbly. Serve hot with spaghetti

Chicken-Spaghetti Casserole

1 (3-4 pound) chicken
1 cup diced celery
1/2 cup diced onion
1/2 cup diced bell pepper
1/2 cup margarine, cubed

6 cups chicken broth
1 (12 ounce) package spaghetti
1 (10 3/4 ounce) can cream of mushroom soup
1 (10 3/4 ounce) can cream of celery soup
1 pound Velveeta cheese, cubed

Stew chicken. Debone and cut in bite size pieces. Reserve broth. Sauté celery, onion and pepper in margarine. Cook spaghetti in 6 cups reserved chicken broth until tender (DO NOT DRAIN). Add the two soups, chicken and cheese. Mix and place in a greased 11x14 inch baking pan. Bake uncovered at 350 degrees for about 20 minutes or until cheese is melted and casserole is hot and bubbly.

Fancy Mac and Cheese

sea salt
vegetable oil
1 pound elbow macaroni or cavatappi
4 cups milk
1 stick unsalted butter, divided
1/2 cup all-purpose flour
4 cups (12 ounces) Gruyere, grated
2 cups (8 ounces) extra-sharp Cheddar, grated
1 teaspoon freshly ground black pepper
1/2 teaspoon ground nutmeg
4 small fresh tomatoes
5 slices white bread, crusts removed

Preheat the oven to 375 degrees. Drizzle oil into a large pot of boiling salted water. Add the macaroni and cook according to the directions on the package, 6 to 8 minutes. Drain well.

While macaroni is cooking, heat the milk in a small saucepan, but don't boil. In a large pot, melt 6 tablespoons of butter and add the flour. Cook over low for 2-3 minutes, stirring with a whisk. Do not burn. While whisking, add hot milk and cook for a minute or two more or until thick and smooth, like gravy. Remove from heat and add the Gruyere, Cheddar, sea salt, pepper, and nutmeg. Add the cooked macaroni and stir well. Pour into a large baking dish.

Slice fresh tomatoes and arrange on top. Melt the remaining 2 tablespoons of butter and combine with fresh bread crumbs. Sprinkle on the top and bake for 30 to 35 minutes, or until the sauce is bubbly, and the macaroni is lightly browned on the top.

Chicken Enchilada Dip Roll-Ups

2 (8 ounce) packages cream cheese, softened
1 1/3 cup shredded Mexican blend cheese
1 teaspoon garlic, finely minced (I used my garlic press)
1 1/2 tablespoon chili powder
1 teaspoon cumin
cayenne pepper to taste
salt to taste
1 Rotisserie chicken, skinned and shredded - If you
 can find a southwest flavored chicken, that would
 be even better.
1/2 bunch cilantro, chopped
4 green onions, chopped
10 ounce can Rotel tomatoes
1 package jalapeno cheddar tortillas

Mix cheeses together until well blended. Add all remaining ingredients and mix well. Cover and refrigerate for at least one hour. Place one heaping spoonful onto tortilla. Spread to edges using a metal spatula. Roll and cut into slices.

Old Fashioned Biscuits

2 cups all-purpose flour
1 tablespoon sugar
3 teaspoons baking powder
1 teaspoon salt
6 tablespoons butter
2/3 cup milk

Preheat oven to 425 degrees. In large bowl, combine flour, sugar, baking powder, and salt. Cut in shortening with 2 knives. Gently work dough with fingers until mixture looks like fine crumbs. Stir in milk until dough leaves side of bowl (dough will be soft and sticky).
On lightly floured surface, gently roll dough in flour and knead lightly 10 times. Roll or pat 1/2 inch thick. Cut with floured 2 1/2-inch biscuit cutter. On ungreased cookie sheet, place biscuits about 1 inch apart for crusty sides, touching for soft sides.
Bake 10 to 12 minutes or until golden brown.

Sweet Roll Dough

1/2 cup warm water
2 packages active dry yeast
1/2 cup sugar plus 1 tablespoon, divided
2 teaspoons salt
1 1/2 cups lukewarm milk
2 eggs
1/2 cup soft shortening
7 to 7 1/2 cups Gold Medal Flour

In large mixing bowl, combine water, yeast, and 1 tablespoon sugar, stirring to dissolve. In another bowl, combine milk, sugar, salt, eggs, shortening. Add yeast mixture. Add half of the flour and mix with spoon (or mixer if you have a dough hook) until smooth. Add enough remaining flour to handle easily; mix with hand. Turn onto lightly floured board; knead until smooth and elastic (about 5 minutes). Round up in greased bowl, greased side up. Cover with damp cloth. Let rise in warm place until double (about 1 1/2 hr.).
Punch down; let rise again until almost double (about 30 min.). Divide dough for desired rolls and coffee cakes. Shape, let rise until light (15-20 minutes), bake rolls at 400 degrees for 12-15 minutes or until lightly browned.

Sawdust Pie

1 1/2 cups sugar
1 1/2 cups coconut
7 egg whites
1 1/2 cups crushed graham crackers
1/2 cup chopped pecans
1/2 cup chocolate chips
9 inch pie shell

Mix all ingredients by hand. Put into pie shell. Bake 35 minutes at 350 degrees or until center if firm. Do not cut until completely cool. Serve with whipped cream if desired.

Bread Pudding

12 slices of toasted bread
2 eggs
1 1/2 cup sugar
2 cups milk
1 stick butter
1 teaspoon vanilla
1 1/4 teaspoon cinnamon (may add raisins)

Preheat oven to 350 degrees. Melt 1/2 stick of butter in 2-quart baking dish. Tear toasted bread into baking dish. In another bowl, beat eggs and 1 cup sugar. Add milk and vanilla to egg mixture; mix well.
Pour mixture over toast. Sprinkle 1/2 cup sugar over toast and milk/egg mixture. Sprinkle with 1 1/4 teaspoon cinnamon. Top with 1/2 stick butter in pats.
Bake at 350 degrees for 45 minutes. Top with ice cream or whipped cream.

Piña Colada Cake
Serves 24

1 box (18.5 ounces) white cake mix
1 can (15 ounces) cream of coconut
1 can (4 ounces) coconut

Mix cake according to package directions, adding coconut. Bake according to directions for oblong cake. Remove from oven; poke holes with fork. Pour cream of coconut over warm cake. Allow cake to cool before icing.

ICING

1 carton (8 ounces) frozen whipped topping, thawed
1 can (4 ounces) coconut

Combine whipped topping and coconut; spread over cake. Refrigerate.

Bill Hagan's Blueberry Roll

5 eggs
1 medium ripe banana, mashed
1 teaspoon baking powder
1/4 teaspoon salt
2 teaspoons vanilla
1 cup flour
1 cup sugar
1 can blueberry pie filling
1 1/2 packages cream cheese (12 ounces)
1 cup powdered sugar
1/2 teaspoon cinnamon

Preheat oven to 375 degrees. Beat eggs well; add mashed banana, and sugar. Mix well. Add baking powder, salt, vanilla, flour, and mix well.

Spray a jelly roll pan or cookie sheet with Pam and pour batter. Bake for 12-15 minutes. When done, turn onto clean cloth that has been dusted with powdered sugar. Roll up in cloth, jelly roll style, and cool.

Cream powdered sugar and cream cheese. Unroll cake and remove cloth. Spread with cream cheese mixture. Sprinkle with cinnamon. Spread blueberry pie filling over this and roll again. Sprinkle with powdered sugar. Keep refrigerated. Slice and serve.

Monkey Bread
Recipe from my mother, Gayla Mize

1 package frozen pull apart Clover Leaf Rolls
1 stick melted butter
1/2 cup sugar
2 teaspoons cinnamon
1 package butterscotch pudding (cook & serve)

Grease bundt pan. Pull apart defrosted rolls and dip in melted butter. Place in bundt pan. Mix sugar, cinnamon, and butterscotch pudding and pour over buttered rolls. Pour remainder of butter on top (if it looks dry, add melted butter). Place buttered wax paper over roll mixture and let it rise for 6-7 hours (overnight). Bake at 350 degrees for 30 minutes. Cool slightly and dump bundt pan contents onto cake plate.

Sock-It-To-Me Cake

1 (18 ounce) package yellow cake mix (reserve 2
 tablespoons for filling)
4 eggs
1 cup sour cream
1/3 cup vegetable oil
1/4 cup water
1/4 cup sugar
2 tablespoons cake mix (reserved)
2 tablespoons brown sugar
2 teaspoons cinnamon, ground
1 cup nuts, finely chopped
1 cup confectioners' sugar
2 tablespoons milk
1 teaspoon vanilla

Preheat oven to 375 degrees. Grease and flour a 10-inch tube or bundt pan. In a small bowl, combine 2 tablespoons cake mix, brown sugar, and cinnamon. Stir in pecans. Set aside.

Combine remaining cake mix, eggs, sour cream, oil, water, and sugar in a bowl. Beat at medium speed with electric mixer for 2 minutes. Pour two-thirds of batter into pan; sprinkle struesel filling. Spoon remaining batter over filling. Bake for 45 to 55 minutes or until toothpick inserted in center comes out clean. Cool in pan 25 minutes and invert onto a serving plate.

In another small bowl, combine confectioners' sugar, vanilla, and milk. Stir until smooth and drizzle onto cake.

Texas Sheet Cake I

1 cup butter
1 cup water
2 cups all-purpose flour
2 cups sugar
2 large eggs
1/2 cup sour cream
1 teaspoon almond extract
1 teaspoon salt
1 teaspoon baking soda

FROSTING:
 1/2 cup butter, cubed
 1/4 cup milk
 4-1/2 cups confectioners' sugar
 1/2 teaspoon almond extract
 1 cup chopped walnuts

Bring butter and water to a boil in a large saucepan. Remove from heat and let cool slightly. Stir in flour, sugar, eggs, sour cream, almond extract, salt, and baking soda until smooth. Pour into a greased 15x10 inch baking pan. Bake at 375 degrees for 18-22 minutes or until cake is golden brown and a toothpick inserted in the center comes out clean. Cool for 20 or so minutes and then frost.

For the frosting: combine butter and milk in a saucepan; bring to a boil; remove from heat; add sugar and extract and mix well. Stir in nuts and spread over warm cake.

Old Fashioned Sugar Cookies

Yields 3 1/2 dozen

1 1/2 cups of sugar
1 cup butter
3 eggs
1/2 teaspoon nutmeg
1 cup sour cream
1/2 teaspoon vanilla
4 1/2 cups of flour

In a mixing bowl, cream sugar and butter until fluffy. Add eggs one at a time, beating well. Stir in nutmeg, sour cream, and vanilla.

In another bowl
1 teaspoon baking soda
3 teaspoons baking powder
1/2 teaspoon salt
Sugar for sprinkling cookies (colored sprinkles/optional)

Sift together flour, baking powder and salt. Add a little at a time to the creamed mixture until well blended.

Chill 2 hours minimum. Roll. Cut into shapes with cookie cutters, sprinkle with sugar. Place on ungreased cookie sheet. Bake 10 minutes at 350 degrees. Decorate with colored sprinkles if desired.

Yummy Banana Bread

Makes 2 loaves

3/4 cup butter, softened
1 (8-ounce) package cream cheese, softened
2 cups sugar
2 eggs, beaten well
1 1/2 cups mashed ripe bananas (about 4 medium)
1 teaspoon vanilla
3 cups flour
1/2 teaspoon baking powder
1/2 teaspoon baking soda
1/2 teaspoon salt
2 cups chopped nuts

In a large mixing bowl, cream together butter, cream cheese, and sugar. Mix in beaten eggs. Add bananas and vanilla, mixing well. Combine flour, baking powder, baking soda, and salt and add to cream mixture. Fold in nuts. Pour into greased and floured loaf pans. Bake at 350 degrees for 1 hour and 15 minutes or until toothpick inserted in center comes out clean.

Grandma Esther's Chocolate Chip Cookies

1 cup plus 2 tablespoons flour
1/2 teaspoon baking soda
1/2 teaspoon salt
1/2 cup sugar
1/4 cup firmly packed brown sugar
1 egg
1 teaspoon vanilla
1/2 cup butter
chocolate chips
golden raisins (soften in water and dry well)

Sift together flour, baking soda, salt. Mix sugars, egg, vanilla, and butter. Mix dry and moist ingredients together until smooth and well blended (about 1 minute). Add chocolate chips and raisins. Drop by teaspoon onto ungreased baking sheet about 2 inches apart. Bake at 350 degrees for 10-12 minutes.

Quick Lemon Pie

1 cup plus 4 tablespoons sugar, divided
3 tablespoons cornstarch
1 cup milk
3 egg yolks, beaten
1/4 cup freshly squeezed lemon juice
1 tablespoon grated lemon zest
1/4 cup butter
1 cup sour cream
1 9-inch pie crust, baked
1 cup whipping cream
Lemon zest for garnish, optional

In a heavy saucepan, combine sugar and cornstarch. Add milk, egg yolks, lemon juice, zest, and butter. Cook, stirring constantly, over medium-high heat until thick. Remove from heat. Cool. Stir in sour cream and pour into baked pie crust. Whip cream with the remaining 4 tablespoons sugar and spread on top of filling. Sprinkle with small strips of lemon zest if desired. Refrigerate for several hours before serving.

Parfaits

Makes 6-8 servings

1 (10 ounce) package frozen raspberries, thawed
1/4 cup sugar
2 tablespoons cornstarch
2 cups strawberries, sliced
2 teaspoons lemon juice
1 quart vanilla ice cream
1 cup sour cream

Drain raspberries; keep the syrup. Add enough water to syrup to make one cup. In saucepan, combine sugar and cornstarch. Stir in syrup. Add strawberries. Cook and stir over medium high heat until the mixture is thick and boils. Remove from the heat. Stir in raspberries and lemon juice. Chill. In parfait glass, layer ice cream, berry sauce, sour cream, berry sauce.

Repeat layers.

Oatmeal Cake

Serves 20

1 1/4 cups boiling water
1 cup quick-cooking oats
1/2 cup (l stick) margarine
1 cup sugar
2 eggs
1 1/3 cups all-purpose flour
1 cup brown sugar
1 teaspoon baking soda
1/2 teaspoon cinnamon

Pour boiling water over oats and 1 stick margarine; let stand for 20 minutes. Stir in by hand sugar, eggs, flour, brown sugar, baking soda, and cinnamon; do not use mixer. Pour into greased and floured 13x9 inch pan and bake 35 minutes at 350 degrees.

ICING
3/4 cup evaporated milk
3/4 cup sugar
1/3 cup butter
2 egg yolks, beaten slightly
1 teaspoon vanilla
1 1/3 cups angel flake coconut
1 cup chopped pecans (optional

Combine evaporated milk, sugar, butter, egg yoks, and vanilla in saucepan. Cook, stirring constantly, on medium heat until thickened and golden brown, about 10 minutes. Remove from heat. Stir in coconut and pecans. Cool to room temperature, and spreading consistency, before spreading on cooled cake.

Overnight Sausage Quiche

Recipe from my mother, Gayla Mize

Butter or margarine
white bread
1 pound of mild pork sausage
1 package grated Cheddar cheese
6 eggs
1-pint milk
1 teaspoon dry mustard
1 teaspoon salt

Butter 9x15 baking dish. Line the bottom with trimmed bread. Butter the top of the bread.

Cook 1 pound of pork sausage and drain. Sprinkle over bread and sprinkle 1 package of grated Cheddar cheese. Beat 6 eggs and add 1 pint of milk. Add 1 teaspoon dry mustard and 1 teaspoon salt to the egg mixture.

Pour egg mixture over bread, sausage, and cheese. Refrigerate overnight. Bake at 350 degrees for 40 minutes. Cut into 12 servings.

Eagle Scout Punch

large package strawberry Jell-O
3 cups sugar
6 cups boiling water
5 bananas, liquefied in blender
8 ounces can crushed pineapple, liquefied in blender
12 ounce can frozen unsweetened orange juice, thawed
12 ounce can frozen unsweetened pineapple juice, thawed
juice from 2 lemons
4 liters of ginger ale

Dissolve sugar and Jell-O in boiling water, then set aside to cool. Add fruits and juices. Pour into two 1-gallon Ziploc bags and freeze. Remove from freezer 1 to 2 hours before serving time. Knead bags occasionally as they are thawing. Pour contents into punch bowl and stir in ginger ale.

Texas Sheet Cake II

1 cup butter
1 cup water
4 tablespoons cocoa
2 cups sugar
2 cups all-purpose flour
1 teaspoon salt
1 teaspoon baking soda
1 teaspoon cinnamon
2 large eggs
1/2 cup sour cream
1 teaspoon vanilla

FROSTING:
1/2 cup butter, cubed
4 tablespoons cocoa
6 tablespoons milk
1 pound confectioners' sugar
1 teaspoon vanilla
1 cup chopped walnuts, chopped

Bring butter, water, and cocoa to a boil in a large saucepan. Remove from heat and add the rest of the batter ingredients. Mix with electric mixer until smooth. Pour into a greased 15x10 inch baking pan. Bake at 375 degrees for 18-22 minutes or until a toothpick inserted in the center comes out clean. Cool for 20 or so minutes and then frost.

For the frosting, bring margarine (or butter), cocoa, and milk to a boil. Remove from heat and stir in confectioners' sugar, nuts, and vanilla. Pour on cake as soon as it comes out of the oven.

Sopapilla Cheesecake

2 cans Pillsbury crescent rolls
2 (8 ounce) packages cream cheese, room temperature
1 1/2 cups sugar
1 1/2 teaspoons vanilla extract
1 teaspoon cinnamon
1 stick butter
1/4 cup honey (optional)

Spray a 9x13 pan with cooking spray. Unroll and press 1 can crescent rolls into the bottom of your baking dish. Press the seams together.

In a separate bowl, blend the cream cheese, 1 cup sugar, and 1 1/2 teaspoons vanilla together and spread over top of dough. Unroll the second can of crescent rolls and place on top of the cream cheese mixture pressing seams together again.

Mix the remaining 1/2 cup of sugar and teaspoon of cinnamon together. Sprinkle cinnamon sugar mixture generously over the top. If you don't think that's enough cinnamon sugar on top; add more it's really up to you. Bake at 350 degrees for 30 minutes until bubbly and bottom crust is slightly brown. Remove from the oven and drizzle with honey. Cool completely in the pan before cutting into 12 squares.

Dr. Bird Cake

3 cups all-purpose flour
2 cups sugar
1 teaspoon salt
1 teaspoon baking soda
1 1/2 teaspoon ground cinnamon
3 large eggs, beaten
1 1/2 cups vegetable oil
1 1/2 teaspoons vanilla extract
1 (8 ounce) can crushed pineapple, undrained
2 cups bananas, mashed
2 cups pecans, chopped
CREAM CHEESE FROSTING
1/2 cup chopped pecans

Combine dry ingredients in a large bowl. Add eggs and oil. Stir until moistened. Do not beat. Sir in vanilla, pineapple, 1 cup pecans and bananas. Spoon batter into 3 well-greased and floured 9 inch pans. Bake at 350 degrees for 25 minutes or until toothpick inserted in center comes out clean. Cool in pan. Remove cakes from pans to wire racks and cool at least 1 hour before frosting. Frost with CREAM CHEESE FROSTING and sprinkle with chopped pecans.

CREAM CHEESE FROSTING

2 (8-ounce) package cream cheese, softened
1 cup butter or margarine, softened
2 (16 ounce) packages powdered sugar, sifted
2 teaspoons vanilla extract

Beat together cream cheese and butter until smooth. Add sugar, beating until light and fluffy. Stir in vanilla.

Cream Cheese Pound Cake

3 sticks butter
1 (8 ounce) cream cheese, softened
3 cups sugar
1 teaspoon vanilla extract
1 teaspoon lemon extract
1 teaspoon orange extract
1-2 teaspoons lemon zest
1-2 teaspoons orange zest
6 large eggs, room temperature
3 cups all-purpose flour, sifted
1/2 teaspoon salt
1 teaspoon baking powder

Cream butter, cheese, and sugar until light and fluffy. Add eggs one at a time, beating well after each. Add extracts and zest, and mix well. Combine flour, salt, and baking powder. Stir (by hand not mixer) a little at a time into cake mixture, mixing only until blended. DO NOT OVERBEAT. Spoon batter into greased and floured 10 inch tube pan. Bake at 320 for 1 1/2 hours. Let cake cool in pan for 15 minutes. Then turn cake out onto serving plate. Cover cake with tube pan to keep moisture in. Drizzle with CREAM CHEESE GLAZE.

CREAM CHEESE GLAZE
1 (3 ounce) package cream cheese
1 cup powdered sugar
1/4 teaspoon vanilla

Mix ingredients together and drizzle over cake.

Coconut Cream Pie

2/3 cup sugar
1/2 teaspoon salt
2 1/2 tablespoons cornstarch
1 tablespoon flour
3 cups milk
3 egg yolks, slightly beaten (whites reserved)
1 tablespoon butter, softened
1 1/2 teaspoons vanilla
3/4 cup moist coconut.
9 inch pie shell, baked

Mix sugar, salt, cornstarch, and flour in a saucepan. Stir in 3 cups milk and cook over medium heat, stirring constantly until mixture thickens and boils. Boil 1 minute and then remove from heat.

Lightly beat 3 egg yolks in a bowl. Stir a little of the hot milk mixture into the beaten egg yolks, and then add the yolk mixture into hot ingredients in the saucepan. Boil 1 minute more, stirring constantly. Remove from heat. Add butter and vanilla. Pour into baked 9 inch pie shell. Top with NO WEEP MERINGUE and sprinkle with coconut. Bake in 425 degree oven until meringue and coconut are lightly toasted.

No-weep Meringue

1/2 cup water
1 tablespoon cornstarch
1/4 cup sugar
1/2 teaspoon vanilla
pinch of salt
3 egg whites

Combine above ingredients except egg whites and cook over low heat until clear or translucent. Cool. Beat 3 egg whites very stiff; fold in cooled mixture. Spread on pie. Bake in a 350 degree oven until golden brown.

Chocolate Cream Pie

1 1/2 cup sugar
1/2 teaspoon salt
2 1/2 tablespoons cornstarch
1 tablespoon flour
3 cups milk
3 squares unsweetened chocolate
3 egg yolks, slightly beaten (whites reserved)
1 tablespoon butter, softened
1 1/2 teaspoons vanilla
9 inch pie shell

Mix sugar, salt, cornstarch, and flour in a saucepan. Stir in 3 cups milk and 3 squares unsweetened chocolate. Cook over medium heat, stirring constantly until mixture thickens and boils. Boil 1 minute and then remove from heat.

Lightly beat 3 egg yolks in a bowl. Stir a little of the hot milk mixture into the beaten egg yolks, and then add the yolk mixture into hot ingredients in the saucepan. Boil 1 minute more, stirring constantly. Remove from heat and add butter and vanilla. Pour into baked 9 inch pie shell. Top with NO WEAP MERINGUE. Bake in 425 degree oven until meringue is lightly toasted.

**If using Cocoa powder, 9 level tablespoons of cocoa powder plus 3 tablespoons butter is the equivalent of 3 squares unsweetened baking chocolate.

Cherries Jubilee

1 pint vanilla ice cream
1 pound fresh, ripe sweet cherries, Bing
1/2 cup sugar
1 lemon
1/2 cup brandy

Evenly scoop the ice cream into 4 dishes or decorative glasses and put in the freezer until ready to serve (this can be done up to 4 hours ahead).

Wash and pit the cherries. (Use a plastic drinking straw to push through the cherry, and the seed will pop out.) Put the cherries and sugar in a large skillet. Peel 2 strips of zest from the lemon in wide strips with a peeler and add to the cherries. Squeeze the juice of half the lemon over the top. Stir to combine evenly. Cover and cook the cherries over medium-low heat until the sugar dissolves, about 4 minutes. Uncover and cook over medium-high until cherries get juicy, about 5 minutes more.

To flambé the brandy: If cooking over a gas flame, pull the pan off the heat and add the rum. Ignite the alcohol with a long match. Swirl the pan slightly until the flames subside, about 30 seconds.

If cooking over an electric stove, put the rum in a small sauce pan. Warm it over medium-low heat and carefully light it with a long match. Pour the lit rum over cherries and swirl the pan gently until the flames subside, about 30 seconds.

Ladle the cherries and juice over prepared ice cream. Serve immediately.

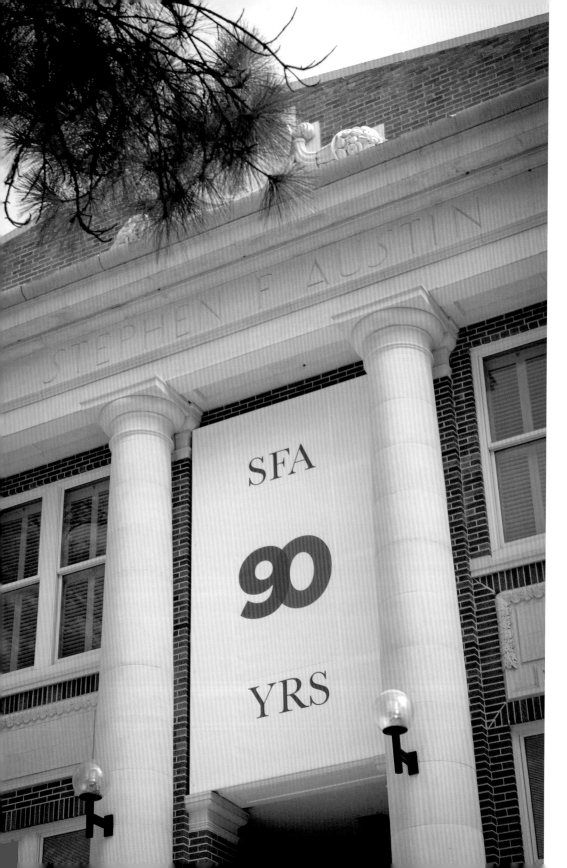

"All Hail to SFA"

SFA Celebrates 90th Birthday

Dr. Baker Pattillo, 90th Anniversary Celebration, 2013

Oldest and Youngest Alumni Association Members, 2013
Left to Right: Dr. Baker Pattillo, Paige Pattillo-Brown,
Jackson Baker Brown (90 days old and being held by his mother)
Era Elizabeth Billingsley (105), Jeff Davis

Baker Pattillo Student Center

In 41 years of distinguished service to SFA, Dr. Pattillo's first priority has always been the students. In his role as Vice President for University Affairs, he worked closely with student leadership and tirelessly with our elected officials to guide our newest building on campus through the legislative process to make this building a reality.

The Board of Regents wishes to honor him for his loving dedication to this university and could find no finer tribute to him than the magnificent [newly renovated] student center that opened this week. Upon motion by Regent Ertz, seconded by Regent Wulf, with all members voting aye, it was ordered that the SFA Student Center be named the Baker Pattillo Student Center.

—Stephen F. Austin State University
Minutes of the Board of Regents
April 23 and 24, 2007

SFA Student Center, 1960

Baker and Janice Pattillo with grandson and future Lumberjack,
Jackson Baker Brown, 2016

Janice Pattillo Early Childhood Research Center

The Building and Grounds committee recommends that the board name the facility, whose opening occurred on July 19, 2009, located at 2428 Raguet Street, Nacogdoches, TX 75961 and currently housing the Early Childhood Research Center, for Dr. Janice Pattillo, long-time educator at Stephen F. Austin State University. THEREFORE, the following resolution was adopted:

WHEREAS, Dr. Janice Pattillo joined the SFA faculty in 1969 serving as the first teacher in the university kindergarten and instructor in the new Early Childhood teacher preparation; and

WHEREAS, she has served Stephen F. Austin State University for 42 years as a teacher of children, professor of early childhood education, Coordinator of Early Childhood Programs and Chair of the Department of Elementary Education; and

WHEREAS, through her visionary leadership the elementary teacher preparation courses today are cohesive programs of learning that are based on her philosophy of how children develop and construct knowledge in the learning process; and

WHEREAS, Dr. Pattillo had a vision for the SFA laboratory school a nd worked with the families at the Early Childhood Lab and Nacogdoches ISD leadership to establish the NISD/SFASU Charter School in 1998 as the first collaborative university and school district charter school in Texas, now known as the SFASU Charter School; and

WHEREAS, Dr. Pattillo saw the need to change the way programs are delivered and worked with the elementary faculty to develop and deliver some of the first online programs at SFA, earning the Texas STAR Award for Excellence in 2008; and

WHEREAS, the opening of the Early Childhood Research Center in 2009 was the result of Dr. Pattillo's leadership and her vision for SFA elementary teacher preparation programs as a place where children learn, student teachers observe and work in model classrooms and elementary education faculty teach classes and work all in the same building; and

WHEREAS, her life of dedication to teaching and learning has touched the lives of thousands of young children and shaped the teaching practices of teachers in Texas and beyond;

NOW, THEREFORE, LET IT BE RESOLVED, the Board of Regents expresses its admiration, gratitude and high regard for Dr. Janice Pattillo by naming Early Childhood Research Center at Stephen F. Austin State University the Janice Pattillo Early Childhood Research Center

Stephen F. Austin State University
Minutes of the Board of Regents
July 18 and 19, 2011

Mr. and Mrs. Jim Perkins

Mr. and Mrs. Tom Wright

William Arscott, 2010

Steve McCarty (left) and Homer Bryce (right)

President, Dr. Baker Pattillo and Athletic Director Emeritus, Steve McCarty, 2008

Lumberjack Landing, 2011

Senator Kay Bailey Hutchison, SFA Library, 2012

Charlie Wilson, 2004

James Campbell Plaza Dedication, 2012

President Baker Pattillo and Provost Steven H. Bullard, 2016

Dr. Todd Brown, 2010

Left to Right: Betty Ford, Bob Sitton and Mitzi Blackburn, 2012

SFA Azalea Gardens

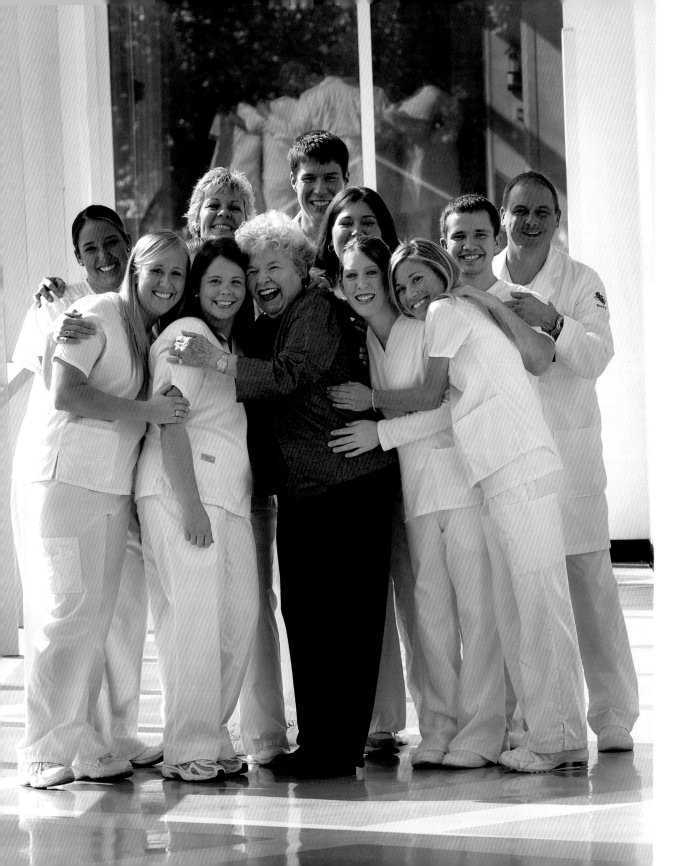

Lucille Marie DeWitt, 2008

THE OLDEST TOWN IN TEXAS HAS GOT IT COOKING